THE GREATEST THREAD AND NEEDLE IN THE WORLD.

DESIGNED BY SUSAN MARSH

TYPE COMPOSED IN ITC BODONI BY DUKE & COMPANY

PREPRESS BY QUEBECOR WORLD PREMEDIA-LEXINGTON

PRINTED ON MOHAWK SUPERFINE PAPER

BY GRAFOS, BARCELONA, SPAIN

Index

- *Sits atop a small elephant designed by Gianlorenzo Bernini*
- *Pair to an obelisk now in Urbino, Italy*

ROME, PIAZZA DELLA ROTONDA

- Inscribed for Pharaoh Ramesses II (1279–1213 BCE) and raised in Heliopolis
- Brought to Rome at an unknown date; raised in the Serapaeum
- Set up by the Church of San Macuto around 1400
- Moved to the Piazza della Rotonda (in front of the Pantheon) for Pope Clement XI in 1711
- *Pair to the obelisk at the Villa Celimontana*

ROME, PIAZZA DI MONTECITORIO

- Inscribed for Pharaoh Psammetichus II (595–589 BCE) and raised at Heliopolis
- Moved to Rome by Emperor Augustus in 10 BCE; raised in the Campus Martius as the gnomon of a meridian instrument
- Discovered several times between 1500 and 1750
- Erected for Pope Pius VI outside the Curia Apostolica (now Palazzo Montecitorio) in 1792
- *Sometimes called the Solarium or Horologium obelisk*

ROME, PIAZZA DI SAN GIOVANNI IN LATERANO

- Begun by Pharaoh Thutmose III (1479–1425 BCE); finished by Pharaoh Thutmose IV (1400–1390 BCE), and erected at Karnak
- Moved to Alexandria by Emperor Constantine between about 324 and 337 CE
- Moved to Rome by Emperor Constantius; raised in the Circus Maximus in 357 CE
- Excavated and erected for Pope Sixtus V at San Giovanni in Laterano in 1588

ROME, PIAZZA NAVONA

- Inscribed for Roman Emperor Domitian, after 81 CE
- Raised in Rome at the Serapaeum
- Moved by Emperor Maxentius to the Circus of Maxentius, outside the city, probably between 309 and 312 CE
- Excavated and erected for Pope Innocent X in the Piazza Navona in 1650
- *Centerpiece of Gianlorenzo Bernini's Fountain of the Four Rivers*

ROME, TRINITÀ DEI MONTI (SPANISH STEPS)

- 1st- or 2nd-century-CE Roman copy of the obelisk now in the Piazza del Popolo
- Excavated in 1734; moved to the Lateran by Pope Clement XII
- Erected at the Trinità dei Monti for Pope Pius VI in 1789
- *Sometimes called the Sallustian obelisk*

ROME, VILLA CELIMONTANA

- Inscribed for Pharaoh Ramesses II (1279–1213 BCE) and raised in Heliopolis
- Brought to Rome at an unknown date; raised in the Serapaeum
- Set up on the Capitoline Hill in the 14th century
- Presented to Ciriaco Mattei by the Roman government in 1582 and set up in his garden
- Restored around 1820, perhaps after falling
- *Pair to the obelisk at the Piazza della Rotonda*

VATICAN CITY, PIAZZA DI SAN PIETRO

- Made for an unidentified pharaoh
- Raised in Alexandria by Cornelius Gallus between 28 and 26 BCE
- Moved to Rome by Emperor Nero around 37 CE; raised in the Vatican Circus
- Moved for Sixtus V to the front of St. Peter's in 1586
- *Only Roman obelisk to remain standing through the Middle Ages*

1803; incorporated into a monument to General Desaix (one of Napoleon's generals in Egypt) in 1810; removed 1814
- Purchased by King Ludwig I of Bavaria in 1815; moved to Munich, erected in the Egyptian Room of the Glyptothek
- Toppled and damaged in an air raid, 1943 or 1944
- Re-erected in the Hofgarten in 1972, outside the Egyptian collection in the Residenz

NEW YORK, CENTRAL PARK
- Inscribed for Pharaoh Thutmose III (1479–1425 BCE) and raised at Heliopolis
- Moved to Alexandria by Emperor Augustus between 23 and 12 BCE; erected in front of the Caesarium
- Moved to New York in 1881; erected in Central Park, just west of the Metropolitan Museum of Art in 1882
- *Usually called Cleopatra's Needle*
- *Pair to the London obelisk*

PARIS, PLACE DE LA CONCORDE
- Inscribed for Pharaoh Ramesses II (1279–1213 BCE) and raised at Luxor
- Moved to Paris in 1836; erected in the Place de la Concorde
- *Pair to the remaining obelisk in Luxor*

ROME, MONTE PINCIO
- Inscribed for Emperor Hadrian and dedicated to his deified lover, Antinous, between 130 and 138 CE; erected at a mortuary chapel in Rome (exact location unknown)
- Appropriated by Sixtus Varius Marcellus or his son, Heliogabalus, between 200 and 225 CE; transported to the Circus Varianus
- Excavated in 1570; erected in same location, now the gardens of the Saccoccia brothers
- Toppled and reburied, possibly during reconstruction of the Acqua Vergine around 1585
- Excavated again in 1630; transported

to Via Quattro Fontane by Cardinal Francesco Barberini
- Pieces placed in front of the Palazzo Barberini; never erected there
- Erected in the public park on Monte Pincio in 1822, for Pope Pius VII

ROME, PIAZZA DELL'ESQUILINO
- Original date and pharaoh unclear
- Set up in Rome in the 1st century CE, at the Mausoleum of Augustus
- Excavated in 1519; pieces placed in Via di Ripetta
- Pieces moved to the Esquiline Hill in 1585 or 1586, by order of Pope Sixtus V
- Erected for Sixtus V at the Basilica of Santa Maria Maggiore in 1587
- *Sometimes called the Esquiline obelisk*
- *Pair to the obelisk in Piazza del Quirinale*

ROME, PIAZZA DEL POPOLO
- Inscribed for Pharaoh Seti I (1294–1279 BCE) and Pharaoh Ramesses II (1279–1213 BCE) and raised at Heliopolis
- Moved to Rome by Emperor Augustus around 10 BCE; raised in the Circus Maximus
- Excavated and erected for Pope Sixtus V in the Piazza del Popolo in 1589
- *Sometimes called the Flaminian obelisk*

ROME, PIAZZA DEL QUIRINALE
- Original date and pharaoh unclear
- Set up in Rome in the 1st century CE, at the Mausoleum of Augustus
- Excavated in 1781; erected on the Quirinal Hill for Pope Pius VI in 1786
- *Pair to the obelisk at the Piazza dell'Esquilino*

ROME, PIAZZA DELLA MINERVA
- Inscribed for Pharaoh Apries (589–570 BCE)
- Brought to Rome at an unknown date; raised in the Serapaeum
- Excavated and erected for Pope Alexander VII outside the church of Santa Maria sopra Minerva in 1665

The Wandering Obelisks: A Cheat Sheet

What follows is neither a catalogue of all obelisks nor a list of every obelisk that has been moved. Rather, this list is meant to help readers keep track of the wandering obelisks mentioned in this book, who raised them, who moved them, and when.

DORSET, ENGLAND, KINGSTON HALL
- Inscribed for Pharaoh Ptolemy IX (107–80 BCE) and raised at the temple of Isis in Philae
- Discovered in 1815 by William John Bankes
- Moved to Kingston Lacy in 1819 by Giovanni Belzoni
- *Known as the Bankes obelisk*

FLORENCE, BOBOLI GARDENS
- Inscribed for Pharaoh Ramesses II (1279–1213 BCE) and raised in Heliopolis
- Brought to Rome at an unknown date; raised in the Serapaeum
- Erected at Rome's Villa Medici about 1587 by Cardinal Fernando de'Medici
- Moved to Florence in 1790; raised behind the Palazzo Pitti in the Boboli Gardens

ISTANBUL, HIPPODROME
- Inscribed for Pharaoh Thutmose III (1479–1425 BCE) and raised at Karnak
- Moved to Alexandria by Emperor Constantius II, probably in the 350s CE
- Moved to Constantinople by Emperor Theodosius I; erected in the Hippo-drome (Circus) in 390 CE

LONDON, THAMES EMBANKMENT
- Inscribed for Pharaoh Thutmose III (1479–1425 BCE) and raised at Heliopolis
- Moved to Alexandria by Emperor Augustus between 23 and 12 BCE; erected in front of the Caesarium
- Moved to London in 1877–78; erected on the Thames Embankment
- *Usually called Cleopatra's Needle*
- *Pair to the New York obelisk*

MUNICH, RESIDENZ
- Inscribed for a Sextus Africanus, possibly during the reign of Emperor Trajan (98–117 CE)
- In the mid-17th century, described by Athanasius Kircher as part of the fabric of the Palazzo Cavalieri-Maffei in Piazza Branca (now Piazza Cairoli)
- Moved to the Villa Albani in Rome in the 18th century
- Moved to Paris for Napoleon about

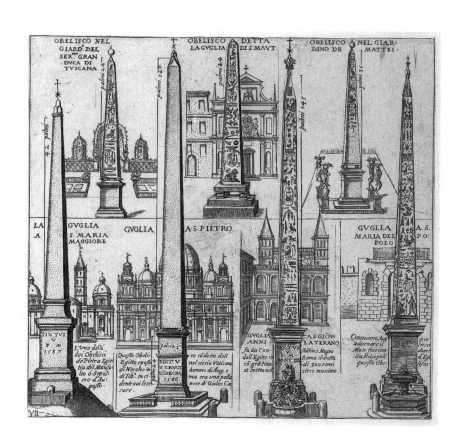

Illustrations

Unless otherwise noted, all images are reproduced courtesy of the Burndy Library Collection, Henry E. Huntington Library, Art Gallery, and Botanical Gardens, San Marino, California.

All efforts have been made to determine the copyright holders of images. Please contact the authors, care of the MIT Press, if you have information regarding images that have been improperly attributed.

TITLE PAGE
Francis Frith, *Fallen Obelisk. Carnac*, late 1850s. Albumen print. Prints and Photographs Division, Library of Congress, Washington, D.C., LC-ppmsca-04544.

INTRODUCTION
page 6: Maison Bonfils, *Obelisk at Heliopolis*, 1868–99. Albumen print. Courtesy Benjamin Weiss.
page 11: Nicolaus van Aelst, *The Lateran Obelisk*, 1589. Engraving.

CHAPTER ONE
page 12: Francis Frith, *Hatshepsut's Obelisk at Karnak*, late 1850s. Albumen print. Courtesy George Eastman House.

page 15: Photographic department, American Colony (Jerusalem), *Egyptian views; Karnak. Avenue of sphinxes in front of 1st pylon*, about 1900–20. Glass plate, stereograph. Eric and Edith Matson Photograph Collection, Prints and Photographs Division, Library of Congress, Washington, D.C., LC-matpc-01536.
page 16: Francis Frith, *The Great Hall &c. Carnac*, late 1850s. Albumen print. Prints and Photographs Division, Library of Congress, Washington, D.C., LC-DIG-ppmsca-04543.
page 17: Maison Bonfils, *Pylon and Obelisk at Luxor*, 1868–99. Albumen print. Prints and Photographs Division, Library of Congress, Washington, D.C., LC-ppmsca-03979.
page 19 (left): Angelo Maria Bandini, *De obelisco Caesaris Augusti* (Rome, 1750) plate 1 (detail).
page 19 (right): Obelisk of Ihy, Dynasty 6, about 2323–2150 BCE. Found at Giza, G 5221, offering room debris. Limestone. Height: 64 cm (25 3/16 in). Museum of Fine Arts, Boston. Harvard University–Boston Museum of Fine Arts Expedition, 21.958. Photograph © 2007 Museum of Fine Arts, Boston.
page 22: Courtesy Brian Curran.

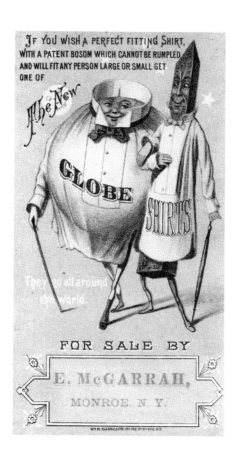

of the Obelisk. With the Details of Experiments Made in Quarrying the Granite. Boston: Printed by S. N. Dickinson, 1843.

Wilson, Erasmus. Cleopatra's Needle, with Brief Notes on Egypt and Egyptian Obelisks. London: Brain and Co., 1878.

Winckelmann, Johann Joachim. History of Ancient Art. Trans. G. Henry Lodge. 2 vols. Boston, 1860. Repr. New York: F. Ungar Pub. Co., 1969.

———. Werke. 2 vols. Stuttgart: Hofmann, 1847.

Winner, Matthias. "Raffael malt einen Elefanten." Mitteilungen des Kunsthistorischen Institutes in Florenz 11 (1964) 71–109.

Wirsching, Armin. "Das Doppelschiff: die Altägyptische Technologie zur Beförderung schwerster Steinlasten." Studien zur altägyptischen Kultur 27 (1999) 389–408.

———. "How the Obelisks Reached Rome: Evidence of Roman Double-Ships." International Journal of Nautical Archaeology 29 (2000) 273–83.

———. "Die Obelisken auf dem Seeweg nach Rom." Mitteilungen des Deutschen Archäologischen Instituts 109 (2002) 141–56.

The Wisdom of Egypt: Changing Visions Through the Ages. Ed. Peter Ucko and Timothy Champion. London: UCL Press, 2003.

Witt, Reginald E. Isis in the Graeco-Roman World. Ithaca: Cornell University Press, 1971.

Wittkower, Rudolf. Allegory and the Migration of Symbols. London: Thames & Hudson, 1977.

———. Studies in the Italian Baroque. London: Thames & Hudson, 1975.

Woolf, Anne. How Many Miles to Babylon? Travels and Adventures to Egypt and Beyond. Liverpool: Liverpool University Press, 2003.

Yates, Frances A. Giordano Bruno and the Hermetic Tradition. London: Routledge and Kegan Paul, 1964.

Zanker, Paul. The Power of Images in the Age of Augustus. Ann Arbor: University of Michigan Press, 1988.

Zen, Stefano. Baronio storico: Controriforma e crisi del metodo umanistico. Naples: Vivarium, 1994.

Ziegler, Jakob, et al. In C. Plinii De naturali historia librum secundum commentarius: quo difficultates Plinianae, praesertim astronomicae, omnes tolluntur.... Basel: Excudebat Henricus Petrus, 1531.

Zippel, Giuseppe. Niccolò Niccoli. Contributo alla storia dell'umanesimo. Florence: Bocca, 1890.

Zoega, Georg. Briefe und Dokumente, I: 1755–1785. Ed. Øjvind Andreasen. Copenhagen: Munksgaard, 1957.

———. De origine et usu obeliscorum. Rome: typis Lazzarinii typographi cameralis, 1797.

Zuccari, Alessandro. I pittori di Sisto V. Rome: Palombi, 1992.

Zweite, Armin. Barnett Newman: Paintings, Sculptures, Works on Paper. Rev. ed. Trans. John Brogden. Ostfildern-Ruit: Hatje Cantz, 1999.

"Viator." *Sur l'emplacement de l'obé-
lisque de Louqsor.* Paris: Imprimerie
de decourchant, [1833].

Viggiani, Claudia. *Exploring EUR,
Cultural Itineraries.* Rome: Eur SpA,
[n.d.].

*La Villa di Massenzio sulla Via Appia:
Il Circo.* Ed. Giovanni Ioppolo and
Giuseppina Pisani Sartorio. Rome:
Istituto Nazionale di Studi Romani,
1999.

*Villa Torlonia: l'ultima impresa del
mecenatismo romano.* Ed. Alberta
Campitelli. Rome: Istituto Poli-
grafico e Zecca dello Stato, Libreria
dello Stato, 1997.

Visceglia, Maria Antonietta. "Buro-
crazia, mobilità sociale e patronage
alla corte di Roma tra cinque e
seicento: Alcuni aspetti del recente
dibattito storiografico e prospettive
di ricerca." *Roma moderna e con-
temporanea* 3 (1995) 11–55.

Vitruvius. *Ten Books on Architecture.*
Ed. Thomas Noble Howe. Trans.
Ingrid D. Rowland. Cambridge:
Cambridge University Press, 1999.

Vittozzi, Serena Ensoli. *Musei Capito-
lini: La Collezione Egizia.* Rome:
Silvana editoriale, 1990.

Volkmann, Ludwig. *Bilderschriften der
Renaissance.* Leipzig: K. W. Hierse-
mann, 1923.

*Voyages en Égypte des années 1589, 1590,
& 1591, le vénitien anonyme, le sei-
gneur de Villamont, Jan Sommer.*
Ed. Carla Burri, et al. Collection des
voyageurs occidentaux en Égypte 3.
Cairo: Institut Français d'Archéo-
logie Orientale, 1971.

Walker, D. P. *The Ancient Theology.*
London: Duckworth, 1972.

Warren, George Washington. *History of
the Bunker Hill Monument Associa-
tion During the First Century of the
United States of America.* Boston:
J. R. Osgood, 1877.

Weinstein, Donald. *Savonarola and
Florence.* Princeton: Princeton
University Press, 1970.

Weiss, Roberto. "The Medals of Julius II
(1503–1513)." *Journal of the Warburg
and Courtauld Institutes* 28 (1964)
163–82.

———. *The Renaissance Discovery of
Classical Antiquity.* 2nd ed. London,
1969. Repr. New York: Humanities
Press, 1988.

———. "Traccia per una biografia di
Annio da Viterbo." *Italia medioevale
e umanistica* 5 (1962) 425–41.

Weisse, John Adam. *The Obelisk and
Freemasonry According to the Discov-
eries of Belzoni and Commander
Gorringe: Also, Egyptian Symbols
Compared with those Discovered in
American Mounds.* New York: J. W.
Bouton, 1880.

West, Nathanael. *Miss Lonelyhearts and
The Day of the Locust.* New York: New
Directions Books, 1933, 1962.

Wheelock, Arthur. *A Collector's Cabinet.*
Exh. cat. National Gallery of Art,
Washington. Washington, D.C.:
National Gallery of Art, 1998.

Wheildon, William W. *Memoir of Solo-
mon Willard. Architect and Super-
intendent of the Bunker Hill Monu-
ment.* Boston: Prepared and printed
by direction of the Monument Asso-
ciation, 1865.

White, K. D. *Greek and Roman Technol-
ogy.* Ithaca: Cornell University Press,
1984.

Whitehouse, Helen. "Egyptology
and Forgery in the Seventeenth
Century." *Journal of the History of
Collections* 1 (1989) 187–95.

Wild, Robert A. *Water in the Cultic
Worship of Isis and Sarapis.* Leiden:
E. J. Brill, 1981.

Wilkinson, John Gardner. *Hand-book
for Travellers in Egypt: Including
Descriptions of the Course of the Nile
to the second Cataract, Alexandria,
Cairo, the Pyramids, and Thebes,
the overland transit to India, the
peninsula of Mount Sinai, the oases,
&c. Being a new ed., corr. and con-
densed, of Modern Egypt and Thebes.*
London: J. Murray, 1847.

Willard, Solomon. *Plans and Sections*

vita e geste di Sisto quinto sommo pontefice dell'ordine de' Minori Conventuali di S. Francesco. Rome: a spese de' Remondini di Venezia, 1758.

Temples of Ancient Egypt. Ed. Byron E. Shafer. Ithaca: Cornell University Press, 1997.

Testaguzza, Otello. *Portus: Illustrazione dei porti di Claudio e Traiano e della città di Porto a Fiumicino.* Ed. R. Peliti. Rome: Julia, 1970.

Testi umanistici su l'Ermetismo. Ed. Eugenio Garin, et al. Rome: Bocca, 1955.

Thieme, Thomas. "La geometria di Piazza San Pietro." *Palladio* 23 (1973) 129–44.

Thompson, Jason. *Sir Gardner Wilkinson and His Circle.* Austin: University of Texas Press, 1992.

Topografia ed edilizia di Roma antica. Studi e materiali del Museo della Civiltà Romana 13. Rome: "L'Erma" di Bretschneider, 1989.

Train, George Francis. *An American Merchant in Europe, Asia, and Australia: A Series of Letters from Java, Singapore, China, Bengal, Egypt, and the Holy Land . . . etc.* New York: G. P. Putnam & Co., 1857.

Traveling Through Egypt: From 450 B.C. to the Twentieth Century. Ed. Deborah Manley and Sahar Abdel-Hakim. Cairo: The American University in Cairo Press, 2004.

Two Renaissance Book Hunters: The Letters of Poggius Bracciolini to Nicolaus de Niccolis. Ed. and trans. Phyllis Walter Goodhart Gordan. New York: Columbia University Press, 1974.

Tyldesley, Joyce A. *Hatshepsut, the Female Pharaoh.* London: Penguin, 1998.

Ullman, Berthold L. *The Origin and Development of Humanistic Script.* Rome: Edizioni di storia e letteratura, 1960.

Valeriano, Pierio. *Hieroglyphica: Lyon, 1602.* The Renaissance and the Gods 17. Lyon, 1602. Repr. New York: Garland, 1976.

———. *Hieroglyphica, sive De sacris Aegyptiorum, aliarumque gentium literis commentarij Ioannis Pierii Valeriani. . . .* Basel: apud Thomam Guarinum, 1575.

della Valle, Pietro. *The Pilgrim: The Travels of Pietro della Valle.* Ed. and trans. George Bull. London: Hutchinson, 1989.

———. *Viaggi di Pietro della Valle il Pellegrino: descritti da lui medesimo in lettere familiari: all'erudito suo amico Mario Schipano.* 3 vols. Bologna: Presso Gioseffo Longhi Valle, 1672.

Vasari, Giorgio. *Le opere di Giorgio Vasari.* 2nd ed. Ed. Gaetano Milanesi. 9 vols. Florence, 1906. Repr. Florence: Sansoni, 1981.

Verninac de Saint Maur, Raimond Jean-Baptiste de. *Voyage du Luxor en Égypte: entrepris par ordre du roi pour transporter de Thèbes à Paris l'un des obélisques de Sésostris.* Paris: Arthus Bertrand, 1835.

Verrocchio and Late Quattrocento Italian Sculpture. Ed. Steven Bule and Alan P. Darr. Florence: Le Lettere, 1992.

Vespasiano da Bisticci. Renaissance Princes, Popes and Prelates: The Vespasiano Memoirs. Ed. Myron Gilmore. Trans. William George and Emily Waters. New York: Harper & Row, 1963.

Vespignani, Giorgio. *Il Circo di Constantinopoli nuova Roma.* Quaderni della Rivista di Bizantinistica 4. Spoleto: Centro Italiano di Studi sull'alto medioevo, 2001.

Vestigia: Studi in onore di Giuseppe Billanovich. Ed. Rino Avesani, et al. 2 vols. Storia e letteratura 162, 163. Rome: Edizioni di storia e letteratura, 1984.

Viaggiatori veneti alla scoperta dell'Egitto. Ed. Alberto Siliotti. Exh. cat. Museo archeologico del Teatro romano, Verona. Venice: Arsenale editrice, 1985.

Simoncini, Giorgio. *Roma restaurata: Rinnovamento urbano al tempo di Sisto V.* Florence: Leo S. Olschki, 1990.

Sisto V. Ed. Marcello Fagiolo and Maria Luisa Madonna. 2 vols. Rome: Istituto Poligrafico e Zecca dello Stato, 1992.

Sketchley, Arthur. *Mrs. Brown on Cleopatra's Needle.* London: G. Routledge and Sons, about 1879.

Slonimsky, Nicolas. *Perfect Pitch: A Life Story.* Oxford; New York: Oxford University Press, 1988.

Solé, Robert. *Le grand voyage de l'obélisque.* Paris: Editions du Seuil, 2004.

Solmsen, Friedrich. *Isis among the Greeks and Romans.* Martin Classical Lectures 25. Cambridge, Mass.: Published for Oberlin College by Harvard University Press, 1979.

Soros, Susan Weber. *James "Athenian" Stuart, 1713–1788. The Rediscovery of Antiquity.* Exh. cat. Bard Graduate Center for Studies in the Decorative Arts, Design, and Culture. New Haven: Published for the Bard Graduate Center for Studies in the Decorative Arts, Design, and Culture by Yale University Press, 2006.

Spargo, John Webster. *Virgil the Necromancer: Studies in Virgilian Legends.* Cambridge, Mass.: Harvard University Press, 1934.

Spezzaferro, Luigi, and Maria Elisa Tittoni Monti. *Il Campidoglio e Sisto V.* Rome: Edizioni Carte segrete, 1991.

Spring, Peter. "The Topographical and Archaeological Study of the Antiquities of Rome 1420–1447." Ph.D. diss., University of Edinburgh, 1972.

Steinmetz, Wiebke. *Heinrich Rantzau (1526–1598): Ein Vertreter des Humanismus in Nordeuropa und seine Wirkungen als Förderer der Künste.* Frankfurt: Peter Lang, 1991.

Stenhouse, William. *Reading Inscriptions and Writing Ancient History: Historical Scholarship in the Late Renaissance.* Bulletin of the Institute of Classical Studies, Supplement 86. London: Institute of Classical Studies, 2005.

Stephens, Walter, Jr. *Giants in Those Days: Folklore, Ancient History, and Nationalism.* Lincoln: University of Nebraska Press, 1989.

Stinger, Charles R. *The Renaissance in Rome.* Bloomington: University of Indiana Press, 1985.

Stolzenberg, Daniel. "Egyptian Oedipus: Antiquarianism, Oriental Studies, and Occult Philosophy in the Work of Athanasius Kircher." Ph.D. diss., Stanford University, 2003.

Storia della Chiesa di Cesena. Ed. Marino Mengozzi. 3 vols. Cesena: Editrice Stilgraf, 1998.

Strabo. *The Geography of Strabo.* Trans. Horace Leonard Jones. 8 vols. Loeb Classical Library. Cambridge, Mass.: Harvard University Press, 1960–70.

Strasser, G. F. "La contribution d'Athanasius Kircher à la tradition humaniste hiéroglyphique." *XVIIe Siècle* 40 (1988) 79–82.

Sutcliffe, Anthony. *Paris. An Architectural History.* New Haven; London: Yale University Press, 1993.

Swinburne, Algernon Charles. *Letters.* Ed. Cecil Y. Lang. 6 vols. New Haven: Yale University Press, 1959–62.

Syndram, Dirk. *Die Ägyptenrezeption unter August dem Starken: Der "Apis-Altar" Johann Melchior Dinglingers.* Mainz: Verlag Philipp von Zabern, 1999.

Takács, Sarolta A. *Isis and Sarapis in the Roman World.* Religions in the Graeco-Roman World 124. Leiden: E. J. Brill, 1995.

Talvacchia, Bette. *Taking Positions: On the Erotic in Renaissance Culture.* Princeton: Princeton University Press, 1999.

Tempesti, Casimiro Liborio. *Storia della*

tianizing *Monuments of Imperial Rome*. Études préliminaires aux religions orientales dans l'empire romain 20. Leiden: E. J. Brill, 1972.

Rowland, Ingrid D. *The Culture of the High Renaissance: Ancients and Moderns in Sixteenth-Century Rome*. Cambridge: Cambridge University Press, 1998.

———. *The Ecstatic Journey: Athanasius Kircher in Baroque Rome*. Chicago; London: University of Chicago Press, 2000.

———. *The Scarith of Scornello: A Tale of Renaissance Forgery*. Chicago; London: University of Chicago Press, 2004.

———. "'Th' United Sense of th' Universe': Athanasius Kircher in Piazza Navona." *Memoirs of the American Academy in Rome* 46 (2001) 153–81.

Ruderman, David. "Giovanni Mercurio da Correggio's Appearance as Seen Through the Eyes of an Italian Jew." *Renaissance Quarterly* 28 (1975) 309–22.

Salvolini, François. *Traduction et analyse grammaticale des inscriptions sculptées sur l'obélisque égyptien de Paris, suivie d'une notice relative à la lecture des noms de rois qui y sont mentionnés*. Paris: Imprimerie de Vᵉ Dondey-Dupré, 1837.

Sampsell, Bonnie M. *A Traveler's Guide to the Geology of Egypt*. Cairo; New York: American University in Cairo Press, 2003.

Sandys, George. *A relation of a iourney begun an: Dom: 1610: Foure bookes. Containing a description of the Turkish Empire, of Ægypt, of the Holy Land, of the remote parts of Italy, and ilands adioyning*. London: Printed [by Richard Field] for W: Barrett, 1615.

Sarton, George. "Agrippa, Fontana and Pigafetta: The erection of the Vatican obelisk in 1586." *Archives Internationales d'Histoire des Sciences* 8 (1949) 827–54.

Saxl, Fritz. *Lectures*. 2 vols. London: Warburg Institute, University of London, 1957.

Scalamonti, Francesco. "Vita viri clarissimi et famosissimi Kyriaci Anconitani." Ed. and trans. Charles Mitchell and Edward W. Bodnar, S.J. *Transactions of the American Philosophical Society* 86, pt. 4. Philadelphia: American Philosophical Society, 1996.

Scamuzzi, Ernesto. *La Mensa Isiaca del Regio Museo di Antichità di Torino*. Rome: G. Bardi-Editore, 1939.

Scarlini, Luca. *Le opere e i giorni. Angelo Maria Bandini collezionista e studioso*. Florence: Edizioni Polistanpa, 2003.

Scarpellini, Pietro, and Maria Rita Silvestrelli. *Pintoricchio*. Milan: Federico Motta, 2004.

von Schlosser, Julius. *Die Kunst- und Wunderkammern der Spätrenaissance: ein Beitrag zur Geschichte des Sammelwesens*. Leipzig: Klinkhardt & Biermann, 1908.

Schmidt-Biggemann, Wilhelm. *Philosophia Perennis*. Dordrecht: Springer, 2004.

Schott, Gaspar. *Mechanica hydraulico-pneumatica*. Frankfurt: Sumptu heredum Joannis Godefridi Schönwetteri, 1657.

Schütz, Michael. "Zur Sonnenuhr des Augustus auf dem Marsfeld." *Gymnasium* 97 (1990) 432–57.

Seznec, Jean. *The Survival of the Pagan Gods*. New York: Pantheon Books, 1953.

Sforza, Giovanni. "Episodi della storia di Roma nel secolo XVIII." *Archivio storico italiano* 4th ser., 19, 20 (1887) various locations.

Shalev, Zur. "Measurer of All Things: John Greaves (1602–1652), the Great Pyramid, and Early Modern Metrology." *Journal of the History of Ideas* 63:4 (2002) 555–75.

Shaw, Christine. *Julius II: The Warrior Pope*. Oxford; New York: Blackwell, 1993.

Ramesside Inscriptions Translated and Annotated. Ed. Kenneth A. Kitchen. 2 vols. Oxford: Blackwell Publishers, 1996.

Ramus, Petrus. *P. Rami professio regia hoc est Septem artes liberales: in regia cathedra per ipsum Parisiis apodictico docendi genere propositæ & per Ioan. Thomam Freigivm in tabulas perpetuas . . . ad publicum omnium Rameæ philosophiæ studiosorum usum editæ. . . .* Basel: Per Sebastianum Henricpetri, 1576.

Randolph Parks, N. "On the Meaning of Pinturicchio's Sala dei Santi." *Art History* 2 (1979) 291–317.

Ray, John. *Observations topographical, moral, & physiological made in a journey through part of the low-countries, Germany, Italy, and France: with a catalogue of plants not native of England, found spontaneously growing in those parts, and their virtues . . . ; whereunto is added a brief account of Francis Willughby, Esq., His voyage through a great part of Spain.* London: Printed for John Martyn . . . , 1673.

del Re, Niccolò. *La curia capitolina.* Rome: Regionale, 1954.

———. *La curia romana: Lineamenti storico-giuridici.* 3rd ed. Rome: Edizioni di Storia e Letteratura, 1970.

Redding, Moses Wolcott. *The Scarlet Book of Free Masonry; containing a thrilling and authentic account of the imprisonment, torture, and martyrdom of Free Masons and Knights Templars, for the past six hundred years.* New York: Redding and Co., 1889.

Reid, Donald Malcolm. *Whose Pharaohs? Archaeology, Museums, and Egyptian National Identity from Napoleon to World War I.* Berkeley: University of California Press, 2002.

Reill, Peter Hanns. *The German Enlightenment and the Rise of Historicism.* Berkeley: University of California Press, 1975.

Repertori di parole e immagini: Esper-

ienze cinquecentesche e moderni data bases. Ed. Paola Barocchi and Lina Bolzoni. Pisa: Scuola Normale Superiore, 1997.

The Republic of Letters and the Levant. Ed. Alastair Hamilton, Maurits H. van den Boogert, and Bart Westerweel. Leiden: E. J. Brill, 2005.

Rheticus, Georg. *Georgii Joachimi Rhetici Narratio prima.* Ed. and trans. Henri Hugonnard-Roche, et al. Studia Copernicana 20. Wrocław: Ossolineum, 1982.

Riccomini, Anna Maria. *La ruina di si bela cosa: Vicende e trasformazioni del Mausoleo di Augusto.* Milan: Electa, 1996.

Richter, Otto. *Topographie der Stadt Rom.* 2nd ed. Munich: C. H. Beck, 1901.

Rivosecchi, Valerio. *Esotismo in Roma barocca: Studi sul Padre Kircher.* Rome: Bulzoni, 1982.

Roma di Sisto V: le arti e la cultura. Ed. M. L. Madonna. Exh. cat. Palazzo Venezia. Rome: Edizioni de Luca, 1993.

Roma, Centro ideale della cultura dell'Antico nei secoli XV e XVI: Da Martino V al Sacco di Roma 1417–1527. Ed. Silvia Danesi Squarzina. Milan: Electa, 1989.

Rome Reborn: The Vatican Library and Renaissance Culture. Ed. Anthony Grafton. Exh. cat. Library of Congress. New Haven; London: Yale University Press, 1993.

Roorda, Eric. *The Dictator Next Door: The Good Neighbor Policy and the Trujillo Regime in the Dominican Republic, 1930–1945.* Durham: Duke University Press, 1998.

Rosenberg, Harold. *Barnett Newman: Broken Obelisk and Other Sculptures.* Seattle: Published for the Henry Art Gallery by the University of Washington Press, 1971.

Rossi, Corinna. *Architecture and Mathematics in Ancient Egypt.* Cambridge: Cambridge University Press, 2004.

Roullet, Anne. *The Egyptian and Egyp-*

tecture, and Design. 2 vols. London: Thames & Hudson, 1968.

———, and S. Lang. "The Egyptian Revival." *Architectural Review* 119 (1956) 242–54.

Phillipson, D. W. "The Significance and Symbolism of Aksumite Stelae." *Cambridge Archaeological Journal* 4 (1994) 189–210.

Pico della Mirandola, Giovanni. *De hominis dignitate, Heptaplus, De ente et uno, e scritti vari.* Ed. Eugenio Garin. Florence: Vallecchi, 1942.

Pigafetta, Filippo. *Discorso di M. Filippo Pigafetta d'intorno all'historia della Aguglia, et alla ragione del muoverla.* Rome: Bartolomeo Grassi, 1586.

Pignoria, Lorenzo. *Mensa Isiaca, qua sacrorum apud Aegyptios ratio & simulachra subiectis tabulis aeneis simul exhibentur & explicantur.* Amsterdam: Sumptibus Andreae Frisii, 1670.

Piranèse et les Français, colloque tenu à la Villa Médicis, 12–14 Mai 1976. Ed. Georges Brunel. Collection Académie de France à Rome 2. Rome: Edizioni dell'Elefante, 1978.

Piranesi, Giovanni Battista. *Diverse maniere di adornare i cammini ed ogni altra parte degli edifizi: desunte dall'architettura Egizia, Etrusca, e Greca con un Ragionamento Apologetico in difesa dell'Architettura Egizia, e Toscana.* Rome: Nella Stamperia di Generoso Salomoni, 1769.

Plato. *Laws.* Trans. R. G. Bury. 2 vols. Loeb Classical Library. Cambridge, Mass.; London: Heinemann, 1926.

———. *The Collected Dialogues of Plato, Including the Letters.* Ed. Edith Hamilton and Huntington Cairns. 2nd printing. Princeton: Princeton University Press, 1963.

Pliny the Elder. *Natural History.* Ed. and trans. H. Rackham, W. H.-S. Jones, and D. E. Eichholz. 10 vols. Loeb Classical Library. Cambridge, Mass.: Harvard University Press; London: W. Heinemann, 1938–63.

Pococke, Richard. *A Description of the East and Some Other Countries.* 2 vols. London: Printed for the author, 1743–45.

'A Poet in Paradise': Lord Lindsay and Christian Art. Ed. Aidan Weston-Lewis. Exh. cat. National Gallery of Scotland. Edinburgh: National Gallery of Scotland, 2000.

Poeschel, Sabine. *Alexander Maximus: Das Bildprogramm des Appartamento Borgia im Vatikan.* Weimar: VDG, 1999.

Pollès, Renan. *La Momie de Khéops à Hollywood: Généalogie d'un mythe.* Paris: Amateur, 2001.

Pope, Maurice. *The Story of Decipherment, from Egyptian Hieroglyphs to Maya Script.* Rev. ed. London: Thames & Hudson, 1999.

Popper, Nicholas. "'Abraham, Planter of Mathematics': Histories of Mathematics and Astrology in Early Modern Europe." *Journal of the History of Ideas* 67 (2006) 87–106.

Porterfield, Todd. *The Allure of Empire. Art in Service of French Imperialism, 1798–1836.* Princeton: Princeton University Press, 1998.

Preimesberger, R. "Obeliscus Pamphilius: Beiträge zu Vorgeschichte und Ikonographie des Vierströmebrunnens auf Piazza Navona." *Münchner Jahrbuch der Bildenden Kunst* 25 (1974) 77–162.

Prelovšek, Damjan. *Jože Plečnik, 1872–1957: Architectura Perennis.* Trans. Patricia Crampton and Eileen Martin. New Haven; London: Yale University Press, 1997.

Prown, Jules David. "A Course of Antiquities at Rome, 1764." *Eighteenth-Century Studies* 31.1 (1997) 90–100.

Purcell, Sarah J. "Commemoration, Public Art, and the Changing Meaning of the Bunker Hill Monument." *The Public Historian* 25.2 (2003) 55–71.

Raffaello architetto. Ed. Christoph Liutpold Frommel, Stefano Ray, and Manfredo Tafuri. Milan: Electa, 1984.

Paris: Faite en septembre 1850, par suite de la nouvelle et prodigieuse découverte de la langue originelle et universelle, ainsi que la traduction littérale de la première face de l'Obélisque. . . . Paris: Schlesinger Frères, 1851.

O'Malley, John W. *Trent and All That: Renaming Catholicism in the Early Modern Era.* Cambridge, Mass.: Harvard University Press, 2000.

Der Obelisk des Antinoos: Eine kommentierte Edition. Ed. Alfred Grimm, Dieter Kessler, and Hugo Meyer. Munich: W. Fink Verlag, 1994.

Obeliscus Vaticanus Sixti . V. Pont. Opt. Max. pietate invictissimae cruci sacer opera divina: stabilis ad perpetuitatem: praeclaris eruditorum virorum litteris laudatus egregie. Rome: Bartholomeo Grassi, 1585.

Oestmann, Günther. *Heinrich Rantzau und die Astrologie: ein Beitrag zur Kulturgeschichte des 16. Jahrhunderts.* Braunschweig: Braunschweigisches Landesmuseum, 2004.

Orbaan, J. A. F. *Sixtine Rome.* New York: Baker and Taylor, 1911.

The Origins of Museums: The Cabinet of Curiosities in Sixteenth- and Seventeenth-Century Europe. Ed. Oliver Impey and Arthur MacGregor. Oxford: Oxford University Press, 1985.

Orrison, Katherine. *Written in Stone: Making Cecil B. DeMille's Epic, The Ten Commandments.* New York: Vestal Press, 1990.

Oryshkevich, Irina. "The History of the Roman Catacombs from the Age of Constantine to the Renaissance." Ph.D. diss., Columbia University, 2003.

Oxford Classical Dictionary. 3rd ed. rev. Ed. Simon Hornblower and Antony Spawforth. Oxford: Oxford University Press, 2003.

The Oxford Encyclopedia of Ancient Egypt. Ed. Donald B. Redford. 3 vols. Oxford: Oxford University Press, 2001.

The Oxford History of Ancient Egypt. New ed. Ed. Ian Shaw. Oxford: Oxford University Press, 2000.

Pankhurst, Richard. "Ethiopia, the Aksum Obelisk, and the Return of Africa's Cultural Heritage." *African Affairs* 98 (1999) 229–39.

Panofsky, Erwin. "Canopus Deus: The Iconography of a Non-Existent God." *Gazette des Beaux-Arts* 6.57 (1961) 193–216.

Parisciani, Gustavo. *Sisto V e la sua Montalto.* Padua: EMP, 1986.

Parker, Grant. "Narrating Monumentality: The Piazza Navona Obelisk." *Journal of Mediterranean Archaeology* 16.2 (2003) 193–215.

Parks, N. Randolph. "On the Meaning of Pinturicchio's Sala dei Santi." *Art History* 2 (1979) 291–317.

Parsons, William Barclay. *Engineers and Engineering in the Renaissance.* Baltimore, 1939. Repr. with an introduction by Robert S. Woodbury, Cambridge, Mass.: MIT Press, 1968.

von Pastor, Ludwig. *History of the Popes from the Close of the Middle Ages, Drawn from the Secret Archives of the Vatican and Other Original Sources.* Ed. and trans. Frederick I. Antrobus and Ralph Kerr. 5th edition. 40 vols. London: Kegan Paul, 1923–53.

Patrignani, Antonio. "L'obeliscomania di Sisto V." *Note di medaglistica papale classica* 13.4 (1950) 9–15.

Pecchiai, Pio. *Roma nel cinquecento.* Bologna: Licinio Cappelli, 1948.

Pécout, Roland. *Les Mangeurs de momie: Des tombeaux d'Égypte aux sorciers d'Europe.* Paris: P. Belfond, 1981.

Penni, Giovanni Jacopo. *La magnifica et sumptuoso festa alli S. R. per il Carnevale. M.D. XIII.* Rome: [n.p.], about 1513.

Petzet, M. "Der Obelisk des Sonnenkönigs. Ein Projekt Claude Perraults von 1666." *Zeitschrift für Kunstgeschichte* 47.4 (1984) 439–64.

Pevsner, Nikolaus. *Studies in Art, Archi-*

Where White Men Fear to Tread: The Autobiography of Russell Means. New York: St. Martin's Press, 1995.

Meijer, Cornelis. *L'arte di restituire à Roma la tralasciata navigatione del suo Tevere.* Rome: Nella stamperia del Lazzari Varese, 1685.

Memoria dell'antico nell'arte italiana. Ed. Salvatore Settis. 3 vols. Biblioteca di storia dell'arte, n.s. 1. Turin: G. Einaudi, 1984.

Mercati, A. "Raffaello d'Urbino e Antonio da Sangallo Maestri delle Strade di Rome sotto Leone X." *Rendiconti della Pontificia Accademia Romana di Archeologia* 1 (1923) 121–29.

Mercati, Michele. *De gli obelischi di Roma.* Rome: Domenico Basa, 1589.

———. *Gli obelischi di Roma.* Ed. Gianfranco Cantelli. Rome, 1589. Repr. Bologna: Cappelli Editore, 1981.

Merchants and Marvels: Commerce, Science, and Art in Early Modern Europe. Ed. Pamela H. Smith and Paula Findlen. London; New York: Routledge, 2002.

Mese, Jeanine Guérin-Dalle. *Égypte: La mémoire et le rêve. Itinéraires d'un voyage, 1320–1601.* Biblioteca dell'Archivum Romanicum, 1st ser., Storia, letteratura, paleografia 237. Florence: Leo S. Olschki, 1991.

Miel, François. *Sur l'Obélisque de Louqsor et les embellissements de la Place de la Concorde et des Champs-Élysées, Extrait du "Constitutionnel" des 18 et 26 novembre et 14 décembre 1834.* [Paris]: Impr. de Smith, [1834].

Minor, Heather Hyde. *Reforming Rome: Architecture and Culture, 1730–58.* Ph.D. diss., Princeton University, 2002.

Moiret, Joseph-Marie. *Mémoires sur l'expédition d'Égypte.* L'Épopée Napoléonienne. Paris: Pierre Belfond, 1984.

Moldenke, Charles Edward. *The New York Obelisk, Cleopatra's Needle. With a Preliminary Sketch of the History, Erection, Uses, and Signification of Obelisks.* New York, 1891.

Mozart, Wolfgang Amadeus. *Mozart's Letters, Mozart's Life. Selected Letters.* Ed. and trans. Robert Spaethling. New York; London: W. W. Norton, 2000.

Mucillo, Maria. *Platonismo, ermetismo, e "prisca theologia": ricerche di storiografia filosofica rinascimentale.* Florence: Leo S. Olschki, 1996.

Müller, Hans Wolfgang. *Der Isiskult im Antiken Benevent und Katalog der Skulpturen aus den ägyptischen Heiligtümern im Museo del Sannio zu Benevent.* Berlin: B. Hessling, 1969.

Müller-Wiener, Wolfgang. *Bildlexikon zur Topographie Istanbuls: Byzantion, Konstantinupolis, Istanbul bis zum Beginn d. 17. Jh.* Tübingen: Wasmuth, 1977.

Munro-Hay, Stuart. *Aksum: An African Civilisation of Late Antiquity.* Edinburgh: Edinburgh University Press, 1991.

Muratori, Lodovico Antonio. *Epistolario di L. A. Muratori.* Ed. Matteo Campori. 14 vols. Modena: Tipi dell Società Tipografica Modenese, 1901.

———, and Giuseppe Tartini. *Rerum Italicarum scriptores . . . Supplementum.* 2 vols. Florence: P. C. Viviani, 1748.

Nightingale, Florence. *Letters from Egypt: A Journey on the Nile, 1849–1850.* Ed. Anthony Sattin. New York: Weidenfeld & Nicolson, 1987.

Noakes, Aubrey. *Cleopatra's Needles.* London: H. F. & G. Weatherby, 1962.

Noblecourt, Christiane Desroches. *Ramsès II: La Véritable Histoire.* Paris: Pygmalion/Gérard Watelet, 1996.

Norden, Frederik Ludvig. *Travels in Egypt & Nubia.* 2 vols. London: Lockyer Davis & Charles Reymer, 1757.

Nussdorfer, Laurie. *Civic Politics in the Rome of Urban VIII.* Princeton: Princeton University Press, 1992.

O'Donnelly, Terence Joseph. *Extrait de la traduction authentique des hiéroglyphes de l'Obélisque de Louqsor à*

———. *Inventaire préliminaire des documents égyptiens découverts en Italie.* Leiden: E. J. Brill, 1972.

Manetti, Giannozzo. *De dignitate et excellentia hominis.* Ed. Elizabeth R. Leonard. Thesaurus mundi 12. Padua: Antenore, 1975.

Mantova e l'Antico Egitto da Giulio Romano a Giuseppe Acerbi. Atti del Convegno di Studi, Mantova, 23–24 maggio 1992. Florence: Leo S. Olschki, 1994.

Manuel, Frank. *The Eighteenth Century Confronts the Gods.* Cambridge, Mass., 1959. Repr. New York: Atheneum, 1967.

The Marvels of Rome = Mirabilia urbis Romae. Ed. and trans. Francis Morgan Nichols. 2nd ed., with new introduction, gazetteer, and bibliography by Eileen Gardiner. New York: Italica Press, 1986.

Marangoni, Giovanni. *Delle cose gentilesche, e profane: trasportate ad uso, e adornamento delle chiese.* Rome: Nella stamperia di Niccolò, e Marco Pagliarini, mercanti di libri, e stampatori a Pasquino, 1744.

Marconi, Nicoletta. *Edificando Roma barocca: macchine, apparati, maestranze e cantieri dal XVI al XVIII secolo.* Ricerche, fonti e testi per la storia di Roma 2. Rome: CROMA; Città di Castello (Perugia): Edimond, 2004.

Mariette, Pierre-Jean. *Description des travaux qui ont précédé, accompagné et suivi la fonte en bronze de Louis XV le Bien Aimé. . . .* Paris: De l'Imprimerie de P. G. Le Mercier, 1768.

Marrone, Caterina. *I geroglifici fantastici di Athanasius Kircher.* Viterbo: Nuovi Equilibri, 2002.

Marsilio Ficino e il ritorno di Ermete Trismegisto/Marsilio Ficino and the Return of Hermes Trismegistus. Ed. Sebastiano Gentile and Carlos Gilly. Exh. cat. Biblioteca Medicea Laurenziana, Florence, and Bibliotheca Philosophica Hermetica, Amsterdam. Florence: Centro Di, 1999.

Le Mascrier, Jean-Baptiste, and Benoît de Maillet. *Description de l'Égypte, contenant plusieurs remarques curieuses sur la géographie ancienne et moderne de ce païs. . . .* Paris: L. Genneau et J. Rollin, 1735.

Masini, Francesco. *Discorso di Francesco Masini sopra un modo nuovo, facile, e reale, di trasportar su la Piazza di San Pietro la guglia, ch'è in Roma, detta di Cesare.* Cesena: Bartolomeo Raverij, 1586.

Maspéro, Gaston. "Horapollon et la fin du paganisme égyptien." *Bulletin de l'Institut Français d'Archéologie Orientale* 11 (1914) 164–95.

Master Gregorius. *The Marvels of Rome.* Ed. and trans. John Osborne. Mediaeval sources in translation 31. Toronto: Pontifical Institute of Mediaeval Studies, 1987.

The Mathematics of Egypt, Mesopotamia, China, India, and Islam: A Sourcebook. Ed. Victor J. Katz. Princeton: Princeton University Press, 2007.

Mazzocchi, Jacopo. *Epigrammata antiquae urbis.* Rome: Jacopo Mazzocchi, 1521.

McCahill, Elizabeth. "Humanism in the Theater of Lies: Classical Scholarship in the Early Quattrocento Curia." Ph.D. diss., Princeton University, 2005.

McDowell, Peggy, and Richard E. Meyer. *The Revival Styles in American Memorial Art.* Bowling Green: Bowling Green State University Popular Press, 1994.

McGrath, R. L. "The Old and New Illustrations for Cartari's 'Imagini dei dei degli antichi': A Study of 'Paper Archaeology' in the Italian Renaissance." *Gazette des Beaux-Arts* 6.59 (1963) 213–26.

McLellan, Andrew. *Inventing the Louvre. Art, Politics, and the Origins of the Modern Museum in Eighteenth-Century Paris.* Berkeley: University of California Press, 1994.

Means, Russell, and Marvin J. Wolf.

World. Berkeley: University of California Press, 1978.

Lattimore, Richard. "Portents and Prophecies in Connection with the Emperor Vespasian." *Classical Journal* 29 (1934) 441–49.

Laurens, Henry, et al. *L'Éxpédition d'Égypte, 1798–1801.* Paris: Armand Colin, 1989.

Lebas, Jean-Baptiste Apollinaire. *L'Obélisque de Luxor: histoire de sa translation à Paris.* Paris: Carilian-Goeury et Dalmont, 1839.

Lefcourt, Peter. *The Woody. A Novel.* New York: Simon and Schuster, 1998.

Lehmann, Phyllis Williams. *Cyriacus of Ancona's Egyptian Visit and its Reflections in Gentile Bellini and Hieronymus Bosch.* Locust Valley, N.Y.: J. J. Augustin, 1977.

Lembke, Katja. *Das Iseum Campense in Rom: Studie über den Isiskult unter Domitian.* Archäologie und Geschichte 3. Heidelberg: Verlag Archäologie und Geschichte, 1994.

Leospo, Enrica. *La Mensa Isiaca di Torino.* Leiden: E. J. Brill, 1978.

Leventhal, Robert. "The Emergence of Philological Discourse in the German States, 1770–1810." *Isis* 77 (1986) 243–60.

Lichtheim, Miriam. *Ancient Egyptian Literature. Volume II. The New Kingdom.* Berkeley: The University of California Press, 1976, 2006.

Ligota, C. R. "Annius of Viterbo and Historical Method." *Journal of the Warburg and Courtauld Institutes* 50 (1987) 44–56.

Lindeberg, Peter. *Hypotyposis arcium, palatiorum, librorum, pyramidum, obeliscorum, molarum, fontium, monumentorum et epitaphiorum.* Rostock, 1590. Repr. with changes, Hamburg, 1591 and Frankfurt, 1592.

Liverani, Paolo. *La topografia antica del Vaticano.* Monumenta Sanctae Sedis 2. Vatican City: Monumenti musei e gallerie pontificie, 1999.

Lollio Barberi, O., G. Parola, and M. P.

Toti. *Le antichità egiziane di Roma imperiale.* Rome: Istituto Poligrafico e Zecca dello Stato, Libreria dello Stato, 1995.

Lorand, Sándor. *Clinical Studies in Psychoanalysis.* New York: International Universities Press, 1950.

Luchetta, Giuliano. "Contributi per una biografia di Pierio Valeriano." *Italia medioevale e umanistica* 9 (1966) 461–76.

Lugli, Adalgisa. *Naturalia et mirabilia: Il collezionismo enciclopedico nelle Wunderkammern d'Europa.* Milan: Mazzotta, 1983.

Lumbroso, G. "Descrittori Italiani dell'Egitto e di Alessandria." *Atti della Reale Accademia dei Lincei, Rendiconti, Memorie, Classe di scienze morali, storiche, e filologiche,* 3d ser., 3 (1879) 429–503.

Luzio, A. "Federico Gonzaga, ostaggio alla corte di Giulio II." *Archivio della Reale Società Romana di Storia Patria* 9 (1886) 580.

MacDonald, William L., and John Pinto. *Hadrian's Villa and its Legacy.* New Haven; London: Yale University Press, 1995.

Mackey, Piers. *British Victory in Egypt, 1801.* London; New York: Routledge, 1995.

Malamud, Margaret. "Pyramids in Las Vegas and in Outer Space: Ancient Egypt in Twentieth-Century American Architecture and Film." *Journal of Popular Culture* 34.1 (2000) 31–47.

Magnuson, Torgil. "The Project of Nicholas V for Rebuilding the Borgo Leonino in Rome." *Art Bulletin* 36.2 (1954) 89–115.

———. *Rome in the Age of Bernini.* 2 vols. Stockholm: Almqvist & Wiksell, 1982–86.

Mahé, Jean-Pierre. *Hermès en Haute-Égypte.* 2 vols. Québec: Presses de l'Université Laval, 1978–82.

Malaise, Michel. *Les conditions de pénétration et de diffusion des cultes égyptiennes en Italie.* Leiden: E. J. Brill, 1972.

Leiden." *Jaarboekje voor geschiedenis en oudheidkunde van Leiden en omstreken* 71 (1979) 71–74.

Jones, Mark Wilson. *Principles of Roman Architecture.* New Haven; London: Yale University Press, 2000.

Julian, the Apostate. *The Works of the Emperor Julian.* Trans. Wilmer C. Wright. 3 vols. Loeb Classical Library. Cambridge, Mass.: Harvard University Press; London: William Heinemann, 1913–23.

Julien, Alexis A. *Notes of Research on the New York Obelisk.* New York, 1893.

———. "A Study of the New York Obelisk as a Decayed Boulder." *Annals of the New York Academy of Sciences* 8.1 (1894) 93–166.

Jung, Carl Gustav. *Psychology of the Unconscious: A Study of the Transformations and Symbolisms of the Libido: A Contribution to the History of the Evolution of Thought.* Trans. Beatrice M. Hinkle. New York, 1916. Repr. Mineola, N.Y.: Dover Books, 2003.

Katalog der Skulpturen. Vatikanische Museen, Museo gregoriano profano ex lateranense. Ed. Georg Daltrop and Hansgeorg Oehler. 3 vols. Mainz am Rhein: Verlag Philipp von Zabern, 1991ff.

Kepler, Johannes. *Gesammelte Werke.* Ed. Max Caspar, et al. 21 vols. Munich: C. H. Beck, 1937ff.

King, Rev. James. *Cleopatra's Needle. The History of the Obelisk. With an Exposition of the Hieroglyphs.* 3rd ed. By-paths of Bible Knowledge 1. London: The Religious Tract Society, 1886.

Kircher, Athanasius. *Ad Alexandrum VII. . . . Obelisci Aegyptiaci nuper inter Isaei romani rudera effossi interpretatio hieroglyphica.* Rome: Ex typographia Varesij, 1666.

———. *Iconismi e mirabilia da Athanasius Kircher.* Ed. Eugenio Lo Sardo. Rome: Edizioni dell'Elefante, 1999.

———. *[Athanasii Kircheri . . .] Obeliscus Pamphilius. . . .* Rome: typis Ludovici Grignani, 1650.

———. *Oedipus Aegyptiacus. . . .* 3 vols. Rome: ex typographia Vitalis Mascardi, 1652–55.

Kitchen, Kenneth A. *Pharaoh Triumphant: The Life and Times of Ramesses II, King of Egypt.* Warminster: Aris & Phillips, 1982.

Klaczko, Julian. *Rome and the Renaissance: The Pontificate of Julius II.* Trans. John Dennie. New York; London: G. P. Putnam's Sons, 1903.

Kobishchanov, Yuri M. *Axum.* Ed. Joseph W. Michels. Trans. Lorraine T. Kapitanoff. University Park: Pennsylvania State University Press, 1979.

Krautheimer, Richard. *The Rome of Alexander VII, 1655–1667.* Princeton: Princeton University Press, 1985.

———. *Rome: Profile of a City, 312–1308.* Princeton: Princeton University Press, 1980.

Kristeller, Paul Oskar. *Studies in Renaissance Thought and Letters.* 4 vols. Storia e letteratura 54, 166, 178, 193. Rome: Edizioni di storia e letteratura, 1956–96.

Kuentz, Charles. *Obélisques. Catalogue général des antiquités égyptiennes du Musée du Caire.* Cairo: Institut Français d'Archéologie Orientale, 1932.

LaFaye, Georges. *Histoire du culte des divinités d'Alexandrie. Sérapis, Isis, Harpocrate et Anubis hors de l'Égypte.* Bibliothèque des Écoles Françaises d'Athènes et de Rome, fasc. 33. Paris: E. Thorin, 1884.

Lamy, Florimond, and Marie-Cécile Bruwier. *L'Égyptologie avant Champollion.* Louvain-la-Neuve: Versant Sud, 2005.

Lancaster, Lynn. "Building Trajan's Column." *American Journal of Archaeology* 103 (1999) 419–39.

Lanciani, Rodolfo. "L'Iseum et Serapeum della Regione IX." *Bullettino della Commissione Archeologica Comunale di Roma,* 2nd ser., 9 (1883) 33–131.

Landels, J. G. *Engineering in the Ancient*

Horapollo. *The Hieroglyphics of Hora-
pollo.* Trans. George Boas. New York,
1950. Reprint ed. with a foreword by
Anthony Grafton, Princeton: Prince-
ton University Press, 1993.

Hsia, R. Po-Chia. *The World of Catholic
Renewal, 1540–1779.* Cambridge:
Cambridge University Press, 1998.

von Hübner, Joseph Alexander. *The Life
and Times of Sixtus the Fifth.* 2 vols.
Trans. Herbert E. H. Jerningham.
London: Longmans, Green, 1872.

Hülsen, Christian. *La Roma antica
di Ciriaco d'Ancona: disegni inediti
del secolo XV.* Rome: E. Loescher,
W. Regenberg, 1907.

Humbert, Jean-Marcel. *L'Égypte à
Paris. Paris et son patrimoine.* Paris:
Action artistique de la ville de Paris,
1998.

Humphrey, John H. *Roman Circuses:
Arenas for Chariot Racing.* Berkeley:
University of California Press,
1986.

*Imhotep Today: Egyptianizing Archi-
tecture.* Ed. Jean-Marcel Humbert
and Clifford Price. Encounters
with Ancient Egypt. London: UCL;
Routledge-Cavendish, 2003.

*In urbe architectus: modelli, disegni,
misure: la professione dell'archi-
tetto, Roma, 1680–1750.* Ed. Bruno
Contardi and Giovanna Curcio.
Exh. cat. Museo Nazionale di Castel
Sant'Angelo. Rome: Argos, 1991.

Iside: il mito, il mistero, la magia.
Ed. Ermanno A. Arslan. Exh. cat.
Palazzo Reale, Milan. Milan: Electa,
1997.

*Italian Studies. Presented to E. R. Vin-
cent on His Retirement from the Chair
of Italian at Cambridge.* Ed. C. P.
Brand, K. Foster, and U. Limentani.
Cambridge: W. Heffer, 1962.

Iversen, Erik. *Egyptian and Hermetic
Doctrine.* Copenhagen: Museum
Tusculanum Press, 1984.

———. "Horapollo and the Egyptian
Conception of Eternity." *Rivista
degli studi orientali* 38 (1963) 177–86.

———. *The Myth of Egypt and its Hiero-
glyphs in European Tradition.*
Copenhagen: GAD, 1961.

———. *The Myth of Egypt and its Hiero-
glyphs in European Tradition.* Rev.
ed. Princeton: Princeton University
Press, 1993.

———. *Obelisks in Exile.* 2 vols. Copen-
hagen: GAD, 1968, 1972.
Volume 1: *The Obelisks of Rome.*
Volume 2: *The Obelisks of Istanbul
and England.*

al-Jabartī, 'Abd al-Raḥmān. *Napoleon in
Egypt. Al-Jabarti's Chronicle of the
French Occupation, 1798.* Ed. Robert
L. Tignor. Trans. Shmuel Moreh.
Princeton; New York: Marcus Wie-
ner, 1993.

James, Montague Rhodes. *A Descriptive
Catalogue of the Latin Manuscripts
in the John Rylands University
Library, Part 1.* 2nd ed. Ed. Frank
Taylor. Manchester; London: The
University Press, 1921. Repr. Munich:
Kraus Reprint, 1980.

Jardine, Nicholas. *The Birth of History
and Philosophy of Science.* Cam-
bridge: Cambridge University Press,
1984.

Jennings, Hargrave. *The Obelisk:
Notices of the Origin, Purpose, and
History of Obelisks.* London: J. Bur-
sill, 1877.

de Joannis, Léon. *Campagne pittoresque
du Luxor.* 2 vols. Paris: Huzard, 1835.

de Jode, Cornelis. *De quadrante geo-
metrico libellus. In quo quidquid ad
linearum et superficierum, utpote
altitudinum et latitudinum, dimen-
siones facit lucidissime demonstratur.*
Nuremberg: typis C. Lochneri, 1594.

Johnson, Trevor. "Holy Fabrications:
The Catacomb Saints and the
Counter-Reformation in Bavaria."
Journal of Ecclesiastical History 47
(1996) 274–97.

Jollois, Prosper. *Journal d'un ingénieur
attaché à l'Éxpédition d'Égypte 1798–
1802.* Ed. P. Lefèvre-Pontalis. Biblio-
thèque Égyptologique 6. Paris:
Ernest Leroux, 1904.

de Jonge, H. J. "Josephus Scaliger in

Remigio Sabbadini. Miscellanea di storia Veneta, ser. III, vol. VIII. 3 vols. Venice: A spese della Società, 1915–19.

Gwynne, Paul. "*Tu alter Caesar eris:* Maximilian I, Vladislav II, Johannes Michael Nagonius, and the *renovatio Imperii.*" *Renaissance Studies* 10 (1996) 56–71.

Haas, Christopher. *Alexandria in Late Antiquity: Topography and Social Conflict.* Baltimore: The Johns Hopkins University Press, 1997.

Habachi, Labib. *The Obelisks of Egypt: Skyscrapers of the Past.* Ed. Charles C. Van Siclen, III. New York: Charles Scribner's Sons, 1977.

Hamilton, Alastair. *The Copts and the West, 1439–1822: The European Discovery of the Egyptian Church.* Oxford-Warburg Studies. Oxford: Oxford University Press, 2006.

Hartswick, Kim J. *The Gardens of Sallust: A Changing Landscape.* Austin: University of Texas Press, 2004.

Haskell, Francis, and Nicholas Penny. *Taste and the Antique: The Lure of Classical Sculpture 1500–1900.* New Haven; London: Yale University Press, 1981.

Hatshepsut: From Queen to Pharaoh. Ed. Catharine H. Roehrig, Renee Dreyfus, and Cathleen A. Keller. Exh. cat. Metropolitan Museum of Art. New York: Metropolitan Museum of Art, 2005.

Haynes, Jonathan. *The Humanist as Traveler: George Sandys's Relation of a journey begun an. dom. 1610.* Rutherford: Fairleigh Dickinson University Press, 1986.

Hayward, R. A. *Cleopatra's Needles.* Hartington, Buxton: Moorland Publishing Company, 1978.

Heckscher, William S. "Bernini's Elephant and Obelisk." *Art Bulletin* 29 (1947) 155–82.

Heilbron, J. L. *The Sun in the Church: Cathedrals as Solar Observatories.* Cambridge, Mass.: Harvard University Press, 1999.

Henninger-Voss, Mary. "Working Machines and Noble Mechanics: Guidobaldo del Monte and the Translation of Knowledge." *Isis* 91 (2000) 232–59.

Henninges, Hieronymus. *Genealogiae aliquot familiarum nobilium in Saxonia.* Hamburg: Ex officina Jacobi Wolfii, 1590.

Henrichs, Albert. "Vespasian's Visit to Alexandria." *Zeitschrift für Papyrologie und Epigraphik* 3 (1968) 51–80.

Herklotz, Ingo. *Cassiano dal Pozzo und die Archäologie des 17. Jahrhunderts.* Munich: Hirner, 1999.

Hermetica. The Greek Corpus Hermeticum and the Latin Asclepius in a New English Translation. Ed. and trans. Brian P. Copenhaver. Cambridge: Cambridge University Press, 1992.

Hermeticism and the Renaissance: Intellectual History and the Occult in Early Modern Europe. Ed. Ingrid Merkel and Allen G. Debus. Washington, D.C.: Folger Shakespeare Library, 1988.

Herwarth von Hohenburg, J. F. *Admiranda Ethnicae Theologiae Mysteria Propalata.* Ingolstadt: Nicolaus Henricus, 1623.

Herwart von Hohenburg, Johann Georg. *Thesaurus Hieroglyphicorum.* [Munich?]: [n.p.], about 1608–10.

Hess, Jacob. *Kunstgeschichtliche Studien zur Renaissance und Barock.* 2 vols. Rome: Edizioni di storia e letteratura, 1967.

Heurnius, Otto. *Philosophiae barbaricae antiquitatum libri duo: I Chaldaicus, II Indicus. Opus historicum & philosophicum.* Leiden: Ex Officina Plantiniana, apud Christophorum Raphelengium, Academiae Lugduno-Bat. Typographum, 1600.

Heyob, Sharon Kelly. *The Cult of Isis among Women in the Graeco-Roman World.* Leiden: E. J. Brill, 1975.

Hölbl, Günther. *A History of the Ptolemaic Empire.* Trans. Tina Saavedra. London: Routledge, 2001.

Gibbon, Edward. *Miscellaneous Works of Edward Gibbon, Esq.: With Memoirs of His Life and Writings Composed by Himself, illustrated from His letters, with occasional notes and narrative by the Right Honorable John, Lord Sheffield.* 3 vols. Dublin: Printed for P. Wogan, et al., 1796.

Giehlow, Karl. "Die Hieroglyphenkunde des Humanismus in der Allegorie der Renaissance." *Jahrbuch der Kunsthistorischen Sammlungen des Allerhöchsten Kaiserhauses* 32 (1915) 1–229.

Gillispie, Charles Coulston. *Science and Polity in France: The Revolutionary and Napoleonic Years.* Princeton: Princeton University Press, 2004.

Giovanni Colonna da Tivoli, 1554. Ed. Maria Elisa Micheli. Xenia Quaderni 2. Rome: De Luca, 1992.

Giuliano, Antonio. "Roma 1300." *Xenia* 4 (1982) 16–22.

von Goethe, Johann Wolfgang. *Italian Journey.* Trans. Robert R. Heitner. Ed. Thomas P. Saine and Jeffrey L. Sammons. Goethe's Collected Works 6. New York: Suhrkamp Publishers, 1989.

———. *Italienische Reise.* Ed. Andreas Beyer and Norbert Miller. Sämtliche Werke nach Epochen seines Schaffens. Münchner Ausgabe 15. Munich: Carl Hanser Verlag, 1992.

Golzio, Vincenzo. *Raffaello nei documenti, nelle testimonianze dei contemporanei e nella letteratura del suo secolo.* Vatican City; Spoleto: Panetto and Petrelli, 1936.

Gombrich, E. H. *The Heritage of Apelles: Studies in the Art of the Renaissance.* Oxford: Oxford University Press, 1976.

———. *Symbolic Images: Studies in the Art of the Renaissance II.* 2nd ed. Oxford: Phaidon, 1978.

Goñi, Uki. *The Real Odessa: How Perón Brought the Nazi War Criminals to Argentina.* London: Granta, 2002.

Gorman, Michael John, and Nick Wilding. *La Technica Curiosa di Gaspar Schott.* Rome: Edizioni dell'Elefante, 2000.

Gorringe, Henry Honeychurch. *Egyptian Obelisks.* New York: Published by the author, 1882.

Gosselin-Schick, Constance. "Nostalgies d'obélisques." *Bulletin de la Société Théophile Gautier* 12.2 (1990) 261–71.

Goulding, Robert. "Method and Mathematics: Petrus Ramus's History of the Sciences." *Journal of the History of Ideas* 67 (2006) 63–85.

Gouwens, Kenneth. *Remembering the Renaissance: Humanist Narratives of the Sack of Rome.* Leiden: E. J. Brill, 1998.

Grafton, Anthony. *Defenders of the Text: The Traditions of Scholarship in an Age of Science, 1450–1800.* Cambridge, Mass.: Harvard University Press, 1991.

———. *Magic and Technology in Early Modern Europe.* Dibner Library Lecture, 2002. Washington, D.C.: Smithsonian Institution Libraries, 2005.

———. "Rhetoric, Philology and Egyptomania in the 1570s: J. J. Scaliger's Diatribe against Melchior Guilandinus's *Papyrus*." *Journal of the Warburg and Courtauld Institutes* 42 (1979) 167–94.

Graham, Matilda Winifred Muriel. *The Needlewoman.* London: Mills and Boon, 1911.

Gran, Peter. *Islamic Roots of Capitalism, Egypt 1760–1840.* Austin: University of Texas Press, 1978.

The Great Art of Knowing: The Baroque Encyclopedia of Athanasius Kircher. Ed. Daniel Stolzenberg. Stanford: Stanford University Libraries, 2001.

Greaves, John. *Pyramidographia: Or a Description of the Pyramids in Aegypt.* London: Printed for George Badger, 1646.

Greener, Leslie. *The Discovery of Egypt.* London: Cassell, 1966.

Guarino Veronese. *Epistolario.* Ed.

ipsius origo, cum ædificiis maximè conspicuis antiquitùs, & recèns ibidem constitutis . . .] Rome: Nella stamparia di Gio: Francesco Buagni, 1694.

Fontana, Domenico. *Della trasportatione dell'obelisco vaticano et delle fabriche di nostro signore Papa Sisto V, fatte dal cavallier Domenico Fontana, architetto di Sua Santita.* Rome: Domenico Basa, 1590.

———. *Della trasportatione dell'obelisco vaticano, 1590.* Ed. Adriano Carugo with an introduction by Paolo Portoghesi. Rome, 1590. Repr. Milan: Il Polifilo, 1978.

———. *Della trasportatione dell'obelisco vaticano.* Ed. Ingrid D. Rowland. Trans. David Sullivan. Rome, 1590. Repr. Oakland, Ca.: Octavo, 2002.

Fowden, Garth. *The Egyptian Hermes: A Historical Approach to the Late Pagan Mind.* Princeton: Princeton University Press, 1986.

———. "Nicagoras of Athens and the Lateran Obelisk." *Journal of Hellenic Studies* 107 (1987) 51–57.

———. "The Pagan Holy Man in Late Antique Society." *Journal of Hellenic Studies* 102 (1982) 33–59.

Frankfort, Henri. *Kingship and the Gods. A Study of Ancient Near Eastern Religion as the Integration of Society & Nature.* Chicago: University of Chicago Press, 1948.

Fraser, Peter. *Ptolemaic Alexandria.* 3 vols. Oxford: Clarendon Press, 1972.

Freedberg, David. *The Eye of the Lynx: Galileo, His Friends, and the Beginnings of Modern Natural History.* Chicago; London: University of Chicago Press, 2002.

Freud, Sigmund. *The Interpretation of Dreams.* Trans. James Strachey. New York, 1965. Repr. New York: Avon Books, 1998.

———. *The Standard Edition of the Complete Psychological Works of Sigmund Freud.* 24 vols. London: Hogarth Press, 1957–74.

Frommel, C. L. "Papal Policy: The Planning of Rome During the Renaissance." *Journal of Interdisciplinary History* 17 (1986) 39–65.

Fulvio, Andrea. *L'antichità di Roma . . . di nuovo con ogni diligenza corretta & ampliata, con gli adornamenti di disegni de gli edificij antichi & moderni, con le aggiuntioni et annotationi di Girolamo Ferrucci.* Venice: Per Girolamo Francini, 1588.

———. *Antiquaria urbis.* Rome: Jacopo Mazochio, 1513.

Gaisser, Julia Haig. *Catullus and His Renaissance Readers.* Oxford: Oxford University Press, 1993.

———. *Pierio Valeriano on the Ill Fortune of Learned Men: A Renaissance Humanist and His World.* Ann Arbor: University of Michigan Press, 1999.

Galesino, Pietro [Petrus Galesinus]. *Ordo dedicationis obelisci quem S.D.N. Sixtus V. Pont. Max. in foro vaticano ad limina apostolorum erexit et benedictionis item Crucis quam in eius fastigio collocauit. . . .* Rome: ex typographia Bartholomaei Grassij, 1586.

Galt, John. *The Life, Studies, and Works of Benjamin West, Esq., president of the Royal Academy of London, composed from materials furnished by himself.* 2 vols. London: Printed for Cadell and Davies, 1820.

Gamrath, Helge. *Roma Sancta Renovata: studi sull'urbanistica di Roma nella seconda metà del sec. XVI con particolare riferimento al pontificato di Sisto V, 1585–1590.* Rome: L'Erma di Bretschneider, 1987.

Gardiner, Alan H. *Egyptian Hieratic Texts, Series I: Literary Texts of the New Kingdom.* Leipzig: J. C. Hinrichs, 1911.

Gasparoni, Francesco. *Sugli obelischi Torlonia nella villa Nomentana: ragionamento storico-critico.* Rome: Tip. Salviucci, 1842.

Gautier, Théophile. *Émaux et camées, édition critique.* Ed. Jacques Madeleine. Paris: Librairie Hachette, 1927.

No. 34, Imprimerie le Normant, Rue de Seine, No. 8., 1839.

Émy, Armand-Rose. *Traité de l'art de charpenterie*. 3 vols. Liège: Avanzo, 1841–42.

Encyclopedia of Africa South of the Sahara. Ed. John Middleton. 4 vols. New York: Charles Scribner's Sons, 1997.

Das Ende des Hermetismus: historische Kritik und neue Naturphilosophie in der Spätrenaissance. Dokumentation und Analyse der Debatten um die Datierung der hermetischen Schriften von Genebrard bis Casaubon (1567–1614). Ed. Martin Mulsow. Tübingen: Mohr Siebeck, 2002.

Engelbach, Reginald. *The Problem of the Obelisks from a Study of the Unfinished Obelisk at Aswan*. New York: George H. Doran, 1923.

Eriksson, Gunnar. *The Atlantic Vision: Olaus Rudbeck and Baroque Science*. Canton, Mass.: Science History, 1994.

Erman, Adolf. "Römische Obelisken." *Abhandlungen der Königlich Preussischen Akademie der Wissenschaften* 4 (1917) 10–17, 28–47.

Europa und der Orient, 800–1900. Ed. Gereon Sievernich and Hendrik Budde. Exh. cat. Martin-Gropius-Bau, Berlin. Gütersloh: Bertelsmann Lexikon Verlag, 1989.

Evans, Amelia Ann Blanford. *A Thousand Miles up the Nile*. London, 1878. Repr. London: Routledge, 1892.

Evans, R. J. W. *The Making of the Habsburg Monarchy 1550–1700: An Interpretation*. Oxford: Clarendon, 1979.

Excavating in Egypt: The Egypt Exploration Society, 1882–1982. Ed. T. G. H. James. London: British Museum Publications; Chicago; London: University of Chicago Press, 1982.

L'Expédition d'Égypte, une entreprise des Lumières 1798–1801. Actes du colloque international organisé par l'Académie des inscriptions et belles-lettres et l'Académie des sciences sous les auspices de l'Institut de France et du Muséum national d'histoire naturelle 8–10 juin 1998. Ed. Patrice Bret. Paris: Institut de France; Académie des sciences; Éditions Technique et documentation, 1999.

Fahmy, Khaled. *All the Pasha's Men: Mehmed Ali, His Army, and the Making of Modern Egypt*. Cairo; New York: American University in Cairo Press, 1997, 2002.

Farman, Elbert Eli. *Egypt and its Betrayal: An Account of the Country during the Periods of Ismail and Tewfik Pashas, and of How England Acquired a New Empire*. New York: The Grafton Press, 1908.

———. "The Negotiations for the Obelisk." *The Century. A Popular Quarterly* 24.6 (October 1882) 879–89.

Faure, Alain. *Champollion, Le savant déchiffré*. Paris: Librairie Arthème Fayard, 2004.

Fehrenbach, Frank. *Compendia mundi: Gianlorenzo Berninis Fontana dei Quattro Fiumi (1648–51) und Nicola Salvis Fontana di Trevi (1732–62)*. Mandorli 7. Munich: Deutscher Kunstverlag, 2008.

de Felice, Mauro. *Miti ed allegorie egizie in Campidoglio*. Bologna: Pàtron, 1982.

The First Writing: Script Invention as History and Process. Ed. Stephen D. Houston. Cambridge: Cambridge University Press, 2004.

Ficino, Marsilio. *Opera omnia*. Ed. Mario Sancipriano. Basel, 1576. Repr. Turin: Bottega d'Erasmo, 1959.

Findlen, Paula. *Possessing Nature: Museums, Collecting, and Scientific Culture in Early Modern Italy*. Berkeley: University of California Press, 1994.

Flaubert, Gustave. *Voyage en Égypte*. Ed. Pierre-Marc de Biasi. Paris: B. Grasset, 1991.

Fontana, Carlo. *Il Tempio Vaticano e sua origine con gl'edifitii più cospicui antichi, e moderni fatti dentro, e fuori di esso . . .* [*Templum Vaticanum et*

Dinsmoor, William B. "Early American Studies of Mediterranean Archaeology." *Proceedings of the American Philosophical Society* 87.1 (1943) 70–104.

Discorso sopra il nuovo ornato della guglia di S. Pietro. Rome: G. M. Salvioni, 1723.

Ditchfield, Simon. *Liturgy, Sanctity and History in Tridentine Italy: Pietro Maria Campi and the Preservation of the Particular.* Cambridge: Cambridge University Press, 1995.

Dizionario Biografico degli Italiani. Ed. Alberto Maria Ghisalberti, et al. Rome: Istituto della Enciclopedia Italiana, 1960 ff.

Documentary Culture. Florence and Rome from Grand-Duke Ferdinand I to Pope Alexander VII. Ed. Elizabeth Cropper, Giovanna Perini, and Francesco Solinas. Villa Spelman Colloquia 3. Bologna; Baltimore: Nuova Alfa Editoriale, 1992.

Donadoni, Sergio, Silvio Curto, and Anna Maria Donadoni Roveri. *Egypt from Myth to Egyptology.* Trans. Elizabeth Poore and Francesco L. Rossi. Milan: Fabbri, 1990.

D'Onofrio, Cesare. *Le fontane di Roma.* 3rd ed. Studi e testi per la storia della città di Roma 7. Rome: Romana Società Editrice, 1986.

———. *Gli obelischi di Roma: storia e urbanistica di una città dall'età antica al XX secolo.* 3rd ed. Studi e testi per la storia della città di Roma 12. Rome: Romana Società Editrice, 1992.

———, ed. *Visitiamo Roma mille anni fa: La città dei Mirabilia.* Studi e testi per la storia della città di Roma 8. Rome: Romana Società Editrice, 1988.

———, ed. *Visitiamo Roma nel Quattrocento: La città degli Umanisti.* Studi e testi per la storia della città di Roma 9. Rome: Romana Società Editrice, 1989.

Doxiadis, Euphrosyne. *The Mysterious Fayum Portraits: Faces from Ancient Egypt.* New York: Harry N. Abrams, 1995.

Drachmann, A. G. *The Mechanical Technology of Greek and Roman Antiquity: A Study of the Literary Sources.* Copenhagen: Munksgaard, 1963.

Dupront, Alphonse. "Les fresques de la bibliothèque de Sixte-Quint: Art et Contre-Reforme." *Mélanges d'archéologie et d'histoire de l'École Française de Rome* 48 (1931) 292–307.

L'Egitto fuori dell'Egitto, Dalla riscoperta all'Egittologia. Ed. Cristiana Morigi Govi, Silvio Curto, and Sergio Pernigotti. Bologna: CLUEB, 1991.

L'Egitto in Italia dall'antichità al Medioevo, Atti del 3. Congresso internazionale italo-egiziano, Roma, CNR-Pompei, 13–19 novembre 1995. Ed. N. Bonacasa, et al. Rome: Consiglio nazionale delle ricerche, 1998.

L'Égypte de 1828 à 1830. Correspondance des consuls de France en Égypte. Ed. Georges Douin. Rome: Stampato nell' Istituto poligrafico dello stato per la Reale Società di Geografia d'Egitto, 1935.

Egyptomania: Egypt in Western Art 1730–1930. Ed. Christiane Ziegler, Jean-Marcel Humbert, and Michael Pantazzi. Exh. cat., National Gallery of Canada, Ottawa, and Musée du Louvre, Paris. Ottawa: National Gallery of Canada; Paris: Réunion des Musées Nationaux, 1994.

el-Daly, Okasha. *Egyptology: The Missing Millennium. Ancient Egypt in Medieval Arabic Writings.* London: UCL Press, 2005.

L'Emblème à la Renaissance: actes de la journée d'études du 10 mai 1980. Ed. Yves Giraud, et al. Paris: Société d'édition d'enseignement supérieur, 1982.

Embellissemens de la Place de la Concorde. Explication des Monumens qui la décorent. Nouvelle edition. Ornée de gravures. Paris: Chez Gauthier, Libraire, Marché-Neuf,

Cyriacus of Ancona. *Commentariorum Cyriaci Anconitani nova fragmenta notis illustrata.* Ed. Annibale Olivieri degli Abati. Pesaro: [n.p.], 1763.

———. *Kyriaci Anconitani itinerarium nunc primum ex ms. cod. in lucem erutum ex bibl. illus. clarissimique Baronis Philippi Stosch.* Ed. Laurentius Mehus. Florence, 1742. Repr. Bologna: Forni, 1969.

Dacos, Nicole. *Roma quanta fuit: Tre pittori fiamminghi nella Domus Aurea.* New ed. Trans. Maria Baiocchi. Rome: Donzelli, 2001.

D'Alton, Martina. *The New York Obelisk, or, How Cleopatra's Needle Came to New York and What Happened When it Got Here.* New York: Metropolitan Museum of Art/Abrams, 1993.

Dandelet, Thomas James. *Spanish Rome: 1500–1700.* New Haven; London: Yale University Press, 2001.

Dannenfeldt, Karl H. "Egypt and Egyptian Antiquities in the Renaissance." *Studies in the Renaissance* 6 (1959) 7–27.

———. "Late Renaissance Interest in the Ancient Orient." Ph.D. diss., University of Chicago, 1948.

———. "The Renaissance and Pre-Classical Civilizations." *Journal of the History of Ideas* 13 (1952) 435–49.

Da Pisanello alla nàscita dei Musei Capitolini: L'antico a Roma alla vigilia del Rinascimento. Ed. Anna Cavallaro and Enrico Parlato. Exh. cat. Musei Capitolini, Rome. Milan: A. Mondadori; Rome: DeLuca, 1988.

Daston, Lorraine and Katharine Park. *Wonders and the Order of Nature, 1150–1750.* New York: Zone, 1998.

Davies, Penelope J. E. *Death and the Emperor: Roman Imperial Funerary Monuments from Augustus to Marcus Aurelius.* Cambridge: Cambridge University Press, 2000.

Davies, W. V. *Reading the Past: Egyptian Hieroglyphs.* Berkeley: University of California Press; London: The British Museum, 1987.

Davis, Whitney. "Plato on Egyptian Art." *Journal of Egyptian Archaeology* 65 (1979) 121–27.

The Dedication of the Washington National Monument, with the Orations by Hon. Robert C. Winthrop and Hon. John W. Daniel. February 21, 1885. Published by Order of Congress. Washington: Government Printing Office, 1885.

DeLaine, Janet. *The Baths of Caracalla: A Study in the Design, Construction, and Economics of Large-Scale Building Projects in Imperial Rome.* Portsmouth, R.I.: Journal of Roman Archaeology, Supplementary Series, 1997.

De la Place Louis XV à la Place de la Concorde. Exh. cat. Musée Carnavalet. Paris: n.p., [1982].

Delumeau, Jean. *Vie économique et sociale de Rome dans la seconde moitié du XVIe siècle.* 2 vols. Paris: E. de Boccard, 1957.

Denon, Vivant. *Voyage dans la Basse et la Haute Égypte, pendant les campagnes du général Bonaparte.* Paris: P. Didot, 1802.

Derby, Lauren. "The Dictator's Seduction: Gender and State Spectacle during the Trujillo Regime." *Callaloo* 23.3 (2000) 1112–46.

Desmaizeaux, Pierre, ed. *Scaligerana, Thuana, Perroniana, Pithoeana, et Colomesiana. Ou Remarques historiques, critiques, morales, & litteraires de Jos. Scaliger, J. Aug. de Thou, le cardinal du Perron, Fr. Pithou, & P. Colomiés. Avec les notes de plusieurs savans. . . .* 2 vols. Amsterdam: Chez Covens & Mortier, 1740.

Deutsche Aksum-Expedition. 4 vols. Berlin: F. Reiner, 1913.

Dibner, Bern. *Moving the Obelisks.* Norwalk: Burndy Library, 1991.

Dieckmann, Liselotte. *Hieroglyphics: The History of a Literary Symbol.* St. Louis: Washington University Press, 1970.

scrites de Champollion le jeune. Paris: chez Firmin-Didot, rue Jacob, no. 24, Décembre 1833.

Chicago Tribune Tower Competition. Ed. Stanley Tigerman, et al. New York: Rizzoli, 1981.

Ciampini, Emanuele M. *Gli obelischi iscritti di Roma.* Rome: Libreria dello Stato, Istituto Poligrafico e Zecca dello Stato, 2004.

Cipriani, Giovanni. *Gli obelischi egizi: Politica e cultura nella Roma Barocca.* Florence: Leo S. Olschki, 1993.

Ciseri, Ilaria. *L'ingresso trionfale di Leone X in Firenze nel 1515.* Florence: Leo S. Olschki, 1990.

The Classics in the Middle Ages. Ed. Aldo S. Bernardo and Saul Levin. Medieval & Renaissance Texts & Studies 69. Binghamton, N.Y.: Center for Medieval and Early Renaissance Studies, 1990.

Cleopatra's Egypt: Age of the Ptolemies. Ed. R. S. Bianchi, et al. Exh. cat. Brooklyn Museum. Brooklyn: Brooklyn Museum, 1988.

Codice topografico della città di Roma. Ed. Roberto Valentini and Giuseppe Zucchetti. 4 vols. Fonti per la storia d'Italia, pub. dal R. Istituto Storico Italiano per il Medio Evo. Scrittori. Secoli I–XV 81, 88, 90–91. Rome: Tipografia del Senato, 1940–53.

Collins, Jeffrey. "'Non Tenuis Gloria': The Quirinal Obelisk from Theory to Practice." *Memoirs of the American Academy in Rome* 42 (1997) 187–225.

———. "Obelisks as Artifacts in Early Modern Rome: Collecting the Ultimate Antiques." *Ricerche di Storia dell'Arte* 72 (2001: Special Issue: "Viewing Antiquity: The Grand Tour, Antiquarianism and Collecting") 49–68.

———. *Papacy and Politics in Eighteenth-Century Rome: Pius VI and the Arts.* Cambridge: Cambridge University Press, 2004.

Conciliorum oecumenicorum decreta. Ed. Giuseppe Alberigo, et al. 3rd ed. Bologna: Istituto per le scienze religiose, 1973.

Cooper, W. R. *A Short History of the Egyptian Obelisks.* London: Samuel Bagster and Sons, 1877.

Cosmelli, Flaminia. "L'elefante, l'albero e l'obelisco." *Storia dell'Arte* 66 (1985) 107–18.

Curl, James Stevens. *The Egyptian Revival: Ancient Egypt as an Inspiration for Design Motifs in the West.* London; New York: Routledge, 2005.

Curran, Brian A. "'De sacrarum litterarum Aegyptiorum interpretatione.' Reticence and Hubris in Hieroglyphic Studies of the Renaissance: Pierio Valeriano and Annius of Viterbo." *Memoirs of the American Academy in Rome* 43/44 (1998/99) 139–82.

———. *The Egyptian Renaissance: The Afterlife of Egypt in Early Modern Italy.* Chicago; London: University of Chicago Press, 2007.

———. "The Hypnerotomachia Poliphili and Renaissance Egyptology." *Word and Image* 14 (1998) 156–85.

———. "Jean-Marcel Humbert, Michael Pantazzi, and Christiane Ziegler, *Egyptomania: Egypt in Western Art, 1730–1930.*" *The Art Bulletin* 78.4 (1996) 739–44.

———, and Anthony Grafton. "A Fifteenth-Century Site Report on the Vatican Obelisk." *Journal of the Warburg and Courtauld Institutes* 58 (1995) 234–48.

———, and Giancarla Periti. "Titulos et Veteres Inscriptiones Monumenti Pyramidibus, Obeliscis, Mausoleis . . . invenire et inventa . . . in libellum concinnare: Michele Fabrizio Ferrarini and the Epigraphic Study of Egyptian Hieroglyphs in Renaissance Italy." For submission, 2009.

Curran, John R. *Pagan City and Christian Capital: Rome in the Fourth Century.* Oxford: Oxford University Press, 2000.

years 1685 and 1686. Amsterdam: Printed for the Widow Swart, Bookseller in the Beurs Stege, 1688.

Burroughs, Charles. "Below the Angel: An Urbanistic Project in the Rome of Pope Nicholas V." *Journal of the Warburg and Courtauld Institutes* 45 (1982) 94–124.

———. *From Signs to Design: Environmental Process and Reform in Early Renaissance Rome.* Cambridge, Mass.: MIT Press, 1990.

Burton, Richard D. E. *Blood in the City. Violence and Revelation in Paris, 1789–1945.* Ithaca: Cornell University Press, 2001.

Butterfield, Herbert. *Man on His Past.* Cambridge: Cambridge University Press, 1955.

Butters, Suzanne B. *The Triumph of Vulcan: Sculptor's Tools, Porphyry, and the Prince in Ducal Florence.* 2 vols. Florence: Leo S. Olschki, 1996.

Cali, Giuseppe. *Della vita e delle opere di G. P. Valeriano.* Catania: Cav. Gianotta, 1901.

Cancellieri, Francesco. *Il mercato, il Lago dell'Acqua Vergine, ed il Palazzo Panfiliano nel circo Agonale detto volgarmente Piazza Navona, descritte da Francesco Cancellieri, con un'appendice di XXXII documenti ed un trattato sopra gli obelischi.* Rome: F. Bourlié, 1811.

Canons and Decrees of the Council of Trent. Trans. H. J. Schroeder. Rockford, Ill.: Tan Books and Publishers, 1978.

Capecchi, Gabriele. *Il Giardino di Boboli, un anfiteatro per la gioia dei granduchi.* Florence: Edizioni Medicea, 1993.

Capecchi, Gabriella. *Da Roma a Firenze: le vasche romane di Boboli e cinquanta anni di vicende toscane.* Accademia delle Arti di Disegno, monografie 9. Florence: Leo S. Olschki, 2002.

Cappelletto, R. "Niccolò Niccoli e il codice di Ammiano Vat. lat. 1873." *Bollettino del comitato per la pre-*parazione dell'edizione nazionale dei classici greci e latini n.s. 26 (1976) 57–84.

Capponi, Livia. *Augustan Egypt: The Creation of a Roman Province.* London; New York: Routledge, 2005.

Carrott, Richard G. *The Egyptian Revival: Its Sources, Monuments, and Meaning, 1808–1858.* Berkeley: University of California Press, 1978.

Castagnoli, Ferdinando. *Il Vaticano nell'antichità classica.* Studi e documenti per la storia del Palazzo apostolico vaticano 6. Vatican City: Biblioteca Apostolica Vaticana, 1992.

Castelli, Patrizia. *I geroglifici e il mito dell'Egitto nel Rinascimento.* Florence: Edam, 1979.

Catalogus Translationum et Commentariorum: Mediaeval and Renaissance Latin Translations and Commentaries: Annotated Lists and Guides. Ed. Paul Oskar Kristeller, F. Edward Cranz, Virginia Brown, et al. 8 vols. Washington, D.C.: Catholic University of America Press, 1960–2003.

Catholicism and Austrian Culture. Ed. Ritchie Robertson and Judith Beniston. Edinburgh: Edinburgh University Press, 1999.

Celenza, Christopher S. *Renaissance Humanism and the Papal Curia: Lapo da Castiglionchio the Younger's 'De curiae commodis.'* Ann Arbor: University of Michigan Press, 1999.

Champollion, Jean-François. *Lettres et journaux écrits pendant le voyage d'Égypte.* Ed. H. Hartleben. Collections "Epistémè." Paris: Christian Bourgois, 1986.

———. *Précis du système hiéroglyphique des anciens Égyptiens . . .* 2nd ed. Paris: L'Imprimerie royale, 1827–28.

Champollion-Figeac, Jacques-Joseph. *L'Obélisque de Louqsor transporté à Paris. Notice historique, descriptive et archéologique sur ce mouvement, par M. Champollion-Figeac; avec la figure de l'obélisque et l'interprétation de ses inscriptions hiéroglyphiques, d'après les dessins et les notes manu-*

Benocci, Carla. "L'obelisco di Villa Celimontana." *L'Urbe*, n.s. 5 (1987) 5–21.

———. "Roma, Villa Mattei al Celio: le sistemazioni cinque-seicentesche del giardino, di Giovanni e Domenico Fontana." *Storia della città* 46 (1989) 102–24.

Bentivoglio, Enzo. "Bramante e il geroglifico di Viterbo." *Mitteilungen des Kunsthistorischen Instituts in Florenz* 16 (1992) 167–74.

Bernini, Domenico. *Vita del cavalier Gio. Lorenzo Bernino.* Rome: a spese di Rocco Bernabò, 1713.

Beschi, Luigi. "L'Anonimo Ambrosiano: un itinerario in Grecia di Urbano Bolzanio." *Accademia Nazionale dei Lincei, Rendiconti, Classe di scienze morali, storiche e filologiche,* ser. 8, 39 (1984) 3–22.

Bianchi, Lorenzo. *Ad limina Petri: Spazio e memoria della Roma cristiana.* Rome: Donzelli, 1999.

Billington, David P. *The Art of Structural Design: A Swiss Legacy.* Exh. cat. Princeton University Art Museum. New Haven; London: Yale University Press, 2003.

Boatwright, Mary Taliaferro. *Hadrian and the City of Rome.* Princeton: Princeton University Press, 1987.

Bober, Phyllis Pray, and Ruth Rubinstein. *Renaissance Artists and Antique Sculpture: A Handbook of Sources.* Rev. ed. London: Harvey Miller Publishers; Oxford; New York: Oxford University Press, 1987.

Böck, Angela. *Das Dekorationsprogramm des Lesesaals der Vatikanischen Bibliothek.* Schriften aus dem Institut für Kunstgeschichte der Universität München 32. Munich: Tuduv, 1988.

Bonifacio VIII e il suo tempo: Anno 1300 il primo giubileao. Ed. Marina Righetti Tosti-Croce. Milan: Electa, 2000.

Borel, Petrus. *L'Obélisque de Louqsor.* Paris: Chez les marchands de nouveautés, 1836.

Bose, Georg Matthias. *Commercium epistolicum de Sesostridis, Augusti et Benedicti XIV. Obelisco. Obiter Plinius Historiographus et Diodorus Siculus emendantur.* Greifswald: [n.p.], 1751.

Bowersock, Glen W. *Julian the Apostate.* Cambridge, Mass.: Harvard University Press, 1978.

Brahe, Tycho. *Opera omnia.* Ed. J. L. E. Dreyer. 15 vols. Copenhagen [Havniae]: in Libraria Gyldendaliana, 1913–29.

Bredekamp, Horst. *The Lure of Antiquity and the Cult of the Machine.* Trans. Allison Brown. Princeton: Markus Wiener Publishers, 1995.

Brown, Peter. *Power and Persuasion in Late Antiquity: Towards a Christian Empire.* Madison: University of Wisconsin Press, 1992.

———. *The Rise of Western Christendom: Triumph and Diversity, A.D. 200–1000.* 2nd ed. Malden, Mass.: Blackwell, 2003.

Bruce, James. *Travels Through Part of Africa, Assyria, Egypt, and Arabia into Abyssinia, to Discover the Source of the Nile.* London: J. F. Dove, [n.d.].

Buchner, Edmund. "Ein Kanal für Obelisken: Neues vom Mausoleum des Augustus in Rom." *Antike Welt* 27 (1996) 161–68.

———. *Die Sonnenuhr des Augustus.* Mainz am Rhein: Verlag Philipp von Zabern, 1982.

Budge, Sir E. A. Wallis. *Cleopatra's Needles and Other Egyptian Obelisks.* London: Religious Tract Society, 1926.

———. *An Egyptian Hieroglyphic Dictionary.* 2 vols. London, 1920. Repr. New York: Dover, 1978.

Burmeister, Karlheinz. *Georg Joachim Rhetikus, 1514–1574: Eine Bio-Bibliographie.* 3 vols. Wiesbaden: Pressler, 1967–68.

Burnet, Gilbert. *Some letters, containing an account of what seemed most remarkable in Switzerland, Italy, some parts of Germany, &c. in the*

Rezeption des antiken Mythos in Europa, Beiheft 2. Berlin: Gebr. Mann, 1997.

Apollodorus, of Athens. *Apollodori Atheniensis Bibliothecae libri tres et fragmenta.* Ed. Christian Gottlob Heyne. 2nd ed. 2 vols. Göttingen: Typis Henrici Dieterich, 1803.

Arnold, Dieter. *Building in Egypt: Pharaonic Stone Masonry.* Oxford: Oxford University Press, 1991.

Art and Architecture in the Service of Politics. Ed. Henry A. Millon and Linda Nochlin. Cambridge, Mass.: MIT Press, 1978.

Art in Rome in the Eighteenth Century. Ed. Edgar Peters Bowron and Joseph J. Rishel. Exh. cat. Philadelphia Museum of Art. Philadelphia: Philadelphia Museum of Art, 2000.

Le arti a Roma da Sisto IV a Giulio II. Ed. Anna Cavallaro. Rome: Bagatto, 1985.

Artistic Exchange and Cultural Translation in the Italian Renaissance City. Ed. Stephen J. Milner and Stephen J. Campbell. Cambridge: Cambridge University Press, 2004.

Assmann, Jan. *Ägypten: Theologie und Frömmigkeit einer frühen Hochkultur.* Stuttgart: W. Kohlhammer, 1984.

———. *Moses the Egyptian: The Memory of Egypt in Western Monotheism.* Cambridge, Mass.: Harvard University Press, 1997.

———. *The Search for God in Ancient Egypt.* Trans. David Lorton. Ithaca: Cornell University Press, 2001.

Athanasius Kircher: Il Museo del Mondo. Ed. Eugenio Lo Sardo. Rome, 2001.

Athanasius Kircher: The Last Man Who Knew Everything. Ed. Paula Findlen. New York: Routledge, 2004.

Aufrère, Sydney H. *La Momie et la tempête: Nicholas-Claude Fabri de Peiresc et la curiosité égyptienne en Provence au début du XVIIe siècle.* Avignon: Editions A. Barthélemy, 1990.

Baffoni, Giovanni, and Paola Mattiangeli. *Annio da Viterbo: Documenti e ricerche.* Contributi alla storia degli studi etruschi e italici 1. Rome: Consiglio nazionale delle ricerche, 1981.

Bagnall, R. S. *Egypt in Late Antiquity.* Princeton: Princeton University Press, 1993.

Baines, John R. "Bnbn: Mythological and Linguistic Notes." *Orientalia* 39 (1970) 389–404.

Balfour, Sir Andrew. *Letters writen to a friend by the learned and judicious Sir Andrew Balfour . . . ; containing excellent directions and advices for travelling thro' France and Italy; with many curious and judicious remarks and observations made by himself in his voyages thro' these countreys; published from the author's original M.S.* Edinburgh: [n.p.], 1700.

Bandini, Angelo Maria. *De obelisco Caesaris Augusti e Campi Martii ruderibus nuper eruto commentarius auctore Angelo Maria Bandinio. Accedunt cll. virorum epistolae atque opuscula.* Rome: Excudebant N. & M. Palearini, 1750.

Bargaeus, Petrus [Pietro Angeli]. *Petri Angelii Bargaei Commentarius de obelisco: ad sanctiss. et beatiss. D.N.D. Xystvm V. Pont. Max.* Rome: Ex officina Bartholomaei Grassij, 1586 [1587].

Baronio storico e la Controriforma. Ed. Romeo de Maio, et al. Sora: Centro di Studi Sorani "V. Patriarca," 1982.

Barrett, Anthony A. *Caligula: The Corruption of Power.* New Haven; London: Yale University Press, 1989.

Barthélemy, Auguste. *L'Obélisque de Luxor.* Paris: Imprimerie Everat, 1833.

Bassett, Sarah Guberti. "The Antiquities in the Hippodrome of Constantinople." *Dumbarton Oaks Papers* 45 (1991) 87–96.

Beard, Mary, John North, and Simon Price. *Religions of Rome.* 2 vols. Cambridge: Cambridge University Press, 1998.

Bedini, Silvio A. *The Pope's Elephant.* Manchester: Carcanet, 1997.

Ed. Alison E. Cooley. Bulletin of the Institute of Classical Studies, Supplement 75. London: Institute of Classical Studies, School of Advanced Study, University of London, 2000.

Age of the Marvelous. Ed. Joy Kenseth. Exh. cat. Hood Museum of Art. Chicago; London: University of Chicago Press, 1991.

D'Agnel, Arnaud. "Marseille et le second obélisque de Louqsor." *Répertoire des travaux de la Société de Statistique de Marseille* 46 (1905) 155–63.

Agrippa, Camillo. *Trattato di Camillo Agrippa Milanese De trasportar la guglia in su la piazza di San Pietro.* Rome: Francesco Zanetti, 1583.

Aiken, Roger C. "The Capitoline Hill during the Reign of Sixtus V." Ph.D. diss., University of California, Berkeley, 1977.

Aiton, E. J. "Johannes Kepler and the Astronomy without Hypotheses." *Japanese Studies in the History of Science* 14 (1975) 49–71.

The Aksum Archaeological Area: A Preliminary Assessment. Ed. Rodolfo Fattovich, et al. Naples: Istituto Universitario Orientale, Centro interdipartimentale di servizi per l'archeologia, 2000.

Alberti, Leon Battista. *De re aedificatoria.* Ed. Giovanni Orlandi. Trans. Paolo Portoghesi. 2 vols. Trattati di architettura 1. Milan: Edizioni Il Polifilo, 1966.

Albertini, Francesco. *Opusculum de mirabilibus novae & veteris urbis Romae.* Rome: Jacopo Mazzocchi, 1510.

Alexander, Sir James Edward. *Cleopatra's Needle. The Obelisk of Alexandria. Its Acquisition and Removal to England Described.* London: Chatto and Windus, 1879.

Alföldy, Géza. *Der Obelisk auf dem Petersplatz in Rom: ein historisches Monument der Antike: vorgetragen am 9. Dezember 1989.* Sitzungsberichte der Heidelberger Akademie der Wissenschaften, Philosophisch-Historische Klasse; Jahrg. 1990, Bericht 2. Heidelberg: C. Winter, 1990.

Allen, Don Cameron. *Mysteriously Meant: The Rediscovery of Pagan Symbolism and Allegorical Interpretation in the Renaissance.* Baltimore: The Johns Hopkins University Press, 1970.

———. "The Predecessors of Champollion." *Proceedings of the American Philosophical Society* 105 (1960) 527–47.

Ammianus Marcellinus. *Rerum gestarum libri.* Trans. John C. Rolfe. 3 vols. Loeb Classical Library. Cambridge, Mass.: Harvard University Press; London: William Heinemann, 1950–52.

Amory, Martha Babcock. *The Domestic and Artistic Life of John Singleton Copley, R.A. With Notices of His Works, and Reminiscences of His Son, Lord Lyndhurst, Lord High Chancellor of Great Britain. By His Granddaughter. . . .* Boston; New York: Houghton, Mifflin and Company, 1882.

Ancient African Civilizations: Kush and Axum. Ed. Stanley Burstein. Princeton: Markus Wiener Publishers, 1998.

Ancient Egyptian Kingship. Ed. David O'Conner and David P. Silverman. Probleme der Ägyptologie 9. Leiden: E. J. Brill, 1995.

Ancient Egyptian Literature: History and Forms. Ed. Antonio Loprieno. Leiden: E. J. Brill, 1996.

Angelin, Justin Pascal. *Expédition du Louxor, ou, Relation de la campagne faite dans la Thébaide: pour en rapporter l'obélisque occidental de Thèbes.* Paris: Thomine, libraire; Imprimerie d'Amédée Saintin, 1833.

Der Antike Mythos und Europa: Texte und Bilder von der Antike bis ins 20. Jahrhundert. Ed. Francesca Cappelletti and Gerlinde Huber-Rebenich. Ikonographische Repertorien zur

Bibliography

MANUSCRIPTS

Florence, Biblioteca Laurenziana
MS 69.27
MS 71.33

Oxford, Bodleian Library
Casaubon 52

Rome, Archivio di Stato
Camerale I, busta 1527, fasc. 49,
Congregatio super viis pontibus et
fontibus, I

Rome, Archivio Storico Capitolino
C. C., Cred. I, T. 28, c. 28, 1580–85
C. C., Cred. I, T. 29, c. 29, 1586–91

Rome, Biblioteca Angelica
Lat. 502

Rome, Biblioteca Nazionale Centrale
Fondo Gesuiti 164, c. 79

*San Marino, California, Burndy Library
Collection, at Henry E. Huntington
Library, Gardens, and Art Gallery
[Formerly, Cambridge, Massachusetts,
Burndy Library]*
MS acc# 27699

*Vatican City, Biblioteca Apostolica
Vaticana*
Ottobon. lat. 2967
Urb. lat. 301
Urb. lat. 1053
Urb. lat. 1054
Vat. lat. 1794
Vat. lat. 5684
Vat. lat. 6848
Vat. lat. 7721
Vat. lat. 8492
Vat. lat. 9152
Vat. lat. 12142

*Vienna, Österreichische
Nationalbibliothek*
9737m
13752

PRINTED WORKS

Achermann, H. *De Katakombenheiligen
und ihre Translationen in der
schweizerischen Quart des Bistums
Konstanz.* Stans: Verlag Historischer
Verein Nidwalden, 1979.
*The Afterlife of Inscriptions: Reusing,
Rediscovering, Reinventing, and
Revitalizing Ancient Inscriptions.*

cas, "The Monumental Stelae of Aksum (3rd–4th century A.D.)," in *Timeline of Art History* (New York: The Metropolitan Museum of Art, 2000ff.) http://www.metmuseum.org/toah/hd/aksu_2/hd_aksu_2.htm (October 2000), last accessed October 1, 2006. Also, Yuri M. Kobishchanov, *Axum* (University Park, 1979); and Stuart Munro-Hay, *Aksum: An African Civilisation of Late Antiquity* (Edinburgh, 1991). For a collection of documents, see *Ancient African Civilizations: Kush and Axum* (Princeton, 1998); and see D. W. Phillipson, "The Significance and Symbolism of Aksumite Stelae," *Cambridge Archaeological Journal* 4 (1994) 189–210.

30. For a summary of the story to 1999, see Richard Pankhurst, "Ethiopia, the Aksum Obelisk, and the Return of Africa's Cultural Heritage," *African Affairs* 98 (1999) 229–39.

31. "Rome Obelisk Struck by Lightning," BBC News, World Edition, May 28, 2002, http://news.bbc.co.uk/2/hi/Europe/2012770.stm (last accessed October 1, 2006); BBC News, International Version, April 19, 2005, "Obelisk Arrives Back in Ethiopia," http://news.bbc.co.uk/2/hi/Africa/4458195; and April 25, 2005, "Final Obelisk Section in Ethiopia," http://news.bbc.co.uk/2/hi/Africa/4472259 (last accessed October 1, 2006); Ethiopian Embassy, UK, "The Axum Obelisk," http://www.ethioembassy.org.uk/Facts%20about%20ethiopia/Facts%20about%20Ethiopia%20homepage.htm (last accessed October 1, 2006); and UNESCO, World Heritage, "Aksum, Ethiopia," http://whc.unesco.org/en/list/15/ (last accessed October 1, 2006).

32. Ian Limbach, "Special report: The Axum Obelisk Returns, but Some Still Grumble," *Archaeology* 58 (July/August 2005), http://www.archaeology.org/507/etc/specialreport.html (last accessed October 1, 2006).

33. *Ramesside Inscriptions: Translated & Annotated* (Oxford, 1996) 2:296. North face, right-hand text.

11. Russell Means, *Where White Men Fear to Tread: The Autobiography of Russell Means* (New York, 1995) 491; Peter Lefcourt, *The Woody. A Novel* (New York, 1998).

12. Sophie Pons, "L'obélisque de la Place de la Concorde à Paris coiffé d'un preservatif rose," Agence France-Presse, December 1, 1993.

13. "World Aids Day," *The Guardian* (December 2, 2005) 20.

14. http://www.crystal-emporium.com/crystal-obelisks.html, last accessed March 31, 2007. For another example, see http://www.fengshui-shop-online.com/obelisk -crystals.html, last accessed March 31, 2007.

15. For the Star Trek episode, first broadcast on October 4, 1968, see http://www.startrek .com/startrek/view/series/TOS/episode/68776.html, last accessed March 31, 2007.

16. http://www.ems.psu.edu/obelisk/, last accessed March 31, 2007.

17. *Chicago Tribune Tower Competition* (New York, 1981) 128 (plate 159). The other obelisk tower was submitted by the New York team of Alfred Fellheimer and Steward Wagner, page 127 (plate 158). Also, Richard A. Fazzini and Mary E. McKercher, "Egyptomania and American Architecture," in *Imhotep Today: Egyptianizing Architecture* (London, 2003) 140.

18. Margaret Malamud, "Pyramids in Las Vegas and in Outer Space: Ancient Egypt in Twentieth-Century American Architecture and Film," *Journal of Popular Culture* 34.1 (2000) 33-38.

19. David P. Billington, *The Art of Structural Design: A Swiss Legacy* (New Haven, 2003) 192-200.

20. Sarah J. Purcell, "Commemoration, Public Art, and the Changing Meaning of the Bunker Hill Monument," *The Public Historian* 25.2 (2003) 55-71.

21. Harold Rosenberg, *Barnett Newman: Broken Obelisk and Other Sculptures* (Seattle, 1971) 13; also Armin Zweite, *Barnett Newman: Paintings, Sculptures, Works on Paper* (Ostfildern-Ruit, 1999) 269-96.

22. Damjan Prelovšek, *Jože Plečnik, 1872–1957: Architectura Perennis* (New Haven, 1997) 127-30.

23. Uki Goñi, *The Real Odessa: How Perón Brought the Nazi War Criminals to Argentina* (London, 2002) xv.

24. Lauren Derby, "The Dictator's Seduction: Gender and State Spectacle during the Trujillo Regime," *Callaloo* 23.3 (2000) 1119.

25. Eric Roorda, *The Dictator Next Door: The Good Neighbor Policy and the Trujillo Regime in the Dominican Republic, 1930–1945* (Durham, 1998) 117.

26. Larry Rohter, "Santo Domingo Journal. The Three Sisters, Avenged: A Dominican Drama," *The New York Times* (February 15, 1997) 4.

27. D'Onofrio, *Obelischi*, 468-71.

28. Claudia Viggiani, *Exploring EUR, Cultural Itineraries* (Rome, [n.d.]) 22-23; d'Onofrio, *Obelischi*, 464.

29. The first modern excavations of ancient Aksum were carried out by a German team in the early twentieth century; see *Deutsche Aksum-Expedition* (Berlin, 1913). For a recent assessment of the site, see *The Aksum Archaeological Area: A Preliminary Assessment* (Naples, 2000) 51-52 for the stelae. Concise accounts of ancient Aksum include David W. Phillipson, "Aksum," *Encyclopedia of Africa South of the Sahara* (New York, 1997) 1:25-27; and Department of Arts of Africa, Oceania, and the Ameri-

39. Moldenke, *The New York Obelisk*, [vii]–viii.

40. Julien, "The Misfortunes of an Obelisk," 66.

41. Henry Honeychurch Gorringe, *Egyptian Obelisks* (New York, 1882) 51.

42. "The Obelisk. The Departed Glory of Cleopatra's Needle," *Brooklyn Eagle* (October 10, 1886) 10. Reprinted from the *North American Review*.

43. Alexis A. Julien, "A Study of the New York Obelisk as a Decayed Boulder," *Annals of the New York Academy of Sciences* 8.1 (1894) 93–166.

44. "Henry H. Gorringe Dead," *New York Times* (July 7, 1885) 5.

45. Gorringe, *Egyptian Obelisks*, 33.

46. Gorringe, *Egyptian Obelisks*, 37–38.

47. Gorringe, *Egyptian Obelisks*, 18.

48. "The Masonic Obelisk Parade," *Brooklyn Eagle* (September 21, 1880) 2.

49. Moses Wolcott Redding, *The Scarlet Book of Free Masonry* (New York, 1889) 457–94.

50. John Adam Weisse, *The Obelisk and Freemasonry According to the Discoveries of Belzoni and Commander Gorringe* (New York, 1880) 165–69.

51. Hargrave Jennings, *The Obelisk: Notices of the Origin, Purpose, and History of Obelisks* (London, 1877).

52. W. R. Cooper, *A Short History of the Egyptian Obelisks*, 7–8.

53. Terence Joseph O'Donnelly, *Extrait de la traduction authentique des hiéroglyphes de l'Obélisque de Louqsor à Paris* (Paris, 1851) 85–86.

CHAPTER TWELVE

The Twentieth Century and Beyond

1. Nicolas Slonimsky, *Perfect Pitch: A Life Story* (Oxford, 1988) 241.

2. Talvacchia, *Taking Positions*, 203.

3. For Jennings, see Chapter 11, note 51.

4. Algernon Charles Swinburne, *Letters* (New Haven, 1959–62) 2:157.

5. For "tree trunks," see Sigmund Freud, *The Interpretation of Dreams* (New York, 1965) 389; for the rest, see Sigmund Freud, *Introductory Lectures on Psycho-Analysis*, in Sigmund Freud, *The Standard Edition of the Complete Psychological Works of Sigmund Freud* (London, 1957–74) 15:154–55.

6. Carl Gustav Jung, *Psychology of the Unconscious* (Mineola, N.Y., 2003) 180.

7. Nathanael West, *Miss Lonelyhearts and The Day of the Locust* (New York, 1933, 1962) 19.

8. For the historical background and making of the film, see Katherine Orrison, *Written in Stone: Making Cecil B. DeMille's Epic, The Ten Commandments* (New York, 1990).

9. Henri Frankfort, *Kingship and the Gods. A Study of Ancient Near Eastern Religion as the Integration of Society & Nature* (Chicago, 1948) 381n27.

10. "Fetishism in statu nascendi," in Sándor Lorand, *Clinical Studies in Psychoanalysis* (New York, 1950) 14.

18. King, *Cleopatra's Needle*, 7.

19. Arthur Penrhyn Stanley, as quoted in Wilson, *Cleopatra's Needle*, 184.

20. Margaret S. Drower, "The Early Years," in *Excavating in Egypt: The Egypt Exploration Society, 1882–1982* (Chicago, 1982) 9–36.

21. For a discussion of the full range of the Egyptian revival in the United States, see Richard G. Carrott, *The Egyptian Revival: Its Sources, Monuments, and Meaning, 1808–1858* (Berkeley, 1978).

22. From the Bunker Hill Monument Association's May 23, 1823 petition to the Massachusetts legislature, as reprinted in George Washington Warren, *History of the Bunker Hill Monument Association During the First Century of the United States of America* (Boston, 1877) 43.

23. William W. Wheildon, *Memoir of Solomon Willard. Architect and Superintendent of the Bunker Hill Monument* (Boston, 1865) 79. Willard's comments are quoted from a letter he wrote to George Ticknor, whose context suggests that Willard's scheme may in fact have been suggested by Ticknor, who was on the selection committee. The architect Robert Mills, of Charleston, South Carolina, also submitted an obelisk design and always claimed Willard had stolen his idea.

24. Wheildon, *Memoir of Solomon Willard*, 66–67.

25. Solomon Willard, *Plans and Sections of the Obelisk* (Boston, 1843).

26. Train, *An American Merchant*, 280.

27. "Opening of the Wire Suspension Bridge over the Ohio," *The Daily Wheeling Gazette* (November 17, 1849) 2, reproduced at http://wheeling.weirton.lib.wv.us/history/landmark/bridges/SUSP/opening.htm, last accessed January 17, 2007.

28. "Anti-Monumental," *New York Daily Times* (June 22, 1855) 4.

29. *The Dedication of the Washington National Monument, with the Orations by Hon. Robert C. Winthrop and Hon. John W. Daniel. February 21, 1885. Published by Order of Congress* (Washington, 1885) 52–53.

30. *Dedication of the Washington National Monument*, 60–61.

31. *The American Art Review* 1 (1879), as cited in Peggy McDowell and Richard E. Meyer, *The Revival Styles in American Memorial Art* (Bowling Green, 1994) 137.

32. E. E. Farman, "The Negotiations for the Obelisk," in *The Century. A Popular Quarterly* 24.6 (October 1882) 879.

33. "That Obelisk. Astonishment in Cairo over the Remarkable News from America," *New York Times* (December 24, 1877) 1.

34. Farman's initial account, in Farman, "The Negotiations for the Obelisk," 879–89, is fleshed out somewhat in Elbert Eli Farman, *Egypt and its Betrayal: An Account of the Country during the Periods of Ismail and Tewfik Pashas, and of How England Acquired a New Empire* (New York, 1908) 142–67.

35. "The Navigation of Obelisks," *New York Times* (October 21, 1877) 6.

36. Martina D'Alton, *The New York Obelisk, or, How Cleopatra's Needle Came to New York and What Happened When it Got Here* (New York, 1993) 11.

37. Alexis A. Julien, "The Misfortunes of an Obelisk," in *Notes of Research on the New York Obelisk* (New York, 1893) 69.

38. Charles Edward Moldenke, *The New York Obelisk, Cleopatra's Needle* (New York, 1891).

66. Porterfield, *The Allure of Empire*, 13-15.

67. *Embellissemens de la Place de la Concorde. Explication des Monumens qui la décorent* (Paris, 1839).

68. Auguste Barthélemy, *L'Obélisque de Luxor* (Paris, 1833).

69. Lebas, *L'Obélisque de Luxor*, 194-211. In a similar vein, Armand-Rose Emy celebrated the woodwork constructed for the erection of the obelisk in his book on timber construction: Armand-Rose Émy, *Traité de l'art de charpenterie* (Liège, 1841-42) 2:583-86, also plates in vol. 3.

70. Barthélemy, *L'Obélisque de Luxor*.

71. Théophile Gautier, *Émaux et camées* (Paris, 1927) 46-54; Constance Gosselin-Schick, "Nostalgies d'obélisques," *Bulletin de la Société Théophile Gautier* 12.2 (1990) 261-71.

72. Gustave Flaubert, *Voyage en Égypte* (Paris, 1991) 375-76.

73. Florence Nightingale, *Letters from Egypt: A Journey on the Nile, 1849-1850* (New York, 1987) 80.

74. Amelia Ann Blanford Evans, *A Thousand Miles up the Nile* (London, 1892) 139.

75. Arnaud D'Agnel, "Marseille et le second obélisque de Louqsor," *Répertoire des travaux de la Société de Statistique de Marseille* 46 (1905) 155-63.

CHAPTER ELEVEN

Cleopatra's Needles: London and New York

1. George Francis Train, *An American Merchant in Europe, Asia, and Australia* (New York, 1857) 280.

2. Aubrey Noakes, *Cleopatra's Needles* (London, 1962) 12-13; *OiE* 2:104-7.

3. R. A. Hayward, *Cleopatra's Needles* (Hartington, 1978) 24-27; *OiE* 2:108-11.

4. *OiE* 2:107.

5. John Gardner Wilkinson, *Hand-book for Travellers in Egypt: Including Descriptions of the Course of the Nile* (London, 1847) 92; Jason Thompson, *Sir Gardner Wilkinson and his Circle* (Austin, 1992) 191-93.

6. Sir James Edward Alexander, *Cleopatra's Needle* (London, 1879) 19, 24.

7. Alexander, *Cleopatra's Needle*, 13-14.

8. Alexander, *Cleopatra's Needle*, 68.

9. "Cleopatra's Needle," *The Times* (September 7, 1877) 6.

10. *The Times* (October 3, 1877) 5.

11. Noakes, *Cleopatra's Needles*, 61-65.

12. "Alexandria," in Letters to the Editor, *The Times* (August 23, 1877) 9.

13. "Sea-Going Obelisks," *New York Times* (March 17, 1877) 4.

14. "Dean Stanley on Industrial Work," *The Times* (December 31, 1877) 10.

15. Arthur Sketchley, *Mrs. Brown on Cleopatra's Needle* (London, about 1877) passim, esp. 150-54.

16. Matilda Winifred Muriel Graham, *The Needlewoman* (London, 1911).

17. Rev. James King, *Cleopatra's Needle. The History of the Obelisk* (London, 1886) 5.

38. Champollion, *Lettres et journaux*, 29.

39. Champollion, *Lettres et journaux*, 181.

40. Champollion, *Lettres et journaux*, 155.

41. Champollion, *Lettres et journaux*, 249.

42. Champollion, *Lettres et journaux*, 387.

43. Champollion, *Lettres et journaux*, 387.

44. Alain Faure, *Champollion, le savant déchiffré* (Paris, 2004) 720–23.

45. The events are summarized in Robert Solé, *Le grand voyage de l'obélisque*, 23–28. Some of the relevant diplomatic correspondence is in *L'Égypte de 1828 à 1830. Correspondance des consuls de France en Égypte* (Rome, 1935) 229–35, 321–30.

46. Nearly all of the main figures who played a role in fetching the Luxor obelisk wrote memoirs. For technical matters, the key text is Jean-Baptiste Apollinaire Lebas, *L'Obélisque de Luxor: histoire de sa translation à Paris* (Paris, 1839). There are rich accounts of the voyage in Raimond Jean-Baptiste de Verninac de Saint-Maur, *Voyage du Luxor en Égypte* (Paris, 1835); Justin Pascal Angelin, *Expédition du Louxor* (Paris, 1833); and Léon de Joannis, *Campagne pittoresque du Luxor* (Paris, 1835). There is an excellent recent account in Solé, *Le grand voyage de l'obélisque*, and a useful abbreviated description in Bern Dibner, *Moving the Obelisks*, 55–58.

47. M. Petzet, "Der Obelisk des Sonnenkönigs. Ein Projekt Claude Perraults von 1666," *Zeitschrift für Kunstgeschichte* 47.4 (1984) 439–64.

48. Jean-Marcel Humbert, *L'Égypte à Paris. Paris et son patrimoine* (Paris, 1998) 34–36.

49. *Egyptomania*, 216–19 (cat. 112–15); also, Humbert, *L'Égypte à Paris*, 92–95.

50. *Egyptomania*, 213–15 (cat. 111); Humbert, *L'Égypte à Paris*, 77–84.

51. On Napoleon's contributions to the Paris cityscape, see Anthony Sutcliffe, *Paris. An Architectural History* (New Haven, 1993) 67–74.

52. "Viator," *Sur l'Emplacement de l'obélisque de Louqsor* (Paris, 1833) 15–16.

53. "Viator," *Sur l'Emplacement de l'obélisque*, 18–19.

54. François Miel, *Sur L'Obélisque de Louqsor et les embellissements de la Place de la Concorde et des Champs-Élysées* ([Paris], [1834]).

55. Petrus Borel, *L'Obélisque de Louqsor* (Paris, 1836) 13.

56. Borel, *L'Obélisque de Louqsor*, 14–15.

57. Borel, *L'Obélisque de Louqsor*, 5–6.

58. Borel, *L'Obélisque de Louqsor*, 16.

59. Lebas, *L'Obélisque de Luxor*, 1–9.

60. Angelin, *Expédition du Louxor*, 1.

61. Jacques-Joseph Champollion-Figeac, *L'Obélisque de Louqsor transporté à Paris* (Paris, 1833).

62. Pierre-Jean Mariette, *Description des travaux qui ont précédé, accompagné et suivi la fonte en bronze de Louis XV le bien aimé . . .* (Paris, 1768).

63. On the various monuments, see *De la Place Louis XV à la Place de la Concorde* (Paris, 1982) 47–123; on the Place's post-Revolution symbolism, see Richard D. E. Burton, *Blood in the City. Violence and Revelation in Paris, 1789–1945* (Ithaca, 2001) 41–71.

64. Todd Porterfield, *The Allure of Empire* (Princeton, 1998) 15.

65. Burton, *Blood in the City*, 64; for the obelisk and the political symbolism of its setting more generally, see Porterfield, *The Allure of Empire*, 13–41.

13. Robert Solé, *Le grand voyage de l'obélisque* (Paris, 2004) 11.

14. *The Philadelphia Magazine and Review; or Monthly Repository of Information . . .* Vol. 1, No. 6 (June 1799) 342.

15. In light of the well-publicized destruction of the French fleet, it's possible that the Philadelphia letter should be read in a spirit of irony. For the general history of the French military campaign, see Henry Laurens, et al., *L'Expédition d'Égypte, 1798–1801* (Paris, 1989).

16. Laurens, *L'Expédition d'Égypte,* 39.

17. Patrice Bret, "Le Physicien, la pyramide et l'obélisque: problèmes d'archéologie monumentale selon Coutelle," in *L'Expédition d'Égypte, une entreprise des lumières 1798–1801* (Paris, 1999) 129–56, esp. 146.

18. Patrice Bret, "Le Physicien, la pyramide et l'obélisque," 148.

19. For the end of the expedition, see Laurens, *L'Expédition d'Égypte,* 308–320; also, generally, Piers Mackey, *British Victory in Egypt, 1801* (London, 1995).

20. Gillispie, *Science and Polity,* 576.

21. Jean-François Champollion, *Précis du système hiéroglyphique des anciens Égyptiens* (Paris, 1827–28) 6.

22. W. V. Davies, *Egyptian Hieroglyphs* (London, 1987) 50–51.

23. Champollion, *Précis du système hiéroglyphique,* 13.

24. Champollion, *Précis du système hiéroglyphique,* 92.

25. Davies, *Egyptian Hieroglyphs,* 54. For the Bankes obelisk generally, see *OiE* 2:62–85.

26. Champollion, *Précis du système hiéroglyphique,* 184.

27. Champollion, *Précis du système hiéroglyphique,* 92–100.

28. The story is, naturally, far more complex than that presented here. For a more fully fledged account, see Maurice Pope, *The Story of Decipherment,* 43–84.

29. Champollion, *Précis du système hiéroglyphique,* 436–37.

30. Salvolini, *Traduction et analyse grammaticale,* i. Champollion expressed very similar sentiments in his letters (see Jean-François Champollion, *Lettres et journaux écrits pendant le voyage d'Égypte* [Paris, 1986] 273) suggesting that Salvolini's introduction may be plagiarized from one of the manuscripts he stole from Champollion's house after Champollion's death in 1832. The sordid affair is described in Sir E. A. Wallis Budge, *An Egyptian Hieroglyphic Dictionary* (1920; repr. New York, 1978) 1: xxiii–xxv.

31. Francesco Gasparoni, *Sugli obelischi Torlonia nella villa Nomentana: ragionamento storico-critico* (Rome, 1842) 41. Also, *Villa Torlonia: l'ultima impresa del mecenatismo romano* (Rome, 1997) 228–47.

32. Personal communication, Peter Der Manuelian, April 2006.

33. Gasparoni, *Sugli obelischi Torlonia,* 63.

34. *OiE* 2:98–99.

35. Khaled Fahmy, *All the Pasha's Men: Mehmed Ali, His Army, and the Making of Modern Egypt* (Cairo, 1997, 2002) 82–83.

36. Samuel Briggs, letter to Benjamin Blomfield, dated April 11, 1820. Quoted in Erasmus Wilson, *Cleopatra's Needle, with Brief Notes on Egypt and Egyptian Obelisks* (London, 1878) 186–90.

37. Fahmy, *All the Pasha's Men,* 2–3.

56. Zoega, *Briefe und Dokumente*, 1:317.

57. Zoega, *De origine*, 598.

58. Zoega, *De origine*, 1–126. Zoega compares these two massive collections of information to the paired obelisks often erected by the Egyptians.

59. Zoega, *De origine*, 137.

60. Zoega, *De origine*, 139.

61. Zoega, *De origine*, 174–75. For the wider context, see Jan Assmann, *Moses the Egyptian: The Memory of Egypt in Western Monotheism* (Cambridge, Mass., 1997).

62. Zoega, *Briefe und Dokumente*, 1:273.

63. Iversen, *Myth of Egypt*, 114–17.

64. Zoega, *De origine*, 68.

65. Zoega, *De origine*, 67.

66. Zoega, *De origine*, 598.

67. Zoega, *De origine*, 598.

CHAPTER TEN

Napoleon, Champollion, and Egypt

1. François Salvolini, *Traduction et analyse grammaticale des inscriptions sculptées sur l'obélisque égyptien de Paris* (Paris, 1837) i.

2. For Pius's downfall, see chapter 8, above, and Collins, *Papacy and Politics*.

3. 'Abd al-Raḥmān al-Jabartī, *Napoleon in Egypt. Al-Jabarti's Chronicle of the French Occupation, 1798* (Princeton, 1993) 6–7. For a general discussion of economic relations between Europe and Egypt in the eighteenth and nineteenth centuries, see Peter Gran, *Islamic Roots of Capitalism, Egypt 1760–1840* (Austin, 1978) esp. ch. 2.

4. Quoted and translated in Charles Coulston Gillispie, *Science and Polity in France: The Revolutionary and Napoleonic Years* (Princeton, 2004) 558.

5. Gillispie, *Science and Polity*, 560.

6. Letter of Prosper Jollois to his father, 21 germinal an VI (10 April 1798), in Prosper Jollois, *Journal d'un ingénieur attaché à l'Expédition d'Égypte 1798–1802* (Paris, 1904) 3.

7. For a general overview and bibliography on the scientific expedition, see Gillispie, *Science and Polity*, 557–600.

8. Jollois, *Journal*, 41.

9. Joseph-Marie Moiret, *Mémoires sur l'expédition d'Égypte* (Paris, 1984) 36.

10. Vivant Denon, *Voyage dans la basse et la haute Égypte, pendant les campagnes du général Bonaparte* (Paris, 1802) 21.

11. Denon, *Voyage dans la basse et la haute Égypte*, 140. The temple at Philae has, in fact, been moved, but by the Egyptians, to escape the rising waters of the reservoir behind the first Aswan dam.

12. For Napoleon's art collecting, see Andrew McLellan, *Inventing the Louvre. Art, Politics, and the Origins of the Modern Museum in Eighteenth-Century Paris* (Berkeley, 1994) 114–23.

ghese," in *Piranèse et les Français* (Rome, 1978) 1–32; *Egyptomania*, 40–41, 96–98 (cat. 35–37), 101–03 (cat. 39–40); Curl, *Egyptian Revival*, 168.

30. *Egyptomania*, 298; an example is Museum of Fine Arts, Boston, acc. no. 2005.202.1-6.

31. Hellmut Hager, "Fontana, Carlo," in *DBI* 48: 624–36.

32. Carlo Fontana, *Templum Vaticanum et ipsius origo* (Rome, 1694) 1–2.

33. On the character of Fontana's writings, see Hellmut Hager, "Le opere letterarie di Carlo Fontana come autorappresentazione," in *In urbe architectus: modelli, disegni, misure: la professione dell'architetto, Roma 1680–1750* (Rome, 1991) 155–203.

34. Fontana, *Templum Vaticanum*, 110–16.

35. Luca Scarlini, *Le opere e i giorni. Angelo Maria Bandini collezionista e studioso* (Florence, 2003) 16.

36. Scarlini, *Opere e i giorni*, 15–16.

37. Bandini, *De obelisco*, xvi–xix.

38. Bandini, *De obelisco*, 13.

39. Bandini, *De obelisco*, 15.

40. Bandini, *De obelisco*, 23.

41. Lodovico Antonio Muratori to Angelo Maria Bandini, letter dated prid. Kal. Jan. 1748, number 5661 in Lodovico Antonio Muratori, *Epistolario di L. A. Muratori* (Modena, 1901 ff.) 5241–44. Other letters in the exchange can be found in Georg Matthias Bose, *Commercium epistolicum de . . . obelisco* (Greifswald, 1751).

42. Bandini, *De obelisco*, 113.

43. Ziegler's commentary, slightly miscited by Bandini, is Jakob Ziegler, et al. *In C. Plinii De naturali historia librum secundum commentarius* (Basel, 1531); Bandini, *De obelisco*, 108.

44. Bandini, *De obelisco*, xxii.

45. Giovanni Marangoni, *Delle cose gentilesche, e profane: trasportate ad uso, e adornamento delle chiese* (Rome, 1744) x.

46. Marangoni, *Delle cose gentilesche*, chaps. 1–2.

47. Marangoni, *Delle cose gentilesche,* 358–65.

48. Georg Zoega, *De origine et usu obeliscorum* (Rome, 1797) [iiii–v].

49. Zoega, *De origine*, v–vi.

50. Christian Gottlob Heyne, "Praefatio," in *Apollodori Atheniensis Bibliothecae libri tres et fragmenta* (Göttingen, 1803) vii. On Heyne and the University of Göttingen, see in general Herbert Butterfield, *Man on his Past* (Cambridge, 1955); Peter Hanns Reill, *The German Enlightenment and the Rise of Historicism* (Berkeley, 1975); Robert Leventhal, "The Emergence of Philological Discourse in the German States, 1770–1810," *Isis* 77 (1986) 243–60.

51. See especially Frank Manuel, *The Eighteenth Century Confronts the Gods* (1959; repr. New York, 1967) 303–04.

52. Georg Zoega, *Briefe und Dokumente. I: 1755–1785* (Copenhagen, 1957) 1:316.

53. Zoega, *De origine*, 186–87, 191.

54. See in general Iversen, *Myth of Egypt*, 117–21.

55. John Galt, *The Life, Studies, and Works of Benjamin West, Esq.* (London, 1820) 1:132; William B. Dinsmoor, "Early American Studies of Mediterranean Archaeology," *Proceedings of the American Philosophical Society* 87.1 (1943) 77.

1735) 142–48, esp. 147–48; Iversen, *Myth of Egypt*, 108; and Donald Malcolm Reid, *Whose Pharaohs? Archaeology, Museums, and Egyptian National Identity from Napoleon to World War I* (Berkeley, 2002) 27–29.

9. Reid, *Whose Pharaohs?*, 27.

10. Reid, *Whose Pharaohs?*, 27; and Lamy and Bruwier, *L'Égyptologie avant Champollion*, 158–68.

11. Frederik Ludvig Norden, *Travels in Egypt & Nubia* (London, 1757); Iversen, *Myth of Egypt*, 108–09; and James Stevens Curl, *The Egyptian Revival: Ancient Egypt as an Inspiration for Design Motifs in the West* (London, 2005) 144–46.

12. Richard Pococke, *A Description of the East and Some Other Countries* (London, 1743–45) 1:7, 23.

13. Pococke, *Description*, 1:106–07.

14. Pococke, *Description*, 1:117.

15. James Bruce, *Travels Through Part of Africa, Assyria, Egypt, and Arabia into Abyssinia, to discover the Source of the Nile* (London, n.d.) 78–79.

16. The fragmentary torso was not installed and seems to have been lost. See Mauro de Felice, *Miti ed allegorie egizie in Campidoglio* (Bologna, 1982); *Egyptomania*, 38, 105–06 (cat. 43–44); and Kim J. Hartswick, *The Gardens of Sallust: A Changing Landscape* (Austin, 2004) 130–38.

17. *Egyptomania*, 38–40.

18. *OiE* 1:167–70.

19. Heather Hyde Minor, *Reforming Rome: Architecture and Culture, 1730–58* (Ph.D. diss., Princeton University, 2002).

20. Curl, *Egyptian Revival*, 141–42.

21. Iversen, *Myth of Egypt*, 106, 113–17; Brian A. Curran, Review of "Jean-Marcel Humbert, Michael Pantazzi, and Christiane Ziegler, *Egyptomania: Egypt in Western Art, 1730–1930*," *The Art Bulletin* 78.4 (1996) 739–44.

22. *Laws* 2.656e; in Plato, *Plato. Laws. Books I–VI.* (Cambridge, Mass., 1926) 102–03; Plato, *The Collected Dialogues of Plato, Including the Letters* (Princeton, 1963) 1254. For discussion, see Whitney Davis, "Plato on Egyptian Art," *Journal of Egyptian Archaeology* 65 (1979) 121–27.

23. For Winckelmann's Egyptian chapters, see Johann Joachim Winckelmann, *Werke* (Stuttgart, 1847) 1:37–69; and J. J. Winckelmann, *History of Ancient Art* (Boston, 1860; repr. New York, 1969) 63–105. For further discussion, see Curran, "Review: *Egyptomania*," 743.

24. Rudolf Wittkower, "Piranesi and Eighteenth-Century Egyptomania," in Rudolf Wittkower, *Studies in the Italian Baroque* (London, 1975) 260–73; *Egyptomania*, 39–40, 66–74 (cat. 14–21); and Curl, *Egyptian Revival*, 155–67.

25. Piranesi, *Diverse maniere*, plates 5, 10, 14, 24, 32; for discussion, see *Egyptomania*, 69–74.

26. Piranesi, *Diverse maniere*, 18, quoted in Iversen, *Myth of Egypt*, 112–13.

27. Piranesi, *Diverse maniere*, 9.

28. Dirk Syndram, *Die Ägyptenrezeption unter August dem Starken: Der "Apis-Altar" Johann Melchior Dinglingers* (Mainz, 1999).

29. Pierre Arizzoli-Clementel, "Charles Percier et la salle égyptienne de la Villa Bor-

Obelischi, 435–45; *Der Obelisk des Antinoos;* and MacDonald and Pinto, *Hadrian's Villa*, 149n353.

CHAPTER NINE

The Eighteenth Century: New Perspectives

1. Giovanni Battista Piranesi, *Diverse maniere di adornare i cammini* (Rome, 1769) 18, quoted in Iversen, *Myth of Egypt*, 112–13.

2. For an anthology of early travel accounts, see Florimond Lamy and Marie-Cécile Bruwier, *L'Égyptologie avant Champollion* (Louvain-la-Neuve, 2005). For discussion and other examples, see G. Lumbroso, "Descrittori Italiani dell'Egitto e di Alessandria," *Atti della Reale Accademia dei Lincei, Rendiconti, Memorie, Classe di scienze morali, storiche, e filologiche*, 3rd ser., 3 (1879) 429–503; Dannenfeldt, "Egypt in the Renaissance," 11–16; Leslie Greener, *The Discovery of Egypt* (London, 1966); Giuliano Lucchetta, "I viaggiatori veneti dal medioevo all'età moderna," in *Viaggiatori veneti alla scoperta dell'Egitto* (Venice, 1985) 43–68; Jeanine Guérin-Dalle Mese, *Égypte: La mémoire et le rêve. Itinéraires d'un voyage, 1320–1601* (Florence, 1991); and Anne Woolf, *How Many Miles to Babylon? Travels and Adventures to Egypt and Beyond* (Liverpool, 2003).

3. Text in *Voyages en Égypte des années 1589, 1590, & 1591, le vénitien anonyme, le seigneur de Villamont, Jan Sommer* (Cairo, 1971) 90–91; 7–28, 30–153; translation based in part on Sergio Donadoni, et al., *Egypt From Myth to Egyptology* (Milan, 1990) 60.

4. For early travelers, see Greener, *Discovery of Egypt;* Mese, *Égypte;* Woolf, *How Many Miles to Babylon?; Traveling Through Egypt: From 450 B.C. to the Twentieth Century* (Cairo, 2004).

5. George Sandys, *A relation of a iourney begun an: Dom: 1610* (London, 1615) 127.

6. For Sandys, see Jonathan Haynes, *The Humanist as Traveler: George Sandys's Relation of a journey begun an. dom. 1610* (Rutherford, 1986); for della Valle, see Pietro della Valle, *Viaggi di Pietro della Valle il Pellegrino* (Bologna, 1672) 1:371–89; translation in Pietro della Valle, *The Pilgrim: The Travels of Pietro della Valle* (London, 1989) 48–63. For della Valle's mummies, now in Dresden, see Euphrosyne Doxiadis, *The Mysterious Fayum Portraits: Faces from Ancient Egypt* (New York, 1995) 18–19, 122–25.

7. John Greaves, *Pyramidographia: Or a Description of the Pyramids in Aegypt* (London, 1646). For discussion see Helen Whitehouse, "Towards a Kind of Egyptology," 68–69; and Zur Shalev, "Measurer of All Things: John Greaves (1602–1652), the Great Pyramid, and Early Modern Metrology," *Journal of the History of Ideas* 63.4 (October 2002) 555–75; also Zur Shalev, "The Travel Notebooks of John Greaves," in *The Republic of Letters and the Levant* (Leiden, 2005) 77–102.

8. Jean-Baptiste Le Mascrier and Benoît de Maillet, *Description de l'Égypte, contenant plusieurs remarques curieuses sur la géographie ancienne et moderne de ce païs* (Paris,

age is Jeffrey Collins, *Papacy and Politics in Eighteenth-Century Rome: Pius VI and the Arts* (Cambridge, 2004); see 9–17 for Braschi's earlier career and character, 30–86 for his taste in imagery (including triumphal arches), and 132–92 for his programs in the Vatican "Pio-Clementine" Museum, which included the installation of Egyptian statues in the Sala a Croce Greca – the monumental "entrance foyer" to the complex.

24. For the full story of this discovery and the resulting monument, see *OiE* 1:115–27; Collins, "Obelisks as Artifacts," 58–60; and Collins, *Papacy and Politics,* 195–203.

25. For the "horse-tamers," see Francis Haskell and Nicholas Penny, *Taste and the Antique: The Lure of Classical Sculpture, 1500–1900* (New Haven, 1981) 136–41.

26. Sforza, "Episodi della storia," 20:415, 426.

27. Sforza, "Episodi della storia," 20:426; *Art in Rome in the Eighteenth Century,* 191–93.

28. *Egyptomania: Egypt in Western Art, 1730–1930,* 41–42; and Collins, *Papacy and Politics,* 200.

29. *OiE* 1:123–27.

30. Francesco Cancellieri, *Il mercato, il Lago dell'Acqua Vergine, ed il Palazzo Panfiliano nel circo Agonale detto volgarmente Piazza Navona* (Rome, 1811) 164–80; see *OiE* 1:134; and Collins, *Papacy and Politics,* 200.

31. Cancellieri, *Mercato,* translated in Collins, *Papacy and Politics,* 200.

32. Sforza, "Episodi della storia," 20:419; Collins, *Papacy and Politics,* 205.

33. Goethe, *Italian Journey,* 398; Collins, *Papacy and Politics,* 207.

34. For the history of and various opinions on the projects, see *OiE* 1:128–41; Collins, "Obelisks as Artifacts," 60–61; and Collins, *Papacy and Politics,* 203–10.

35. John Ray, *Observations topographical, moral, & physiological made in a journey through part of the low-countries, Germany, Italy, and France* (London, 1673) 356.

36. *OiE* 1:149–50.

37. Translation and original text from *OiE* 1:151–52, 150n4.

38. The results were published in Angelo Maria Bandini, *De obelisco Caesaris Augusti* (Rome, 1750). See *OiE* 1:152–55.

39. *OiE* 1:154–56. For Stuart, see Susan Weber Soros, *James "Athenian" Stuart, 1713–1788. The Rediscovery of Antiquity* (New Haven, 2006).

40. As quoted in Collins, *Papacy and Politics,* 215.

41. For the restoration and its antiquarian context, see *OiE* 1:157–60; Collins, "Obelisks as Artifacts," 61–65; and Collins, *Papacy and Politics,* 210–19.

42. For Antinori's argument, see Collins, "Obelisks as Artifacts," 61–63; and *Papacy and Politics,* 215–16.

43. Sforza, "Episodi della storia," 20:440; also *OiE* 1:159.

44. For the eighteenth-century sundial project, see Collins, *Papacy and Politics,* 216–19. For the modern project, see the website of Franco Zagari: http://www.francozagari .it/HOME/Piazza%20Montecitorio/montecitorio.htm, last accessed August 28, 2006.

45. Collins, "Obelisks as Artifacts," 58.

46. *OiE* 1:123–27.

47. See *OiE* 1:161–73; Boatwright, *Hadrian and the City of Rome,* 239–60; D'Onofrio,

4. *OiE* 1:44; Thomas Thieme, "La geometria di Piazza San Pietro," *Palladio* 23 (1973) 129–44.

5. Klaas van Berkel, " 'Cornelius Meijer inventor et fecit.' On the Representation of Science in Late Seventeenth-Century Rome," in *Merchants and Marvels: Commerce, Science, and Art in Early Modern Europe* (New York, 2002) 277–94.

6. Cornelis Meijer, *L'arte di restituire à Roma la tralasciata nauigatione del suo Tevere* (Rome, 1685) figures 11 (Piazza del Popolo) and 15 (Piazza San Pietro).

7. J. L. Heilbron, *The Sun in the Church: Cathedrals as Solar Observatories* (Cambridge, Mass., 1999).

8. *Discorso sopra il nuovo ornato della guglia di S. Pietro* (Rome, 1723) 5: "... alcuni difetti, che attentamente esaminati, disgustavano non poco l'occhio dilicato de'più versati nello studio delle bell'Arti."

9. *OiE* 1:45.

10. For Alexander's building programs in political context, see Richard Krautheimer, *The Rome of Alexander VII, 1655–1667* (Princeton, 1985) esp. 131–47.

11. For the dedicatory inscriptions, see Cipriani, *Obelischi Egizi*, 118–20.

12. For a general introduction to Rome's role in the eighteenth century, see *Art in Rome in the Eighteenth Century* (Philadelphia, 2000) esp. 17–46.

13. Gilbert Burnet, *Some letters, containing an account of what seemed most remarkable in Switzerland, Italy, some parts of Germany, &c. in the years 1685 and 1686* (Amsterdam, 1688) 162.

14. Sir Andrew Balfour, *Letters writen to a friend by the learned and judicious Sir Andrew Balfour . . .* (Edinburgh, 1700) 267–68.

15. Balfour, *Letters writen to a friend*, 274.

16. Johann Wolfgang von Goethe, *Italian Journey* (New York, 1989) 104. Translation slightly modified after comparison with Johann Wolfgang von Goethe, *Italienische Reise* (Munich, 1992) 147.

17. Goethe, *Italian Journey*, 363, 443.

18. For Byers, and the experience of being a tourist, see Jules David Prown, "A Course of Antiquities at Rome, 1764," *Eighteenth-Century Studies* 31.1 (1997) 90–92.

19. Edward Gibbon, *Miscellaneous Works of Edward Gibbon, Esq.* (Dublin, 1796) 1:127.

20. Letter from John Singleton Copley to his wife, Rome, December 4, 1774. Martha Babcock Amory, *The Domestic and Artistic Life of John Singleton Copley, R.A.* (Boston, 1882) 42. Copley was repeating himself; two months earlier he had written from Genoa: "if I should suddenly be transported to Boston, I should think it only a collection of wren boxes, it is on so small a scale compared to the cities of Europe – and much greater remain to be seen. Rome will make Genoa even seem small, if I mistake not." Letter from John Singleton Copley to his wife, Genoa, October 8, 1774. Amory, *The Domestic and Artistic Life*, 35.

21. Giovanni Sforza, "Episodi della storia di Roma nel secolo XVIII," *Archivio storico italiano*, 4th ser., vols. 19, 20 (1887, 1887) 20:408, 410.

22. Wolfgang Amadeus Mozart, postscript to his sister, added to a letter of Leopold Mozart, Rome, April 14, 1770. *Mozart's Letters, Mozart's Life. Selected Letters* (New York, 2000) 121. Goethe, *Italian Journey*, 115.

23. Collins, "Obelisks as Artifacts," 58. The fundamental study of Pius VI and his patron-

10. Anthony Grafton, "Kircher's Chronology," in *Athanasius Kircher: The Last Man Who Knew Everything*, 171–87.

11. D. C. Allen, "The Predecessors of Champollion," *Proceedings of the American Philosophical Society* 105 (1960) 527–47; Allen, *Mysteriously Meant*, 124–31; Pope, *Story of Decipherment*, 28–33; *Great Art of Knowing*, 115–39; Rowland, "United Sense of th' Universe"; and Stolzenberg, "Egyptian Oedipus," 257–60, 266–79.

12. *Great Art of Knowing*, 127–30ff; Rowland, "United Sense of th' Universe," 157–66; and Stolzenberg, "Egyptian Oedipus," 184–88, 256–96, 322–39.

13. For the best description, see Stolzenberg, "Egyptian Oedipus," 167–78.

14. Athanasius Kircher, *Oedipus Aegyptiacus* (Rome, 1652–55) 3:80–160; and Stolzenberg, "Egyptian Oedipus," 287–89.

15. See Kircher, *Oedipus Aegyptiacus*, 3:49; Iversen, *Myth of Egypt*, 96–97; and *Great Art of Knowing*, 115–39. On Kircher's many errors in Coptic, see Hamilton, *Copts*, 203–28.

16. William S. Heckscher, "Bernini's Elephant and Obelisk," *Art Bulletin* 29 (1947) 155–82; *OiE* 1:93–100; Flaminia Cosmelli, "L'elefante, l'albero e l'obelisco," *Storia dell'Arte* 66 (1985) 107–18; D'Onofrio, *Obelischi*, 302–23; and Collins, "Obelisks as Artifacts," 56–57.

17. *OiE* 1:98n1.

18. Kircher published his study of the obelisk and its hieroglyphs in a volume dedicated to the pope — the *Ad Alexandrum VII. . . . Obelisci Aegyptiaci nuper inter Isaei romani rudera effossi interpretatio hieroglyphica* (Rome, 1666) in which he correctly identified the find-spot as the ancient site of the Roman Temple of Isis Campensis.

19. Athanasius Kircher, *Vita Reverendi Patris Athanasii Kircheri, a semetipso conscripta*, ÖNB, MS 13752, fol. 28.

20. ÖNB, MS 13752, fols. 17–18. On this text see Howard Louthan, "Popular Piety and the Autobiography of Athanasius Kircher, SJ," in *Catholicism and Austrian Culture* (Edinburgh, 1999).

21. Gaspar Schott, *Mechanica hydraulico-pneumatica* (Frankfurt, 1657); Michael John Gorman and Nick Wilding, *La Technica Curiosa di Gaspar Schott* (Rome, 2000).

22. Domenico Bernini, *Vita del cavalier Gio. Lorenzo Bernino* (Rome, 1713).

23. Athanasius Kircher, *Iconismi e mirabilia da Athanasius Kircher* (Rome, 1999).

24. See Anthony Grafton, *Magic and Technology in Early Modern Europe* (Washington, D.C., 2005); and Gorman and Wilding, *Technica Curiosa*.

25. Grafton, *Magic and Technology*.

CHAPTER EIGHT

Grandeur: Real and Delusional

1. Translation adapted from *OiE* 1:124n4.

2. *OiE* 1:103–05.

3. Jeffrey Collins, "Obelisks as Artifacts," 57–58.

1. Athanasius Kircher, *Athanasii Kircheri . . . Obeliscvs Pamphilivs* (Rome, 1650) 505.

2. For the Mensa Isiaca, see Ernesto Scamuzzi, *La Mensa Isiaca del Regio Museo di Antichità di Torino* (Rome, 1939); and Enrica Leospo, *La Mensa Isiaca di Torino* (Leiden, 1978).

3. Lorenzo Pignoria, *Mensa Isiaca, qua sacrorum apud Aegyptios ratio & simulachra subiectis tabulis aeneis simul exhibentur & explicantur* (Amsterdam, 1670) 1–2; translation from Donadoni, et al, *Egypt from Myth to Egyptology,* 56–57.

4. Johann Georg Herwart von Hohenburg, *Thesaurus Hieroglyphicorum* (Munich [?], about 1608–10). For discussion, see Iversen, *Myth of Egypt,* 86–87; and Helen Whitehouse, "Towards a Kind of Egyptology: The Graphic Representation of Ancient Egypt, 1587–1666," in *Documentary Culture. Florence and Rome from Grand-Duke Ferdinand I to Pope Alexander VII* (Bologna, 1992) 63–79, esp. 72–73.

5. J. F. Herwart von Hohenburg, *Admiranda Ethnicae Theologiae Mysteria Propalata* (Ingolstadt, 1623); compare Whitehouse, "Towards a Kind of Egyptology," 72–73.

6. For Kircher's Egyptological studies, see Iversen, *Myth of Egypt,* 89–100; Pope, *Story of Decipherment,* 28–39; R. J. W. Evans, *The Making of the Habsburg Monarchy 1550–1700* (Oxford, 1979) 433–42; Valerio Rivosecchi, *Esotismo in Roma barocca: Studi sul Padre Kircher* (Rome, 1982) 49–75; G. F. Strasser, "La contribution d'Athanasius Kircher à la tradition humaniste hiéroglyphique," *XVIIe Siècle* 40 (1988) 79–82; Ingrid D. Rowland, *The Ecstatic Journey: Athanasius Kircher in Baroque Rome* (Chicago, 2000); *Athanasius Kircher: Il Museo del Mondo* (Rome, 2001) 101–41; *The Great Art of Knowing: The Baroque Encyclopedia of Athanasius Kircher* (Stanford, 2001) esp. 115–39; Caterina Marrone, *I geroglifici fantastici di Athanasius Kircher* (Viterbo, 2002); Daniel Stolzenberg, "Egyptian Oedipus: Antiquarianism, Oriental Studies, and Occult Philosophy in the Work of Athanasius Kircher" (Ph.D. diss., Stanford University, 2003); and *Athanasius Kircher: The Last Man Who Knew Everything* (New York, 2004) esp. 1–48; Curran, *Egyptian Renaissance,* 283–87.

7. For Peiresc as an Egyptological figure, see Sydney H. Aufrère, *La momie et la tempête;* Whitehouse, "Towards a Kind of Egyptology," 63–79; and Peter N. Milner, "Copts and Scholars: Athanasius Kircher in Peiresc's Republic of Letters," in *Athanasius Kircher: The Last Man Who Knew Everything,* 133–48. On Scaliger and della Valle, see Alastair Hamilton, *The Copts and the West, 1439–1822* (Oxford, 2006) 199, 201.

8. See Ingrid D. Rowland, "'Th' United Sense of th' Universe': Athanasius Kircher in Piazza Navona," *Memoirs of the American Academy in Rome* 46 (2001) 153–81. Also *OiE* 1:76–92; R. Preimesberger, "Obeliscus Pamphilius: Beiträge zu Vorgeschichte und Ikonographie des Vierströmebrunnens auf Piazza Navona," *Münchner Jahrbuch der Bildenden Kunst* 25 (1974) 77–162; D'Onofrio, *Obelischi,* 288–301; Jeffrey Collins, "Obelisks as Artifacts," 54–56; Grant Parker, "Narrating Monumentality: The Piazza Navona Obelisk," *Journal of Mediterranean Archaeology* 16.2 (2003) 193–215; and Frank Fehrenbach, *Compendia mundi: Gianlorenzo Berninis Fontana dei Quattro Fiumi (1648–51) und Nicola Salvis Fontana di Trevi (1732–62)* (Munich, 2008) 15–201.

9. Stolzenberg, "Egyptian Oedipus," 300–16ff.

Petrus Ramus's History of the Sciences," *Journal of the History of Ideas* 67 (2006) 63–85.

34. E. J. Aiton, "Johannes Kepler and the Astronomy without Hypotheses," *Japanese Studies in the History of Science* 14 (1975) 49–71.

35. Mercati, *Obelischi* (1981).

36. Mercati, *Obelischi* (1981) 103–32.

37. Mercati, *Obelischi* (1981) 116.

38. Mercati, *Obelischi* (1981) 114.

39. Mercati, *Obelischi* (1981) 96–97.

40. Gualtieri, *Sixti Quinti . . . Ephemerides,* Burndy MS, acc# 27699, fols. 134v–35r.

41. For further discussion of Sixtus's attitudes and priorities regarding the obelisks, see Antonio Patrignani, "L'obeliscomania di Sisto V," *Note di medaglistica papale classica* 13.4 (1950) 9–15; Giovanni Cipriani, *Gli obelischi Egizi: Politica e cultura nella Roma barocca* (Florence, 1993) 9–75; and Jeffrey Collins, "Obelisks as Artifacts in Early Modern Rome: Collecting the Ultimate Antiques," in *Ricerche di Storia dell'Arte* 72 (2001: Special Issue: "Viewing Antiquity: The Grand Tour, Antiquarianism, and Collecting") 49–68, esp. 50–54.

42. Hieronymus Henninges, *Genealogiae aliquot familiarum nobilium in Saxonia* (Hamburg, 1590) 72v; see also Peter Lindeberg, *Hypotyposis arcium, palatiorum, librorum, pyramidum, obeliscorum, molarum, fontium, monumentorum et epitaphiorum* (Rostock, 1590; repr. with changes, Hamburg, 1591 and Frankfurt, 1592); and Wiebke Steinmetz, *Heinrich Rantzau (1526–1598): Ein Vertreter des Humanismus in Nordeuropa und seine Wirkungen als Förderer der Künste* (Frankfurt, 1991). On Rantzau's astrological work, see now Günther Oestmann, *Heinrich Rantzau und die Astrologie: Ein Beitrag zur Kulturgeschichte des 16. Jahrhunderts* (Braunschweig, 2004).

43. Gunnar Eriksson, *The Atlantic Vision: Olaus Rudbeck and Baroque Science* (Canton, Mass., 1994).

44. Letter of M. de Minutiis to Rantzau, July 8, 1590, Vienna, ÖNB, MS 9737 m, fol. 35r; copy at fol. 36r.

45. BAV, MS Vat. lat. 5684, fol. 11r. This ill-judged decision was famously penalized by Isaac Casaubon: see *Das Ende des Hermetismus: historische Kritik und neue Naturphilosophie in der Spätrenaissance. Dokumentation und Analyse der Debatten um die Datierung der hermetischen Schriften von Genebrard bis Casaubon (1567–1614)* (Tübingen, 2002).

46. The frescoes are described by Fontana, *Della trasportatione,* fols. 82r–96v, esp. 89v (for the inscription). For more on this cycle in general, see Alphonse Dupront, "Les fresques de la bibliothèque de Sixte-Quint: Art et Contre-Réforme," *Mélanges d'archéologie et d'histoire de l'École Française de Rome* 48 (1931) 292–307; Jacob Hess, "Some Notes on Paintings in the Vatican Library," in J. Hess, *Kunstgeschichtliche Studien zur Renaissance und Barock* (Rome, 1967) 1:163–79; Angela Böck, *Das Dekorationsprogramm des Lesesaals der Vatikanischen Bibliothek* (Munich, 1988) esp. 60–62; *Roma di Sisto V,* 59–90; and Alessandro Zuccari, *I pittori di Sisto V* (Rome, 1992) 47–101.

Jahrhunderts (Munich, 1999); David Freedberg, *The Eye of the Lynx: Galileo, His Friends, and the Beginnings of Modern Natural History* (Chicago, 2002); Ingrid D. Rowland, *The Scarith of Scornello: A Tale of Renaissance Forgery* (Chicago, 2004).

23. For Egyptian objects imported to Europe during the period, see K. H. Dannenfeldt, "Egypt and Egyptian Antiquities in the Renaissance," *Studies in the Renaissance* 6 (1959) 7–27; Sydney H. Aufrère, *La momie et la tempête: Nicholas-Claude Fabri de Peiresc et la curiosité égyptienne en Provence au début du XVIIe siècle* (Avignon, 1990); and Helen Whitehouse, "Egyptology and Forgery in the Seventeenth Century," *Journal of the History of Collections* 1 (1989) 187–95. For *mummia* and the mummy trade during the Renaissance, see Roland Pécout, *Les Mangeurs de momie: Des tombeaux d'Égypte aux sorciers d'Europe* (Paris, 1981); and Renan Pollès, *La Momie de Khéops à Hollywood: Généalogie d'un mythe* (Paris, 2001) 13–32.

24. Pierre Desmaizeaux, ed. *Scaligerana* (Amsterdam, 1740) 2:484. See H. J. de Jonge, "Josephus Scaliger in Leiden," *Jaarboekje voor geschiedenis en oudheidkunde van Leiden en omstreken* 71 (1979) 71–74.

25. Anthony Grafton, "Rhetoric, Philology and Egyptomania in the 1570s: J. J. Scaliger's *Diatribe* against Melchior Guilandinus's *Papyrus*," *Journal of the Warburg and Courtauld Institutes* 42 (1979) 167–94.

26. Dannenfeldt, "Egypt and Egyptian Antiquities," 17–21.

27. Isaac Casaubon, note in his copy of Herodotus, ed. H. Estienne (Geneva, 1570), Cambridge University Library, Adv.a.3.2. See also his defense of Herodotus's seeking information from the Egyptians, the Persians, and other barbarians in Bodleian Library, MS Casaubon 52, fol. 105r.

28. Giovanni Battista Adriani, "Lettera di M. Giovambatista di M. Marcello Adriani a M. Giorgio Vasari nella quale brevemente si racconta i nomi e l'opere de' più eccellenti artefici in pittura, in bronzo ed in marmo . . . ," in Giorgio Vasari, *Le vite de' più eccellenti pittori, scultori ed architettori* (1568), in *Le opere di Giorgio Vasari* (1906; repr. Florence, 1981) 1:19.

29. See Walker, *The Ancient Theology,* and the more recent studies of Maria Mucillo, *Platonismo, ermetismo, e "prisca theologia": ricerche di storiografia filosofica rinascimentale* (Florence, 1996); Wilhelm Schmidt-Biggemann, *Philosophia Perennis* (Dordrecht, 2004); and Nicholas Popper, "'Abraham, Planter of Mathematics': Histories of Mathematics and Astrology in Early Modern Europe," *Journal of the History of Ideas* 67 (2006) 87–106.

30. See Georg Rheticus, *Georgii Joachimi Rhetici Narratio prima* (Wrocław, 1982), and Nicholas Jardine, *The Birth of History and Philosophy of Science* (Cambridge, 1984).

31. Johannes Kepler, *Gesammelte Werke* (Munich, 1937ff.) 3:6.

32. Karl Heinz Burmeister, *Georg Joachim Rhetikus, 1514–1574: Eine Bio-Bibliographie* (Wiesbaden, 1967–68) 3:139.

33. Petrus Ramus, *P. Rami professio regia hoc est septem artes liberales: in regia cathedra per ipsum Parisiis apodictico docendi genere propositæ* (Basel, 1576) fols. 1v–2r; Rheticus, *Narratio prima,* 238; cf. Tycho Brahe, *Opera omnia* (Copenhagen, 1913–29) 6:88–89. The larger context and development of Ramus's history of ancient science have been greatly clarified by Robert Goulding, "Method and Mathematics:

version of this manuscript is in BAV, MS Vat. lat. 12142, while a copy in the Biblioteca Nazionale Centrale in Rome (Fondo Gesuiti 164, c. 79), is the most complete. For Gualtieri, see V. Gallo, "Gualtieri, Guido," *DBI* 60:206–08.

12. For Sixtus's activities on the Capitoline Hill, which included the installation of a pair of Egyptian lions at the foot of the *cordonata,* the main entrance ramp to the area, see Roger C. Aiken, "The Capitoline Hill during the reign of Sixtus V" (Ph.D. diss., University of California, Berkeley, 1977); and Luigi Spezzaferro and Maria Elisa Tittoni Monti, *Il Campidoglio e Sisto V* (Rome, 1991).

13. Gualtieri, *Sixti Quinti . . . Ephemeride*s, Burndy, MS acc# 27699, fol. 64r.

14. Gualtieri, *Sixti Quinti . . . Ephemeride*s, Burndy, MS acc. # 27699, fols. 63v–64r: "felicitatem ei non defuturam credendum est cum praesertim sanctissimae crucis vexillum obelisco sit impositurus."

15. Galesino, *Ordo,* C2r.

16. An important revisionist study shows that the catacombs never ceased to be visited and explored in the Middle Ages: Irina Oryshkevich, *The History of the Roman Catacombs from the Age of Constantine to the Renaissance* (Ph.D. diss., Columbia University, 2003). On the sale of relics, see the splendid studies by H. Achermann, *De Katakombenheiligen und ihre Translationen in der schweizerischen Quart des Bistums Konstanz* (Stans, 1979) and Trevor Johnson, "Holy Fabrications: The Catacomb Saints and the Counter-Reformation in Bavaria," *Journal of Ecclesiastical History* 47 (1996) 274–97.

17. For Baronio and the history and archaeology of the early church, see Gamrath, *Roma Sancta Renovata;* Silvia Grassi Fiorentino, "Note sull'antiquaria romana nella seconda metà del secolo xvi," in *Baronio storico e la Controriforma* (Sora, 1982) 197–211; Stefano Zen, *Baronio storico: controriforma e crisi del metodo umanistico* (Naples, 1994); and Simon Ditchfield, *Liturgy, Sanctity and History in Tridentine Italy: Pietro Maria Campi and the Preservation of the Particular* (Cambridge, 1995).

18. Galesino, *Ordo,* B2v.

19. Augustine, *De doctrina christiana,* 2.40.60–61.

20. Galesino, *Ordo,* B3r.

21. For collections of Egyptian statues and other "grand" antiquities in the period, see Nikolaus Pevsner and S. Lang, "The Egyptian Revival," *Architectural Review* 119 (1956) 242–54, reprinted in Pevsner, *Studies in Art, Architecture, and Design,* 1:212–35; Roullet, *The Egyptian and Egyptianizing Monuments;* and O. Lollio Barberi, G. Parola, and M. P. Toti, *Le antichità egiziane di Roma imperiale* (Rome, 1995).

22. For these collections in general, see Julius von Schlosser, *Die Kunst- und Wunderkammern der Spätrenaissance: ein Beitrag zur Geschichte des Sammelwesens* (Leipzig, 1908); Adalgisa Lugli, *Naturalia et mirabilia: Il collezionismo enciclopedico nelle wunderkammern d'Europa* (Milan, 1983); *The Origins of Museums: The Cabinet of Curiosities in Sixteenth- and Seventeenth-Century Europe* (Oxford, 1985); Joy Kenseth, *Age of the Marvelous* (Chicago, 1991); Paula Findlen, *Possessing Nature* (Berkeley, 1994); Horst Bredekamp, *The Lure of Antiquity and the Cult of the Machine* (Princeton, 1995); Lorraine Daston and Katharine Park, *Wonders and the Order of Nature, 1150–1750* (New York, 1998); Arthur Wheelock, *A Collector's Cabinet* (Washington, D.C., 1998); Ingo Herklotz, *Cassiano dal Pozzo und die Archäologie des 17.*

committee overseeing construction of the Capitoline and for the decretal bestowing the obelisk upon him, see Archivio Storico Capitolino, C. C. Cred. I, T. 28, cat. 28, (1580–85) fol. 106r (the committee) and fol. 117v (the gift).

41. Dibner, *Moving the Obelisks*, 41; *OiE* 1:47–54; D'Onofrio, *Obelischi*, 238–41.

42. *OiE* 1:55–62; and Fontana, *Della trasportatione*, fols. 70v–71r.

43. *OiE* 1:62; and Fontana, *Della trasportatione*, fols. 71r–72v.

44. *OiE* 1:71; Fontana, *Della trasportatione*, fol. 75r–v; D'Onofrio, *Obelischi*, 260–67.

45. D'Onofrio, *Obelischi*, 236–37; Lembke, *Iseum Campense*, 204 (cat. 50); Gabriele Capecchi, *Il Giardino di Boboli, un anfiteatro per la gioia dei granduchi* (Florence, 1993); Gabriella Capecchi, *Da Roma a Firenze: le vasche romane di Boboli e cinquanta anni di vicende toscane* (Florence, 2002).

Changing the Stone: Egyptology, Antiquarianism, and Magic

1. Pietro Galesino [Petrus Galesinus], *Ordo dedicationis obelisci . . .* (Rome, 1586) D2v.

2. It was installed on the Fountain of Marforio after this famous "speaking statue" was set up on the Capitoline Hill in 1594. After several further moves, the sphere was added to the collection of historic bronzes at the Capitoline Museum, where it can be seen today. For the Sistine investigation of the sphere, see Pigafetta, *Discorso di M. Filippo Pigafetta*. Also *OiE* 1:31–32.

3. *OiE* 1:40.

4. *OiE* 1:39–40.

5. *OiE* 1:38.

6. Galesino, *Ordo*, C3v.

7. Pietro Angelio da Barga, *Petri Angelii Bargaei Commentarius de obelisco* (Rome, 1586 [1587]) 73.

8. Guido Gualtieri, *Sixti Quinti Pontificis Opt. Max Ephemerides*, Burndy Library, MS acc# 27699, fols. 114v–15r.

9. For the pontificate of Sixtus V, see Casimiro Liborio Tempesti, *Storia della vita e geste di Sisto quinto sommo pontefice dell'ordine de'Minori Conventuali di S. Francesco* (Rome, 1758); Joseph Alexander von Hübner, *The Life and Times of Sixtus the Fifth* (London, 1872); and Pastor, *History of the Popes*, vols. 21 and 22.

10. For Sixtus's urban and building projects, see J. A. F. Orbaan, *Sixtine Rome* (New York, 1911); Torgil Magnuson, *Rome in the Age of Bernini* (Stockholm, 1982–86) 1:1–38; Gamrath, *Roma Sancta Renovata;* Giorgio Simoncini, *Roma restaurata: rinnovamento urbano al tempo di Sisto V* (Florence, 1990); *Sisto V* (Rome, 1992); *Roma di Sisto V: le arti e la cultura* (Rome, 1993).

11. Gualtieri, *Sixti Quinti . . . Ephemerides*, Burndy MS acc# 27699, fols. 63v–64r: "cocleis Traiani, et Antonini Columnis Apostolorum Petri, et Pauli simulacra imponi mandavit, easque illis dicavit"; "urbis praesidibus Potentissimis." A much-abbreviated

25. Fontana, *Della trasportatione,* fols. 10v–13v.

26. *Avvisi di Roma,* BAV, MS Urb. lat. 1053, fol. 527r–v (November 16, 1585).

27. Fontana, *Della trasportatione,* fols. 13v–14r. Fontana mistakenly gives the year as 1585, rather than 1586, possibly a slip brought about by the correlation between his own operation and the papal coronation the previous year.

28. Fontana, *Della trasportatione,* fol. 14r.

29. Fontana, *Della trasportatione,* fol. 14r–v.

30. *Avvisi di Roma,* BAV, MS Urb. lat. 1054 ("de'ultimo d'Aprile 1586") fol. 165r–v: "Capo N[ostr]o"; "se bene à spectacolo cosi degno era concorsa gran parte di Roma et che molti Car[dina]li et altri Principi fossero accampati in quei contorni."

31. Fontana, *Della trasportatione,* fols. 14v–17r and 18r; *Avvisi di Roma,* BAV, MS Urb. lat. 1054, fol. 183v (7 da Maggio [15]86): "senza che nel'abassare tanta gran machina sia successa q[ue]lla fratura et rovina dubitata da molti, et grandi ingegnieri in tal atto."

32. Fontana, *Della trasportatione,* fol. 23r–v.

33. Fontana, *Della trasportatione,* fols. 23v, 25r, 27r; *Avvisi di Roma,* BAV, MS Urb. lat. 1054, fol. 430r (li 30 d'Agosto [1586]): "Si chiude la Piazza di San Pietro con grossi steccati"; "quelle Maestranze non habbino d'essere impedito dal concorso."

34. Fontana, *Della trasportatione,* fol. 33r; *Avvisi di Roma,* BAV, MS Urb. lat. 1054, fol. 444v (alli xiii di [Settem]bre 1586): "gli Architetti . . . per dar anco la vista del loro mirabile arteficio di questa impresa"; "smettero un gran pezzo senza far nulla fin 'a' tanto, che furono a vista di cosi rara mossa."

35. Fontana, *Della trasportatione,* fol. 33r–v; *Avvisi di Roma,* BAV, MS Urb. lat. 1054, fols. 447v–48r (li 13 Settembre 1556).

36. Fontana, *Della trasportatione,* fols. 33v–36v. As Iversen and others have pointed out, other sources from the time make clear that the date was the 26th of September, not the 27th, which is the date Fontana mistakenly gives. *OiE* 1:37–38. *Avvisi di Roma,* BAV, MS Urb. lat. 1054, fol. 490v (27th [Settem]bre 1586): "eri consorsa la meta di Roma"; and for Fontana's citizenship, Archivio Storico Capitolino, C. C. Cred. I, T. 29, cat. 29, 1586–91, fols. 49v–50r: "ob eius ingentem virtutem et scientiam in conductione Piramidis et illius elevatione."

37. Andrea Fulvio, *L'antichità di Roma* (Venice, 1588) 316–17 [*recte* 216–17].

38. Cornelis de Jode, *De quadrante geometrico libellus* (Nuremberg, 1594) esp. A3r–v.

39. Mercati, *Obelischi,* 354 (for Ammianus's description) and 360: "quanto sia diversa questa nuova maniera di drizzare gli Obeleschi, da quella che usarono gli antichi." For the illustrations in Fontana's treatise, see Nicoletta Marconi, *Edificando Roma barocca: macchine, apparati, maestranze e cantieri dal XVI al XVIII secolo* (Rome, 2004) 232. The obelisk inspired many smaller writings, including odes and sonnets. Several bound collections exist, often with very similar contents; examples can be found at the Vatican Library, Princeton University, Harvard University, and the Burndy Library, now housed at the Henry E. Huntington Library, San Marino, California.

40. *OiE* 1:51 and 106–14; and for the prior history of the obelisk and its move to the Capitoline, see especially D'Onofrio, *Obelischi,* 61–81; and Carla Benocci, "L'obelisco di villa Celimontana," *L'Urbe* n.s. 5 (1987) 5–21. For Ciriaco's appointment to the

Fontana," *The Dictionary of Art* (New York, 1996) 11:271–74; Giorgio Simoncini, *"Roma restaurata"*; and Gustavo Parisciani, *Sisto V e la sua Montalto* (Padua, 1986).

12. For the structure of Rome's government, see Niccolò del Re, *La curia capitolina* (Rome, 1954); and Laurie Nussdorfer, *Civic Politics in the Rome of Urban VIII* (Princeton, 1992) esp. 60–114, which deals primarily with a slightly later period but is highly informative on the commune of Rome in general and its relationships to the papacy.

13. Fontana, *Della trasportatione,* fol. 5r; and for the 1585 *Avvisi,* BAV, MS Urb. lat. 1053, fol. 410r. For a discussion of the *Avvisi* and their reliability, see Delumeau, *Vie économique et sociale de Rome,* 1:25–36.

14. Fontana, *Della trasportatione,* fol. 5r.

15. Fontana, *Della trasportatione,* fol. 8r, for the illustration of models. A reprint edition includes valuable introductory essays: Domenico Fontana, *Della trasportatione dell'obelisco vaticano, 1590* (Rome, 1590; repr. Milan, 1978); for further discussion of the models, see Dibner, *Moving the Obelisks,* 25; and *OiE* 1:29–30.

16. Fontana, *Della trasportatione,* fol. 5r.; and D'Onofrio, *Obelischi,* 475, for a transcription of part of Fontana's account book (ASR, Camerale I, busta 1527, fasc. 49), which includes a payment of 25 *scudi* to Colantonio Liante for a model made on September 5, 1585.

17. For the minutes of the meetings of this standing committee of Rome's civic administration, which includes a list of attendees, the location of the meeting, and brief summaries of the decisions taken, see, ASR, *Congregatio super viis pontibus et fontibus,* I, 1585/1587, fols. 157r–58r. For papal administration and a history of the congregations, see Niccolò del Re, *La curia Romana: Lineamenti storico-giuridici* (Rome, 1970).

18. ASR, *Congregatio super viis pontibus et fontibus,* I, 1585/1587, fols. 157r–58r (Sept. 18, 1586); and see D'Onofrio, *Obelischi,* 71–75, who provides transcriptions of the relevant documents in the footnotes.

19. Fontana, *Della trasportatione,* fol. 5v; D'Onofrio, *Obelischi,* 77n11. For Sixtus's involvement, see *Avvisi di Roma,* BAV, MS Urb. lat. 1053, fol. 416r (August 31, 1585), fols. 441v–42r (Sept. 21, 1585), and fols. 446v–47r (Sept. 25, 1585).

20. Fontana, *Della trasportatione,* fol. 6r–v. For an account of Fontana's troubles after the death of Sixtus, see Paolo Portoghesi, "Domenico Fontana architetto e urbanista," in Fontana, *Della trasportatione* (1590; repr. Milan, 1978) xii–xiii.

21. Fontana, *Della trasportatione,* fols. 5v–6v.

22. Filippo Pigafetta, *Discorso di M. Filippo Pigafetta d'intorno all'historia della aguglia, et alla ragione del muoverla* (Rome, 1586). For Pigafetta, see Sarton, "Agrippa, Fontana and Pigafetta"; and for Pigafetta's translation of Guidobaldo del Monte's treatise on mechanics, Mary Henninger-Voss, "Working Machines and Noble Mechanics: Guidobaldo del Monte and the Translation of Knowledge," *Isis* 91 (2000) 232–59.

23. Fontana, *Della trasportatione,* fols. 3r–36v; and Dibner, *Moving the Obelisks,* esp. 23–40, which contains a succinct technical summary.

24. Fontana, *Della trasportatione,* fols. 6v–7r.

age alla corte di Roma tra cinque e seicento: Alcuni aspetti del recente dibattito storiografico e prospettive di ricerca," *Roma moderna e contemporanea* 3 (1995) 11–55.

3. For an introduction to the Catholic reform and the Council of Trent, see R. Po-Chia Hsia, *The World of Catholic Renewal, 1540–1779* (Cambridge, 1998) esp. 1–25; and John W. O'Malley, *Trent and All That: Renaming Catholicism in the Early Modern Era* (Cambridge, Mass., 2000). For the canons and decrees of the Council, see *Conciliorum oecumenicorum decreta* (Bologna, 1973); and for an English translation, *Canons and Decrees of the Council of Trent* (Rockford, Ill., 1978). For the Catholic reform and urbanization, see esp. Helge Gamrath, *Roma Sancta Renovata: studi sull'urbanistica di Roma nella seconda metà del sec. XVI con particolare riferimento al pontificato di Sisto V, 1585–1590* (Rome, 1987); and Giorgio Simoncini, *"Roma restaurata": Rinnovamento urbano al tempo di Sisto V* (Florence, 1990).

4. Mercati adds that many people credited Michelangelo with the invention of the capstans, or *argani,* that were often used to move large stones in Rome. Michele Mercati, *De gli obelischi di Roma* (Rome, 1589) 343–44 ("E se si rompesse?"). For a reprint edition with useful introduction, see Michele Mercati, *Gli obelischi di Roma* (Rome, 1589; repr. Bologna, 1981).

5. D'Onofrio, *Obelischi,* esp. 97–141. For the citation, see Ludwig von Pastor, *The History of the Popes from the Close of the Middle Ages. Vol. 20: Gregory XIII (1572–1585)* (London, 1952) 20:598 and 598n2, citing an *Avviso di Roma* of July 27, 1574, from the State Archive of Vienna.

6. For a summary of Agrippa's life and writings, see George Sarton, "Agrippa, Fontana and Pigafetta: The erection of the Vatican obelisk in 1586," *Archives internationales d'histoire des sciences* 8 (1949) 827–54, esp. 832–36; and G. L. Barni, "Agrippa, Camillo," *DBI* 1:503. For Michelangelo and Antonio da Sangallo's reactions to moving the obelisk, see *OiE* 1:28. And see Camillo Agrippa, *Trattato di Camillo Agrippa Milanese De trasportar la guglia in su la piazza di San Pietro* (Rome, 1583). The Acqua Vergine was the first of the ancient aqueducts to be fully repaired, in 1570. See Cesare D'Onofrio, *Le fontane di Roma* (Rome, 1986) 230, cited from BAV, MS Barb. lat. 2016, c. 537: "Virginiam aquam duxit tantum Mavortis in agrum / Marcus Agrippa, et opus dicitur egregium. / At collis in Pincii verticem Camillus Agrippa / Extulit, ingenium cernitur eximium."

7. For the meeting in the Metallotheca Vaticana, see D'Onofrio, *Obelischi,* 140–41. Also Agrippa, *Trattato . . . de trasportar,* 3–5; Mercati, *Obelischi* (1589), 344–46.

8. Agrippa, *Trattato . . . de trasportar,* 5–30.

9. William Barclay Parsons, *Engineers and Engineering,* 155–56; and for the dialogue, Agrippa, *Trattato . . . de trasportar,* 29–48.

10. Francesco Masini, *Discorso di Francesco Masini sopra un modo nuovo, facile, e reale, di trasportar su la Piazza di San Pietro la guglia, ch'è in Roma, detta di Cesare* (Cesena, 1586). The only known copy is in Rome, Biblioteca di Archeologia e Storia dell'Arte, shelf mark Roma X 245.2. For Adovardo [Edoardo] Gualandi, see Piero Altieri, "L'attuazione della riforma tridentina," *Storia della chiesa di Cesena* (Cesena, 1998) 1.1:261–87.

11. A. Ippoliti, "Fontana, Domenico," *DBI* 48:638–43; Matthias Quast, "(2) Domenico

1999) 24–27; Lina Bolzoni, "Dès *Hieroglyphica* de Piero Valeriano à l'*Iconologia* de Cesare Ripa, ou le changement de statut du signe iconique," in *Repertori di parole e immagini: Esperienze cinquecentesche e moderni data bases* (Pisa, 1997) 49–97; and Curran, "De sacrarum litterarum."

39. For the Palazzo Te hieroglyphs, see Bertrand Jaeger, "L'Egitto Antico alla corte dei Gonzaga (La Loggia delle Muse al Palazzo Te ed altre testimonianze)," in *L'Egitto fuori dell'Egitto: dalla riscoperta all'Egittologia* (Bologna, 1991) 233–53; and Bertrand Jaeger, "La Loggia delle Muse nel Palazzo Te e la reviviscenza dell'Egitto Antico nel Rinascimento," in *Mantova e l'Antico Egitto da Giulio Romano a Giuseppe Acerbi* (Florence, 1994) 21–39.

40. For the Colonna Missal and the "Egyptian Page," see Montague Rhodes James, *A Descriptive Catalogue of the Latin Manuscripts in the John Rylands University Library, Part 1* (Manchester, 1921; repr. Munich, 1980) 18–20 (Taylor), 87–95 (James) pl. 77; Nikolaus Pevsner and S. Lang, "The Egyptian Revival" (1956), in Nikolaus Pevsner, *Studies in Art, Architecture, and Design* (London, 1968) 1:212–35, esp. 222–23, 247n58, fig. 29; Dirk Syndram, "Das Erbe der Pharaonen: zur Ikonographie Ägyptens in Europa," in *Europa und der Orient, 800–1900* (Gütersloh, 1989) 18–57, esp. 19 (pl. 1), and 389–90 (cat. 1/9); and Nicholas Barker, *'A Poet in Paradise': Lord Lindsay and Christian Art* (Edinburgh, 2000) 148–49 (cat. 62).

41. See Jean Seznec, *The Survival of the Pagan Gods* (New York, 1953) 219–56; R. L. McGrath, "The Old and New Illustrations for Cartari's 'Imagini dei dei degli antichi': A Study of 'Paper Archaeology' in the Italian Renaissance," *Gazette des Beaux-Arts* 6.59 (1963) 213–26; Allen, *Mysteriously Meant*, 249–78; and C. Volpi, "Le fonti delle Immagini degli dei degli antichi di Vincenzo Cartari," in *Der Antike Mythos und Europa: Texte und Bilder von der Antike bis ins 20. Jahrhundert* (Berlin, 1997) 58–73, 238.

42. Erwin Panofsky, "Canopus Deus: The Iconography of a Non-Existent God," *Gazette des Beaux-Arts* 6.57 (1961) 193–216.

CHAPTER FIVE
Moving the Vatican Obelisk

1. Domenico Fontana, *Della trasportatione dell'obelisco vaticano* (Rome, 1590; repr. Oakland, 2002) fol. 33r.

2. Since reliable population statistics are not available for this period, the number given is only a very general estimate. See Pio Pecchiai, *Roma nel cinquecento* (Bologna, 1948) 445–48. Thomas James Dandelet, *Spanish Rome: 1500–1700* (New Haven, 2001) 120–21, describes a procession of Philip II's ambassador, the Count of Olivares, accompanied by two hundred coaches for his initial visit to the papal palace. For a general discussion of travelers and pilgrims in Rome, see Jean Delumeau, *Vie économique et sociale de Rome dans la seconde moitié du XVIᵉ siècle* (Paris, 1957) 1:135–220. Also, Maria Antonietta Visceglia, "Burocrazia, mobilità sociale e *patron-*

26. For Leo as Augustus, see Curran, "Sphinx in the City."

27. Pierio Valeriano, *Hieroglyphica* (Lyon, 1602; repr. New York, 1976) 1:34, 14. For Latin text, see Curran, *Egyptian Renaissance*, 352n1.

28. A. Mercati, "Raffaello d'Urbino e Antonio da Sangallo Maestri delle Strade di Roma sotto Leone X," *Rendiconti della Pontificia Accademia Romana di Archeologia* 1 (1923) 121–29; *Raffaello architetto* (Milan, 1984) 84–87; C. L. Frommel, "Papal Policy: The Planning of Rome During the Renaissance," *Journal of Interdisciplinary History* 17 (1986) 39–65.

29. The 1490s discovery is noted by Bernardo Rucellai, *Commentarium in Publ. Victorem de regionibus urbis (c. 1497)*, in Lodovico Antonio Muratori and Giuseppe Tartini, *Rerum Italicarum Scriptores . . . Supplementum* (Florence, 1748) 2: col. 1004; *OiE* 1:48n3.

30. For contemporary plans and drawings, see *OiE* 1:48–51; D'Onofrio, *Obelischi*, 88–94; and Riccomini, *La ruina di si bela cosa*, 30–69.

31. Vincenzo Golzio, *Raffaello nei documenti, nelle testimonianze dei contemporanei e nella letteratura del suo secolo* (Vatican City, 1936) 101.

32. Florence, Uffizi UA 1232r, inscribed "per la guglia dil popolo quali si è a santo rocho," see *Raffaello architetto*, 229–30 (no. 212); and D'Onofrio, *Obelischi*, 93, fig. 45.

33. This thesis was proposed by Wendy Stedman Sheard, "Verrocchio's Medici Tomb and the Language of Materials: With a Postscript on His Legacy in Venice," in *Verrocchio and Late Quattrocento Italian Sculpture* (Florence, 1992) 63–90. Tortoise astragals provide support for two later Medici obelisks. The first was discovered at the Iseum Campense and erected about 1574–88 in the Villa Medici, Rome. See D'Onofrio, *Obelischi*, 236–37; Lembke, *Iseum Campense*, 204 (cat. 50). The second are the two "modern" obelisks in the Piazza di Santa Maria Novella, Florence (erected 1608–09).

34. *Raffaello architetto*, 230 (for *Hypnerotomachia* influence); and D'Onofrio, *Obelischi*, 93–94 (on the resemblance to Nicholas V's scheme). For Hanno, see Matthias Winner, "Raffael malt einen Elefanten," *Mitteilungen des Kunsthistorischen Institutes in Florenz* 11 (1964) 71–109; and Silvio A. Bedini, *The Pope's Elephant* (Manchester, 1997).

35. *HN* 36.67.196–97.

36. Plutarch, *De Iside et Osiride* 9 (354c); and Giovanni Pico della Mirandola, *De hominis dignitate, Heptaplus, De ente et uno, e scritti vari* (Florence, 1942) 156.

37. For Valeriano's life and career, see Giuseppe Cali, *Della vita e delle opere di G. P. Valeriano* (Catania, 1901); Giuliano Luchetta, "Contributi per una biografia di Pierio Valeriano," *Italia medioevale e umanistica* 9 (1966) 461–76; L. Gualdo Rosa, "Dalle Fosse, Giovanni Pietro (Pierio Valeriano)," *DBI* 32:85–88; Julia Haig Gaisser, *Catullus and his Renaissance Readers* (Oxford, 1993) 109–13; Kenneth Gouwens, *Remembering the Renaissance: Humanist Narratives of the Sack of Rome* (Leiden, 1998) 143–67; and J. H. Gaisser, *Pierio Valeriano on the Ill Fortune of Learned Men: A Renaissance Humanist and his World* (Michigan, 1999) 2–23.

38. For Valeriano's hieroglyphic studies, see Giehlow, "Hieroglyphenkunde," 113–29, Iversen, *Myth of Egypt*, 70–73; Dieckmann, *Hieroglyphics*, 48–50; Maurice Pope, *The Story of Decipherment. From Egyptian Hieroglyphs to Maya Script* (London,

13. For more on Julius as the Second Julius Caesar, see Stanislaus von Moos, "The Palace as a Fortress: Rome and Bologna under Julius II," in *Art and Architecture in the Service of Politics* (Cambridge, Mass., 1978) 46–79; Stinger, *Renaissance in Rome*, 235–46; and Paul Gwynne, "*Tu alter Caesar eris:* Maximilian I, Vladislav II, Johannes Michael Nagonius, and the *renovatio Imperii*," *Renaissance Studies* 10 (1996) 56–71. Christine Shaw, *Julius II: The Warrior Pope* (Oxford, 1993) 189–207, questions the extent of the Julius-as-Caesar theme.

14. Egidio da Viterbo, *Historia viginti saeculorum*, Rome, Biblioteca Angelica, MS lat. 502, fol. 194r. Previously cited in Rowland, *Culture of the High Renaissance,* 172–73.

15. E. H. Gombrich, "Hypnerotomachiana" (1951), in Gombrich, *Symbolic Images: Studies in the Art of the Renaissance II* (Oxford, 1978) 102–08. For further discussion, see Enzo Bentivoglio, "Bramante e il geroglifico di Viterbo," *Mitteilungen des Kunsthistorischen Instituts in Florenz* 16 (1992) 167–74.

16. A. Laelius Podager, manuscript note in Jacopo Mazzocchi, *Epigrammata antiquae urbis* (Rome, 1521); BAV, MS Vat. lat. 8492, fol. 21r. See *OiE* 1:147–48; D'Onofrio, *Obelischi,* 387–88. For an illustration of the page, see *Rome Reborn,* 119, plate 94.

17. Translated from a letter written to Isabella d'Este and dated February 1513. A. Luzio, "Federico Gonzaga, ostaggio alla corte di Giulio II," *Archivio della Reale Società Romana di storia patria* 9 (1886) 580. See also the brief description by Giovanni Jacopo Penni, *La magnifica et sumptuoso festa alli S. R. per il Carnevale. M.D. XIII* (Rome, about 1513), fol. Aiiiiv. For discussion, see Julian Klaczko, *Rome and the Renaissance: The Pontificate of Julius II* (New York, 1903) 360–66; and Stinger, *Renaissance in Rome,* 58.

18. For Fra Urbano, see Giehlow, "Hieroglyphenkunde," 102–13; Luigi Beschi, "L'Anonimo Ambrosiano: un itinerario in Grecia di Urbano Bolzanio," *Accademia Nazionale dei Lincei, Rendiconti, Classe di scienze morali, storiche e filologiche,* ser. 8, 39 (1984) 3–22; L. Gualdo Rosa, "Dalle Fosse (Bolzanio), Urbano," *DBI* 32:88–92; and Curran, "De sacrarum litterarum," 158–62, 178–79.

19. The cup is now known as the Tazza Farnese after a later owner. See Phyllis Pray Bober and Ruth Rubinstein, *Renaissance Artists and Antique Sculpture: A Handbook of Sources* (London, 1987) 104–05 (no. 68).

20. Ludwig von Pastor, *History of the Popes from the Close of the Middle Ages* (London, 1923–53) 8:174–75.

21. Ilaria Ciseri, *L'ingresso trionfale di Leone X in Firenze nel 1515* (Florence, 1990) 74–77.

22. For much of what follows, see Brian Curran, "The Sphinx in the City: Egyptian Memories and Urban Spaces in Renaissance Rome (and Viterbo)," in *Artistic Exchange and Cultural Translation in the Italian Renaissance City* (Cambridge, 2004) 294–326.

23. Bober and Rubinstein, *Renaissance Artists and Antique Sculpture,* 101–02 (no. 65).

24. They were recorded for the first time in Andrea Fulvio's *Antiquaria urbis* (Rome, 1513) fol. Eiir (lines 20–23). See Roullet, *Egyptian Monuments,* 134–35 (cat. 284–85); *Egyptomania: Egypt in Western Art 1730–1930* (Ottawa, 1994) 87–91 (cat. 29–30).

25. Suzanne B. Butters, *The Triumph of Vulcan: Sculptor's Tools, Porphyry, and the Prince in Ducal Florence* (Florence, 1996) 116–17n38.

199–200; David Ruderman, "Giovanni Mercurio da Correggio's Appearance as Seen Through the Eyes of an Italian Jew," *Renaissance Quarterly* 28 (1975) 309–22.

6. Otto Heurnius, *Philosophiae barbaricae antiquitatum libri duo* (Leiden, 1600).

7. For the textual tradition and its relation to the growing interest in Egyptian and Middle Eastern antiquities in the period, see the still-unsurpassed studies of Karl Dannenfeldt, "Late Renaissance Interest in the Ancient Orient" (Ph.D. diss., University of Chicago, 1948); also his "The Renaissance and Pre-Classical Civilizations," *Journal of the History of Ideas* 13 (1952) 435–49; and "Egypt and Egyptian Antiquities in the Renaissance," *Studies in the Renaissance* 6 (1959) 7–27.

8. For the hieroglyphs and other Egyptian elements in the *Hypnerotomachia*, see Brian Curran, "The *Hypnerotomachia Poliphili* and Renaissance Egyptology," *Word and Image* 14 (1998) 156–85.

9. For Annius and his "Egyptological" theses, see Roberto Weiss, "Traccia per una biografia di Annio da Viterbo," *Italia medioevale e umanistica* 5 (1962) 425–41; Walter Stephens, Jr., *Giants in those Days: Folklore, Ancient History, and Nationalism* (Lincoln, 1989) 58–138; C. R. Ligota, "Annius of Viterbo and Historical Method," *Journal of the Warburg and Courtauld Institutes* 50 (1987) 44–56; Anthony Grafton, "Invention of Traditions and Traditions of Invention in Renaissance Europe: The Strange Case of Annius of Viterbo," in Anthony Grafton, *Defenders of the Text: The Traditions of Scholarship in an Age of Science, 1450–1800* (Cambridge, Mass., 1991) 76–103; Ingrid D. Rowland, *The Culture of the High Renaissance: Ancients and Moderns in Sixteenth-Century Rome* (Cambridge, 1998) 46–53.

10. For the Viterbo "hieroglyphs" and Annius's reading of them, see Roberto Weiss, "An Unknown Epigraphic Tract by Annius of Viterbo," in *Italian Studies Presented to E. R. Vincent on His Retirement from the Chair of Italian at Cambridge* (Cambridge, 1962) 101–20; Brian Curran, "'De sacrarum litterarum Aegyptiorum interpretatione.' Reticence and Hubris in Hieroglyphic Studies of the Renaissance: Pierio Valeriano and Annius of Viterbo," *Memoirs of the American Academy in Rome* 43/44 (1998/99) 139–82; and Amanda Collins, "Renaissance Epigraphy and its Legitimating Potential: Annius of Viterbo, Etruscan Inscriptions, and the Origins of Civilization," in *The Afterlife of Inscriptions: Reusing, Rediscovering, Reinventing, and Revitalizing Ancient Inscriptions* (London, 2000) 57–76; Curran, *Egyptian Renaissance*, 121–31.

11. For the Sala dei Santi frescoes, see Fritz Saxl, "The Appartamento Borgia," in Saxl, *Lectures* (London, 1957) 1:174–88; N. Randolph Parks, "On the Meaning of Pinturicchio's Sala dei Santi," *Art History* 2 (1979) 291–317; Paola Mattiangeli, "Annio da Viterbo ispiratore di cicli pittorici," in Giovanni Baffoni and Paola Mattiangeli, *Annio da Viterbo: Documenti e ricerche* (Rome, 1981) 257–303; Claudia Cieri Via, "Mito, allegoria e religione nell'appartamento Borgia," in *Le arti a Roma da Sisto IV a Giulio II* (Rome, 1985) 77–104; Sabine Poeschel, *Alexander Maximus: Das Bildprogramm des Appartamento Borgia im Vatikan* (Weimar, 1999); and Pietro Scarpellini and Maria Rita Silvestrelli, *Pintoricchio* (Milan, 2004) 112–28, 160–89; Curran, *Egyptian Renaissance*, 107–21.

12. Roberto Weiss, "The Medals of Julius II (1503–1513)," *Journal of the Warburg and Courtauld Institutes* 28 (1964) 163–82; and Charles R. Stinger, *The Renaissance in Rome* (Bloomington, 1985) 235–38, fig. 26.

41. Leon Battista Alberti, *De re aedificatoria* (Milan, 1966) 2:697 [Alberti, bk. 8, ch. 4].

42. Curran, *Egyptian Renaissance,* 99–105; and the forthcoming study by Curran and Giancarla Periti, "Titulos et Veteres Inscriptiones Monumenti Pyramidibus, Obelis-cis, Mausoleis . . . invenire et inventa . . . in libellum concinnare: Michele Fabrizio Ferrarini and the Epigraphic Study of Egyptian Hieroglyphs in Renaissance Italy," for submission, 2009.

43. Giannozzo Manetti, *De dignitate et excellentia hominis* (Padua, 1975) 58 [L.II].

44. BAV, MS Vat. lat. 6848, fol. 7v. "Pyramis est sive lapis sive edificium quadratum lon-gum a lato incipiens et instar flamme tendens semper in angustum: quales plerique ex veteribus pro sepulchris habuerunt. nunc Romae plereque cernuntur."

45. BAV, MS Urb. lat. 301, fol. VIr–v. "Pyramides sunt moles maximae, ita constructae ut e lato in acutum tendant: quales Romae adhuc extant duae: iam vetustate fatiscentes: dictae: vel quod flammarum similitudinem habent: graeci enim πῦρ ignem vocant: vel a lapide pyropoecilo: ex quo saepe aedificabantur: hic et thebaicus vocatur: ab ignea quadam varietate pyropoecilos dictus. A graecis enim πῦρ ignis dicitur ποικίλος varius. Pyramidem nostri metam vocant: quod termini agrorum: qui a metiendo hoc est mensurando metae dicuntur: forma pyramidum aedificari solent: atque ea figura pyramidalis vocatur. Quamvis Paulus iuris consultus metam esse dicit partem molis inferiorem: et Catillum superiorem. Differunt pyramides ab obeliscis: quod hi trabes sunt lapidei: longe pyramidibus minores: solis numini sacrati: propter quod ad radiorum similitudinem fiebant. Apud aegyptios nomen habent a radio: et plane talis est radii forma dum per fenestram intrat. Graeci a veru similitudine ei nomen imposuere: apud quos ὀβελός veru est et eius diminutivum est ὀβελίσκος."

CHAPTER FOUR

The High Renaissance: Ancient Wisdom and Imperium

1. Pierio Valeriano, *Hieroglyphica* (Basel, 1575), title page. For Latin text, see Curran, *Egyptian Renaissance,* 366–67n1.

2. On what follows, see above all the classic works of Frances A. Yates, *Giordano Bruno and the Hermetic Tradition* (London, 1964); D. P. Walker, *The Ancient Theology* (London, 1972); and *Hermetica.*

3. Florence, Biblioteca Laurenziana, MS 71.33, fols. 123–45; see *Marsilio Ficino e il ritorno di Ermete Trismegisto/Marsilio Ficino and the Return of Hermes Trismegistus* (Florence, 1999) 41–43 (cat. 1). For Ficino's edition, see Marsilio Ficino, *Opera omnia* (1576; repr., Turin, 1959).

4. Benci's Italian version did not appear in print until 1548. For a fuller account, see Karl Dannenfeldt, "Hermetica," in *CTC* 1:138–48; *Marsilio Ficino e il ritorno di Ermete Trismegisto,* 27, 41–64 (cat. 1–10).

5. See Ludovico Lazzarelli, "Epistola Enoch," in *Testi umanistici su l'Ermetismo* (Rome, 1955); Paul Oskar Kristeller, *Studies in Renaissance Thought and Letters* (Rome, 1956–96); Donald Weinstein, *Savonarola and Florence* (Princeton, 1970)

(London, 2005) 21–22. For discussion and an illustration from Poggio's collection (BAV, MS Vat. lat. 9152), see *Rome Reborn: The Vatican Library and Renaissance Culture* (New Haven, 1993) 92–94, plate 76. For Poggio's contribution to humanist lettering, see Berthold L. Ullman, *The Origin and Development of Humanistic Script* (Rome, 1960) 21–57.

29. Francesco Scalamonti, "Vita viri clarissimi et famosissimi Kyriaci Anconitani," *Transactions of the American Philosophical Society* 86, pt. 4 (1996) 40, 112 (ch. 42). Cyriacus seems to have derived his terminology from a misreading of Tacitus, *Annals* 11.15.

30. Cyriacus of Ancona, *Kyriaci Anconitani itinerarium* (Florence, 1742; repr. Bologna, 1969) 48–49. For Latin text, see also Curran, *Egyptian Renaissance,* 311n47. Compare BAV, MS Ottobon. Lat. 2967, fols. 20r–21v.

31. Cyriacus of Ancona, *Commentariorum Cyriaci Anconitani nova fragmenta notis illustrata* (Pesaro, 1763) 56ff.; Cyriacus, *Itinerarium,* 50–51; translation derived in part from Phyllis Williams Lehmann, *Cyriacus of Ancona's Egyptian Visit and its Reflections in Gentile Bellini and Hieronymus Bosch* (Locust Valley, 1977) 11, 30n.

32. Cyriacus, *Kyriaci Anconitani Itinerarium,* 51. For Latin text, see also Curran, *Egyptian Renaissance,* 311n53.

33. Cyriacus writes that he visited the pyramids in September of the year now believed to be 1436. For Niccoli's death, see Zippel, *Nicolò Niccoli,* 64n1.

34. For Medieval antecedents and Renaissance variations of this motto, see Nicole Dacos, *Roma quanta fuit: tre pittori fiamminghi nella Domus Aurea* (Rome, 2001) 10–15.

35. A version of what seems to be Alberti's discussion of the Vatican obelisk is included in Angelo Decembrio's *De politia litteraria,* BAV, MS Vat. lat. 1794, fols. 137v–39v. For an edition, translation, and commentary, see Brian Curran and Anthony Grafton, "A Fifteenth-Century Site Report on the Vatican Obelisk," *Journal of the Warburg and Courtauld Institutes* 58 (1995) 234–48.

36. Translation from Torgil Magnuson, "The Project of Nicholas V for Rebuilding the Borgo Leonino in Rome," *Art Bulletin* 36.2 (1954) 93.

37. For the weight, as estimated by Domenico Fontana in 1585–86, see William Barclay Parsons, *Engineers and Engineering in the Renaissance* (1939; repr. Cambridge, Mass., 1968) 160.

38. For this critique, see Charles Burroughs, "A Planned Myth and a Myth of Planning," reprinted in Burroughs, *From Signs to Design: Environmental Process and Reform in Early Renaissance Rome* (Cambridge, Mass., 1990) 1–49ff.

39. For this point and much of what follows, see Curran and Grafton, "A Fifteenth-Century Site Report," 234–48.

40. For "topographical" readings of the scene, see Christian Hülsen, *La Roma antica di Ciriaco d'Ancona del secolo XV* (Rome, 1907) 32; *Da Pisanello alla nàscita dei Musei Capitolini: L'antico a Roma alla vigilia del Rinascimento* (Milan, 1988) 41–42. For the Marcanova MS in relation to Nicholine Rome, see Charles Burroughs, "Below the angel: an urbanistic project in the Rome of Pope Nicholas V," *Journal of the Warburg and Courtauld Institutes* 14 (1982) 115–22; *Da Pisanello alla nàscita dei Musei Capitolini,* 28–31, 38–45.

Christopher S. Celenza, *Renaissance Humanism and the Papal Curia: Lapo da Cas-tiglionchio the Younger's 'De curiae commodis'* (Ann Arbor, 1999); and Elizabeth McCahill, "Humanism in the Theater of Lies: Classical Scholarship in the Early Quattrocento Curia" (Ph.D. diss., Princeton University, 2005).

21. John Webster Spargo, *Virgil the Necromancer: Studies in Virgilian Legends* (Cambridge, Mass., 1934) 228–35.

22. The most useful and extensive study of hieroglyphs in the Renaissance is still Karl Giehlow, "Die Hieroglyphenkunde des Humanismus in der Allegorie der Renais-sance," *Jahrbuch der Kunsthistorischen Sammlungen des Allerhöchsten Kaiserhauses* 32 (1915) 1–229. Among the many later studies, see Ludwig Volkmann, *Bilderschriften der Renaissance* (Leipzig, 1923); Iversen, *The Myth of Egypt;* Liselotte Dieckmann, *Hieroglyphics: The History of a Literary Symbol* (St. Louis, 1970); Rudolf Wittkower, "Hieroglyphics in the Early Renaissance," in *Allegory and the Migration of Symbols* (London, 1977) 114–28; Don Cameron Allen, *Mysteriously Meant: The Rediscovery of Pagan Symbolism and Allegorical Interpretation in the Renaissance* (Baltimore, 1970); Patrizia Castelli, *I geroglifici e il mito dell'Egitto nel Rinascimento* (Florence, 1979); and Charles Dempsey, "Renaissance Hieroglyphic Studies and Gentile Bel-lini's 'Saint Mark Preaching in Alexandria,'" in *Hermeticism and the Renaissance: Intellectual History and the Occult in Early Modern Europe* (Washington, D.C., 1988) 342–65.

23. For Niccoli, see Vespasiano da Bisticci, *Renaissance Princes, Popes and Prelates: The Vespasiano Memoirs* (New York, 1963) 395–403; Giuseppe Zippel, *Niccolò Nic-coli. Contributo alla storia dell'Umanesimo* (Florence, 1890); Weiss, *Renaissance Discovery,* 63, 135–36, 155, 169–84; *Two Renaissance Book Hunters. The Letters of Poggius Bracciolini to Nicolaus de Niccolis* (New York, 1974); and Philip A. Stadter, "Niccolò Niccoli: Winning Back the Knowledge of the Ancients," in *Vestigia: Studi in onore di Giuseppe Billanovich* (Rome, 1984) 2:747–64.

24. Niccoli's "Egyptological" interests are demonstrated by the marginal notes he added to the relevant sections of the manuscript before he made a copy and sent the origi-nal to Poggio in Rome. See R. Cappelletto, "Niccolò Niccoli e il codice di Ammiano Vat. lat. 1873," *Bollettino del Comitato per la preparazione dell'edizione nazionale dei classici greci e latini* n.s. 26 (1976) 57–84, esp. 62–69; Stadter, "Niccolò Niccoli," in *Vestigia,* 2:758–760.

25. The manuscript discovered by Buondelmonti entered the collection of the Medici and is now in Florence, Biblioteca Laurenziana MS 69.27. For discussion, see Gieh-low, "Hieroglyphenkunde," 12–18; Iversen, *The Myth of Egypt,* 65; Weiss, *Renais-sance Discovery,* 155; Sandra Sider, "Horapollo," *CTC* 6:15–29.

26. Giehlow, "Hieroglyphenkunde," 16–19.

27. Cesare D'Onofrio, ed., *Visitiamo Roma nel Quattrocento: La città degli Umanisti* (Rome, 1989) 81–82. For Latin text, see also Curran, *Egyptian Renaissance,* 308n10.

28. For Poggio's study and collection of inscriptions, see Peter Spring, *The Topographi-cal and Archaeological Study of the Antiquities of Rome 1420–1447* (Ph.D. diss., Univer-sity of Edinburgh, 1972) 218–28; Weiss, *Renaissance Discovery,* 63, 147; and William Stenhouse, *Reading Inscriptions and Writing Ancient History: Historical Scholarship in the Late Renaissance,* Bulletin of the Institute of Classical Studies, Supplement 86

5. Cesare D'Onofrio, *Visitiamo Roma mille anni fa: La città dei Mirabilia* (Rome, 1988) 72; *The marvels of Rome = Mirabilia urbis Romae* (New York, 1986) 33–34. For the *Mirabilia* in its context, see Chiara Frugoni, "L'antichità: dai 'mirabilia' alla propaganda politica," in *Memoria dell'antico nell'arte italiana* (Turin, 1984) 1:5–72; and Dale Kinney, "Mirabilia urbis Romae," in *The Classics in the Middle Ages* (Binghamton, 1990) 207–21.

6. Master Gregorius, *The Marvels of Rome* (Toronto, 1987) 33–34.

7. Master Gregorius, *The Marvels of Rome,* 34–35, 91.

8. Aretino uses the term in Sonetto 3. Bette Talvacchia, *Taking Positions: On the Erotic in Renaissance Culture* (Princeton, 1999) 203.

9. *OiE* 1:106–114; Roullet, *Egyptian and Egyptianizing Monuments,* 73–74 (cat. 73); D'Onofrio, *Obelischi,* 61–81; and Lembke, *Das Iseum Campense,* 204–06 (cat. 51).

10. For various proposals, see Richard Krautheimer, *Rome: Profile of a City, 312–1308* (Princeton, 1980) 198–99, 354–55; Antonio Giuliano, "Roma 1300," *Xenia* 4 (1982) 16–22; Norberto Gramaccini, "La prima riedificazione del Campidoglio e la rivoluzione senatoriale del 1144," in *Roma, Centro ideale della cultura dell'Antico nei secoli XV e XVI: Da Martino V al Sacco di Roma 1417–1527* (Milan, 1989) 33–47; and D'Onofrio, *Obelischi,* 28, 37–40, 61–72.

11. Two of these lions were discovered at the villa in 1966, but one was later stolen. They presumably came along with the obelisk in 1582. See Alessandro Cremona, in *Bonifacio VIII e il suo tempo: Anno 1300 il primo giubileao* (Milan, 2000) 169 (cat. 114).

12. *OiE* 1:108n8.

13. The dismantled upper shaft and globe were sketched by Giovanni Colonna da Tivoli, in BAV, MS Vat. lat. 7721, fol. 6r (dated 1554); see *Giovanni Colonna da Tivoli, 1554* (Rome, 1992) 77, 88–90. For the transfer and later history of the monument, see *OiE* 1:109–14; and Carla Benocci, "L'obelisco di Villa Celimontana," *L'Urbe,* n.s. 5 (1987) 5–21.

14. *Codice topografico della città di Roma,* 4:68–69.

15. Text published in *Codice topografico della città di Roma,* 4:129–32; and D'Onofrio, *Visitiamo Roma mille anni fa,* 150–52. For Latin text, see also Brian Curran, *The Egyptian Renaissance. The Afterlife of Ancient Egypt in Early Modern Italy* (Chicago, 2007) 308n10.

16. Roberto Weiss, *The Renaissance Discovery of Classical Antiquity* (1969; repr. New York, 1988) 60–62.

17. In his citation, the Anonimo doubles the height from 20 to 40 feet; compare D'Onofrio, *Visitiamo Roma mille anni fa,* 151n112.

18. For the San Macuto obelisk, see *OiE* 1:101–05; Roullet, *Egyptian Monuments,* 74–75 (cat. 74); D'Onofrio, *Obelischi,* 29–60; and Lembke, *Iseum Campense,* 203 (cat. 49). The Anonimo's association of the area with a *scola Bruti* is enigmatic, but may be relevant to a later identification of this obelisk as the "sepulcher of Brutus."

19. *OiE* 1:128–41; and D'Onofrio, *Obelischi,* 355–64. The Anonimo appears to have confused this monument with one of the obelisks from the Mausoleum of Augustus, a mistake repeated by Francesco Albertini, *Opusculum de Mirabilibus novae & veteris urbis Romae* (Rome, 1510) fol. RIIIv.

20. For the most recent and cogent examinations of this Roman humanist *milieu,* see

44. Ammianus 17.4.13–14, in *Ammianus*, 1:322–25; and Fowden, "Nicagoras of Athens," 54–58.

45. Ammianus 17.4.15–16, in *Ammianus*, 1:324–27; *OiE* 1:56.

46. *OiE* 1:59.

47. Thutmose III had erected the obelisk as one of a pair before the seventh pylon at Karnak, where its original base and that of its companion still stand. They celebrated a successful military campaign that extended the boundaries of Egypt as far as they would ever go – to the Euphrates River. *OiE* 2:9–33.

48. *OiE* 1:9–11; Glen W. Bowersock, *Julian the Apostate* (Cambridge, Mass., 1978); and Julian, *The Works of the Emperor Julian* (Cambridge, Mass., 1913–23) 3:152–55, and 154n1 [letter 48]. One tradition has it that the obelisk ship was blown off course and went to Athens before it finally reached Alexandria.

49. *OiE* 2:12–13.

50. *OiE* 2:13–14.

51. *OiE* 2:34–50.

52. Sarah Guberti Bassett, "The Antiquities in the Hippodrome of Constantinople," *Dumbarton Oaks Papers* 45 (1991) 94; Giorgio Vespignani, *Il Circo di Constantinopoli nuova Roma* (Spoleto, 2001) 8–10, 110–11, 189–190; Wolfgang Müller-Wiener, *Bildlexikon zur Topographie Istanbuls* (Tübingen, 1977) 65, 71.

53. Tacitus, *Annals* XV and XLV.

54. *OiE* 1:20–22; Castagnoli, *Il Vaticano nell'antichità classica*; Bianchi, *Ad limina Petri*; and Liverani, *La topografia antica del Vaticano*.

CHAPTER THREE

Survival, Revival, Transformations: Middle Ages to Renaissance

1. Guarino Veronese, *Epistolario* (Venice, 1915–19) 1:39–40; trans. by E. H. Gombrich in "From the Revival of Letters to the Reform of the Arts" (1967), in Gombrich, *The Heritage of Apelles* (Oxford, 1976) 93–110.

2. *al-qalam al-tayr*, "bird's script"; *al-qalam al-birbawi*, "temple script"; and *al-qalam al-kahini*, "hieratic script." For these terms and themes, see Habachi, *Obelisks*, 3–5, 48; Ulrich Haarmann, "Medieval Muslim Perceptions of Ancient Egypt," in *Ancient Egyptian Literature: History and Forms* (Leiden, 1996) 605–27; Okasha el-Daly, "Ancient Egypt in Medieval Arabic Writings," in *The Wisdom of Egypt: Changing Visions Through the Ages* (London, 2003) 39–63; and Okasha el-Daly, *Egyptology: The Missing Millennium. Ancient Egypt in Medieval Arabic Writings* (London, 2005).

3. Isidore of Seville, *Etymologiae* 18.28–31.

4. *Codice topografico della città di Roma*, 2:180–181, 186. Sixtus V's obelisk specialist, Michele Mercati, reported that the Circus Maximus obelisks showed traces of fire damage and holes drilled for the insertion of toppling-levers. See Mercati, *Obelischi* (Rome, 1589; repr. Bologna, 1981) 152, 314; and *OiE* 1:59.

33. For a critique of the notion of Caligula as an "Isiac," see Anthony A. Barrett, *Caligula: The Corruption of Power* (New Haven, 1989) 219–21.

34. Vespasian's claim to the throne was supported by oracles in the Serapeum at Alexandria. See Richard Lattimore, "Portents and Prophecies"; Henrichs, "Vespasian's Visit to Alexandria." For Flavian and other imperial associations with the Iseum, see Serena Ensoli, "L'Iseo e Serapeo del Campo Marzio con Domiziano, Adriano, e i Severi: l'assetto monumentale e il culto legato con l'ideologia e la politica imperiali," in *L'Egitto in Italia dall'antichità al medioevo* (Rome, 1998) 407–38.

35. For the *Hermetica* and Hermetic movements in late antiquity, see Garth Fowden, "The Pagan Holy Man in Late Antique Society," *Journal of Hellenic Studies* 102 (1982) 33–59; Jean-Pierre Mahé, *Hermès en Haute-Égypte* (Québec, 1978–82); Erik Iversen, *Egyptian and Hermetic Doctrine* (Copenhagen, 1984); Garth Fowden, *The Egyptian Hermes: A Historical Approach to the Late Pagan Mind* (Princeton, 1986); and *Hermetica: The Greek Corpus Hermeticum and the Latin Asclepius* (Cambridge, 1991).

36. For these developments, see Erik Iversen, *The Myth of Egypt and Its Hieroglyphs in European Tradition* (Copenhagen, 1961) 38–56; and R. S. Bagnall, *Egypt in Late Antiquity* (Princeton, 1993) 261–73.

37. For text and translation, see Horapollo, *The Hieroglyphics of Horapollo* (New York, 1950; repr. Princeton, 1993). For the context and attribution to Horapollo the Younger, see G. Maspéro, "Horapollon et la fin du paganisme égyptien," *Bulletin de l'Institut Français d'Archéologie Orientale* 11 (1914) 164–95; Fowden, "Pagan Holy Man," 46–48; Fowden, *Egyptian Hermes*, 184–85; Christopher Haas, *Alexandria in Late Antiquity: Topography and Social Conflict* (Baltimore, 1997) 128–72; and Anthony Grafton's foreword, Horapollo, *Hieroglyphics*, xi–xxi.

38. Among these authentic meanings are *Hieroglyphica* 1.1 (basilisk), 1.11 (vulture/ mother); 1.62 (bee/king). For discussion and more examples, see Horapollo, *Hieroglyphics*, 15–17, 35–36 (notes); and Erik Iversen, "Horapollo and the Egyptian Conception of Eternity," *Rivista degli studi orientali* 38 (1963) 177–86.

39. For Horapollo's method, see Horapollo, *Hieroglyphics*, 3–29; Iversen, *Myth of Egypt*, 47–49; and C.-F. Brunon, "Signe, figure, langage: Les 'Hieroglyphica' d'Horapollon," in *L'Emblème à la Renaissance* (Paris, 1982) 29–47.

40. Among the very large literature on this subject, see Peter Brown, *Power and Persuasion in Late Antiquity: Towards a Christian Empire* (Madison, 1992); Beard, North, and Price, *Religions of Rome;* and Peter Brown, *The Rise of Western Christendom: Triumph and Diversity, A.D. 200–1000* (Malden, Mass., 2003).

41. See *HN* 36.14.66–67, compare Pliny, *Natural History*, 10.53; Ammianus Marcellinus 17.4.12–13, in Ammianus, *Ammianus*, 1.323. For discussion, see *OiE* 1:55–56; and esp. Garth Fowden, "Nicagoras of Athens and the Lateran Obelisk," *Journal of Hellenic Studies* 107 (1987) 51–57.

42. Ammianus 17.4.12–14, in *Ammianus*, 1.323–24; *OiE*, 1:56; and Fowden, "Nicagoras of Athens," 53–54.

43. The base was discovered in fragmentary condition by Pope Sixtus V's excavators in 1587, but Michele Mercati was able to reconstruct the original text. The inscriptions were adapted for use on the obelisk's new pedestal in 1588. For a transcription and translation, see *OiE* 1:57–58, 64.

23. Translation adapted from Budge, *Cleopatra's Needles*, 246.

24. For discussion of the Iseum theory, see *OiE* 1:80–81; and Lembke, *Iseum Campense*, 210–12 (cat. 55). For the Benevento obelisks, see Budge, *Cleopatra's Needles*, 248–49; Hans Wolfgang Müller, *Der Isiskult im Antiken Benevent und Katalog der Skulpturen aus den ägyptischen Heiligtümern im Museo del Sannio zu Benevent* (Berlin, 1969) 10–12; and Michel Malaise, *Inventaire préliminaire des documents égyptiens découverts en Italie* (Leiden, 1972) 296–99.

25. Richard Lattimore, "Portents and Prophecies in Connection with the Emperor Vespasian," *Classical Journal* 29 (1934) 441–49; and Albert Henrichs, "Vespasian's Visit to Alexandria," *Zeitschrift für Papyrologie und Epigraphik* 3 (1968) 51–80.

26. *OiE* 1:78–82; D'Onofrio, *Obelischi*, 288–301; and for the Circus of Maxentius, *La villa di Massenzio sulla Via Appia: Il Circo* (Rome, 1999) 126–31.

27. Earlier generations of scholars attempted to connect the obelisk with a tomb, shrine, or cenotaph in Rome or Hadrian's Villa in Tivoli, but recent studies agree that the obelisk was originally set up in Egypt near the site of the unfortunate boy's tomb. Translation from Budge, *Cleopatra's Needles*, 252–53. For the history and various interpretations of this obelisk, see *OiE* 1:161–73; Mary Taliaferro Boatwright, *Hadrian and the City of Rome* (Princeton, 1987) 239–60; D'Onofrio, *Obelischi*, 435–45; *Der Obelisk des Antinoos: Eine kommentierte Edition* (Munich, 1994); and William L. MacDonald and John Pinto, *Hadrian's Villa and its Legacy* (New Haven, 1995) 149n353.

28. Among the vast literature on this subject, see Georges LaFaye, *Histoire du culte des divinités d'Alexandrie, Sérapis, Isis, Harpocrate et Anubis, hors de l'Égypte* (Paris, 1884); Reginald E. Witt, *Isis in the Graeco-Roman World* (Ithaca, 1971); Michel Malaise, *Les conditions de pénétration et de diffusion des cultes égyptiennes en Italie* (Leiden, 1972); Sharon Kelly Heyob, *The Cult of Isis among Women in the Graeco-Roman World* (Leiden, 1975); Friedrich Solmsen, *Isis among the Greeks and Romans* (Cambridge, Mass., 1979); Robert A. Wild, *Water in the Cultic Worship of Isis and Sarapis* (Leiden, 1981); Sarolta A. Takács, *Isis and Sarapis in the Roman World* (Leiden, 1995); *Iside: il mito, il mistero, la magia* (Milan, 1997).

29. The dedication is described by Dio Cassius, 47.15.14. For discussion, see Takács, *Isis and Sarapis*, 51–70.

30. For the Triumvirate argument, see Otto Richter, *Topographie der Stadt Rom* (Munich, 1901) 218–43. For the history, topography, and finds associated with the Iseum, see Rodolfo Lanciani, "L'Iseum et Serapeum della Regione IX," *Bullettino della Commissione Archeologica Comunale di Roma*, 2nd ser., 9 (1883) 31–33; Guglielmo Gatti, "Topografia dell'Iseo Campense (1943–44)," in *Topografia ed edilizia di Roma antica* (Rome, 1989) 121–67; Roullet, *Egyptian Monuments*, 23–35; Malaise, *Inventaire*, 187–212; Serena Ensoli Vittozzi, *Musei Capitolini: La Collezione Egizia* (Rome, 1990) 30–38 (cat. 2–5), 42 (cat. 8), 52–53 (cat. 11), 59–70; and Katja Lembke, *Iseum Campense*, 18–64, 183–253.

31. The ban is described by Dio Cassius 53.24 and 54.6. See Takács, *Isis and Sarapis*, 69–80.

32. Tiberius's suppression of the Egyptian cults is described by Josephus, *Antiquitates Judaicae* 18.4.65–80; Tacitus, *Annals* 2.85.5; and Suetonius, *Tiberius* 36.1–2.

Wirsching, "Die Obelisken auf dem Seeweg nach Rom," *Mitteilungen des Deutschen Archäologischen Instituts* 109 (2002) 141–56.

14. For illustrations of the cranes described in *De architectura* 10.2.2–7, see Vitruvius, *Ten Books on Architecture* (Cambridge, 1999) 120–23, 295.

15. These methods were still in use during the sixteenth century, so the devices used by Domenico Fontana to move the Vatican obelisk in 1586 provide valuable insight into ancient technology. For general discussion and some specific examples, see Bern Dibner, *Moving the Obelisks*, 17–18; A. G. Drachmann, *The Mechanical Technology of Greek and Roman Antiquity: A Study of the Literary Sources* (Copenhagen, 1963); J. G. Landels, *Engineering in the Ancient World* (Berkeley, 1978) 84–98; K. D. White, *Greek and Roman Technology* (Ithaca, 1984) 78–81; Lynn Lancaster, "Building Trajan's Column," *American Journal of Archaeology* 103 (1999) 419–39; Mark Wilson Jones, *Principles of Roman Architecture* (New Haven, 2000) 170–73. A recent archaeological study that provides considerable information about Roman hauling and building practices is Janet DeLaine, *The Baths of Caracalla: A Study in the Design, Construction, and Economics of Large-Scale Building Projects in Imperial Rome* (Portsmouth, R.I., 1997) esp. 84–205.

16. For the Haterii relief, see "Die Grabdenkmäler (Die Austattung des Hateriergrabes)" in Friederike Sinn and Klaus S. Freyberger, eds., vol. 1, part 2 of *Katalog der Skulpturen, Vatikanische Museen, Museo Gregoriano Profano ex Lateranense* (Mainz, 1991ff.) 1.2:51–69, 136, and plates 11–14.

17. *OiE* 2:15–16.

18. *Codice topografico della città di Roma* (Rome, 1940–53) 1:148–49, 183, 251.

19. Ferdinando Castagnoli, *Il Vaticano nell'antichità classica* (Vatican City, 1992) 57–64; Lorenzo Bianchi, *Ad limina Petri: Spazio e memoria della Roma cristiana* (Rome, 1999); and Paolo Liverani, *La topografia antica del Vaticano* (Vatican City, 1999).

20. For the full history of this obelisk, see *OiE* 1:19–21; D'Onofrio, *Obelischi*, 97–185; and Alföldy, *Obelisk auf dem Petersplatz*.

21. Other obelisks from the Iseum can still be seen in Rome, Florence, and Urbino. See *OiE* 1:93–114, 174–77; Anne Roullet, *The Egyptian and Egyptianizing Monuments of Imperial Rome* (Leiden, 1972) 35, 72–77 (cat. 73–80); and Katja Lembke, *Das Iseum Campense in Rom: Studie über den Isiskult unter Domitian* (Heidelberg, 1994) 202–10 (cat. 48–53).

22. *OiE* 1:47–54, 101–06, 115–27; D'Onofrio, *Obelischi*, 85–95, 235–43, 341–53; Anna Maria Riccomini, *La Ruina di si bela cosa: Vicende e trasformazioni nel Mausoleo di Augusto* (Milan, 1996) 40–48; Edmund Buchner, "Ein Kanal für Obelisken: Neues vom Mausoleum des Augustus in Rom," *Antike Welt* 27 (1996) 161–68, and Jeffrey Collins, "'*Non Tenuis Gloria*': The Quirinal Obelisk from Theory to Practice," *Memoirs of the American Academy in Rome* 42 (1997) 187–225. These obelisks are not mentioned in the sources until the fourth century, when they were noted by Ammianus Marcellinus (17.4.16) and in the Regionary Catalogues. Michele Mercati, *De gli obelischi di Roma* (Rome, 1589; repr. Bologna, 1981) 221–26, proposed that they were raised by Claudius. Iversen, in *OiE* 1:47, prefers a Domitianic date. In recent years, an Augustan date has found some support; see Paul Zanker, *The Power of Images in the Age of Augustus* (Ann Arbor, 1988) 76.

1. *OiE* 1:65–66 and 65n5.

2. Livia Capponi, *Augustan Egypt: The Creation of a Roman Province* (London, 2005).

3. *OiE* 1:19–20; and Edward Courtney, "Cornelius Gallus, Gaius," *Oxford Classical Dictionary* (Oxford, 2003) 394–95. For the Cleopatra thesis, see Géza Alföldy, *Der Obelisk auf dem Petersplatz in Rom: Ein historisches Monument der Antike* (Heidelberg, 1990).

4. *OiE* 2:90–91.

5. *OiE* 1:142–43; and D'Onofrio, *Obelischi*, 260–67 and 369–402.

6. *OiE* 1:65–66 and 65n5 for translation of the inscription. For the sun cult in Rome and its association with the Circus Maximus, see John H. Humphrey, *Roman Circuses: Arenas for Chariot Racing* (Berkeley, 1986) 91–92 and 269–72; and Penelope J. E. Davies, *Death and the Emperor: Roman Imperial Funerary Monuments from Augustus to Marcus Aurelius* (Cambridge, 2000) 83–85. For the association of religion and the Circus Maximus in the fourth century, see John R. Curran, *Pagan City and Christian Capital: Rome in the Fourth Century* (Oxford, 2000) 218–59.

7. For a history of the obelisk, see *OiE* 1:64–75; and D'Onofrio, *Obelischi*, 260–66. For Roman religion, see esp. Mary Beard, John North, and Simon Price, *Religions of Rome* (Cambridge, 1998).

8. *HN* 36.14–15, in Pliny, *Natural History,* 10:56–59, for the obelisk as memorial to Augustus; and *OiE* 1:66–67. For the cult of Apollo and Augustus, see Beard, North, and Price, *Religions,* 198–99 and (for circus games) 262–63. For the circus as a metaphor for the cosmos, see Davies, *Death and the Emperor,* esp. 83–89; and Humphrey, *Roman Circuses,* esp. 91–95 and 269–72.

9. *HN* 36.15, in Pliny, *Natural History,* 10:56–59; *OiE* 1:142–43. For the history of the obelisk in general, see *OiE* 1:142–60; D'Onofrio, *Obelischi*, 369–421; and Edmund Buchner, *Die Sonnenuhr des Augustus* (Mainz, 1982). For a critique, see Michael Schütz, "Zur Sonnenuhr des Augustus auf dem Marsfeld," *Gymnasium* 97 (1990) 432–57, who argues convincingly that the obelisk served as a meridian instrument.

10. *OiE* 1:142–43; and Strabo, *Geography* 17.1.27, in Strabo, *The Geography of Strabo* (Cambridge, Mass., 1960–70) 8:79.

11. *HN* 36.14.69–72.

12. The ship was excavated by Otello Testaguzza in 1957–60.

13. *HN* 6.76.201–02 and 36.14.70; compare Ammianus Marcellinus, *Ammianus Marcellinus. Rerum gestarum libri* (Cambridge, Mass., 1950–52) 17.4.13–14. For the excavations at Fiumicino, see Otello Testaguzza, *Portus: Illustrazione dei porti di Claudio e Traiano e della città di Porto a Fiumicino* (Rome, 1970). And see Armin Wirsching, "Das Doppelschiff: die Altägyptische Technologie zur Beförderung schwerster Steinlasten," *Studien zur altägyptischen Kultur* 27 (1999) 389–408; Armin Wirsching, "How the Obelisks Reached Rome: Evidence of Roman Double-Ships," *International Journal of Nautical Archaeology* 29 (2000) 273–83; and Armin

città dall'età antica al XX secolo (Rome, 1992) 243–59; and Emanuele M. Ciampini, *Gli obelischi iscritti di Roma* (Rome, 2004) 28–35.

23. For text and translation, see Budge, *Cleopatra's Needles*, 143–59; and Ciampini, *Obelischi iscritti*, 57–87.

24. *OiE* 1:65–66; Kenneth A. Kitchen, "Ramesses II," *OEAE* 3:116–18; and Rainer Stadelmann, "Sety I," *OEAE* 3:272–73.

25. Robert Morkot, "Aswan," *OEAE* 1:151–54; and Bonnie M. Sampsell, *A Traveler's Guide to the Geology of Egypt* (Cairo, 2003) 56–63.

26. Alan H. Gardiner, *Egyptian Hieratic Texts, Series I: Literary Texts of the New Kingdom* (Leipzig, 1911) 17–19. Also *The Mathematics of Egypt, Mesopotamia, China, India, and Islam: A Sourcebook* (Princeton, 2007).

27. For general discussion, see Dibner, *Moving the Obelisks*, 8–10; Habachi, *Obelisks*, 15–37; and Arnold, *Building in Egypt*, 36–40, 47–52, 57–73.

28. Reginald Engelbach, *The Problem of the Obelisks from a Study of the Unfinished Obelisk at Aswan* (New York, 1923).

29. Arnold, *Building in Egypt*, 11–12, 251–57; and Corinna Rossi, *Architecture and Mathematics in Ancient Egypt* (Cambridge, 2004) 185–99.

30. Engelbach, *Problem of the Obelisks*, 32–51; Habachi, *Obelisks*, 17; and Arnold, *Building in Egypt*, 38–39, 251–57.

31. Habachi, *Obelisks*, 32–33; and Arnold, *Building in Egypt*, 36–40.

32. The terminology is Engelbach's.

33. Habachi, *Obelisks*, 18–20; and Arnold, *Building in Egypt*, 66–72. The *Papyrus Anastasi* I; 4–18, 2 (see note 26) instructs the scribe to "empty the magazine that has been loaded with sand under the monument," but this appears to refer to transport at the riverbank rather than erection at the site.

34. This account summarizes Arnold, *Building in Egypt*, 66–70.

35. For this obelisk, see Budge, *Cleopatra's Needles*, 219–24; *OiE* 1:142–60; and D'Onofrio, *Obelischi*, 369–421.

36. *OiE* 2:52–61; and Jack A. Josephson, "Nektanebo," *OEAE* 2:517–18.

37. For the historical and cultural background, see Peter Fraser, *Ptolemaic Alexandria* (Oxford, 1972); *Cleopatra's Egypt: Age of the Ptolemies* (Brooklyn, 1988); Ragnhild Bjerre Finnestad, "Temples of the Ptolemaic and Roman Periods: Ancient Traditions in New Contexts," in *Temples of Ancient Egypt* (Ithaca, 1997) 185–237; and Günther Hölbl, *A History of the Ptolemaic Empire* (London, 2001).

38. The obelisk, 6.7 meters (22 feet) tall, was discovered in 1815 by the British nobleman and scholar William John Bankes. In 1819 Bankes hired the Italian strongman-turned-explorer-excavator Giovanni Belzoni to remove the obelisk to Kingston Lacy, Bankes's estate in Dorset, England. In 1839 Bankes erected the obelisk on its original base in the estate's garden. See Chapter Ten, below, and *OiE* 2:62–85; and Habachi, *Obelisks*, 105–08.

5. *OiE* 1:11–15; John R. Baines, "*Bnbn:* Mythological and linguistic notes," *Orientalia* 39 (1970) 389–404; and Labib Habachi, *The Obelisks of Egypt: Skyscrapers of the Past* (New York, 1977) 3–6.

6. Miriam Lichtheim, *Ancient Egyptian Literature. Volume II. The New Kingdom* (Berkeley, 1976, 2006) 2:27.

7. Lichtheim, *Ancient Egyptian Literature*, 2:28.

8. Lichtheim, *Ancient Egyptian Literature*, 2:28.

9. Habachi, *Obelisks*, 90–98, citation on 94; and for broader context, Kenneth A. Kitchen, *Pharaoh Triumphant: The Life and Times of Ramesses II, King of Egypt* (Warminster, 1982); and Christiane Desroches Noblecourt, *Ramsès II: La véritable histoire* (Paris, 1996).

10. Although an important early shrine at Heliopolis, home of the *ben-ben,* was dedicated to Re.

11. For this discussion, see Jan Assmann, *Ägypten: Theologie und Frömmigkeit einer frühen Hochkultur* (Stuttgart, 1984), translated as *The Search for God in Ancient Egypt* (Ithaca, 2001); *Ancient Egyptian Kingship* (Leiden, 1995); Marie-Ange Bonhême, "Kingship," *OEAE* 2:238–45; and Ulrich H. Luft, "Religion," *OEAE* 3:139–45.

12. Lichtheim, *Ancient Egyptian Literature*, 2:25–26.

13. John Baines, "The Earliest Egyptian Writing: Development, Context, Purpose," in *The First Writing* (Cambridge, 2004) 152–89; W. V. Davies, *Reading the Past: Egyptian Hieroglyphs* (Berkeley, 1987) esp. 6–14. Also, Friedrich Junge with Heike Behlmer, "Language," *OEAE* 2:258–67.

14. For the early obelisks, see Habachi, *Obelisks*, 41–46. For funerary and other small obelisks, see Charles Kuentz, *Obélisques. Catalogue général des antiquités Égyptiennes du Musée du Caire* (Cairo, 1932).

15. There were no set rules for the making of obelisks. Some years earlier Pepi's predecessor Teti (2345–2323 BCE) was responsible for ordering at least one to be carved of quartzite rather than granite. Its original height seems to have been a slight three meters, or just about ten feet. Habachi, *Obelisks*, 40–41.

16. Budge, *Cleopatra's Needles*, 70–88; and Habachi, *Obelisks*, 46–50.

17. For general discussion of the period and its obelisks, see W. R. Cooper, *A Short History of the Egyptian Obelisks* (London, 1877) 28–45; and Betsy M. Bryan, "The 18th Dynasty before the Amarna Period (c. 1550–1352 BC)," *The Oxford History of Ancient Egypt* (Oxford, 2000) 207–64, esp. 220–37.

18. On Thutmose I and his obelisks, see Budge, *Cleopatra's Needles*, 91–98; Habachi, *Obelisks*, 56–57.

19. For Hatshepsut, see Dennis C. Forbes, ed., "Hatshepsut Special," in *K.M.T.: A Modern Journal of Ancient Egypt* 1 (Spring, 1990) 4–33; Joyce A. Tyldesley, *Hatshepsut, the Female Pharaoh* (London, 1998); Jadwiga Lipinska, "Hatshepsut," *OEAE* 2:85–87; and *Hatshepsut: From Queen to Pharaoh* (New York, 2005).

20. For Hatshepsut's obelisks, see Budge, *Cleopatra's Needles*, 100–24; and Habachi, *Obelisks*, 56–72.

21. On Thutmose III's obelisks, see Budge, *Cleopatra's Needles*, 143–76; Habachi, *Obelisks*, 72–77; and Jadwiga Lipinska, "Thutmose III," *OEAE* 3:401–03.

22. *OiE* 1:55–64; Cesare D'Onofrio, *Gli obelischi di Roma: storia e urbanistica di una*

Notes

ABBREVIATIONS

ASR Archivio di Stato di Roma
BAV Biblioteca Apostolica Vaticana
CTC *Catalogus Translationum et Commentariorum*
DBI *Dizionario Biografico degli Italiani*
HN Pliny the Elder, *Historia naturalis*
MS Manuscript
OEAE *Oxford Encyclopedia of Ancient Egypt*
OiE Eric Iversen. *Obelisks in Exile*. 2 vols. Copenhagen: GAD, 1968, 1972.
 Volume 1: *The Obelisks of Rome*
 Volume 2: *The Obelisks of Istanbul and England*
ÖNB Vienna, Österreichische Nationalbibliothek

CHAPTER ONE

The Sacred Obelisks of Ancient Egypt

1. *Ramesside Inscriptions Translated and Annotated* (Oxford, 1996) 2:295.
2. E. A. Wallis Budge, *Cleopatra's Needles and Other Egyptian Obelisks* (London, 1926) 1–22; Bern Dibner, *Moving the Obelisks* (Norwalk, 1991); *OiE* 1:11–18; Charles C. Van Siclen, "Obelisk," *OEAE* 2:561–64; Dieter Arnold, *Building in Egypt: Pharaonic Stone Masonry* (Oxford, 1991) 1–5, 58–63.
3. Erik Iversen, "Obelisk," *Dictionary of Art Online*, http://www.groveart.com/, last accessed May 17, 2006.
4. *HN* 36.14.64, in Pliny the Elder, *Natural History* (Cambridge, Mass., 1938–63) 10:51.

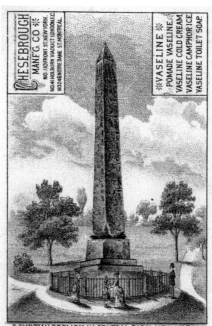

CHESEBROUGH MANF'G. CO. ☀
NO. 110 FRONT ST. NEW YORK.
NO. 41 HOLBORN VIADUCT LONDON E.C.
NO. 246 NOTRE DAME ST MONTREAL.

☀ VASELINE ☀
POMADE VASELINE.
VASELINE COLD CREAM.
VASELINE CAMPHOR ICE.
VASELINE TOILET SOAP.

EGYPTIAN OBELISK IN CENTRAL PARK NEW YORK.

This book is dedicated to Frances Dibner and

to the memory of her husband, David:

businessman, philanthropist, gardener, father, *mensch*.

Individuals played an equally important role, among them Ingrid D. Rowland (*prima inter pares*), Daniel Stolzenberg, Eugenio Lo Sardo, Enzo Crea, William Schmidt-Biggemann, Bill North, Deborah Silverman, Keith Thomas, and Victoria Morse. Also Sarah Rich, Janna Israel, Fabio Barry, Marica Tacconi (Director of the Institute for the Arts and Humanities at Pennsylvania State University), Paul Barolsky, Leonard A. Lauder, Lynda Klitch, Mike Bonnet, Peter Der Manuelian, Lawrence Berman, Barbara T. Martin, and Francis MacLaren. At the Huntington Library, Dan Lewis, David Zeidberg, and Steven Koblik were generous and welcoming hosts. We all thank Annette Imhausen and P. Sinclair Bell for their detailed critique of Chapters 1 and 2. Any remaining errors or omissions are our own.

The Burndy Library and Dibner Institute provided this project a home base, and special thanks are owed to Carla Chrisfield, Rita Dempsey, Bonnie Edwards, Trudy Kontoff, Evelyn Simha, Anne Battis, David McGee, Judith Nelson, George E. Smith, Howard Kennett, and, most of all, a very patient Philip N. Cronenwett, who probably despaired more than the rest of us of this book ever appearing.

For giving the book physical form, we owe a great debt to Robert Lorenzson for his wonderful photography of Burndy's books, and to Susan Marsh, who created an exceptionally beautiful and refined design. We must also thank the sharp-eyed typesetters at Duke & Company, who saved us from many a mistake – flaws that truly were not "typos," but "editos" and "authoros." From cover to cover, this is their work and we are immensely grateful to them.

Neither played a direct role in the writing of this book, but all the authors would be remiss if we did not acknowledge the crucial importance of Erik Iversen and the late Cesare D'Onofrio, the deans of twentieth-century obelisk studies. They blazed the way, and this book could quite literally not have been written without them. D'Onofrio's *Obelischi di Roma* and Iversen's *Obelisks in Exile* are both cited, over and over again, in every chapter – *Obelisks in Exile* so often that it has its own abbreviation, *OiE,* in the notes.

Most important of all, we would like to thank the Dibner family for their unwavering enthusiasm. Bern Dibner's own love of obelisks was the spur to this project. David Dibner, Bern's son, embraced it with enthusiasm, and Brent and Rachel Dibner provided help, patience, and extraordinarily generous support even after the Dibner Institute ceased to be and the Burndy Library found its new home in San Marino.

Acknowledgments

THIS BOOK was originally conceived – in a very different form – by Jed Z. Buchwald, then-Director of the Dibner Institute for the History of Science and Technology. It gained further life after a 1999 exhibit devoted to the Burndy Library's collection of obelisk materials, curated by Benjamin Weiss. Since then, it has been subject to many starts and stops, but has always been greeted with enthusiasm and good will from directors and librarians of both the Burndy Library and Dibner Institute. Our debts are uncountable, and we hope that those who remain uncounted will accept our apologies, for this book could not have seen print without the support, patience, and advice of an especially wide group of individuals and institutions.

An extraordinary collection of granting agencies and institutions have played a role in this work. Pam Long thanks the Shelby Cullom Davis Center for Historical Studies, at the Department of History, Princeton University; the American Academy in Rome (where she was a Fellow in 2003–2004); the Getty Research Center; the National Science Foundation (for grant number SES-0240358); as well as the Dibner Institute for the History of Science and Technology. Brian Curran adds Joseph Connors and the staff of the Villa I Tatti, Florence; also Christina Huemer, Denise Gavio, and the staff of the Library at the American Academy in Rome. Anthony Grafton thanks the electors of the E. A. Lowe Lectureship in Oxford, the Department of History at The University of California, Los Angeles, and the American School of Classical Studies in Athens.

created them, but they are just as much the bearers of all the other ideas that have accreted to them over the many centuries since. Obelisks do not have a single meaning; they carry all the meanings ever applied to them.

Even so, the stones can speak for themselves. In Rome's Piazza del Popolo, still a symbolic gateway to the city, stands the single obelisk conjured from the earth by order of Seti I in the thirteenth century BCE – more than three thousand years ago. It was completed by Ramesses II, who had it erected at Heliopolis, the city of the sun. It stood there for more than a thousand years, until in 10 BCE a new emperor – a conqueror – Augustus, wrenched it from its native place and carried across the sea to Rome. For five centuries it graced the Circus Maximus, until the new empire fell, and with it the obelisk. It broke and sank into the circus's marshy ground. There it waited. Nearly a millennium later, it was excavated by order of an imperial pope and, in 1587, carried to its present site. The obelisk has stood there now for more than four centuries – four times longer than the Republic of Italy itself. Yet through all of the changes – geographical, intellectual, religious – the obelisk has remained the same. From time immemorial it has proclaimed, to all who could understand, the eternal fame of Pharaoh Ramesses II:

> Horus-Falcon, Strong Bull, beloved of Maat;
> Re whom the Gods fashioned, furnishing the Two Lands;
> King of South and North Egypt,
> Usimare Setepenre, Son of Re, Ramesses II,
> Great of name in every land, by the magnitude of his victories;
> King of South and North Egypt, Usimare Setepenre,
> Son of Re, Ramesses II, given life like Re.[33]

Perhaps not the sort Ramesses expected, and maybe a bit delayed, but immortality nonetheless.

November 8, 2003: the Aksum obelisk being disassembled.

designed a scheme using computer-guided jacks, and, in 2003, finally disassembled the obelisk. The dismantling was accompanied by the cheers of a jubilant crowd of Ethiopians, and the monument taken to a warehouse near Rome's airport, very close to the spot where Nero's obelisk ship had been turned into a public monument two thousand years before.

Mussolini's engineers had brought the obelisk to Rome by road and ship. This was no longer possible, as the roads in Ethiopia had disintegrated and the port used in the 1930s was now in Eritrea, a country that after years of war would never have permitted the Ethiopian monument to pass through its territory.[31] Air transport was the only solution. The Italian company in charge, Lattanzi, described the obelisk as "the largest, heaviest object ever transported by air." So big and heavy, in fact, that only two planes in the world were large enough to carry it: a Russian Antonov An-124 or an American Lockheed C5-A Galaxy. Both are themselves imperial objects, designed at the peak of the Cold War to ferry materiel to the far-flung proxy wars of the United States and the Soviet Union. The planes are so huge that the airstrip at Aksum had to be upgraded to handle the An-124 that took the monument home. Heaters were installed in the cargo bay to protect the stones from damage by freezing. Finally, nearly seventy years after the monument left Ethiopia, and almost sixty since the Italians first agreed to return it, on April 19, 2005, the first piece arrived back in Aksum. The other two pieces followed within the week. National celebrations commemorated the return, but there were critics as well. The move ultimately cost six million euros, and some Ethiopians questioned the amount of money spent on the project in a country without a stable and secure food supply. Others, mostly in southern Ethiopia, insisted that the *cause célèbre* was regional, rather than national – that it made little difference to them where the obelisk came to rest.[32] Finally, in 2008, the obelisk rose again at Aksum – the very first wandering monolith ever to return home.

AMID ALL THIS IMPERIAL ASPIRATION, wooly-minded New Age mythologizing, and pure unadulterated commerce, the real obelisks – their message no longer hidden behind a veil of allegory, but easily legible to any who can read hieroglyphs – still stand. Those obelisks are, more often than not, far from their original homes, but most are now equally at home in their new locations. They are majestic embodiments of the ancient culture that

ancient city; more than two hundred survive. The largest of these originally stood thirty-three meters high (nearly a hundred feet) and weighed about 550 metric tons, making it probably the largest monolith ever erected. At ground level its surface is carved with a false door; tiers of false "windows" climb to the top, as in a multi-storied building, perhaps representing royal residences in the next world. These stelae seem to have functioned as giant markers for subterranean tombs, probably those of the Aksumite rulers who governed just before the royal line forsook its polytheistic religion to adopt Christianity. The Aksum kingdom faded by the eighth century, and, like Rome's obelisks, many of the stelae fell in subsequent centuries. Among the fallen was Mussolini's, which was toppled in the sixteenth century, during a Muslim rebellion in Christian Aksum. It broke in three pieces, making it easier to transport when the Italians carried it overland to the coast.[29]

The obelisk stood in Rome for only ten years before Mussolini's fall brought a new government and an admission that the obelisk should never have been taken. In 1947 the new Italian government agreed to return all loot taken from Ethiopia during the occupation. But they didn't send the obelisk back. In 1956 the Italians again signed a treaty with Ethiopia, agreeing that the obelisk "was subject to restitution," though leaving it ambiguous who was to pay the bill to send the stele home. Again, nothing happened. In 1970 the Ethiopian parliament threatened to cut off diplomatic relations with Italy unless the obelisk was returned. Again, nothing. The matter faded somewhat after the overthrow of Emperor Haile Selassie in 1974 brought a long period of political chaos, but the campaign was renewed in the 1990s by a group of Ethiopian and Western intellectuals.[30] When the Italian government finally committed itself to returning the monument, the project was delayed yet again by the 1998–2000 border war between Eritrea and Ethiopia. (Aksum is near the border.) But the case for return was strengthened in 2002 when a lightning strike damaged the obelisk, instantly demolishing the argument that it would be safer in Italy than in Ethiopia.

Even today, moving an obelisk is an engineering challenge. First the stele had to be dismantled. A team of Italian and Ethiopian experts had assembled in 2000 to study the problem. Giorgio Croci, the engineer in charge, explained that the team was anxious to avoid creating cracks or doing any further damage, and planned to separate the pieces where they had been joined when the obelisk was erected in 1937. The engineers

kingdom. The new country almost immediately began trying to acquire overseas colonies. Italy turned first to Africa, but by the end of the nineteenth century other European powers had neatly parceled out almost the whole continent. Only Liberia (effectively a protectorate of the United States) and Africa's northeast corner were not yet part of the colonial system. So Italy focused its attention on the "Horn" of Africa. In short order it acquired both Eritrea and what is now the southern part of Somalia. The Italians tried to conquer Ethiopia as well, but met with an embarrassing defeat in 1896. There matters remained until Mussolini came to power in the 1920s. He renewed Italy's push for empire, and in 1935 managed to defeat Ethiopia.

Mussolini got lucky. Among the benefits of invading Ethiopia was that, like Egypt, it was the seat of an ancient culture, one that had itself been a powerful imperial force. The kingdom of Aksum flourished from the first to the eighth centuries CE, growing rich from control of long-distance trade from the interior of Africa to the Mediterranean and Indian Oceans. Some of that wealth was spent on monuments. In the fourth century CE, the kings of Aksum had erected a series of enormous stone stelae at their capital. The great standing stones are not obelisks exactly, but they were close enough for Mussolini's purposes. In 1937 he ordered one brought to Rome. He originally planned to set it up in the E.U.R., a model city of Fascist planning to the west of Rome's center. Now a tourist attraction in its own right, the neighborhood, like a painting by Giorgio de Chirico come to life, captures better than any other place the aesthetic fantasies that inspired Europe's fascists. Supremely orderly, it is ancient-seeming yet newly made at the same time – a calm, predictable place in a famously noisy, busy, and very unpredictable city. In the end, though, it was decided that the Aksum obelisk was better suited to the city of Rome proper, and Mussolini had it set up in the Piazza di Porta Capena, near the Circus Maximus, in front of the Ministry of the Colonies. E.U.R. received a gigantic "obelisk" dedicated to Guglielmo Marconi instead.[28]

Twenty-four meters (78 feet) high and weighing 160 tons, the monument from Aksum was very much worthy of comparison to the ancient emperors' obelisks. It is made of nepheline syenite, a hard rock similar to granite that was probably quarried about seven miles west of Aksum, at Wuchate Golo. The monument was one of many erected as part of a tomb complex in the

cities. The obelisk became a symbol of the city, but it, too, took on a more sinister cast after Argentina began its long slide into political darkness. One morning in 1974, in what was advertised as an attempt to calm the city's notorious traffic, Porteños awoke to find the obelisk bearing a great lighted sign that read "Silencio es salud" – "Silence is Health." In the age of Argentina's right-wing dictatorship, it didn't take much to realize that the banner referred not only to car horns.[23]

In Latin America obelisks even made the Marxian turn from tragedy to farce. Also in 1936, Rafael Trujillo, dictator of the Dominican Republic, ordered up a gigantic obelisk for Santo Domingo, part of his grand project to modernize and remake the city, which was, of course, renamed Ciudad Trujillo. The traditional imperial symbolism was given a nicely twentieth-century sexual overtone in the dedication ceremonies, during which Jacinto Peynado, Head of the Pro-Erection Committee, praised the monument as mirroring Trujillo's own "superior natural gifts."[24] At the same time, in a blatant sop to the dictator's American sponsors, the seaside road in which the obelisk stands, the Malecón, was renamed Avenida George Washington.[25] Trujillo's government fell in 1961, and, in a pointedly anti-phallic gesture, the obelisk now bears a mural by Elsa Núñez and Amaya Salazar that celebrates the Mirabal sisters, three women who effectively martyred themselves in 1960 to help end the dictatorship. The murals were unveiled in 1997, on International Women's Day.[26]

The twentieth-century political leader who adopted the obelisk with the most historically informed style was Benito Mussolini. In 1932 the Italian dictator had an Art Deco–inflected "obelisk" raised on the banks of the Tiber, north of Rome's old city center. The huge monolith bears no hieroglyphs, just the words "Mussolini Dux" in great blocky letters that run down the monument's side.[27] The largest piece of Carrara marble ever quarried, the obelisk was the centerpiece of the Foro Mussolini (now the Foro Italico), a grand complex of sports stadia and arenas intended as part of the Fascist campaign to encourage physical fitness – itself part of Mussolini's plan to restore Italy's imperial power.

It was a tall order. Italy, seat of the original European empire, came very late to the new imperialism of the nineteenth and twentieth centuries. There had been no country of Italy at all until the 1870s, when Giuseppe Garibaldi united a fractious group of principalities into an equally fractious

itself. Barnett Newman's great, enigmatic *Broken Obelisk* – a huge sculpture of Cor-Ten steel consisting of a pyramid whose apex is just barely kissed by the point of a broken, upturned obelisk – may be the most inscrutable and moving "obelisk" of the century. The whole rises nearly thirty feet (nine meters) before the broken shaft of the steel obelisk trails off into the air. The sculpture not only embodies the very form of an obelisk, but even maintains the curious balance of great size and delicacy that characterizes the Egyptian original. The effect is reinforced by the fact that the contact point between the massive pyramid and the only slightly less massive obelisk is but a few square centimeters. Although Newman claimed some inspiration from his own childhood memories of the Central Park obelisk, he was unwilling to assign the piece specific meaning. Always a bit gnomic about his work, Newman wrote to John de Menil, who acquired one of the three versions of the sculpture, only that: "it is concerned with life and I hope I have transformed its tragic content into a glimpse of the sublime." Perhaps in response, de Menil installed the sculpture as a monument to Dr. Martin Luther King, Jr.[21]

Yet amid this very modern cacophony of meanings, the traditional association of obelisks with political power has never been drowned out completely. Any number of twentieth-century states, cities, and rulers tried to turn obelisks to their own political or commemorative advantage. Nearly all seem to have suffered from cases of equivocal symbolism. In the early 1920s, the government of the newly born Czechoslovak state hired the Slovenian architect Jože Plečnik to oversee the Prague Castle, which was being transformed into the seat of the new government. One of Plečnik's ideas was to raise a gigantic obelisk – a true monolith – as a combined celebration of the new state and memorial to those who had perished in World War I. The obelisk, which would have been one of the largest ever erected, fell down an embankment during transit from the quarry in southern Czechoslovakia and broke in two – an event that in recent years has been taken as an ominous prefiguring of the eventual severing of the state itself. The salvageable half, still a very respectable seventeen meters, stands by St. Vitus's cathedral in the inner court of the castle.[22] Fifteen years later, in 1936, the city of Buenos Aires also built a huge obelisk – this one of concrete and steel – in commemoration both of the city's four-hundredth anniversary and its arrival, in the early twentieth century, as one of the world's great

check-in desk can be reached via a drive-through sphinx. Inside, guests can find (in addition to floor shows and slot machines) a remarkably accurate reconstruction of King Tut's tomb as well as a New Age-inflected movie experience about the mysteries of the pyramids.[18]

Even as new obelisk-shaped monuments sprouted up, the meaning of existing ones shifted. The Bunker Hill Monument is a case in point. It was constructed in the 1820s and 30s as a memorial to a Revolutionary War battle and to the very idea of liberty. So it remained, but by the end of the nineteenth century it had become an even more powerful symbol of place – of Charlestown, Massachusetts. It became the emblem of the city (and after annexation by Boston, the neighborhood), appearing on shop signs, the bottles of the local pickle packager, and the jackets of high-school students. By the 1990s the identification of neighborhood and structure was so complete that when a dramatic new cable-stayed bridge was built across the Charles River from Boston's North End to Charlestown, the designer, Swiss engineer Christian Menn, fashioned the bridge's towers in the shape of obelisks. His reference point was the monument itself, a symbol of place, rather than the ideas the monument was originally intended to embody. The bridge's towers and the monument now form a trio of obelisks across the Charlestown skyline, reinforcing the association yet further.[19]

But symbolism can also come full circle. In 1998 Boston's Institute of Contemporary Art commissioned a major piece by the artist Krzysztof Wodiczko, who has specialized in gigantic projections, generally on the sides of buildings. In Boston he chose the Bunker Hill Monument as his canvas. During the 1970s and 80s, Charlestown, then a tight-knit and somewhat insular neighborhood, had been the scene of violent gang warfare, accompanied by a rash of murders. These became known as the "code of silence" killings, as the police consistently found that eyewitnesses were unwilling to speak about the crimes. By the late 1990s the neighborhood had changed, tensions had calmed, and Wodiczko convinced people to talk about the murders for his projection. For six nights, the monument itself seemed to speak with the voices of many of the victims' mothers, who told of the murders and the murdered – of freedom, loss, and sorrow. It was a plea for peace and liberty, but on a much more personal and visceral level than the monument's designers probably envisioned.[20]

Other twentieth-century artists found inspiration in the obelisk's form

Indians who, at some point in the distant past, had been transported to a faraway planet. There they live in safety, protected by strange forces that emanate from an obelisk that sits on a small altar in the woods. Unlike the *2001* monolith, this one actually looks like a short, fat obelisk and even sports hieroglyph-like inscriptions.[15]

This manifold expansion of meaning and association is characteristic of the whole twentieth century. The very explosion of monument building in the late nineteenth and early twentieth centuries probably helped accelerate this process. Obelisks and obelisk-like monuments sprouted up everywhere in the decades on either side of 1900. Many, to be sure, were dedicated to victory and commemoration, but the sheer number – nearly every city in Europe and the Americas has a brace of them – meant that obelisks were applied to ever-stranger purposes. In 1896, at Pennsylvania State University, Magnus C. Ihlseng, a geology professor, found himself so pestered with questions about the qualities of the stones found in Pennsylvania that he organized the construction of a thirty-three-foot obelisk, made up of all "the representative building stones of the Commonwealth, and thus to furnish in a substantial form an attractive compendium of information for quarrymen, architects, students, and visitors." The stones are organized to reflect the geology of the region, with the oldest ones near the base.[16]

Obelisks took on similarly untraditional forms throughout the century. The 1922 competition to design a new headquarters for the Chicago *Tribune* drew two different proposals for obelisk-shaped towers, including one from Chicago architect Paul Gerhardt, who also submitted a proposal for a building shaped like a gigantic papyrus column. Neither won.[17] Although the idea of an obelisk as haven for office workers seems a long way indeed from Egyptian solar cults, such a building would have been very appropriate to the well-nigh pharaonic ego of the *Tribune*'s publisher, Robert McCormick. Obelisks appeared on every scale and in every imaginable context. Smaller sorts of executives could obtain smaller sorts of obelisks. In the 1960s, for example, the Injection Molders Supply Company offered twenty-inch plastic desk obelisks for the "plastics executive who has nearly everything." The sign for the Luxor Hotel and Casino in Las Vegas, one of a series of thematic fantasylands along the Strip – New York! Venice! Egypt! – is a giant obelisk, complete with accurate hieroglyphs that celebrate the immortal kingship of Ramesses II. The obelisk lures people to the pyramid-shaped hotel, whose

"polishing the obelisk," to the moment on December 1, 1993, when the clothing manufacturer Benetton and the Paris chapter of ActUp marked World AIDS Day by putting a twenty-two meter pink condom on the very same obelisk. That, apparently, made the implicit a bit too explicit; the condom had not been approved by the Ministry of Culture and was gone within hours.[12] Time, however, moves ever more quickly, and a vivid image cannot be kept down; in 2005 Buenos Aires decorated its own gigantic obelisk-shaped monument in a similar manner – this time with the full support of all relevant governmental bodies.[13]

But sex is not the only association obelisks carried through the twentieth century. They have become increasingly caught up in the mystical stew of theosophy, pagan revival, and the occult that has come together in the New Age movements of the last few decades. This has proven fertile ground for the revival of the more outrageous and conspiratorial Victorian writers on obelisks and ancient Egypt. Their books are now, paradoxically, much easier to find and buy than major works of nineteenth-century Egyptology. There is, to this day, no English translation of Champollion's *Précis du système hiéroglyphique,* his *summa* on Egyptian writing, or even of his short letter to Joseph Dacier, the key document explaining his ideas about hieroglyphs; but works by marginal figures like Hargraves Jennings and John Weisse, who found evidence of ancient Freemasons wandering the upper Midwest, have been reprinted and are readily available. Around the world, New Age shops and websites nearly all sport obelisks among the crystals, pyramids, and other mystical gewgaws available to channel good energy or dilute and disperse bad. The obelisks are usually advertised as effective at dispelling negative forces, such as "trapped energy, which could cause destruction like volcanoes."[14]

Hollywood saw this mystical resurgence early and wove it into the science-fiction movies and television shows that proliferated in the 1960s. The mysterious resonating monolith that drives the plot of *2001: A Space Odyssey* is not, technically, an obelisk, but plays perfectly the otherworldly role ascribed to Egyptian obelisks in the farther reaches of the New Age. *2001* was one of the sensations of the spring of 1968; later that year the creators of the television series *Star Trek* were much more explicit, when, in shameless emulation, they included an obelisk in "The Paradise Syndrome." That episode features a wise and peace-loving group of American

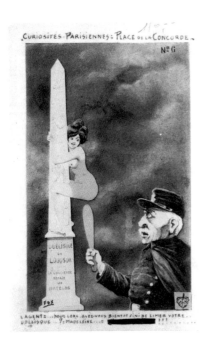

Curiosités Parisiennes No. 6–Place de la Concorde. An early twentieth-century postcard.
The Paris obelisk on December 1, 1993 – World AIDS Day.

analysis of the early stages of fetishistic obsession without even feeling the need to spell out exactly what role the obelisk might play.[10]

Today it is not Egyptian pharaohs, Roman emperors, or Renaissance popes who leap to mind when people stumble across an obelisk; it is Freud. The subtext has become the text itself. Russell Means, the Lakota/Oglala activist who led the 1973 takeover at Wounded Knee, was making a political point when he described the obelisk to Custer at Little Big Horn as "the white man's phallic symbol." But the designers who placed the Washington Monument (pointy side down) between a spread pair of disembodied legs on the cover of a mainstream, trade paperback about the seamy underside of Washington, D.C., likely had no political agenda. They were just trying to sell books. The novel, naturally, was called *The Woody.*[11]

In historical terms this change has been blindingly swift. Obelisks retained their original meaning for thousands of years. Yet it is only a matter of decades between the slightly naughty French postcard of the early 1900s that features a policeman inquiring of a young woman, who clings to the monument in the Place de la Concorde, whether she has finished

poet Algernon Charles Swinburne noted that: "Her majesty has set up – I should say erected – a phallic emblem in stone; a genuine Priapic erection like a small obelisk."[4] But in the nineteenth century such pointed talk was reserved for letters and pub chat. That the obelisk had represented a phallus in antiquity was an intellectually acceptable, if not entirely respectable, idea; that an obelisk might still be one today was a concept best reserved for private moments.

It was Sigmund Freud who let the cat out of the bag. Although Freud did not include obelisks in the extensive and imaginative catalogue of phallic symbols – "things that are long and up-standing" – that occupies many pages of both his *Interpretation of Dreams* and *Introductory Lectures on Psycho-Analysis,* he might as well have. For he did include tree trunks, along with knives, umbrellas, water-taps, fountains, extensible pencils, and zeppelins.[5] In a rare moment of interpretive unanimity, Carl Friedrich Jung concurred, specifically noting the obelisk's "phallic nature" in his *Psychology of the Unconscious.*[6] The two great men had spoken, and from then on nearly everyone who cared to make the connection seems to have done so. In 1933 Nathanael West's Miss Lonelyhearts, sitting in a park, hung over and quite possibly suffering a concussion, became alarmed at an obelisk whose shadow "lengthened in rapid jerks, not as shadows usually lengthen," and which "seemed red and swollen in the dying sun, as though it were about to spout a load of granite seed."[7] A penis, not a phallus. In a more popular context, in the 1956 Biblical epic, *The Ten Commandments,* Cecil B. DeMille made the erection of a great obelisk the centerpiece of an early scene that established the testosterone-fueled rivalry between Yul Brynner's strutting Ramesses II and Charlton Heston's chest-heaving Moses. (DeMille chose the method of raising obelisks proposed by Reginald Engelbach and described in Chapter One.)[8]

Scholars were less vivid in their language, but in 1948 the establishment Egyptologist Henri Frankfort declared – still, it's true, in the discreet context of an endnote – that "it is likely that the obelisk did not serve merely as an impressive support for the stylized *bnbn* stone which formed its tip, but that it was originally a phallic symbol at Heliopolis, the 'pillar city.'"[9] By mid-century, what was once a whispered, almost occult association had become practically banal. In 1950 the psychiatrist Sándor Lorand could include a young boy's dream about New York's Cleopatra's Needle in his

The Twentieth Century and Beyond

I know what an odalisque is; there is one in Central Park!

NICOLAS SLONIMSKY'S SECRETARY[1]

P REVIOUS CENTURIES did not miss the fact that obelisks make a visual rhyme with a certain male body part. In the 1520s, for example, the brilliant poet and pornographer Pietro Aretino was quite specific about the association, using the same word, *guglia,* for both.[2] Even the sex-obsessed and sex-denying nineteenth century made the connection with greater frequency than those looking for evidence of Victorian prudery might expect. There is a faint but persistent undercurrent in nineteenth-century scholarship about the relationship between obelisks and the phallus, though that connection was usually relegated safely to the far distant past. Hargraves Jennings, who hinted at such associations in his pamphlet, *The Obelisk,* was also the author of a series of privately printed books documenting similar ancient monuments throughout the world, part of his attempt to recover the legacy of what he saw as a worldwide prehistoric phallic religion.[3] But in this context the obelisk was a phallus, not a penis. Occasionally, the association could become a bit more explicit, as when the

An enthusiastic sixteenth-century obelisk in the gardens of the Villa d'Este, near Rome.

the Hebrews was translated from French in time for New York to receive its obelisk, were just learned enough to apply a dizzying array of references to Hebrew, hieroglyphs, Coptic, and Greek in an attempt to revive the legacy of Horapollo. And there were a few who simply refused to accept reality. In 1851 Terence Joseph O'Donnelly, an Irish Jesuit resident in Paris, published a small study of the Luxor obelisk. Two years earlier, he had announced his discovery of the original prelapsarian human language, preserved in the obelisk's hieroglyphs – yet another bizarre mix of Kircher, Horapollo, Greek, Hebrew, and fantasy. The scholarly world had ignored him, so now he took his case to the people in a self-published pamphlet. He described his breakthrough as the fruit of many years' hard labor in the beating sun and noisy traffic of the Place de la Concorde, gratefully acknowledging the loan of a telescope from a M. Porcher, an optician in the Rue Nationale. Without that aid, O'Donnelly wrote, he would never have finished the translation, as his binoculars had proven too unstable to allow him to read the signs at the very top of the monument.[53]

The scholarly world ignored O'Donnelly for a second time. By the 1850s, all dispute about obelisks was over. Scholars could read the inscriptions and determine exactly when, why, and by whom most had been set up. But, oddly, that stopped no one. Like the self-taught mathematicians who kept solving the ancient problem of squaring the circle long after it had been proved unsolvable, the cranks and the obsessives soldiered on. There is a certain pathos in the image of a lone madman lurking at the fringes of the Place de la Concorde, furiously uncovering hidden truths, but there is a lesson, too. The desire for obelisks to be something more than just another sort of imperial monument – and for Egypt to be something more than just another ancient civilization – is very strong, and very deeply embedded in western culture. Philology and archaeology make it easy to dismiss characters like O'Donnelly and Weisse – or even publicity seekers such as Hurlbert – but it would be wrong to do so. For in many ways it was the obsessives and the crackpots, the amateur enthusiasts and the businessmen, who were the predictors of the future of obelisks. As much as the Egyptologists, they set the tone for the history and popular perception of obelisks ever since.

Evidence of ancient Masons in Iowa.
An inscribed tablet from an Indian
burial mound, from Weisse's *The Obelisk
and Freemasonry*.

could have built such structures and had spent the better part of a century
finding substitute candidates, from lost tribes of Israelites, to Phoenicians,
to extinct peoples.) A few began imagining a prehistoric past, seeing in obe-
lisks evidence of long-forgotten phallic worship and fertility cults. Hargrave
Jennings, an ardent devotee of the secret and obscure, wove hints about the
obelisk's phallic origins into his little celebratory pamphlet on London's
Needle.[51] Though such ideas didn't please them, serious Egyptologists
could not dismiss the possibility entirely. In his discussion of the meaning
and origin of obelisks, W. R. Cooper acknowledged the phallic argument
only in passing, writing of some reasons "why the obelisk was dedicated
to the sun as the creator . . . which can only be here alluded to" He hid
the (perhaps spurious) archaeological evidence of a phallus-shaped object
wrapped inside an obelisk-shaped box from the collections of the Louvre
in a footnote.[52]

There were those who hunted for a middle ground between mystery and
philology. Acknowledging that Champollion had been correct in his read-
ings of the hieroglyphs, some suggested that, as Kircher had claimed centu-
ries before, there were other, higher readings of the signs as well. Some, like
Frédéric Portal, whose *A Comparison of Egyptian Symbols with those of*

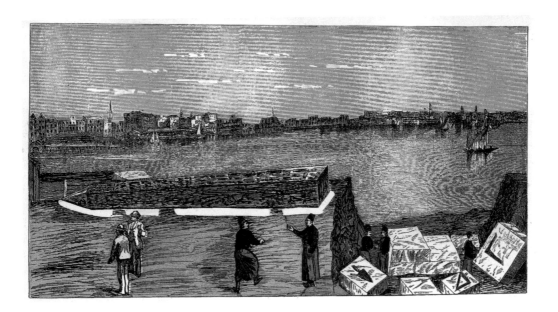

Masonic symbols in Alexandria, from *The Scarlet Book of Freemasonry.*

tion of beliefs about the immanence of spiritual forces in art, was at work on the obelisks. Champollion and other Egyptologists had opened up vast new realms, but they had closed something off as well. By translating the hieroglyphs, Champollion had begun the process of stripping away some of what had made Egypt so fascinating over the centuries. The very fact that it seemed a place apart from time – grand, dignified, and, most of all, inscrutable – had been one powerful source of Egypt's appeal. In a way, the Masons sought to put back that aura. Rather than reimpose Hermetic mysteries, however, they found historical ones instead. Gorringe's "evidence" was picked up enthusiastically. *The Scarlet Book of Freemasonry,* for example, a very popular collection of gory tales about Masonic martyrs through history, included a long section on the Needle and an analysis of the symbols from the foundation.[49]

Others pushed deeper into the idea of hidden history. The excavation of a small plaque engraved with "obelisks" from an Indian burial site in Iowa encouraged John Adam Weisse to add Egyptian Masons to the long litany of non-natives to whom nineteenth-century Americans gave credit for the earthworks of the Moundbuilder cultures that dot the midwest.[50] (Americans were loath to believe that the ancestors of the Indians they knew

No one greeted the obelisk with more enthusiasm than the Masons. Gorringe was a dedicated Freemason and, upon taking down the Needle in Alexandria, had found carvings on the foundation stones that, he claimed, proved it had been set up by ancient Egyptian Masons. The Masons had always asserted the ancient origins and unbroken traditions of Freemasonry; here was proof. Encouraged by Gorringe, news raced throughout the Masonic world, and in September 1880, when it came time to dedicate the Needle's new foundation, nine thousand Masons processed down Fifth Avenue and into the park.[45] Jesse B. Anthony, the Grand Master in the State of New York, celebrated the discovery, the obelisk, and the ancient Masons who had "wrought in granite blocks the thoughts and aspirations of their day." He encouraged current Masons to draw moral lessons from their example by aiming "to lay the foundation of character on a broad, sure, and deep foundation; let it be such as it will bear the application of the plumb, square, and level" – symbols that Gorringe claimed to have found in Alexandria.[46] Even among Masons there was some doubt about Gorringe's claims. He acknowledged the inevitable differences of opinion but insisted on keeping the dispute within the family: "Those who do not belong to the Order are hardly capable of judging."[47]

Capable or no, outsiders watched the whole affair with amusement. The *Brooklyn Eagle* was dismissive of the Masons' claims, but appreciated the Order nonetheless: "Science has been very busy for the past century demolishing a great many things that our ancestors used to venerate because they did not understand them. . . . It is rapidly reducing the world from a chaos of wonders and mysteries into a realm of law, resolving causes and effects in a manner that threatens to starve the imagination and reduce us all to a dead level of common sense." Celebrating what the anonymous commentator called the "almost canine instinct" of the Masons in pursuit of that endangered species, "the humbug," the paper suggested that: "In a world becoming so densely practical as ours, a society for the preservation and protection of the creatures of the imagination, is deserving of esteem and not derision."[48]

Here was the flip side of nineteenth-century positivism and its relentless celebration of technology and science. The same ebbing away of the mystical and unexplainable that had alarmed Friedrich Nietzsche, depressed Max Weber, and set the German art historian Aby Warburg on his explora-

Cleopatra's Needle: advertiser's dream.

the Secretary of State, celebrated the fact that though this was by no means the first obelisk that had "left its home in Egypt to seek new scenes" . . . "never before has the transfer been as voluntary on the part of the Egyptian government as now."[41]

Those of a more skeptical cast of mind thought that might not have been entirely the case, and for a few years there were voices of strong dissent. As late as 1886 the editors of the *North American Review* were still exercised enough to claim that the Needle "upon our shores, can never be other than a reproach. It was torn from its base at the inspiration of vulgar, concealed private 'enterprise.' It was not a free gift to the nation but the spoils of jobbery. . . . the acquisition was neither creditable to our nation nor to our day."[42] The anger of the righteous was made all the more vivid by the fact that the obelisk did not react well to its new home. Having been burned in antiquity, the obelisk's surface was covered with a network of tiny cracks and deteriorated quickly in the endless cycle of freezing and thawing that is a New York winter. A coat of paraffin helped arrest the flaking, and the decay did at least inspire Alexis Julien's delightfully titled paper: *A Study of the New York Obelisk as a Decayed Boulder.*[43]

For a short time the Needle was the center of attention. Gorringe rode its fame to a successful business as a consulting engineer, and, as the *Times* noted in its obituary, "his name began to feature in the newspapers, in connection sometimes with matters foreign to his profession. He was talked of in April 1882, in connection with the office of Commissioner of Street Cleaning in this city, in consequence of plans that he had submitted for the removal of snow from the streets."[44] There were public lectures, parades, parties, and a lavish ball. Though the obelisk belonged to the *World,* in the end all the papers ran story after story, as did the illustrated weeklies and the more serious monthly magazines. In an age when domestic music making was one of the most widespread of bourgeois pastimes, the obelisk served as inspiration for countless bits of sheet music: Mrs. Lou Fitts composed an *Obelisk Waltz.* There was a *Grand Obelisk March* and an *Obelisk Polka;* Florence Hooper Baker dedicated her *Obelisk March* to Commander Gorringe. And in a competitive commercial metropolis, the Needle was an opportunistic marketer's dream. The obelisk was used to hawk an almost infinite variety of products, from hotels to Vaseline to, inevitably, thread and needles.

saying that the "barefaced king-worship . . . gives its translation a repulsive sound to modern ears."[38] Nonetheless, he prepared a full-length study of the obelisk a few years after it was unveiled. His introduction to the book is worth quoting at length, as it captures perfectly the complicated emotions and intellectual strain many observers felt at the presence of such an object in the United States:

> The oldest nation on the globe sends her greeting to her youngest sister. The "Setting Sun" has shed its last rays on the Old World from Egypt's sunny land and now appears on this western shore as a brilliant "rising sun." In the metropolis of the Western Hemisphere one of Egypt's grandest treasures meets our eyes and, though silent, reminds us of her former greatness. Here stands a monument of two of her greatest Pharaohs, lords and conquerors, scourges of their people, and a terror to their foes. It tells the story of serfs and teems with cringing words and the praise of despots. Yet it was a glorious time when this monument was erected and inscribed, a time of power, pride, learning, greatness, conquest for the lords, but for the people a time of abject subjection, misery, and hardships. Pharaoh was master of all. But the sun of his grandeur has set and vanished, and our obelisk, that proud monument of Pharaonic times, now sees a spectacle which the greatest flight of fancy could not have pictured to any man of those by-gone days. . . . Here in the western land the obsequious adoration of one man is no more. Here the people are not under the lash and miserable; they are with all their cares and labors, a happy and contented people. The realm is not, as in those former days, the result of a despot's triumphant march, but a grand, harmonious union of friends.[39]

Uncomfortable as some were with the sentiments engraved on the obelisk, many Americans were equally ill-at-ease with the notion that the Needle itself could be seen as some sort of imperial trophy. Instead, it was portrayed as an emissary, come to learn from – or perhaps be humbled by – a democratic public, or "an aged traveller, who, after a journey of some five thousand miles . . . has lately settled down within our quiet borders, in the hope of a little repose."[40] At the dedication ceremonies, held inside the Metropolitan Museum of Art on January 22, 1881, William M. Evarts,

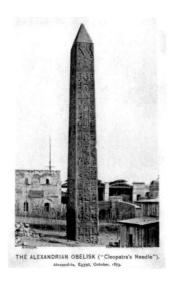

THE ALEXANDRIAN OBELISK ("Cleopatra's Needle").
Alexandria, Egypt, October, 1879.

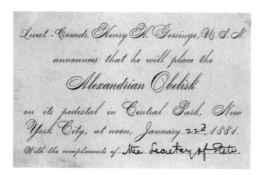

Lieut.-Comdr. Henry H. Gorringe, U.S.N.
announces that he will place the
Alexandrian Obelisk
on its pedestal in Central Park, New
York City, at noon, January 22ᵈ 1881.
With the compliments of the Secretary of State.

Invitation to the installation of Cleopatra's Needle,
January 22, 1881.

Rome has had them this great while and so has Constantinople. Paris has one. London has one. If New York was without one, all those great cities might point the finger of scorn at us and intimate that we could never rise to any real moral grandeur until we had our obelisk."[36]

But only a whiff. In the 1870s New York was, for all its boastfulness, still very much a new and brash place. The institutions that are today among the city's sources of world cultural renown – the Metropolitan Museum, the New York Public Library, Carnegie Hall – were either brand-new or not yet built. An obelisk, whatever its means of arrival, was a big deal and reinforced the sense that New York was taking its place in the world. So admiration seems to outrun cynicism in the geologist Alexis Julien's note that: "A few weeks ago, a friend from a country village, on a hurried visit to New York, wished to be shown first our two surpassing attractions, in his eyes, 'the Brooklyn Bridge and the Pyramid!' Of course he was assured that if our merchants undertook to import a pyramid, that pyramid would have to come; but up to this time only an Obelisk had arrived."[37]

Serious commentators on Cleopatra's Needle were aware of the decades-long conversation about the role of monuments in a republic. Perhaps reflecting that, some who might otherwise have been most enthusiastic about the obelisk tempered their exult. The Egyptologist Charles Moldenke noted that he himself found the text on the obelisk distasteful,

Loading New York's Needle at Alexandria.
Landing on Manhattan; the obelisk came ashore at West 96th Street.

ringe. A man of immense practical capacity, Gorringe quickly became as obsessed with obelisks as his compatriots in London had been, and undertook his task with deadly seriousness of purpose. That seriousness seems to have afflicted almost no one else who observed the project. The mocking tone with which American commentators had greeted London's obelisk was carried over seamlessly to their own. The fact that everyone knew at some level the affair was a grand publicity stunt may have encouraged the tone. Even the *Times,* then as now among the more sober voices in the press, engaged in a little fun. Noting the *World*'s insistence that New York must have Cleopatra's Needle because it had stood outside the temple in Heliopolis, "where Moses learned all the wisdom of the Egyptians in a course of six easy lessons for five drachme," the *Times* suggested that the *World* should think a bit bigger: ". . . Noah not only antedated Moses, but as the inventor of wine and ship-building, was a much more interesting person. Let us, therefore, import Mount Ararat, and having placed it in an eligible locality overlooking the Sound, let us build a Summer hotel on the very spot where Noah landed."[35] Thus, it may have been with a whiff of irony when, in 1881, a reporter for the New York *Herald* wrote: "It would be absurd for the people of any great city to hope to be happy without an Egyptian Obelisk.

Ismail Pasha, the khedive of Egypt, told William Henry Hurlbert, editor of the New York *World,* that the United States should have an obelisk. Or so Hurlbert reported. Whether the offer was made, even in passing, is unclear, but just as the London obelisk began its journey in 1877, reports reached Cairo that the Americans had been offered the other Needle and were preparing to pick it up, the cost of carriage to be paid by an anonymous benefactor.[32] The news came as a great surprise in Egypt. As one resident of Cairo noted, while hesitating to break "the great bubble which has been dancing in the air . . . not an individual with whom I have conversed, and I have access to many who have daily access to the Khédive, has heard a word on this subject drop from his Highness' lips."[33] In a show of confidence, Hurlbert had already been in discussions with George Dixon, the English engineer who had moved London's Needle, and had secured financial backing from the railroad baron William Henry Vanderbilt. Vanderbilt, hiding behind a somewhat diaphanous veil of anonymity, was not really taking much of a risk, as he had agreed to pay only after the obelisk had arrived and been safely set up in Central Park.

Though he professed surprise in public, the American consul, Elbert Farman, dutifully took up the cause, raising the issue with the khedive at regular intervals over the next year. The circumstances that surround the gift are more than a little murky. Farman wrote a "tell-some" account of the negotiations in 1882, revealing shadows and hints of the larger diplomatic picture – with the obelisk part of a complicated power game involving the khedive, his French and British creditors, foreign advisers, nationalist forces, the military, and the khedive's ambitious son. Sometimes the deal seemed on, sometimes off. Ever the diplomat, Farman carefully failed to reveal enough to allow a reconstruction of what actually happened. The complete story no doubt lies buried somewhere in the interconnections among the British, French, Egyptian, and American diplomatic archives. In his account, Farman fell back on the nineteenth-century idea of Egypt, and the "East" generally, as a place of shadowy mystery and inexplicable changes of fate. Suddenly, in October, the khedive agreed and the papers were signed. Within a month he had abdicated in favor of his son and been driven into exile.[34]

Dixon did not get to move a second obelisk. Instead, the task fell to an American navy officer, Lieutenant Commander Henry Honeychurch Gor-

ously impossible for anything so colossal. Nor could we have been expected to attempt the impossible in deference to Egyptian methods of construction. . . . America is certainly at liberty to present new models in art as well as government, or to improve upon old ones; and, as I ventured to suggest some years ago, our monument to Washington will be all the more significant and symbolic in embodying, as it does, the idea of our cherished National motto, E PLURIBUS UNUM. That compact, consolidated structure, with its countless blocks, inside and outside, held firmly in position by their own weight and pressure, will be ever an instructive type of the National strength and grandeur which can only be secured by the union of "many in one."[29]

The epistemological and aesthetic discomfort represented by a non-monolithic obelisk so neatly turned to philosophical virtue, Winthrop went on to address the question of inscriptions. He justified the monument's plain sides by explaining that the American obelisk was, and would likely ever remain, free of the "despotic," "vainglorious," and "haughty" sentiments expressed by the hieroglyphs on most Egyptian obelisks. In every way, the new obelisk served as a symbol of human progress – all the more powerfully by redeeming a historical symbol of human degradation.[30] As always, though, there were dissenters. In 1880 the architect Henry van Brunt dismissed the monument as a "dumb, monumental chimney."[31]

In light of all this, it seems especially appropriate that the United States, this "nation of readers" whose printing presses had rendered obsolete the monuments of older, less-enlightened civilizations, acquired its obelisk in what was, to a large degree, a publicity stunt organized by a newspaper. For Americans *were* a nation of readers – of novels, magazines, and, in New York especially, newspapers. New York in the 1870s and 1880s was the scene of cutthroat competition among nearly two dozen daily papers. Some aimed high, others low, but all needed to grab the public's attention. What better means to capture circulation than a long-running story about the diplomatic and engineering intrigues associated with bringing an obelisk across the Atlantic and setting it up in the center of the nation's biggest newspaper market?

The seed was planted at the opening of the Suez Canal in 1869, when

clear that he didn't think the Egyptians, at least in the person of the current pasha, were up to the task. The future, in his mind, lay elsewhere.[26]

The idea that *translatio imperii* would be rendered visible in marvels of engineering was widespread. It certainly lies behind Judge Wilson's 1849 dismissal of the Bunker Hill and Washington Monuments as being inferior to Charles Ellett's new suspension bridge over the Ohio River at Wheeling, West Virginia – the longest in the world when finished. The bridge would facilitate "the intercourse of millions of Freemen, conferring benefits upon them to the end of time," whereas the monuments, "however pleasing to the eye of the patriot and however ornamental to the places in which they are situate, are divested of what, in this age, is deemed essential, that is – *utility.*"[27] Along with that utilitarian bias came a sense that the printed word had rendered obelisks and other such memorials pointless. The United States was a literate nation. In such a society commemoration in stone was unnecessary, for history was recorded in books. In 1855 the *New York Times* ran a column under the title "Anti-Monumental":

> What need can there be for a monument to commemorate an event that has been already commemorated by millions of printed books and newspapers? The Egyptian obelisk served the purpose of a historical record, as did the Roman columns and triumphal arches, and Assyrian tablets; but we who are a reading people, and have plenty of books and newspapers, need nothing of the sort, and the people revolt at them as affectations. . . . If strangers ask for our monuments we can show them the Croton Aqueduct and reservoirs, our magnificent institutions of charity, our Churches, Schoolhouses, Asylums and public Libraries.[28]

Eventually, though, the United States proved just as susceptible to the grand, pointless gesture as any other nation, and Americans became accustomed to crafting symbolic exegeses appropriate to a "nation of free men." By 1885, when the Washington Monument was finished, the metaphors had become quite virtuosic. In his dedicatory oration, Robert C. Winthrop played a clever riff on that obelisk's method of construction:

> It is not, indeed, as were those ancient obelisks, a monolith, a single stone cut whole from the quarry; that would have been obvi-

When the monument was still just an idea, there was debate as to the appropriateness of any sort of large memorial structure. Pillars and tombs and obelisks were the sort of artifacts left by kings, and perhaps not fit for a republic. The Association addressed the problem directly in their proposal:

> The beautiful and noble arts of design and architecture have hitherto been engaged in arbitrary and despotic service. The Pyramids and Obelisks of Egypt; the monumental columns of Trajan and Aurelius, have paid no tribute to the rights and feelings of man. Majestic and graceful though they are, they have no record but that of sovereignty, sometimes cruel and tyrannical, and sometimes mild; but never that of a great enlightened and generous people. Providence, which has given us the senses to observe, the taste to admire, and the skill to execute, these beautiful works of art, cannot have intended that, in a flourishing nation of freemen, there should be no scope for their erection . . .[24]

In other words, Americans, should they choose to build monuments, would actually be rescuing artistic forms, born of Providence-dispensed genius, that had been sadly perverted across the centuries by the patronage of despots.

The Bunker Hill Monument also came up against American prejudices about the grand gesture, or at least grand gestures that were purely ornamental. When the monument was not yet finished, Willard wrote a book justifying the effort. It contains not a single aesthetic or symbolic argument. Instead, he trumpeted the technology associated with the project, including advances in quarrying and the laying of the first railroad in the United States.[25] This retreat into practicality was in touch with the spirit of the age. For it was clear that many Americans thought the great monuments of the future would be technological ones. Stopping in Alexandria on a world tour in 1857, George Francis Train contemplated the "mastodonic Beacons" of two previous great ages, those of Egypt (Cleopatra's Needle) and Rome (Pompey's Pillar). He wondered what Egypt's new monuments would be and hazarded a guess as to who would build them: "What shall be the memory that binds the present period with the Pillar and the Needle, to the Pyramids and the Sphinx? Shall it not be the railway, the steamboat, the telegraph, bringing about the moral and the physical change that everywhere follows the footsteps of the Anglo-Saxon race?" Train made it quite

along with other Egyptian artifacts, had become neither a threat to nor an endorsement of Christian doctrine. It was a thing – an old and evocative thing to be sure – but an artifact of human history rather than a potentially active spiritual force.

The third, and last, obelisk to leave Egypt during the nineteenth century went not to St. Petersburg or Vienna, Berlin or Tokyo – seats of emperors all – but to the greatest city in the one great nineteenth-century nation that insisted most forcefully it was not an empire of any kind: New York. New York was not even a capital, except a commercial one. Champollion's decipherment had long since rendered it impossible to deny the intimate association of obelisks with kingship and autocratic power. So what business had an insistently self-described republic with an obelisk, the ultimate symbol of empire? It was a question Americans had wrestled with long before they had to contend with the possibility of getting an actual obelisk in the late 1870s. Decades earlier, during a fit of Egyptomania that filled the United States with Egyptian cemetery gates and reservoir pumping stations, Americans had first toyed with the idea of adopting obelisks for memorials. A small brick one was built in honor of Columbus at Baltimore as early as the 1790s, but the first really prominent obelisk-shaped monument in the United States was the 225-foot tower raised in Charlestown, Massachusetts, to commemorate the Revolutionary War battle of Bunker Hill.[21]

As the fiftieth anniversary of the battle approached in 1825, there was fear that the site, still open, might be divided up for house plots. In response, a group of citizens, chartered as the Bunker Hill Monument Association, bought the land. They proposed to build a monument that would be dedicated to the battle, but also to liberty and "the spirit of representative government, which is advancing with the general and irresistible march of intelligence, round the globe."[22] At first the Association expected that the monument would be a great classical column, but they held an open competition, and a few of the entrants submitted obelisks instead. The debate about style went back and forth for some months in early 1825. Solomon Willard, one of the entrants, preferred the obelisk "for its severe cast and its nearer approach to the simplicity of nature than the others. The column might be more splendid. The character of the obelisk . . . seems to me strictly appropriate for the occasion. . . ." The committee must have agreed, for he won the commission.[23]

law or of the Christian gospel."[19] Unlike Pope Sixtus three centuries earlier, Dean Stanley seemed to feel no need to demonstrate Christian mastery over the pagan obelisk. His greater physical distance from sites that reminded of early-Christian struggles no doubt played a role, but the decipherment was at work here as well. Now that obelisks could speak for themselves, some of their mystical power and fruitful obscurity had slipped away. Egypt itself had lost some of its aura of remoteness and danger as the country had become more accessible and its history better understood.

Still, the study of Egypt remained deeply intertwined with religion. Based in London, the Egypt Exploration Society (which Sir Erasmus Wilson helped found) sponsored archaeological expeditions, among whose aims was the search for physical evidence supporting the Bible. But the digs were not Biblical treasure hunts, and the society did not restrict itself to investigating sites with Bible connections. The expeditions were sober-minded archaeological surveys, many done at the cutting edge of what was emerging as "scientific archaeology."[20] By the 1870s the London obelisk,

The Reverend James King's *Cleopatra's Needle*.

Opposite: The flyleaf of King's *Cleopatra's Needle*, listing volumes in the series By-paths of Bible Knowledge.

The series in which King's book appeared – "By-paths of Bible Knowledge" – was meant to provide background material for a richer understanding of the history, both human and natural, of the places described in the Bible. The enterprise was, perhaps, infused with a hopeful belief that there would prove to be perfect concordance between the Biblical narrative and the archaeological and historical record, but the effect was to use scripture as the organizing principle for books devoted to non-religious subjects, not solely to use those subjects as a lens to deliver Christian messages.

Arthur Penrhyn Stanley, the Dean of Westminster Abbey, treated the obelisk with similar emotional distance. In a sermon on the Good Samaritan, he cited the Needle not as symbol of a heathen and despotic past but as evidence that " 'the light that enlighteneth every man' shone also on those who raised it as an emblem of the beneficial rays of the sunlight of the world. It will tell us that as true goodness was possible in the outcast Samaritan, so true wisdom was possible in the hard and superstitious Egyptians, even in that dim twilight of the human race, before the first dawn of the Hebrew

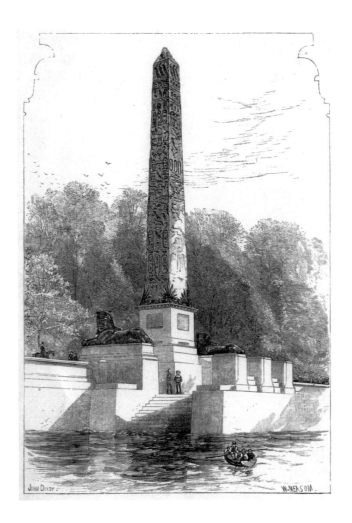

The obelisk in place; the frontispiece to Sir James Alexander's *Cleopatra's Needle*.

ancient monument, old even when first he looked upon it, and read its story of past greatness; the toiling suffering Israelites looked upon it, and we seem to come into a closer fellowship with them as we realize this fact."[18] But King's interest in the monument went beyond mere evocation of Bible stories. A trip to the Holy Land had spurred his interest in ancient Egypt, and the Mosaic theme is the set-up for an archaeological introduction to the monument, its hieroglyphs, and its place in Egyptian history. Clip out the few scriptural citations near the beginning and end of the book and there is almost no evidence of the author's Christian motivation.

Exhibition, the Needle was a favored design, "some dozen or more representations . . . being shown. One imitated the rose granite in oak apples, but ignoring the monolith idea, built up his structure of 1,790 pieces."[14] The obelisk also became an object of contemplation for Mrs. Brown, the central character of a series of cheap comic novels, who, unlearned, often confused, but wise beyond her education, held forth on topics of current interest. Naturally, she thought the Needle was a needle, until she was set straight that it was actually a "nobbylisk," or, sometimes, a "hobbylisk." (Ultimately, she didn't see why Britain had any right to it.[15]) A naughty music-hall song celebrated the *real* use to which Cleopatra had put her Needle, and as late as 1911 the obelisk made an appearance in a popular novel about how the ancient queen, emerging from the monument, swept the London social scene one winter.[16]

The Needle was given a handsome Egyptian-revival setting, complete with bronze sphinxes and sober plaques commemorating the lost sailors, but it never inspired the serious or celebratory publications that had greeted its compatriot in Paris. Indeed, London's was the only nineteenth-century obelisk that failed to have its move recorded in a grand picture book; and while it seems that every person even remotely involved with moving the Paris obelisk wrote a long memoir about his role in the affair, only Alexander and Wilson wrote (very modest) books about the Needle. Ignored by the state, the obelisk remained something of a white elephant. Its site on the Embankment left it far from the symbolic centers of power and very much out of the sequence of spaces that defined imperial London. It was not easily accessible for contemplation by members of Parliament, the Queen, the Admiralty, or even the owners of the great commercial houses – the driving forces of the British empire.

In the end it was the Christians who found a real use for the Needle. Much as the Vatican obelisk had gained fame in the Middle Ages as a witness to St. Peter's crucifixion, Cleopatra's Needle came to serve the nineteenth century as a direct link to the Exodus. In the very first paragraph of his little book on the Needle, the Reverend James King pointed out that the "mysterious-looking characters" covering the obelisk "were carved by workmen who were contemporaries of the Israelites during the time of the Egyptian Bondage."[17] He expanded on this theme at the end of the book's introduction: "The eyes of Moses must have rested many times upon this

MRS BROWN ON CLEOPATRA'S NEEDLE

BY ARTHUR SKETCHLEY

CLEOPATRA'S CALENDAR

1878

JANUARY · FEBRUARY · MARCH · APRIL · MAY · JUNE · JULY

AUGUST · SEPTEMBER · OCTOBER · NOVEMBER · DECEMBER

"CLEOPATRA'S NEEDLE ABANDONED IN THE OLGA IN THE BAY OF BISCAY OCT 5 1877"

THE GRAPHIC
AN · ILLUSTRATED · NEWSPAPER · OF · THE · HIGHEST · CLASS
SIXPENCE · WEEKLY
OFFICE · 190 · STRAND · LONDON

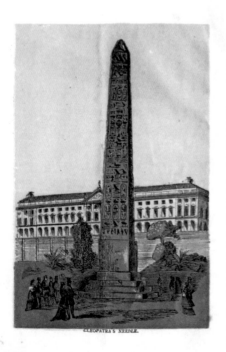

CLEOPATRA'S NEEDLE.

COMPLETE HISTORY

OF THE

ROMANTIC LIFE AND TRAGIC DEATH

OF THE

Beautiful Egyptian Queen

CLEOPATRA;

AND ALL ABOUT HER

NEEDLE,

3,000 YEARS OLD!

And the Events that led to its arrival in

ENGLAND;

WITH AN

INTERPRETATION OF ITS CURIOUS

HIEROGLYPHIC INSCRIPTIONS.

LONDON: Published by W. SUTTON, 9t, St. John Street, W. Smithfield.
PRICE ONE PENNY.

rougher and more unpredictable. On October 14, 1877, the *Olga*, the ship that was towing the obelisk, and the *Cleopatra* were caught up in a large gale in the Bay of Biscay, between Britain and France. The storm proved too much, and the *Olga* cast off the tow-ropes. In the middle of the night the *Olga* managed to rescue the *Cleopatra*'s captain and crew, but a boat with a volunteer crew of six that had gone out to aid the *Cleopatra* at the height of the storm vanished. There was hope the men had found safety on the obelisk. At daybreak the *Olga* found the *Cleopatra*, abandoned. Setting out to search for the crew, they again lost sight of the *Cleopatra*. By midday it seemed that both the men and the obelisk were gone.

The boat and its crew had, in fact, been lost, but the obelisk did not sink. It was found by another steamer, the *Fitzmaurice*, and taken in tow. The affair quickly veered back from tragedy to farce when the *Fitzmaurice*'s owners tried to make a salvage claim on the obelisk. Eventually the legal dispute was settled, and the fire went out of the debate about the site as well. The obelisk was to be raised on the Thames Embankment, the spot that posed the least complications and was most easily accessible from the water. Maneuvered into place over the summer of 1878, the Needle was lowered onto its pedestal on September 14. Though a large crowd was on hand, there were no official festivities. Alexander and Wilson had hoped for an elaborate public ceremony, but shortly before the event the government backed out without explanation. *Engineering* noted discreetly that the Price of Wales had been severely "delayed." As the 1870s wore on, Britain was coming closer and closer to an outright takeover of Egypt (the British would seize control in 1882), so there may have been an unwillingness to embrace a gift from Egypt's ruler so publicly. Such an act might confer greater legitimacy on the khedive at a time when Britain was working to undermine his authority.

Even before it was set up, the Needle inspired songs and odes, special newspaper supplements, and cheap pamphlets describing the history of the monument and the "beautiful queen" after whom it was named. In December 1877, at the Westminster and Pimlico Working Classes Industrial

Mrs. Brown, startled to find her own name among the hieroglyphs.

An obelisk calendar, an insert from the *Graphic*.

A one-penny pamphlet celebrating the Needle.

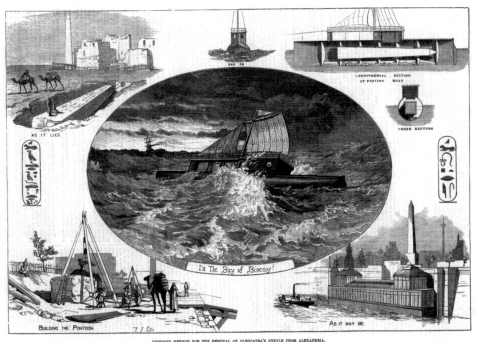

Moving and setting up the obelisk, from the *Illustrated London News*.

the monolith through London's narrow streets to reach the museum: "with modern engineering the task would be a mere bagatelle."[12] Round and round it went as the vibrant London press provided a forum for debate.

Dixon had designed a peculiar cylindrical ship to carry the Needle – the *Cleopatra.* Having no power of its own, save a small sail to control its direction relative to the wind, the *Cleopatra* would have to be towed to England. Though the British papers were full of serious discussion of the principles of nautical architecture involved, the American press had immense fun with the very idea of a seagoing obelisk, amusing itself with commentary as to how an obelisk was quite an improvement on an ironclad: "Of what use would a Russian iron-clad be against a stout and fast British obelisk?" The ironclad could fire all day, but, solid all the way through, the obelisk could repel it all and, using her apex as a ram, sink the enemy "without firing a shot." Soon every navy would sport whole fleets of obelisks.[13]

The voyage began uneventfully. The obelisk was towed safely through the Mediterranean, but after it turned into the Atlantic the seas became

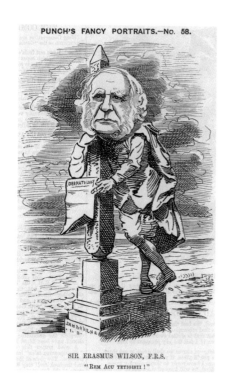

PUNCH'S FANCY PORTRAITS.—No. 58.

SIR. ERASMUS WILSON, F.R.S.
"REM ACU TETIGISTI!"

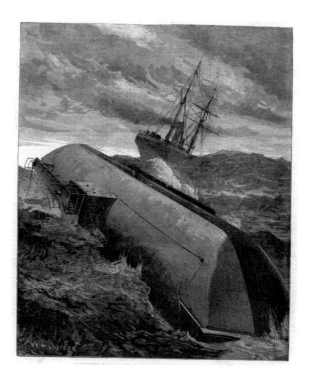

Sir Erasmus Wilson, from *Punch;* the *Cleopatra* in rough seas.

Not all agreed. Dixon, the chief engineer, preferred a site in St. Stephen's Square, in view of the Houses of Parliament and Westminster Abbey. He even arranged to have a mock-up built there to test the effect. Parliament's architect, Charles Barry, objected to that site on aesthetic grounds, preferring Regent's Park.[9] The Metropolitan Railway (ancestor of the Underground) also objected, as the obelisk would sit atop, and potentially endanger, a new railway tunnel. Still, the site had its defenders. Lord Harrowby cited the "moral fitness" of placing a reminder of British military glory near the twin seats of British greatness: representative government and the Anglican church.[10] An anonymous writer, signing himself "A Peer in Response," saw no moral fitness at all in putting an artifact of what he saw as a despotic and heathen culture in that, of all spots; he preferred the forecourt of the British Museum.[11] "Alexandria" concurred, and suggested that placing it at the Museum would "spare" the Needle "from a discordant jostling with the commonplace sculptures of Peel, Derby, and Palmerston, by which the Westminster site is so doubtfully adorned." As for the problem of navigating

pleasant it was "to renew one's recollection of Hindostanee with the las-cars on board" his ship to Egypt.[6] Alexander had no particular interest in obelisks, or even in Egypt, until 1867, when he went to Paris for the great international exhibition there. After admiring the obelisk in the Place de la Concorde, he learned "that as good an obelisk, the property of the British nation, lay imbedded in the sand of the sea-shore at Alexandria."[7]

Almost immediately, Alexander became obsessed with the Needle. He went to Alexandria to investigate the monument and had long talks with the engineer George Dixon about whether it was practicable to move the obelisk, and how much it might cost. The matter took on greater urgency when Alexander learned that the Khedive of Egypt had sold the land on which the obelisk sat, and that the new owner wanted the monument gone; there were even rumors he would break it up for building material. Alexan-der was not himself a man of great means, so upon returning to England he went hunting for sponsors. He found a willing accomplice in Sir Erasmus Wilson. Wilson was Britain's leading dermatologist and, because of that, a very rich man. He became almost as enthusiastic as Alexander about the obelisk, his obsession eventually becoming something of a national joke: a caricature in *Punch* showed him clinging to the Needle for dear life, bearing the banner of dermatology before him.

But Alexander and Wilson's paired obsessions were vital, for without them nothing would have happened. Where collecting the French obelisk had been very much a matter of state, in Britain the key players were private citizens driven by their imaginings of what the state ought to do, rather than the state itself. The result was a monumental public squabble about where the obelisk should be placed, even before it was certain that it was coming. Alexander himself had fond dreams of finding a site on the edge of St. James's Park:

> As a military and naval trophy, the obelisk could not be put in a more appropriate place than this, contiguous to the Admiralty, and to the parade ground used by the flower of the British troops, and overlooked by the head-quarters of the army, backed by foliage; the view of it from the Horse Guards would be very striking, and in the distance it would be an interesting object from Buckingham Palace.[8]

to London, but the city remained remarkably free of the great vistas and imperial bric-à-brac that came to characterize its French counterpart.

Britain suffered periodic bouts of guilt about its obelisk. There were several proposals to collect the gift in the 1830s and 40s, but none came to much. Some veterans of the Egyptian campaign petitioned Parliament about the matter, as did the British Museum. When it seemed that France was making an effort to pick up its Needle from Alexandria, Prince Albert, Queen Victoria's beloved consort, briefly took an interest, but he died before anything could happen.[2] The 1850s saw a proposal to make the obelisk the centerpiece of an Egyptian court to be built into Joseph Paxton's great glass-and-iron exhibition hall – the Crystal Palace – which, after the Great Exposition of 1851, had been disassembled and re-erected in suburban Sydenham – an ancient wonder as complement to a modern one.[3] Again, the plan fizzled. A reviewer in Fraser's Magazine summed up the situation best: "England appears from her apparent bewilderment in the matter, to be in the position of the elderly Lady who won an elephant in the lottery."[4] But there was also real resistance to bringing the obelisk to Britain: passive resistance from the government, which didn't want to pay for the monument, and active resistance from scholars, some of whom opposed removing the obelisk on ethical grounds, and others, such as Sir Gardner Wilkinson, who, though no puritan about collecting artifacts, was dismissive of this particular obelisk's quality.[5]

So matters remained until the 1870s. The man who finally broke the stalemate, Sir James Alexander, was a near-parody of high Victorian imperial vigor. A lifelong bachelor, Alexander (or, more properly, as he announced himself on the title page of his book on obelisks: "Sir James Edward Alexander, Knt., C.B., K.C.L.S , F.R.C.E., author of *Adventures in Kaffirland, Explorations in Africa and America,* etc. . . .") was a military man who spent his career volunteering for duty in remote and inhospitable places – a real-life version of the colonial gentlemen who populate Sherlock Holmes stories. His prose was clipped and bluff, as if dictated, and frequently lacking in pronouns. It is almost possible to hear the rustling of whiskers in Alexander's description of traveling companions, including the "beautiful Italian girl who sat opposite, with fair cheeks and fine sympathetic eyes, if I may be allowed the expression, and raven hair," or his memory of how

Cleopatra's Needles: London and New York

What shall be the memory that binds the present period with the Pil-
lar and the Needle, to the Pyramids and the Sphinx? Shall it not be
the railway, the steamboat, the telegraph, bringing about the moral
and the physical change that everywhere follows the footsteps of the
Anglo-Saxon race?

GEORGE FRANCIS TRAIN ON THE MONUMENTS OF FUTURE AGES, 1857[1]

MARSEILLE COULD DREAM, but London, Paris's real rival in the competition for obelisks, remained curiously indifferent to its own prize. Even though the British had full legal title to one of Cleopatra's Needles, decades passed before anyone made a serious effort to bring it to England. Perhaps Britain, whose rule already spread across much of the world, felt less need for the trappings of empire than did France. The British government was certainly slower to remake the cityscape of London along traditional imperial lines than its French counterpart. Indeed, if a Roman had been brought forward fifteen hundred years to 1870 and asked whether London or Paris were capital of the greater empire, it's a fair bet he would have chosen Paris. Vast riches and archaeological collections flowed

A crucial moment in the installation of New York's obelisk,
from Gorringe's *Egyptian Obelisks*.

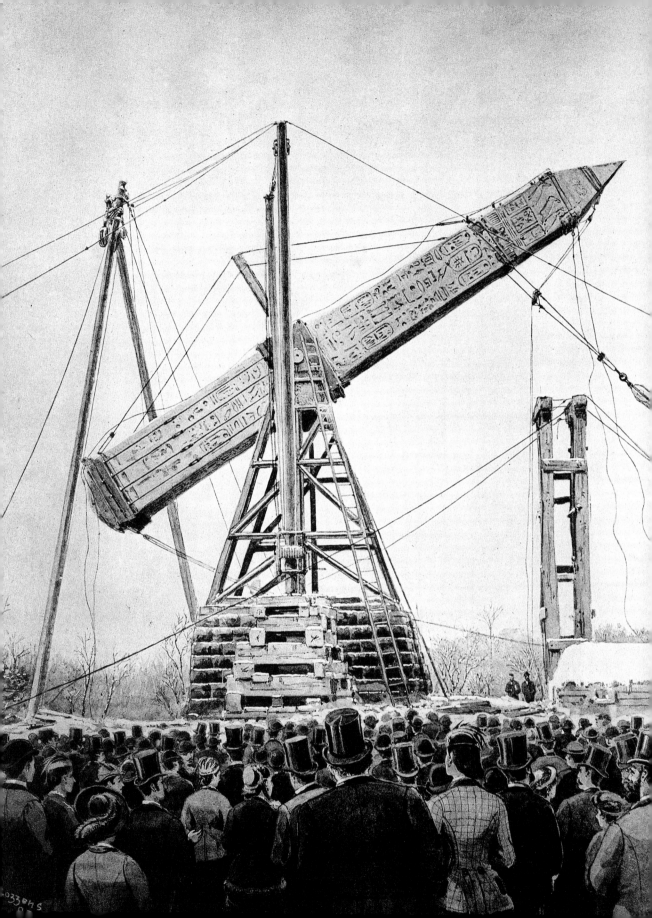

Fontana and Lebas's world had vanished, replaced by one of steam engines, steel cable, and hydraulic jacks. When London got its obelisk, virtuosity of calculation and elegance of concept did not spell the difference between success and failure; the application of simple brute force played a much more prominent role. Risks and challenges remained, but moving obelisks in the 1870s was a more predictable and far less balletic endeavor than it had ever been before.

In an era fixated on the dreary pleasure of pining for lost love, the Paris obelisk, separated after millennia from its twin, prompted an outpouring of Romantic sympathy. In addition to celebrating the inert political culture of ancient Egypt, Barthélemy's poem contemplated the sad musings of the obelisk, now raised on the banks of an alien river.[70] Some years later, and with considerably more literary grace, Théophile Gautier included a pair of poems on the "Nostalgies des obélisques" in his 1855 collection, *Enamels and Cameos* – one each for the Paris obelisk and its mate.[71] Neither was particularly happy. European visitors to Luxor rarely failed to comment on the missing stone. In the journal of his 1850 trip to Egypt, Gustave Flaubert imagined that the Paris obelisk must "miss the Nile" and wondered "what must it think, watching the carriages of the king turn around it, in place of the ancient chariots that once passed its base?"[72] British observers tended to be somewhat more snappish. Passing through Luxor just a few months before Flaubert, Florence Nightingale wrote home of the "widowed obelisk" whose mate "has been carried off, you know by whom."[73] Nearly thirty years later, Amelia Edwards noted the solitary obelisk and sniffed that "its companion . . . , already scaling away by imperceptible degrees under the skyey influences of an alien climate, looks down with melancholy indifference upon the petty revolutions and counter-revolutions of the Place de la Concorde."[74] Of course, Romantic sympathy for the obelisk's plight didn't stop other cities from trying to get their own. Marseille, always in jealous competition with Paris, was even scammed into believing that it could buy the second Luxor obelisk. In 1834 the city council nearly paid out half a million francs to a certain M. le Lorrain to arrange delivery. No obelisk was forthcoming.[75]

who dared mention history or politics when discussing the obelisk tended to use it as an object lesson in good behavior, as did Auguste Barthélemy when he celebrated the monument as the product of a wise nation that had not been riven by political strife.[68] In the end, though, the political symbolism paled against what the French could truly celebrate: the technical mastery that had brought the obelisk to Paris in the first place. The early nineteenth century was one of the great eras of French science and engineering: the École Polytechnique boasted the world's most rigorous scientific and mathematical curriculum; the École des Ponts et Chaussées offered the most complete training in engineering available anywhere. Even better from a political standpoint, French technical prowess had flourished under all forms of government.

Just as Napoleon had been aware of the imperial precedents for his conquest, the engineers, too, were mindful of what had gone before. Lebas's large-format account of the move, *L'Obélisque de Luxor: Histoire de sa translation à Paris,* paid explicit homage to Domenico Fontana's *Della Trasportatione dell'obelisco Vaticano.* Like Fontana, Lebas unveiled for his readers the elaborate array of capstans and counterweights employed in the operation, chronicling each step in words and pictures. He even included a chapter on the Vatican obelisk, reproducing key illustrations from Fontana's book. But Lebas also added an appendix that summarized the mathematics underlying his engineering. Such calculations were far beyond the abilities of the sixteenth century and suggested just how far physics and engineering had progressed in the intervening two hundred and fifty years.[69] The brilliance of Lebas's scheme for lowering and raising the obelisk is commemorated on the monument's very base: the technical drawings reproduced in nearly all the books about the obelisk are carved into its plinth, outlined in gold.

This focus on engineering is understandable. There is real elegance in moving giant stones with only levers, ropes, capstans, and calculations. Although the French engineers had far greater command of physics than had Fontana, the technology they employed, and the materials – wood, hemp, iron – from which they made their tools, were still very much part of Fontana's technological universe. Despite the passage of time, it was possible to compare the two achievements on almost the same terms. That would soon change. By the 1870s, when the next obelisk traveled to Europe,

L'OBÉLISQUE DESCENDU DE SA BASE EN ÉGYPTE
ET EMBARQUÉ POUR LA FRANCE SUR LE NAVIRE LE LOUQSOR
CAPITAINE VERNINAC

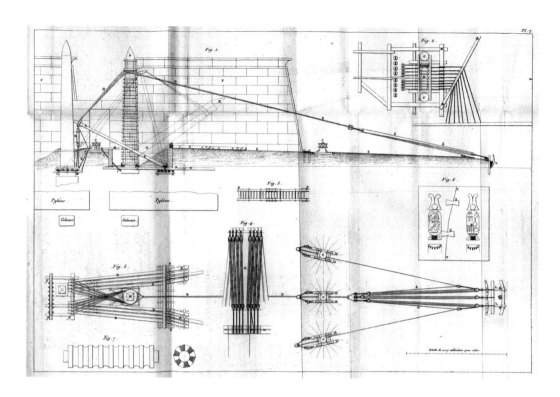

The oft-reproduced diagrams for lowering the obelisk, here in Justin-Pascal Angelin's
Expédition du Louxor, and, opposite, engraved on the plinth of the obelisk.

might one day see there an expiatory monument or a statue of Liberty."[65]
Corrupt and corpulent, Louis-Philippe was known universally as "the Pear"
(caricaturists always depicted him as a pear with legs), leading at least one
wit to claim that his aim was to commission a monument "*expia-poire*" for
the spot. Mockery aside, the king was still the king and got his wish. The
obelisk was raised in the very center of the square, becoming the focus of
a design by Jacques-Ignace Hittorff that was intended to wipe the space
clean of all previous associations. Surrounded by fountains and statues, the
obelisk was the pivot around which was arrayed a complicated, non-political
allegory about national unity and the law.[66]

The denaturing worked. A popular pamphlet from 1839 about the
square's new "embellishments" dutifully walks through a description of
the obelisk, the fountains, and includes short accounts of the cities repre-
sented by the statues. The Place's history does not rear its head.[67] Those few

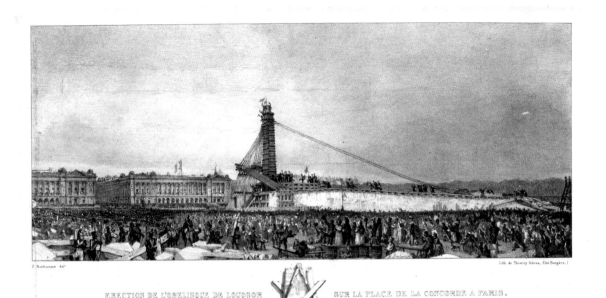

ERECTION DE L'OBELISQUE DE LOUQSOR SUR LA PLACE DE LA CONCORDE A PARIS.

25 Octobre 1836 à 3 heures.

à Paris, chez Rittner et Goupil, Boult.d Montmartre N.º 15.

The obelisk erected, by Ignace-François Bonhommé.

place was taken by the guillotine that claimed the heads of King Louis XVI and Marie Antoinette. With Napoleon's coronation, the square was slated for a triumphal column devoted to the nation. After Napoleon's fall and the restoration of the monarchy in 1816, the Place was again renamed, this time for the executed king. The spot once occupied by the statue of Louis XVI's father was held for a *monument expiatoire* – a statue of the martyred king intended to expiate the sins of the state. And so on.[63] No spot in Paris had greater ability to serve as a symbolic lightning rod.

Louis-Philippe wanted an end to the matter. His goal was a monument that had no political content, a centerpiece that symbolized, effectively, nothing.[64] The obelisk was perfect. It had no clear associations with any faction. Its presence in France was vaguely due to Napoleon, but only vaguely. It celebrated kingship, but not French kingship. As Louis-Philippe noted: "It will recall no political event . . . and is sure to remain there, whereas you

Some, such as the pamphleteer Petrus Borel, objected to the location, and even to the very idea of a Parisian obelisk. Borel dismissed it as "a stone giraffe," insisting that an obelisk "as art, as artifact, as idea, as beauty, as effect, is dead and meaningless."[55] Even if Paris did raise its obelisk, Rome would still have twenty more.[56] Why not leave each sort of monument to its own latitude? Was it not enough that the French had so eagerly destroyed their own monuments of medieval art, both during the Revolution and after: "Must it be that the devastation extend its ravages to the very banks of the Nile?"[57] Borel's polemic drew on the very same scholarship that had given the obelisk new voice. Who, in the end, was "Ramsès, or Rhamessès III, fifth king of the eighteenth dynasty" to the French? Why reuse the monuments of another place and time? Why would the French plant a monument dedicated to a long-ago and far-away king in the middle of a square that still "smoked with the blood" of a king of their own?[58]

In fact, they did so for that very reason. Borel had put his finger on the crux of the matter. He said openly what many others knew but preferred to ignore about the obelisk and its new site. Some, such as Lebas, the engineer in charge of bringing the monument to Paris, could write of it as a trophy that both represented the glory of the French military and warned of the ephemeral nature of power.[59] Others, like Jean-Pascal Angelin, could suggest that its arrival was a symbol of the greater virtue and wisdom of modern Frenchmen than modern Egyptians.[60] For some, following the lead of Champollion's older brother, Jacques-Joseph Champollion-Figéac, the obelisk was a physical manifestation of the brilliance of French philology.[61] But few were willing to state directly what putting the obelisk in the middle of the Place de la Concorde was meant to do. That was politically touchy. For Louis-Philippe's selection of the Place had less to do with France's relationship to Egypt than with France's relationship to itself.

The Place de la Concorde was highly contested symbolic ground. Always one of the city's key open spaces, it had, like Paris itself, suffered a turbulent half century. Its very name was new. Before the Revolution, the square had been the Place Louis XV and had sported an equestrian statue of its namesake – itself the subject of a gigantic celebratory book reminiscent of those that documented the moving of obelisks.[62] That statue was pulled down in 1792, replaced, in proper Revolutionary fashion, by an allegorical figure of Liberty – mounted on Louis's own plinth. During the Terror, Liberty's

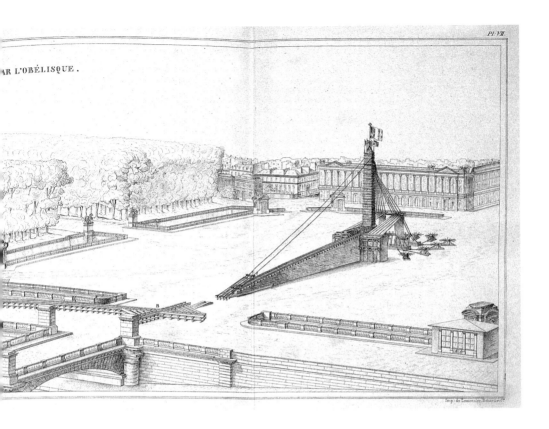

AR L'OBÉLISQUE.

Pl. VII.

artifacts.[52] Viator further proposed that the entire city be seeded with obe-
lisks, imagining whole flocks of them, some original and some newly made
of French granite, planted in the Champs de Mars, where the Eiffel Tower
would later rise.[53] Debate continued all year. At the end of 1834, François
Miel published a series of articles in *Le Constitutionnel,* making a strong
case for the Place de la Concorde, the great square just west of the old royal
palaces of the Louvre and the Tuileries.[54] There, the obelisk would mark
the beginning of the great vista whose other end was closed by the Arc de
Triomphe. Together they would make a neat symbolic package: two ancient
symbols of imperial glory framing a vista with a suitably classical name: the
Champs Elysées – the Elysian Fields – the place where heroes of battle rest
after death. In fact, the Place de la Concorde had always been the leading
candidate. The setting couldn't be better, and, more important, it was the
king's choice. In the end, it was the winner.

An overview of the new site in Jean-Baptiste Lebas's *L'Obélisque de Luxor*.

was Bonaparte who had commissioned the enormous spiral column in the Place Vendôme, modeled after the columns of Trajan and Marcus Aurelius in Rome. It was Bonaparte who began the great triumphal arch – the Arc de Triomphe – that still serves as the centerpiece of the Place de l'Étoile.[51] By the 1820s Napoleon was gone and the projects rang a little hollow, but never, even after Napoleon died in his South Atlantic exile, did work on the great projects cease. With the imminent arrival of another imperial trophy, many took up the question of where the obelisk should best be placed.

There were various proposals. An anonymous author, hiding behind the pseudonym "Viator" (or "Traveler") suggested that the obelisk be raised inside the arms of the Louvre, for reasons both of proportion and museological utility. There, it could be in a setting with "a less exaggerated (but sufficient) grandeur, that would allow the eye to see equally well the bottom and the top"; and it would be close by the museum's other Egyptian

the Republic replaced the statue of Louis XIV in the Place des Victoires. In 1801 there was a proposal to raise two obelisks to the glory of the armies of the Republic, at the center of the same square where Paris would place its real obelisk thirty-five years later.[48] And in 1809, Napoleon, having failed to get Cleopatra's Needle from Egypt, decreed that a giant obelisk-shaped monument be erected at the western point of the Île de la Cité, where the Pont Neuf briefly touches shore during its trip across the Seine.[49] For a moment at the height of Napoleon's power, Paris even managed to get hold of a genuine obelisk that had been taken from the collection of Rome's Albani family after the French conquest. Too small to make much of an impression on its own, the obelisk was incorporated into a monument to General Desaix, one of Napoleon's deputies in Egypt and possibly the man who had planted the idea of liberating the Luxor obelisk in Coutelle's mind back in 1800. The French were ordered to return the obelisk to the Albani after Napoleon's defeat and exile, but the family couldn't afford to bring the monument back to Rome, so it stayed in Paris. Eventually it found its way to Munich, where it now graces the courtyard of the prince's Residenz. Just a few meters tall, it is a fittingly small obelisk for Bavaria, which, by the early nineteenth century had become a modest-sized state with similarly modest political ambitions.[50]

France, of course, did not have modest political ambitions, but the 1820s represented the absolute nadir of French imperial power. The colonies in India were sixty years gone. The country had lost its most important American possessions by war to Britain and by sale to the United States. Haiti won its independence in 1804, leaving only bits and pieces in the western hemisphere: a few islands in the Caribbean, a corner of South America, and St. Pierre and Miquelon, two rocky, foggy islands off the south coast of Newfoundland. The Napoleonic conquests in Europe had melted away; the campaigns in Southeast Asia and Algeria had not yet begun. In the 1820s, more than at any other moment in the five hundred years of European imperialism, Paris was not the head of an empire; it was just the largest city in a large European state. Yet at that very moment the city was busy refashioning itself as an imperial capital on the grandest scale.

The rebuilding was, to a large degree, a hangover from the Napoleonic moment. It was Bonaparte who had begun work on the great church of the Madeleine, resembling a Roman temple, near the center of the city. It

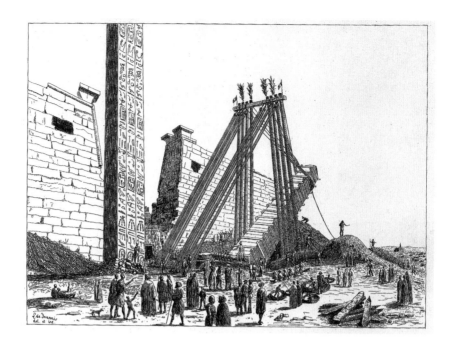

The obelisk being lowered, from Léon de Joannis's *Voyage pittoresque du Luxor*.

gift had been one to the French nation, not its endlessly changing govern-
ment, so France immediately began making plans to fetch its prize. Under
the leadership of Jean-Baptise Apollinaire Lebas, a team of engineers from
the École des Ponts et Chaussées was assembled and dispatched to Egypt.
It took three years of planning, calculation, and labor (including months
of waiting for the Nile floods to raise the river enough that a ship bearing
an obelisk could maneuver), but on December 23, 1833 one of the Luxor
obelisks finally arrived in Paris.[46]

Thus did Paris, which had won and lost Egypt, come to be the first capi-
tal since Constantinople to gain an obelisk. Its primacy was deserved, for
Paris had been preparing itself a long time. The city, or, more precisely, the
court, had erected ephemeral obelisks of wood, paper, and plaster periodi-
cally throughout the early modern period, in celebration of the immortal
glory of this or that French king. The 1660s saw a proposal from Charles
Perrault to erect a giant obelisk atop a globe.[47] Temporary obelisks rose and
fell throughout the eighteenth century, and especially in the aftermath of
the Revolution. In the mid-1790s a small, short-lived obelisk dedicated to

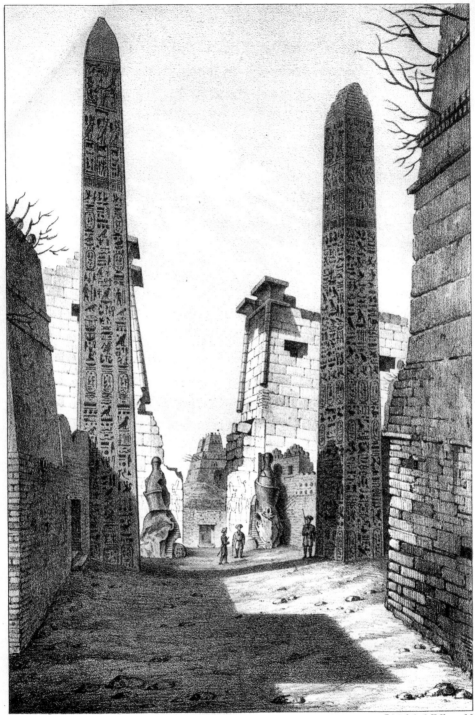

From a Drawing by I. G. Wilkinson. Printed by C. Hullmandel.

OBELISKS IN FRONT OF THE TEMPLE OF LUQSOR.

mixed emotions about the removal of the ceiling of the temple at Denderah, with its zodiacal carvings, simultaneously feeling delight that Paris had captured an artifact nearly the equal of the Rosetta stone and fear that the French might become too much like Lord Elgin in their willingness to rip apart a building to snatch a trophy.[40] But when Champollion arrived in Luxor and saw the magnificent pair of obelisks that flanked the temple's entrance, such scruples melted away.[41] By the end of the trip, he had taken to dismissing Cleopatra's Needles, the very first ancient artifacts he had seen on Egyptian soil, as poor obelisks indeed.[42] He wanted the ones from Luxor instead. Nevertheless, he retained some principles. While pondering the formidable engineering challenges involved in lowering the obelisks and shipping them to Paris, he did insist on one thing: that they be brought whole. They must not be cut into parts; that would be a "sacrilege." It was "all or nothing."[43] Champollion's word had weight in matters Egyptological. Soon after his return to Paris, he had convinced the government that if France were to get any obelisks, it should have the ones from Luxor.[44]

A comic diplomatic dance ensued. The French approached Mehmed with the suggestion that he give them the Luxor obelisks. He agreed, but this time the British were in danger of being left out. So the French suggested a compromise. Each country would retain one of the Alexandria obelisks. In addition, the French would get the two obelisks from Luxor. The British, in turn, would gain rights to the single obelisk at Karnak, the biggest and best of all. This was a trick. Isidore Taylor, who was arranging the deal for the French, knew that the Karnak obelisk could not be moved without destroying the temple complex in which it stood. The French negotiators, who knew more than their English counterparts about the situation of each monument, guessed, correctly, that the British would never go to the trouble of disassembling an entire temple to get an obelisk.[45]

In the middle of the negotiations there was a brief diplomatic scare. France suffered yet another of the political convulsions that were its fate in the nineteenth century. The revolution of 1830 brought Louis-Philippe, grandson of Louis XVI, to the throne, raising fears that a change in government might derail the agreement. Mehmed graciously pointed out that his

Luxor before the removal of the obelisk,
as recorded by the English traveler Sir Gardner Wilkinson.

and massacre in 1811, when he eliminated the remaining heads of the Mamluk clans.[35] It was perfectly clear who ran the country, and it was Mehmed Ali, not the sultan in Constantinople, whom the British approached when they began again their campaign to have an obelisk. Since taking control, Mehmed Ali had engaged in a vigorous program of modernization, building strong commercial and military ties with both France and Britain. In fact, Briggs suggested that Mehmed might want to present an obelisk as a thank-you gift for a new warship the British had recently provided.[36]

He readily agreed. It was an exchange that served both parties, for Mehmed's power had some frustrating limitations. For all practical purposes the ruler of a country, he was, by law, nothing more than the governor of an imperial province. As such, he was hamstrung by diplomatic realities. He could not, for example, dispatch ambassadors to London and Paris.[37] So he dispatched obelisks instead. No fool, Mehmed recognized that sending an obelisk to his friends and patrons in London would inflame the imperial pride of his friends and patrons in Paris. So at the same time he gave the British one of Cleopatra's Needles, he gave the other to the French. France got the one that was standing up; Britain the one that had fallen. And there matters stood. Each country held title to an obelisk, but for the rest of the decade neither did anything to pick up its assigned prize.

Since obelisks had been key to Champollion's decipherment, it is entirely appropriate that he played a pivotal role in jump-starting the migration of obelisks to Europe. In the fall of 1828 Champollion made his first, and only, trip to Egypt. Like everyone else, he began his voyage in Alexandria, paying the obligatory visit to Cleopatra's Needles.[38] Champollion, however, was no ordinary visitor. In his letters, it is possible to feel his almost giddy delight as he travels up the Nile, reading inscription after inscription with ease. From far upriver, at Wadi Halfa, near today's border with Sudan, he reported back to his colleague Dacier "that there is nothing to change in our *Letter on the Hieroglyphic Alphabet.* . . . it applies with equal success to Egyptian monuments of the time of the Romans and Lagides, and further . . . to inscriptions of all the temples, palaces, and tombs of the pharaonic epochs."[39] The decipherment was proved, over and over again.

Champollion had always harbored complicated feelings about taking artifacts, especially large ones, from Egypt. Ten years earlier he had suffered

the Alps, shipping them around Italy from Venice and up the Tiber. He then had Francesco Ungarelli, Rome's leading Egyptologist (and author of a book on the city's obelisks), work up a set of hieroglyphic inscriptions to be carved into the monuments.[31] The inscriptions are almost fully readable, evidence of how complete the decipherment was even at that early moment.[32] At the erection on June 4, 1842, P. E. Visconti read a sonnet that made a virtue of the obelisks' otherwise embarrassing newness; unlike Rome's other obelisks, he noted, the arrival of these had not been occasioned by the shedding of blood.[33] Following longstanding precedent, Torlonia celebrated the obelisks as both monuments and engineering in a special publication distributed to friends and visitors. (He must have given it out with great enthusiasm, for, though expensive, it is not particularly rare.) The prince spared no expense. The book is lavishly illustrated and was even printed on specially watermarked paper. Each page reads "Trasporto ed Innalzamento degli Obelischi Torlonia" – "Transport and Installation of the Torlonia Obelisks" – when held up to the light.

Real glory, however, lay in real obelisks. Both the French and British had cast covetous eyes at Cleopatra's Needles during their occupations of Egypt. The British, following Napoleon's example, even made plans to ship one back to England. After their victory, some British officers took up a subscription to refit a captured French frigate as an obelisk ship. They had already begun building a jetty to embark the monolith when officers higher up the chain of command cancelled the project, noting that it was "displeasing to the Turks." It seems no one had bothered to ask permission. Denied their obelisk, the British officers satisfied their desire for immortality by raising the stone just a bit and installing a marble plaque on its base. An inscription describes the Egyptian career of the British armies in some detail, discreetly avoiding any mention of the obelisk scheme, and noting that the plaque was "deposited here in the year of Christ 1802 by the British army on their evacuating this country and restoring it to the Turkish empire."[34]

The British restored Egypt to the Ottomans, but once wakened the idea of bringing home trophies like those that graced Rome would not sleep. In May of 1819, Samuel Briggs, a London merchant who had once lived in Egypt, traveled to Cairo and approached the Egyptian government about the possibility of obtaining an obelisk. Mehmed Ali had further solidified his rule in the intervening years, most famously at a combination dinner party

W HEN CHAMPOLLION COMPLAINED that he hesitated to render Kircher's translations into French for fear he could not "catch hold of Kircher's idea," it was passages like this he had in mind. Here is Kircher's reading of the hieroglyphs reproduced below, from Domitian's obelisk in the Piazza Navona. (Kircher's version of the same cartouche is reproduced on page 169.) Kircher translates the cartouche from top to bottom (or, here, left to right); the actual text reads from bottom to top (right to left, here).

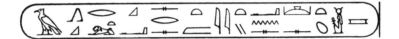

A hidden and unseen movement and a progress of the heavenly Osiris through the beneficent Mophta, distinguished by fourfold rule of the heavens, drives a flood of heavenly moisture in the lower world, and the fields made fertile by this are cultivated by the swiftness and goodness of the Divinity; and the moisture, similarly endowed with a fourfold rule and powerful over the fourfold realm of the lower World, arranges through Isis the principles of the seed powers, which ought accordingly to be celebrated and cultivated with a holy ritual.

This is the actual meaning:

Horus: "the strong bull, beloved of truth." The King of Upper and Lower Egypt, the Lord of both lands, the Lord of offerings. The Son of Re, the Lord of the Diadem: *Autokrator* Caesar Domitian, beloved of Isis.

lost their philosophical overtones, but gained even more resonance as symbols of power and commemoration. Some took advantage of this almost immediately. In the 1830s Prince Alessandro Torlonia decided to celebrate his parents by erecting two grand obelisks at the family villa in Rome. With no ancient examples available, he had new ones cut at a granite quarry in

verbose Latin readings of the hieroglyphs on the Piazza Navona obelisk, the French scholar was unstinting in his contempt for the Jesuit's "ravings": "... words so obscure that I cite them without daring to attempt a French translation, in fear of being utterly unable to catch hold of Kircher's idea."[29] The Rosetta Stone had provided the key; Champollion reconstructed the lock it fit; and, for the first time since antiquity, scholars could read what obelisks had to say.

What they said must have been disappointing, for obelisk inscriptions are actually rather dull. In 1837 François Salvolini summed up the situation with a certain resignation:

> In past times, as in our own, one dared assert that the Egyptians intended obelisks to communicate to future generations fundamental precepts of the sciences or the arts, all the secrets of the sacred philosophy revealed in the sanctuary, and, in a word, the whole philosophical system of the Egyptian sages on matters both divine and human. Nothing occurred to confirm or deny that idea, neither during the French expedition in Egypt nor in the publications that were its fruit, when the decipherment of hieroglyphics revived, all at once, general interest in the matter. Among the monuments of Egyptian architecture, obelisks have always held pride of place in the attention of modern scholars; in the same way, the inscriptions that decorate their surfaces were the first to be submitted to the new ideas about the singular writing system under which they were conceived. And immediately at the very first reading with some certain notion about the entirety of that system, it became clear that obelisks were nothing more than enormous stelae placed at the entrances of major buildings, and communicated nothing more than their dedication to and praise of the kings who raised them.[30]

In the end, then, the obelisks were just what they seemed to be: imposing pharaonic calling cards – but not much more. They recorded who set them up, and when, and why. As earlier scholars had hoped, they were and are religious objects, in the sense that anything set up by the pharaoh and dedicated to the gods embodied the king's divine nature, but the texts carved into them are singularly devoid of mystical insight.

Deflating though it was, the new knowledge had its benefits. Obelisks

the name Ptolemy.[24] He, too, then reached a roadblock. Identifying Ptolemy was all well and good, but to move forward he needed comparative material, preferably other identifiable names. The answer came from England. In 1819 Sir William Bankes brought back from Philae a small obelisk whose base was carved, in Greek, with the names Ptolemy and Cleopatra. The obelisk itself bore hieroglyphs, including two cartouches. One matched the "Ptolemy" cartouche from the Rosetta Stone; Champollion presumed that the other represented Cleopatra. The cartouches shared several signs, including three that Champollion thought represented the sounds "p," "o," and "l."[25] Those characters fit just the right spots in the "Cleopatra" cartouche. That cartouche, in turn, provided yet more signs. Champollion had his solution.

As Champollion presented it, the process of decipherment then unfolded with an almost unstoppable logical force. Having shown that hieroglyphs, at least in the case of royal names of the late period, functioned as an ordinary writing system, he turned to other inscriptions. Zoega had argued that some obelisks, such as that in the Piazza Navona, were late creations; Champollion confirmed that by finding, in one of the obelisk's cartouches, a phonetic rendering of the name of the first-century-CE Roman Emperor Domitian.[26] He did the same over and over again, matching the sounds spelled out by the pictures to names he knew from Latin, Greek, and Coptic. Then Champollion turned to earlier inscriptions. If hieroglyphs of the late period could represent sounds, what of those from before the Greeks had conquered Egypt? Again, obelisks played a key role. There was general agreement about the early date of some obelisks, such as those at Heliopolis and Luxor, as well as a few that had been transported to Rome. Champollion showed that their cartouches worked in the same way as those on later obelisks.[27] Names like Ramesses, familiar from non-Egyptian ancient sources, revealed themselves in their original Egyptian forms. Having demonstrated the phonetic nature of all hieroglyphic names – both early and late – Champollion then picked apart the rest of the system.[28]

At the end of his *Précis du système hiéroglyphique,* the book in which he laid out the whole sweep of his accomplishment, Champollion included a preliminary grammar and explanation of ancient Egyptian. By the time he wrote the book, in the mid-1820s, Champollion had so completely demolished all previous arguments that, when quoting one of Kircher's typically

using it, in effect, as a giant printing plate to make multiple, accurate copies of the hieroglyphs. The French also made a plaster cast of the stone.[20] In the disposition of spoils at the end of the expedition, the British took the original; the cast went to Paris. Britain had thwarted France's imperial ambitions in Egypt, but with copies of the inscriptions circulating in both countries, the study of hieroglyphs quickly became the subject of a quiet imperial struggle of its own. Or, as Jean-François Champollion commented, one in which some of the disputes "had their source in an always respectable sentiment: national spirit."[21]

The first important steps were taken in Britain. Thomas Young began to study the hieroglyphs enclosed in ovals – or cartouches – testing a several-decades-old idea that the cartouches indicated the names of kings. Using the Rosetta cartouches as a starting point and then comparing outward to other texts (some published in the *Description*), Young made a plausible argument that the signs in one of the cartouches spelled out "Ptolemy," a name that also appeared in the Greek inscription. In other words, the pictures seemed to represent sounds, not ideas. So in this particular instance, hieroglyphs appeared to function as a writing system, not a set of philosophical symbols. Having reached that key insight, Young ran out of steam.[22] For Young, hieroglyphs were but one object of research among many, and though he maintained an interest in Egypt, he soon turned back to his work in optics, chemistry, and medicine. In France, Champollion was also working on the hieroglyphs. Unlike Young, Champollion was utterly consumed by the problem of Egyptian writing. In the end, it was he who carried off the palm.

Early on Champollion realized that he had to begin at the beginning: "The science of archaeology has gathered no fruit from the immense works of Kircher on hieroglyphs – which were greeted at first with a blind confidence – because Egyptian studies began with difficulty, as their true sources, the monuments, were enormously rare. . . ."[23] Champollion did use the works of older writers – particularly Zoega's gigantic *De origine et usu obeliscorum,* with its careful illustrations – but he never built his arguments on earlier work. Like Young, he started with the Rosetta Stone, exploiting his knowledge of Greek and Coptic to investigate the hieroglyphs in the cartouches. Following the same train of reasoning as Young, Champollion showed that the hieroglyphs in the Rosetta cartouches probably contained

study, but they still floated largely unanchored, without much to give scholars a sense of how they related to each other or in what order to put them. Napoleon's expedition provided some of that context. The vast amounts of information gathered by the scientists – about ethnography, natural history, archaeology – eventually found a place in a twenty-nine-volume *Description de l'Égypte,* the foundation of all later studies of the country as both a modern place and an ancient one. Sponsored by the French government, the *Description* provided the same sort of framework for the study of ancient Egypt that antiquarian scholars of the fifteenth, sixteenth, and seventeenth centuries had created for the physical leavings of ancient Rome. It gave scholars a large body of organized information against which to measure what they knew, or thought they knew. The sections on Egypt's antiquities were of particular value, because they provided an entirely new set of artifacts and inscriptions to study. The scholars recorded large monuments throughout the Nile valley and brought many smaller artifacts back to Cairo for study and, presumably, transport to France. But when the French army lost to the English, Paris lost its collection of Egyptian treasures to London – and, in particular, one key piece.

Among the antiquities that found themselves in England was a thumb-shaped fragment of a stele – a standing stone – that had been set up at the town of el-Rashid, or Rosetta, in the Nile Delta, early in the second century BCE. The Rosetta Stone, now housed in the British Museum, is carved with three long inscriptions, or, more precisely, the same inscription three times: once in formal Egyptian hieroglyphs, once in "demotic script" (a sort of cursive hieroglyphs), and once in Greek. The stele celebrated Pharaoh Ptolemy V, one of the descendants of the Greek army that had conquered Egypt nearly two hundred years earlier. Since the Greek conquest, Egypt had become, at least at the elite level, a bilingual culture. The Greek conquerors had adopted Egyptian titles, roles, and religion, and Egyptian scribes had learned Greek. The Rosetta Stone's inscription provided both language groups with access to the same text, an otherwise ordinary dedicatory inscription. Here was a find of incredible value, for if hieroglyphs were a mystery to linguists, Greek was not.

Scholars recognized the stone's importance at once. Even while it was still in Egypt, Jean-Joseph Marcel, who was in charge of the expedition's presses, worked out a method of filling the stone's carvings with ink and

Coutelle presented his paper in a spirit of irony or one of pure delusion, it should have been quite clear that no obelisks would accompany the French back to Paris. By 1800 it was simply a matter of when and under what conditions the French would leave Egypt, not whether they could possibly hold the country. The Ottomans had sent a force, commanded by a young Albanian named Mehmed Ali, to help retake the country, and the British, in addition to the blockade, had an expeditionary force in northern Egypt that was causing the French endless trouble. Napoleon was long gone, having left the army under the command of Jean-Baptiste Kléber. (Napoleon had not even told Kléber he was leaving.) Kléber tried to give up in late 1799, but the British refused to accept his terms. So he fought on. His victories, though real, were ephemeral, and he was assassinated in 1800. Alexandria and Cairo fell, and the French sued for peace without terms. The army finally scuttled back to France in British ships in August 1801.[19]

Napoleon's expedition had two revolutionary effects. The first was on politics. Though both European armies, French and English, had left Egypt by 1803, the expedition had disrupted traditional patterns of Egyptian politics. Egypt had been a province of the Ottoman Empire since the fifteenth century, and had long been ruled by a clan of central Asian warriors called the Mamluks. The three years of occupation had shattered traditional political and military structures beyond repair. The Mamluk hold on Egypt was broken for good. With no local government to take control, Egypt fell into a brief civil war, and in 1805 the Ottoman sultan appointed Mehmed Ali governor. Mehmed had already built an alliance with England during the occupation, and with his rule Egypt entered into a new period of closer ties with Europe. Those ties would, by the end of the century, result in Egypt's becoming a "protectorate" of the British Empire and three obelisks leaving Egypt for Europe and the United States. Those three now grace Paris, London, and New York.

The second, and in some ways equally significant, legacy of the expedition was for scholarship. Despite the great interest of the previous few centuries, Egypt was still largely a closed book to Europeans before 1800. Its history and culture were known through the filter of ancient Roman and Greek reports, travelers' tales, and the scattering of artifacts, including obelisks, that had found their way to Europe over the millennia. Those bits and pieces of data – texts and objects both – had been the object of intense

tut National: the Institut National d'Égypte. It held its first sessions on August 28.[16] While the armies fought, the members of the Institut went about their business, holding sessions, conducting experiments, and organizing teams that were sent up the Nile to, in the most literal sense, take the full measure of the country. The exploring teams covered immense distances, making it nearly to modern-day Sudan, and visited many of the important ancient sites along the way, among them the great temple complexes at Karnak and Luxor.

Upon their return to Cairo, the teams provided much fodder for the Institut's meetings. On October 8, 1800, one of the young engineers, Jean-Marie-Joseph Coutelle, presented a paper about his dream of the previous night. He had been charged with determining how to collect and transport some large sculptures the French had left behind upriver. He soon worked through that problem and began looking for other challenges. If one were figuring out how to move big antiquities, why not take on the problem of the largest and greatest of all: the obelisks at Luxor – "or at least one of them." Coutelle stayed up late, chewing on the problem. Eventually the calculations put him to sleep, but a "most agitated" one. All night he dreamed of obelisks. Because "such things go quickly and easily in a dream," he soon worked out the solution.[17] In recounting his method to the Institut, he left out most of the mathematical detail, for fear, he told the audience, "of putting you to sleep" in turn. Coutelle described a scheme that relied heavily on his advanced training in statics and dynamics to allow a very few men, armed with ropes and capstans, to lower the obelisk safely. Getting it to the riverbank was still a matter of brute force, but once the obelisk was down and safely on board ship, Coutelle had no doubts that, technically at least, getting it to France would be very simple.

Technical matters, however, were not the problem. The problem lay in getting the obelisk out of Egypt. More than two years after the destruction of the fleet, no French reinforcements had arrived. The expedition was still bottled up on the river. To get any obelisk out (or any troops in), one first had to find a way past the British blockade. As Coutelle noted, things go easily in a dream; in his, the obelisk itself gave the British pause. Wrapped inside a giant tube, it so impressed them that they avoided firing on it, for fear it was a giant gun.[18]

The Egypt expedition had been an unqualified disaster. Whether

the new Revolutionary calendar – Napoleon reported back to the Directory of his string of easy victories across the Middle East, and of the booty he had directed back to France:

> Cleopatra's celebrated obelisk has been shipped on board the Admiral's ship *L'Orient,* . . . : another man of war has been freighted with the Sphinx, which our engineers removed from the Grand Cairo, and which, I trust, will be thought a proper ornament for the Hall of audience of the Directory. . . . A broken column will be sent from *Carthage.* It records the downfall of that commercial city; and is sufficiently large for an inscription (if the Directory should think proper to place it on the banks of the *Thames*) to inform posterity that it marks the spot where *London once stood.*
>
> <div align="right">Health and respect,</div>
>
> <div align="right">Bonaparte[14]</div>

With France on the ascendant, Napoleon knew exactly the sorts of impractical but symbolically charged things a conqueror was supposed to bring home. Roman emperors had taken dozens of obelisks from Egypt; France, the newest inheritor of the imperial mantle, should have at least one.

The letter was a fake. As well schooled as Napoleon in the language of ancient imperial triumph, a forger (probably an Englishman or American) imagined the French conqueror doing just what his predecessors had done – and with remarkable accuracy, at least in terms of Napoleon's dreams. But reality had intervened. On 18 Prairal – June, by the non-Revolutionary calendar – Napoleon was in Egypt, not Athens, and no obelisk was on its way to Paris. For, less than a month after the French landed, and just days after the army had taken Cairo, a British squadron commanded by Lord Horatio Nelson had appeared off the coast and destroyed the French fleet.[15] The French did control Egypt, but they were trapped there. As it happened, Napoleon was arranging to slip out of the country almost exactly on the date of the fake letter. He alone was able to make an escape; the army remained behind, as did the scientists.

They made the best of a bad situation. Just weeks after the army secured Cairo, the scientists had set up an academy modeled after the French Insti-

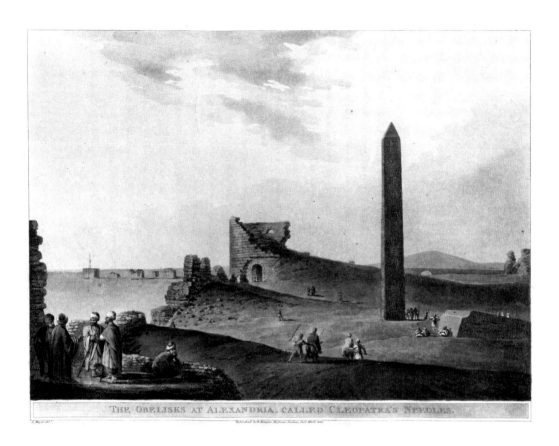

THE OBELISKS AT ALEXANDRIA, CALLED CLEOPATRA'S NEEDLES.

Cleopatra's Needles on the seafront in Alexandria,
shown by Luigi Mayer at the turn of the nineteenth century.

Egypt – and conquering it so quickly – Napoleon joined an elite company.
And in antiquity, at least, Egypt had repaid its conquerors handsomely:
with immense power, unimaginable riches, and trophies worthy of their
greatness – obelisks.

Napoleon ran true to type. He ordered his troops to gather artifacts to
ship back to France, just as he had done during earlier conquests in Italy.[12]
All were destined for a grand museum that would occupy the former royal
palace in the Louvre. Within months of landing, engineers had cleared
the sand from the fallen obelisk at Alexandria. One of them later recalled
Napoleon announcing that he would take the obelisks home to demonstrate
to Europe that he "had been there, where Alexander and Caesar had con-
quered."[13] Writing from Athens nearly a year later – on 18 Prairal 1799 by

wrote his father on the eve of the adventure. He had enlisted, though he knew "only the smallest part" about where he was going and what he would be doing: "It's a matter of a great expedition – scientific, political, and military. Some are convinced it's destined for the isles in the Archipelago recently acquired by the Republic [the Ionian Isles], others Constantinople, still others Italy. Always, though, it is a constant that it will take a large number of scholars, the most distinguished in all the branches of philosophy: mathematicians, mineralogists, chemists, naturalists, astronomers, geographers, civil and mining engineers, military engineers, etc, etc."[6] Napoleon's army, wherever it might be going, would sail under the proud banner of the Enlightenment, bringing the blessings of scholarship and science along with conquest.[7]

The fleet landed at Alexandria on the first of July and met with little resistance. Within a matter of days the French had taken the city. Almost immediately, Jollois and his companions went along to the old port to have a look at the obelisk there, "known in the vernacular as Cleopatra's Needle."[8] Perhaps because they were among the few ancient objects to be seen in Alexandria, the two Needles – one fallen, one still standing – became something of a required stop for the French. Joseph-Marie Moiret sat on the fallen obelisk, and then walked its whole length: "I resembled nothing so much as a dwarf who, having felled a giant, took pleasure in trampling him underfoot. An expressive symbol of the fall of human grandeur!"[9] The more earthbound Vivant Denon noted how easy it would be to take the obelisk home.[10] But Denon had such things on his mind. He assembled a major collection of Egyptian artifacts and also commented that, if one were bent on removing an Egyptian temple to Europe, the one at Philae would be the best candidate, for its combination of relatively small size, diversity of architectural style, and general picturesqueness.[11]

Even as Moiret and Jollois and Denon made their pilgrimages, the army continued its advance. Within a month it had taken Cairo, and Egypt belonged to France. Napoleon, drunk on the idea of imperial grandeur – he would have himself crowned emperor in 1804 – was deeply aware of the precedents for what he had done. Already ancient in antiquity, Egypt, with its aura of age-old power and its rich agricultural lands, had always represented the ultimate imperial prize. Alexander the Great had conquered Egypt. Julius Caesar and Augustus had conquered Egypt. By conquering

equally eager to get the energetic and dangerously popular young general far away from Paris, settled on Egypt instead.

Sudden though it was, the decision to invade Egypt was not entirely arbitrary. France and Egypt had become locked in an ever-tighter embrace over the previous few decades. The relationship was based not on power or alliances, but on cloth. In the eighteenth century India and Egypt were the only significant producers of cotton. The British had driven the French out of their Indian colonies in the 1760s, leaving France almost completely dependent on Egypt for cotton. By the time of the Revolution, Egypt had become France's largest trading partner. Even as early as the 1770s, French politicians had considered the possibility of a "closer" relationship between the two countries.[3] Conquering Egypt also made geopolitical sense, for it would allow French occupation of the Suez, giving the country control over at least one trade route to the Indian Ocean. And there was the symbolism. In less than a decade, republican France had surpassed even the triumphs of Louis XIV, the greatest king of France's self-described *grand siècle*. The new government proved no less susceptible to imperial ambition than the monarchy. In arguing for the expedition, Charles-Maurice de Talleyrand-Périgord, the aristocrat who had served as a bishop under the monarchy, had become an enthusiastic republican during the Revolution, and was now foreign minister (a position he would continue to hold under the Empire) gave a sense of the level of confidence: "Egypt was a province of the Roman Empire; she must become a province of the French Republic. Roman rule saw the decadence of this beautiful country; French rule will bring it prosperity. The Romans wrested Egypt from kings distinguished in arts and science; the French will lift it from the hands of the most appalling tyrants who have ever existed."[4]

The Directory gave its approval in early March 1798; the expedition set sail in the middle of May. By the time it reached Alexandria at the end of June, the fleet included about four hundred ships carrying nearly 36,000 men.[5] Since France had spent the decade in perpetual war, assembling the army, though a logistical triumph, was in some ways less impressive than the quick creation of a three-hundred-man team of scientists, engineers, and artists to accompany the expedition. The team was recruited in total secrecy. One of the young men who went along, Prosper Jollois, a student at the École Polytechnique (essentially the CalTech or MIT of the 1790s),

plate getting new ones from the source. Yet even had Carolingian emperors or Spanish kings commanded the technical skills to pack up an obelisk, take it home, and set it up again, they would never have been given the chance. For nearly the whole fifteen hundred years between the fall of Rome and the beginning of the nineteenth century, Egypt was ruled by a series of Islamic states far more powerful than any Europe had on offer. At different times the various rulers of Egypt – Fatimids and Ayyubids; Mamluks and Ottomans – were all willing to have European merchants visit and trade, but those visitors were kept on a short leash. None was offered an obelisk. Only in the eighteenth century, as the Ottoman Empire settled into a long and painful military decline, did the balance of power begin to shift. The key moment came with the French attempt to conquer Egypt in 1798.

The Egypt expedition was launched almost on a whim, but its roots lay ten years earlier, in the French Revolution. The Revolution of 1789 completely disrupted European politics, as the continent's remaining monarchies, wary of precedent, put aside longstanding differences and set out quickly to isolate, neuter, and, hopefully, destroy the new Republic. They failed. The French fought back, went on the offensive, and for much of the next decade French armies, many under the command of a young Corsican general named Napoleon Bonaparte, marched across Europe overthrowing dynasty after dynasty. Napoleon spent 1797 on campaign in Italy and Austria, putting an end to the obelisk-spiced imperial dreams of Pope Pius VI and further diluting the genuine, if increasingly meaningless, imperial prestige of the Holy Roman Emperor.[2] At year's end he returned to Paris in triumph. Only Britain now posed any real challenge to complete French domination of Europe.

The next obvious goal was London. In winter the Directory (the council that oversaw the Republic) began planning an invasion of England. But while other European countries had been notably weak in the 1790s, Britain was not. The loss of some of their North American colonies notwithstanding, the British were still the world's dominant naval power. The combined challenges of overmastering that navy and sustaining an invading army across Britain's natural moat rendered invading England a far more daunting task than picking off half-a-dozen Rhineland principalities or a weak and tired Papal State. Very quickly it became clear that Britain would have to wait. Napoleon, eager to continue his conquests, and the government,

CHAPTER TEN

Napoleon, Champollion, and Egypt

Among the monuments of Egyptian architecture, obelisks have always held pride of place in the attention of modern scholars; in the same way, the inscriptions that decorate their surfaces were the first to be submitted to the new ideas about the singular writing system under which they were conceived.

<div align="center">

FRANÇOIS SALVOLINI, ON THE ROLE OF OBELISKS

IN THE DECIPHERMENT OF HIEROGLYPHS[1]

</div>

A FTER THE COLLAPSE of the Roman Empire no obelisks left Egypt for more than a thousand years. There were any number of reasons for this, but simple lack of ability was high on the list. The Romans moved obelisks precisely because they were difficult to move. Uprooting one and planting it somewhere else was a demonstration of power and skill, as vivid a sign of imperial mastery as parading enemy captives through the streets – and longer lasting. But as the Empire withered, so too did the engineering prowess that had been one of the Romans' calling cards. It would be many centuries before Europeans were able to move any of the obelisks they already had (unless the act of tipping them over counts), let alone contem-

Diagrams for lowering the obelisk, in Justin-Pascal Angelin's *Expédition du Louxor* (detail).

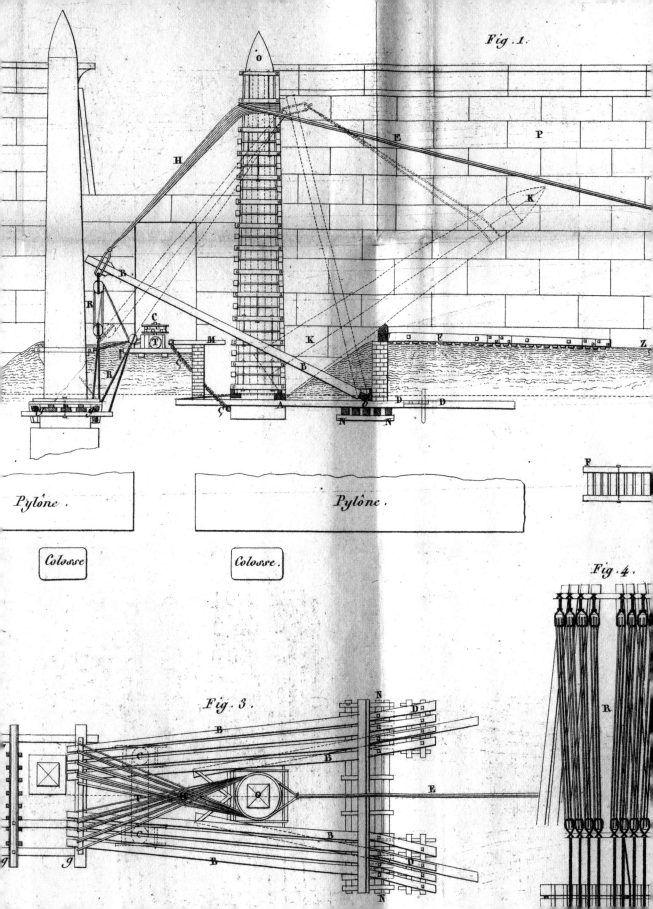

Fig. 1.

O

E

P

H

K

K

B

R

R

C

T

M

K

B

A

N N

D D

Z

F

Pylône.

Pylône.

Colosse.

Colosse.

Fig. 3.

Fig. 4.

B

N

D

C

B

T O

E

E

R

C

B

9 9

B

D

N

stone Egyptian sarcophagus lids in Denmark in 1782, he noted at once that although both were old and genuine, one was "of the finest workmanship" while the other was not only in fragments but "in a worse style."[62] Zoega's sense that the Egyptians had been artists too, and that their art had a history all its own, sharply distinguished his approach from that of Winckelmann, the other great northern connoisseur in Rome.[63]

Zoega, like Piranesi, was convinced that he could detect fine features in Egyptian as in Greek art – features directly related to the larger Egyptian world in which the obelisks were fabricated and carved. Looking at the human figures on the obelisks at the Lateran, in the Piazza del Popolo, and in the Piazza di Montecitorio, he noted that "though they lack the grace that we admire in the works of the Greeks, nonetheless they have a certain beauty that fits the genius of the Egyptians, and that Europeans find not unpleasant."[64] The relatively strict and austere style of these obelisks represented Egyptian art "at the time when their affairs were at their height."[65] Later obelisks, like the one in the Piazza Navona or in the Barberini gardens, revealed on inspection "variety and luxury," "softer and less precise outlines," as well as evidence of the application of new and sophisticated tools.[66] Egyptian art, as exemplified in its highest form by the obelisks, was not stagnant at all. Like any other product of an advanced society, it changed in response to the changing mores and values of its patrons and its makers. This fact, Zoega insisted, "leaps to the eyes" of anyone who consulted the original stones.[67]

The final sections of Zoega's treatise dealt not with what the Egyptians intended obelisks to be and do, but with their modern users – above all the two heroic figures of Sixtus V and Pius VI. Here he was back in the realm of tradition, as his patron had no doubt intended. Just as Zoega never objected to the Roman and Christian appropriations of these splendid objects, so he never set the obelisks and the art they bore on an aesthetic level with the highest productions of the Greeks. But his independence of mind and spirit command respect. Zoega genuinely managed to write new verses – or at least to formulate new theses – about the ancient stones that had been seen for so long through a veil woven of Neoplatonic symbolism, Hermetic mysteries, and Roman misprisions of Egyptian luxury and lore. He could not know it, but he would soon be proven even more correct than he could have imagined.

themselves."[57] Accordingly, he insisted on studying the obelisks patiently, slowly, and in the round. He assembled enormous masses of information: a collection of all the passages from ancient writers that dealt with obelisks, even indirectly, for example, and a catalogue of all the obelisks in Rome and in other European cities, those represented in ancient works of art and those observed by modern travelers in Egypt and elsewhere, all the way to Aksum, in Ethiopia. Indeed, he started his great book with these two massive, stonily dry data dumps – clear signs that those in search of allegories should look elsewhere.[58]

By insisting on the evidence before him, Zoega effectively refuted many ideas widely accepted in the best of the earlier literature. Kircher and others had believed that the shapes and proportions of obelisks had a profound symbolic import: "When you hear the modern interpreters," Zoega wrote, "there is no projection on an obelisk, however tiny, that is not swollen with arcane wisdom."[59] But precise measurement and comparison, he argued, showed that no such system had been in operation. The Egyptians had simply chosen a shape, as they had chosen a raw material, *granito rosso,* because it would be beautiful and durable.[60] Equally deft applications of his historical Occam's razor slashed other theories into ribbons – for example, the notion, still cherished by the great James Stuart, one of Bandini's collaborators, that the obelisks had been instruments for astronomical observation. In fact, Zoega argued, obelisks were simply memorial stones, stelae of a particular kind. They came to be set up in temples and, over time, grew larger and grander, but had no cosmological significance – a sober but reductionist view, and one that flew in the face of mystical views that still inspired so many contemporary writers, artists, and philosophers.[61] In the end, he argued, only his sort of systematic collection and collation of the evidence would ever make it possible to know what obelisks were for – or to crack the hieroglyphic inscriptions that so many of them bore. To that extent, Zoega served as a sort of scholarly John the Baptist to Jean-François Champollion, making straight the way that would in the end lead to decipherment.

Yet Zoega, for all his commitment to the clear-eyed ideals of the Enlightenment, was no dry connoisseur, like the much-caricatured Baron Stosch. From early in life he cherished not only a passion for antiquities, but also a keen sense of the artistry that had gone into fashioning them. Shown two

of splendid modern churches and ruins of what seemed to have been even more splendid temples. Early in the 1780s he was already formulating new thoughts about ancient statues and works of art and forwarding them to Heyne for comment. In 1783 he returned for good to Rome, where he would convert to Catholicism, marry an Italian, and make a scholarly career, like Winckelmann, as a foreign expert on antiquities.

In Rome, Zoega catalogued the Egyptian coins of Cardinal Borgia and studied the ancient bas reliefs in the Villa Albani and elsewhere. He never lost his northerner's passionate love for the city's haunted, broken antiquities; his favorite apartment, across from the Pantheon, enabled him to savor the beauty of the scene that took shape "when the moon rises about its broad dome and its dim interior flickers in the light of the torches in the piazza."[52] But Zoega's cultivated sensibility did not hinder him from applying Heyne's strictly historical method to everything he studied – Egyptian obelisks included – and developing it in strikingly new ways.

Though bent on reconsidering the obelisks systematically, Zoega accepted and passed on some of his predecessors' beliefs. Like Kircher, he thought that the Egyptians must have developed sophisticated machines in order to fashion, move, and erect the obelisks. This one element of the *prisca philosophia,* he argued, must genuinely have existed.[53] Like Kircher and Mercati, too, he could rarely resist the temptation to hare off down one of the many side alleys that any investigation of Egyptian obelisks offered. In Zoega's case, the mention of mummies lured him to undertake a massive survey of burial customs and beliefs about death, not just in Egypt but in modern Tahiti, the New World, and the Mediterranean.[54] In fairness, though, Zoega was not the only eighteenth-century figure to make odd connections outside the Western tradition. When he came to Rome in the 1760s, the American painter Benjamin West, transfixed by the obelisks and their hieroglyphs, convinced himself that the American Indians might hold the key to reading them, since the symbols seemed to him so similar to those on the wampum belts of Eastern Woodlands tribes.[55]

On the whole, however, Zoega attacked the obelisks in a new spirit. Like a good representative of the German Enlightenment, he found "partial, approximate ideas" repulsive – as he noted on one of his early visits to Rome.[56] When the texts offered puzzling and apparently contradictory information, moreover, he knew exactly what to do: "consult the stones

of the larger world in which it took shape: "The central principle of all interpretation," Heyne wrote, "is that when you hear someone else's words, you feel the same thing that the one who pronounced them felt. Accordingly, we do not interpret any ancient writer correctly if we fail to put aside from our mind all our normal ideas, so that we feel and think the same things that our author could and should have felt when he expressed something in words."[50] Heyne admitted that applying this approach to the earliest periods of history posed serious problems, but he insisted that the true scholar must at least attempt to think his way into the alien life-worlds of the distant past. Moreover, though he himself sometimes tended to read ancient myths as physical allegories, he also instructed his students and readers that myths reflected the ways of thinking and speaking of a different, earlier age – a principle that cut the ground from under Kircher's allegories or even Mercati's more sober search for ancient natural philosophy.[51]

Heyne, moreover, devised a uniquely vivid, three-dimensional pedagogy. His lecture courses treated not only Greek and Latin texts, but also Greek and Roman "antiquities" – the customs, institutions, and rituals of ancient society. He urged his students to study coins, inscriptions, and other material forms of evidence. Like Winckelmann, whom Heyne had known as a poor young man in Dresden, he appreciated the central role of art in ancient civilization. Alone among the Göttingen professors, accordingly, he made the fine arts a central object of instruction, giving lectures illustrated by engravings and plaster casts of ancient statues.

Though lonely in Göttingen and put off by some professors' vanity and gruffness, Zoega learned to like and admire Heyne, whose courses he attended semester after semester. Gradually, he abandoned his original plan to become a polymathic philosopher and dedicated himself to the study of the ancients. Back in Denmark, as he set out to become an antiquary, he corresponded regularly with his teacher, keeping him up-to-date on his efforts to master the literature and materials of numismatics and asking his advice on a projected grand tour. The tireless Heyne, who not only gave innovative lecture courses and ran the seminar where young philologists learned to do their own research, but also directed the library and reviewed in print some eight thousand of its new acquisitions, encouraged his young friend to stick to antiquarian scholarship. In 1777, when Zoega first visited Rome, he was captivated at once by its strange, alluring alternation

familiar to readers of previous eras. For, like his predecessors Kircher and, even earlier, Michele Mercati, the Dane Georg Zoega dedicated his massive treatise *On the Origins and Use of Obelisks* to a papal patron whose interest in obelisks lay chiefly in their role as adornments to his city. This was, of course, Pius VI, whom Zoega thanked for rescuing "those noblest remaining works of Egyptian antiquity," the Quirinal, Sallustian and Montecitorio obelisks, from their broken and desolate condition.[48] In the spirit of his predecessors, Zoega couched his thanks to Pius in a set-piece inscription, printed in capitals – a kind of epigraphic poem, appropriate to a master of urban projects on Pius's scale. And like his predecessors, especially Kircher, Zoega framed his text as something richer and more complex than a single, straightforward argument. By quoting earlier scholars – even those with whom he often disagreed, like Kircher – at Baroque length, Zoega offered readers not only his own views, but an anthology of the best that previous obeliscomanes had thought and said.[49]

Yet Zoega came to Rome's obelisks with a new brand of scholarly training and set of concerns. Born in Schleswig, he had studied at the University of Göttingen, an innovative institution. Founded as recently as 1734 and designed to form a modern administrative and juridical elite for the north German states, the university specialized in new kinds of science and historical scholarship. Both the Historical Institute founded by Johann Christoph Gatterer and the Philological Seminar run by Christian Gottlob Heyne offered students something more than formal lectures on set texts. Encouraged to work independently, Göttingen students learned to master the primary sources for any given question, most of them readily available in the university's matchless library. More important still, they learned to analyze any given text or document or work of art by setting it back into its original context, which in turn had to be reconstructed in a rigorous, systematic way.

Göttingen professors disagreed on many issues, from the equality of the races to the best form of government. But all agreed that any given society had a particular character, one that stamped itself as sharply on forms of literature and art as on laws and institutions, and that changed over time. And all insisted that a truly learned man must master not only the traditional crafts of Latin and Greek grammar, rhetoric and poetics, but also the new art of hermeneutics. The informed reader must read any given text in the light

PIO VI. P. M.

QVI VT OMNIA AD VETEREM GLORIAM SPLENDOREMQUE REVO-
CARET ET AD PVBLICAM VTILITATEM REFERRET VRBEM AETER-
NAM AEDIFICIIS INGENTIBVS VATICANVM LIBRIS TABVLIS BENE
PICTIS NVMIS OMNIS GENERIS STVDIOSE COMPARATIS AMPLIFICA-
VIT LOCVPLETAVIT ORNAVIT . MARMOREA AEGYPTIORVM GRAE-
CORVM ETRVSCORVM ROMANORVMQVE MONVMENTA VEL E
TERRAE VISCERIBVS VEL EX ABDITIS LOCIS IN APRICVM PRO-
LATA IN MVSEVM PVBLICVM COMPORTAVIT.
AEGYPTIAE IMPRIMIS ANTIQVITATIS QVAE RELIQVA SVNT NOBI-
LISSIMA OPERA OBELISCOS IN PARTES HINC INDE PER VRBEM
DISIECTOS COENOQVE ET SQVALORE OBSITOS ATTOLLENDOS
INSTAVRANDOS ET IN AREIS MAXIMA VVLGI FREQVENTIA CE-
LEBRATIS STATVENDOS CVRAVIT .

* ς

An inscription in print; Zoega's dedication to Pius VI.

research without threatening their sacred nature in a Christian context, or
being threatened by their pagan past.

All of these eighteenth-century threads, artistic and scholarly, came
together in 1797, in one last, immense Latin folio whose appearance marked
the end of traditional approaches to Egyptian history and art, especially as
they applied to obelisks. In formal terms the book would have appeared very

erudition," noticed, perhaps for the first time, that the building's fabric was filled with reused ancient marble: tomb slabs, inscriptions, cinerary urns, and sarcophagi – pagan objects all, spolia from the giant quarry that was the city of Rome during the Middle Ages. The cleric was horrified and, "in the presence of many people made a strong exclamation, saying that this was a profanation of the Church, and the Sanctuary, a violation of the sacred precincts, that this was an intolerable abuse."[45] Marangoni knew that Rome's churches were filled with just such bits and pieces and decided to set the cleric straight, producing over the next two years an enormous treatise on the reuse of pagan objects in Christian contexts, *Delle cose gentilesche: trasportate ad uso, e adornamento delle chiese* (*Concerning pagan things, moved for the use and ornamentation of churches*). The book has an introductory section devoted to the background to the problem, in which Marangoni describes the various ways early Jews and Christians dealt with idols and other pagan objects, as well as the philosophical and theological arguments they developed to counter pagan beliefs. He explicates the nature of sacredness, the methods used in exorcism, and the other ways that the spirits inherent in sacred things could be altered or removed.[46] The rest of the enormous book is a catalogue of pagan objects that had been reclaimed for Christian use (he includes the Pantheon in its entirety), including a section on the obelisks.[47] Marangoni's take on the obelisks is not especially novel; he lists them and describes their history, both ancient and modern, in a brief chapter placed between his discussions of columns and statues of lions.

Delle cose gentilesche contains little pathbreaking research. Marangoni could never have assembled it so quickly had not many others, also concerned with the early history of the church and its physical remains, investigated these objects before him. Instead, the book's most striking aspect is its very matter-of-factness. These objects – cinerary urns, inscriptions, obelisks – were made in a pagan context and made sacred in pagan rites; now they were Christian, having been exorcised like the obelisks or rendered harmless simply by the passage of time. The philosophical discussion at the beginning allows Marangoni to spend remarkably little time worrying about the religious discordance represented by taking objects sacred in one context and inserting them in a second. It also provides theological cover for them to be placed in historical context and seen as objects of historical

and the answer Muratori had originally suspected.[42] Bandini reported the result near the end of the book, where he also provided a brief history of the debate, starting with Ziegler.[43] More important, he also reprinted a selection of the letters in an appendix nearly as long as the book's main text. They represent a *Who's Who* of mid-eighteenth-century learned culture: the great mathematicians Rudjer Bošković, Leonhard Euler, and Giovanni Poleni; the astronomer Johann Friedrich Weidler, who also wrote an important history of astronomy; the philosopher and philologist Christian, Freiherr van Wolff, or Wolfius; the antiquarian and editor Scipione Maffei, and Muratori himself. Bandini also reprinted a dissertation on the same question by Christopher Müller, presented in 1706 under the direction of Johann Wilhem Bayer, probably at the University of Jena, in Germany.[44] Such dissertations, usually only eight to ten pages long, were published in tiny editions and had only the most local of distribution, so the text was almost certainly sent along by one of Bandini's German correspondents. In the spirit of completeness, Bandini also included his consultation with the Académie des Inscriptions et Belles-Lettres in Paris, as well as letters about the monument by the great English antiquarian James Stuart, who had been involved in the excavations and made the remarkably accurate drawings of the obelisk reproduced in Bandini's book.

In its completed form *De obelisco* is a monument to the slow-moving but extraordinarily cosmopolitan intellectual world of the mid-eighteenth century. It also represents a new, more cautious approach to the question of meaning. Like Carlo Fontana before him, Bandini did not focus his attention on the questions of allegory and hidden knowledge that had obsessed earlier readers. He steered closer to the more sober of ancient sources and to the safe territory of the archival documents that revealed the obelisk's post-antique history. Whether that represents an active rejection of the previous century's more high-flown approach or a simple avoidance of the question, Bandini leaves diplomatically unclear. But his approach fits very well with the eighteenth century's growing concern for close observation, antiquarian rigor, and dispassionate analysis of historical artifacts.

Even some of those who were concerned with obelisks as religious artifacts took to treating them with a new historical distance. In 1742 Giovanni Marangoni was standing in the portico of Santa Maria in Trastevere when "a certain cleric, given more to good spirits than to doctrine and sacred

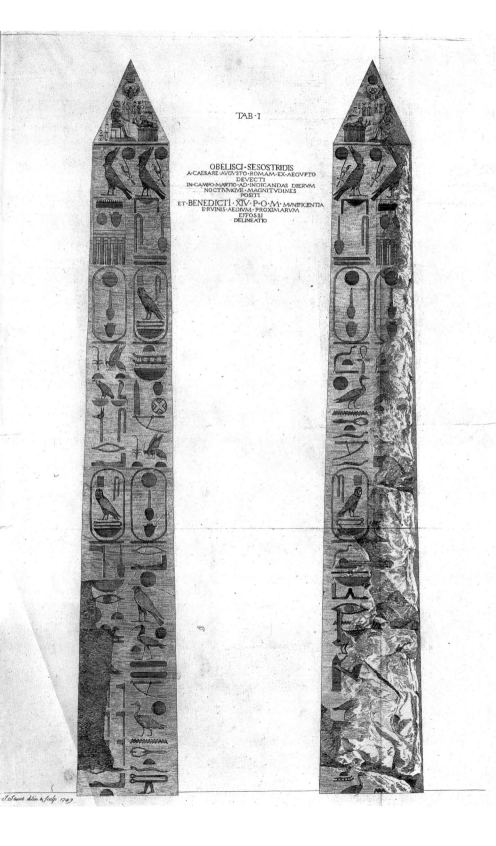

TAB·I

OBELISCI·SESOSTRIDIS
A·CAESARE·AVGVSTO·ROMAM·EX·AEGVPTO
DEVECTI
IN·CAMPO·MARTIO·AD·INDICANDAS·DIERVM
NOCTIVMQVE·MAGNITVDINES
POSITI
ET·BENEDICTI·XIV·P·O·M·MVNIFICENTIA
E·RVINIS·AEDIVM·PROXIMARVM
EFFOSSI
DELINEATIO

J. Stuart delin. & sculp. 1749

have been a simple attempt at flattery, an attempt to reassure the pope that his fragmentary obelisk was, in some way, superior to the more complete examples other popes had resurrected. Even so, unlike Plato and Winckelmann, Bandini at least acknowledged the possibility that Egyptian art had the potential for change over time.

If the problem of the hieroglyphs seemed beyond hope of easy resolution, the question of the obelisk's Roman role as a scientific instrument was another matter. As we have seen before, in book thirty-six of his *Natural History*, devoted to stones, Pliny claimed that Augustus had set up the obelisk as the gnomon of a giant sundial. What exactly that meant, however, was unclear. The problem had been a regular subject of discussion in antiquarian and astronomical circles since the German astronomer Jakob Ziegler first attempted to solve it in his 1531 commentary on Pliny. The debate centered on whether the obelisk had been built into a meridian instrument, which indicated how long the obelisk's shadow should be at noon on any given day, or served as the gnomon of a more complicated sort of instrument that indicated the changing length of daylight through the year. This sort of question was well within the capacity of eighteenth-century scholars to resolve, or at least debate with real expertise. Bandini himself was no expert on matters astronomical, so he turned to Muratori for advice. Muratori was not an astronomer either, but he was one of the most eminent and widely learned scholars in Europe, and was at the center of an extraordinary intellectual and epistolary network. He had a hunch about the "obscure passage" but proposed that the question be put to "a group of masters in astronomy, in the form of a tribunal."[41] That is exactly what Bandini did.

Dense and ferociously learned in both astronomy and classical history, the letters came back from as nearby as Rome and as far away as Berlin. Some were addressed directly to Bandini, but most were probably forwarded to him by Giovanni Jacopo Marinoni, an Italian mathematician who lived in Vienna and had extensive contacts throughout northern Europe. Ultimately, the "tribunal" came to the decision that the obelisk probably functioned as the gnomon of a meridian, the simpler of the possibilities

The Solarium obelisk, rendered with exquisite care by James Stuart, and published in Bandini's *De obelisco*.

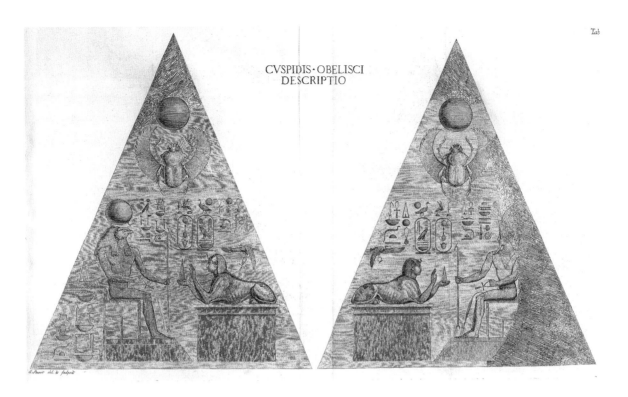

The fine hieroglyphs on the pyramidion of the Solarium obelisk, from Bandini's *De obelisco*.

gion more generally. But Bandini never comes out and says so directly. His method is, instead, rejection by omission. He cites various of Kircher's treatises in the notes but does not mention him often in the main body of the text, and never engages in direct criticism. Bandini was young and in need of a job; this book was, in effect, his audition piece. Although Kircher was no longer the last word on matters Egyptian, perhaps Bandini did not yet feel able to take a strong stand against so influential a figure, no matter how long and safely dead he might be.

Though Bandini despaired of reading the hieroglyphs, he clearly appreciated the obelisk's crisp and beautiful inscriptions. He even went so far as to attempt a rough periodization of Egyptian writing from them. So beautiful are the obelisk's hieroglyphs that "if one considers the perfection of the drawing, or the delicacy of the carving," Bandini felt they must represent a high point in the art, and that "therefore those sculpted on the other obelisks were made before, or after, those of ours."[40] This may

to Kircher's *Obeliscus Pamphilius,* his study of the Piazza Navona obelisk, published exactly a century before. Both are structured as biographies that trace the obelisks' histories from first erection through arrival in Rome, loss, rediscovery, and restoration. That narrative serves as an armature off which to hang excurses on Egyptian history, hieroglyphs, and other subjects deemed necessary to understand the monuments.

That similarity notwithstanding, the two books are strikingly different in tone. Bandini's research is impressively deep, especially for a man of his years, but he is far more cautious in his use of sources than Kircher had been. As befits a scholar who would become one of the eighteenth century's key figures in the study of old manuscripts and handwriting (he spent his later career as keeper of the Laurentian Library in Florence), Bandini was rigorous in his citations, paying far more attention than was usual at the time to issues such as which manuscripts of ancient and Renaissance texts he cited, sometimes even publishing variant versions.[37] He was biased towards ancient sources when describing ancient events, as they were closer witnesses, but he was not blind to new scholarship; in his description of the Egyptian origins of the obelisk he drew on both the canonical ancient authors and more recent ones, including de Maillet.[38] Like many other Italian scholars – most famously the great historian and editor Ludovico Antonio Muratori – Bandini saw scholarship and history not as the domain of pedantry and unexamined tradition, but as a realm of enlightenment, in which research, pursued with moderation and good sense, could arrive at new truths.

Perhaps most important, and most unlike Kircher, Bandini was entirely comfortable admitting there were many things that remained unknown about the original Egyptian context and meaning of his obelisk. Although he agreed that the inscriptions must almost certainly be religious in character – if only because no well-regarded ancient writer suggested otherwise – that was as far as he was willing to go. He described various ideas about Egyptian writing, drawing largely on ancient sources such as Horapollo. He accepted the idea that the hieroglyphs probably worked on two levels, one literal and one more philosophical, but he was not willing to address the question of what the inscriptions actually say.[39] Over the course of his discussion of ancient Egypt, it becomes clear that Bandini had, at the very least, reservations about Kircher's readings, and his take on Egyptian reli-

short essay on the origin of obelisks and their early history, his account makes no mention of Isis and contains no hint of ancient magic. Kircher's name never appears at all. Instead, Fontana's sources are the more soberly archaeological of the ancient writers: authors like Pliny, Strabo, and Ammianus Marcellinus.[34] He never tells the traditional stories about the monument's role as a witness to St. Peter's martyrdom and omits mention of the ceremonies of exorcism and consecration. Never, in fact, does he explain why Sixtus wanted to move the obelisk in the first place. In that dogged avoidance of philosophical speculation, Fontana prefigures later writers such as Nicola Zabaglia, the Vatican's mid-eighteenth-century chief-of-works, who in 1743 produced his own lavish book on the machines used in the construction and maintenance of the basilica, including yet another set of reproductions of Domenico Fontana's illustrations. Zabaglia spent even less time on the spiritual significance of the Vatican complex than had Fontana, so devoted was he to the celebration of the machines used in its construction, upkeep, and repair. That bias may reflect the fact that Zabaglia himself, though by universal agreement a mechanical genius, was reputedly both illiterate and innumerate.

By mid-century Zabaglia had become the city's reigning expert for large engineering projects like moving obelisks. Just a few years after his book appeared, Zabaglia was placed in charge of the excavations when the often-found – and just as often lost – Solarium obelisk of Augustus emerged again from the cellars of the houses where it had been investigated by Kircher three-quarters of a century before.[35] This time the obelisk stayed discovered. It inspired much excitement and provided one young scholar, the Florentine Angelo Maria Bandini, with his chance to make a name in the antiquarian world. Bandini had been drawn to Rome by the brilliance of the city's opportunities for those interested in history and archaeology, and had quickly joined the learned circle around Cardinal Albani, with his collection of Egyptian artifacts. Just twenty-one when the obelisk was discovered, Bandini had already been publishing on various antiquarian topics for several years, issuing, among other things, a series of articles on new archaeological discoveries.[36] He grabbed the opportunity presented by the obelisk, preparing a full-length study that he dedicated to Pope Gregory XIV and published in 1750 as *De Obelisco Caesaris Augusti* (*Concerning the Obelisk of Caesar Augustus*). The book is in many ways a direct parallel

1680 a wave of concern swept Rome that the great dome on St. Peter's, which had developed alarming cracks, was in danger of collapse. Fontana, renowned as an expert in structural matters, was called in as part of a team to assess the dome's stability.[31] After the committee determined that the building was safe, the pope requested that the report be placed in the Vatican archives. Then, perhaps out of concern that no one would actually see the manuscript, it was decided to send the report "to the immortal archive of the printing presses," in the hope of demonstrating to the "ill-informed . . . the stability and solidity of the Vatican's entire structure."[32]

Templum Vaticanum, the book that resulted in 1694, goes far beyond a simple engineer's report. Fontana took the opportunity to prepare what amounts to a complete physical history of the Vatican. He lavished the same sort of infinitesimal care on stones and buildings that Kircher had applied to religion and philosophy just a few decades earlier. Yet *Templum Vaticanum* is as different from one of Kircher's works as a gigantic book can be.[33] Equally long and grand and thorough, it is executed in the manner of an archaeological site report rather than a philosophical essay. Fontana begins with the geology of the Vatican, then traces its history through the ancient Roman period, describing the palaces that stood there and the Circus of Nero, whose *spina* featured the Vatican obelisk. There is a full description of the old Constantinian basilica, a history of the various Renaissance campaigns to replace it with the current building, and a very long discussion of the moving of the obelisk. Fontana illustrated each chapter with careful plans and elevations, drawn to scale and based as much as possible on historical images, including reproductions of all the obelisk pictures from Domenico Fontana's *Della trasportatione* as well as some new, presumably imagined scenes.

What really interested Fontana was the engineering cleverness behind the design for moving the obelisk, rather than the spiritual power represented by the monument. In focusing so closely on the move – he dedicates all seventy pages of Book Three to it – Fontana makes clear that he places the transport on an equal plane with the construction of the first basilica and the building of the great dome in the list of significant events that had happened at the Vatican. He describes the preparations and engineering principles, and the number of men, horses, and pulleys used in each stage. But Fontana shies away from interpretation. Even though he includes a

Romano-Egyptian fantasies – the title page of part three of Piranesi's *Roman Antiquities*.

sphinxes and crocodiles and a coffee pot shaped like a canopic jar – the small, bottle-shaped container the ancient Egyptians used to store organs and viscera from the mummy.[30]

Over the same decades that artists were engaged in closer study and imitation of Egyptian art in general, antiquarians and historians also turned to the obelisks with new eyes. The late seventeenth and eighteenth centuries saw the emergence of a new approach to the obelisks as artifacts. Scholars were increasingly intrigued by the stones themselves and their history, rather than the hieroglyphs they bore or the ancient Egyptian theology they were thought to embody. Among the earliest representatives of this new approach, just before the turn of the eighteenth century, was Carlo Fontana, distant relative of Domenico and implacable opponent of Cornelis Meijer. Fontana came to obelisks from his work as an architect. Around

Piranesi also addressed the apparent austerity of Egyptian architecture, newly revealed in books like those of Norden and Pococke. His argument – logical in light of the rich trove of Egyptian artifacts he knew in Rome – was that the present condition of these complexes was deceptive. They had been stripped of statuary and other ornaments by the Persians and later conquerors. "Let us observe how rich of ornament," he argued, are "those capitals, those obelisks and bases, those lions and sphinxes, which have been brought from Egypt to Rome, and are not entirely destroyed." Or consider further "the ornaments found in the Villa of Hadrian," which show how "a judgment might be formed of the genius of that nation."[27]

Piranesi was an artist first and foremost. His ultimate goal in the "Apologia" was to show that the works of the Egyptians, Etruscans, and all the other cultures of antiquity provided useful models for architecture and design in his own time. Artists took up that challenge with enthusiasm. The result was an extraordinarily inventive efflorescence of Egyptian themes and forms, often characterized, like Piranesi's designs, by striking accuracy of detail and wildly anachronistic settings. There was precedent for this, including the "Apis Altar," a jewel-encrusted fantasy in gold and silver, made for Friedrich Augustus, the Duke of Saxony, in 1731, but the later eighteenth century witnessed the creation of a series of ever more imaginative and outrageous Egyptian ensembles.[28] These included the appropriately Egyptian decorations Anton Raphael Mengs painted in the 1770s for the room that housed the Vatican Library's collection of ancient Egyptian papyri, and, around 1780, the Sala Egiziana at the Villa Borghese in Rome. One of the overwhelmingly sumptuous rooms on the palace's ground floor, the Sala Egiziana housed a display of Egyptian antiquities in an extravagant set-piece of Egyptian-themed frescoes, pavements, and decorative elements, including some faux-Egyptian statues to complement the real ones. Despite the hieroglyphs, the scenes of crocodile and hippopotamus hunts, the images of Apis, and paintings of Cleopatra and Marc Antony, the Sala Egiziana is, underneath, a conventional eighteenth-century European room wearing Egyptian fancy dress, rather than a full-fledged attempt to revive Egyptian style.[29] This was characteristic of the moment, and artists put Egyptian forms and motifs to similarly peculiar, though effective, use in smaller projects as well. In the 1790s the Imperial porcelain manufactory in Vienna made an Egyptian coffee service, complete with

in the Piazza di Spagna were among the first major productions in an Egyptian style in eighteenth-century Rome. The original paintings are now lost, but the designs, a riot of obelisks, sphinxes, bulls, and hieroglyphs, are still known thanks to their inclusion among the engravings in Piranesi's 1769 book, *Diverse maniere d'adornare i cammini – Diverse manners of ornamenting chimneys.*[24] Piranesi also included a number of Egyptian-style fireplace mantels in the book, similarly flamboyant fantasies executed with an antiquarian *horror vacui.*[25] Although the overall designs resemble nothing in actual Egyptian art, these ensembles were composed of a myriad of archaeologically correct details, revealing close and attentive study of genuine Egyptian models.

Like the rest of Piranesi's work, the chimney designs were distributed across Europe and had wide influence, providing designers with yet another treasure trove of Egyptian motifs. As an introduction, Piranesi included an "Apologetical Essay in Defense of the Egyptian and Tuscan Architecture," a kind of manifesto for Egyptian-themed art presented in parallel texts in three languages – Italian, French, and English. In response to the anti-Egyptian biases of scholars like Winckelmann, Piranesi argued that the apparent rigidity and immobility of Egyptian statuary was a conscious product of its intended function as part of larger architectural ensembles. In this sense, he argued, the Egyptians' artistic achievement could be considered superior to that of the Greeks. As an example, he directed the reader to the Egyptian lions that could be seen on one of Sixtus V's fountains in Rome:

> I have in view, among other works of theirs, the two lions which serve to adorn the Felician aqueduct in Rome, together with two others studiously copied both as to action and design from nature, that is, worked after the Grecian manner. What mastery in the Egyptian ones, what gravity and wisdom! What union, and modification of parts! How artfully are those parts set off which are agreeable to architecture, while those are suppressed which are not advantageous to it! Those other lions, on the contrary, which are exactly copied from nature, and to which the artist capriciously gave what attitude he pleased, what have they to do here? They only serve to diminish the great effect which the Egyptian ones give to the architecture of that fountain![26]

were among the first to define and draw systematic distinctions between the artistic styles of the various antique cultures, including the Egyptians.[21] All together, the travelers, their accounts, and the collections of images prompted yet another reassessment of Egyptian art during the eighteenth century.

Winckelmann played a key role in that effort. An advisor to Cardinal Alessandro Albani, and presumably an influence on the formation of his Egyptian collection, Winckelmann is one of the pivotal figures in the history of the history of art. Though German, he lived most of his life in Rome, making money and passing his time by advising collectors and writing guidebooks. He was among the first to insist that Roman sculpture was, in many cases, but a pale imitation of Greek models. His eye for style was keen, but perhaps because of his deep devotion to Greece, his evaluation of Egyptian art was essentially negative. In making his point, Winckelmann drew on the authority of no less a figure than Plato, who had described Egyptian art in admiring terms as the unchanging product of a fixed system of artistic laws:

> And outside this official list [of artistic rules] it was, and still is, forbidden to painters and all other producers of postures and representations to introduce any innovation or invention . . . And, if you look there, you will find that the things depicted or graven there ten thousand years ago (I mean what I say, not loosely but literally ten thousand years), are neither better nor worse than the productions of today; but are wrought with the same art.[22]

Turning Plato's enthusiasm for the invariant stability of the Egyptian system on its head, Winckelmann argued that the art of the Egyptians, while technically impressive, had been artificially locked into a state of primitive archaism by its adherence to age-old formulae – exemplified by the "stiff," "constrained," and "motionless" parts of its human figures.[23]

Not all agreed. Others saw in Egyptian art a vast trove of decorative resources and a compelling formal canon, at least the equal and sometimes the superior of the Roman. Among these, the most imaginative and passionate advocate of the Egyptian manner was Giovanni Battista Piranesi. Painted around 1760, his Egyptian-themed murals for the Caffé degli Inglesi

torso. In 1714 Pope Clement XI bought the statues and presented them to the Roman people. Immediately, the architect Alessandro Specchi was hired to produce a design for their installation on the portico of the Palazzo Nuovo on the Capitoline Hill. Ultimately, the statues were installed in two pairs: Tuya and Arsinoë at the Palazzo Nuovo, the other two across the piazza in the corresponding portico of the Palazzo dei Conservatori.[16]

A number of such displays followed in the ensuing decades. Egyptian artifacts had been on view for centuries, both as curiosities and in galleries of Greek and Roman sculpture, but now they began to be separated out in spaces explicitly devoted to Egyptian antiquities. Among the more important new displays were the Canopus Gallery on the ground floor of the Capitoline's Palazzo Nuovo, given over to a series of Roman Egyptianizing statues discovered on the site of Hadrian's Villa, and two arrays of statuary in the Bath Apartments of the Villa of Cardinal Alessandro Albani (built between 1734 and 1763) – a collection that also included a small obelisk.[17] Egyptian statues could also be seen in many other collections, such as the one at the Palazzo Barberini.[18]

The emergence of these thematic displays went hand-in-hand with scholarly efforts to sort out ancient art into neat stylistic categories – a project very typical of the Enlightenment, and one mirrored in contemporary efforts to map the whole history of letters and science in such libraries as the Corsiniana in Rome.[19] This impulse resulted in a series of publications that aimed at creating a complete conspectus of the arts of antiquity. One of the earliest and most influential was the great compendium of images compiled by the French Benedictine scholar Bernard de Montfaucon, whose ten-volume *L'Antiquité expliquée et représentée en figures* (published at Paris between 1719 and 1724) provided a rich fount of Egyptian motifs collected from a wide variety of sources, including earlier scholars such as Athanasius Kircher and Herwart von Hohenburg.[20] Many others followed, including the seven-volume *Recueil d'antiquités égyptiennes, étrusques, grecques, romaines et gauloises,* or *Collection of Egyptian, Etruscan, Greek, Roman, and Gallic Antiquities,* published at Paris beginning in 1752 by the French collector and antiquarian, the Comte de Caylus. Most influential of all was Johann Joachim Winckelmann's *Geschichte der Kunst des Alterthums,* or the *History of the Art of Antiquity,* which appeared at Dresden in 1764 and was soon translated into French and Italian. These works

the Temple at Luxor, which he identified as the "mausoleum of Ozymandias" described by Diodorus Siculus. Despite the misidentifications, he did note that the Luxor obelisks were "probably . . . the finest in the world."[13] Moving south, Pococke stopped at Aswan to explore the ancient granite quarries, even referring to the unfinished obelisk there. His description matches what can still be seen today:

> From viewing the ruins of the antient Syene, I went about a mile east to the granite quarries, all the country to the east, the islands and bed of the Nile, being red granite, which is the Thebaic stone mentioned by Herodotus; the quarries are not worked in deep, but the stone is hewn out of the sides of the low hills. I saw some columns marked out in the quarries, and shaped on two sides, particularly a long square one, which might be designed for an obelisk; they seem to have worked in round the stones with a narrow tool, and when the stones were almost separated, there is reason to think they forced them out of their beds with large wedges, of which there are great signs in all parts . . .[14]

After mid-century, access to Upper Egypt was largely cut off by a period of unrest, although the Scotsman James Bruce passed through Luxor and other parts of the south in 1768. His report included an eyewitness account of the Valley of the Kings and a short description of the Temples of Karnak and Luxor. He, too, noted the "two obelisks of great beauty, and in good preservation; they are less than those of Rome, but not at all mutilated."[15]

These accounts provided seventeenth- and eighteenth-century Europe with its first glimpse, however hazy, of Egyptian art *in situ.* Never before had European artists and scholars had reliable descriptions of the original context for the Egyptian fragments they had studied for several centuries. At the same time, Europe's own Egyptian artifacts, overwhelmingly in Rome, were receiving new attention. The first key moment came in 1710, with the discovery of five large Egyptian statues in the Roman vineyard of Leone Verospi Vitelleschi, part of the ancient Gardens of Sallust. The find included a three-meter (ten-foot) tall statue of Queen Tuya (the mother of Ramesses II) along with equally impressive sculptures of Ptolemy II Philadelphus, his wife Arsinoë, an unidentified princess or queen, and a damaged

tenure as French consul-general in Egypt and synthesized them in a *Descrip-tion de l'Égypte.* Though de Maillet's principal concerns were political, geographical, and economic, he took some note of Egypt's antiquities, even going so far as to suggest that among the ancient monuments of Alexandria, the giant classical column known as Pompey's Pillar would make a more fit-ting object of transfer to Paris than the standing one of Cleopatra's Needles. De Maillet seems to have sensed that he was treading on delicate ground with this idea, as he proposed that the column be obtained by ruse. The French would apply to the sultan in Constantinople to take the monument to Paris; de Maillet felt sure the sultan would agree. Then, upon arriving in Alexandria, they would tell the Egyptians that the sultan had entrusted the French with the task of taking the monument to Constantinople.[8]

Toward the end of the seventeenth century, however, a few more Euro-peans began to venture south of Cairo – and to come upon and record ruins so vast and distant that no transportation project was conceivable. In 1668, while on their way to a monastery in the Upper Egyptian town of Esna, a pair of Capuchin friars noted the vast ruins of the Temple of Karnak,[9] but it was not until 1714-15 that Claude Sicard, a Jesuit from Lyon who had traveled south looking for Christian manuscripts, identified Luxor as the site of ancient Thebes "of the hundred gates."[10] In 1737 and 1738 Richard Pococke, the Anglican Bishop of Meath, and Frederik Ludvig Norden, a Danish naval officer, were, by chance, both in Upper (that is, southern) Egypt at the same time, though neither knew the other was there. Both saw many of the temples and tombs in the vicinity of Luxor, and both published detailed accounts of their travels, richly illustrated with pictures and plans of monuments barely known even by name to European readers.

Norden's book, which appeared first in French in 1755 and then in English two years later, includes startlingly accurate renditions of Egyp-tian column types and a view of the entrance façade of the Luxor temple, with its great pair of partially buried obelisks.[11] Pococke was quicker to press, in 1743. He provided similar illustrations of the Egyptian "orders" (brought up on Roman architecture, early European observers tended to try to fit Egyptian art into classical categories), along with such details as measurements of the obelisks in Alexandria and Heliopolis, the latter of which he supposed to be "one of the four erected by Sochis."[12] Pococke also included measured plans of the "Great Temple of Jupiter" at Karnak and

the Venetian expressed his admiration in acquisitive terms clearly inspired by recent events in Rome:

> And there is not the equal of these obelisks [*aguglie*] either in Rome, or in Alexandria, or in the whole of Egypt. Those in Rome and Alexandria I have seen and re-seen and measured; [but] these two exceed all the others in size; and they are perfect, and they stand together, where the rare beauty of a variegated granite very pleasing to the eye can be seen, and there are an infinite number of signs, more than I have ever seen, and carved so clearly that they seem to be new, so that my words are incapable of describing their beauty. Oh what a rare thing it would be to see them placed in a superb piazza such as the one in Venice, which is without equal in all the world, and to see such monuments as these. Countless numbers of people would flock there to see these trophies installed there.[3]

The Venetian was exceptionally adventurous. For the most part, those sixteenth- and seventeenth-century Europeans who made their way to Egypt limited their travels to the more accessible and commercially important centers of the north.[4] In 1610 the Oxford-trained poet and translator of Ovid, George Sandys, made a trip through the Ottoman Empire, including a stop at the Giza pyramids – "barbarous monuments of prodigality and vain-glory."[5] In 1614 Pietro della Valle visited the mummy pits of Saqqarah, where he purchased a fine pair of dead Egyptians.[6] Even more remarkable was the voyage of John Greaves, professor of astronomy and mathematics at Oxford. Greaves made an extended research trip to Egypt in the 1630s, collecting manuscripts and studying Arab astronomy. While in Cairo, he made a systematic study of the great pyramid and its neighbors at Giza. Using measurements he took on site, Greaves produced the first reasonably accurate account and images of Khufu's pyramid – including its interior passageways – which he published in his 1646 *Pyramidographia, or a Discourse of the Pyramids in Aegypt.*[7]

Even in the eighteenth century, many Egyptophiles continued to confine their interest to the north – and to those Egyptian ruins that could possibly be appropriated for use in Europe. In 1735 Jean-Baptiste de Mascrier took the notes and observations Benoît de Maillet had compiled during his

The Eighteenth Century: New Perspectives

What mastery in the Egyptian ones, what gravity and wisdom! What union, and modification of parts! How artfully are those parts set off which are agreeable to architecture, while those are suppressed which are not advantageous to it!

GIOVANNI BATTISTA PIRANESI, ON EGYPTIAN SCULPTURE[1]

IN RENAISSANCE AND BAROQUE EUROPE, Egypt was not a place so much as an idea. Almost none of the scholars and artists who found themselves fascinated by Egypt ever set foot in the country. Their picture of Egyptian art and architecture was based entirely on what the Romans had brought to Italy more than a millennium before and the few scraps, mostly tiny scarabs and bits of mummy, that modern traders carried back from the Near East. Still, since the time of Cyriac of Ancona there had always been an intrepid few who made the journey and reported on the wonderful things they saw.[2] About 1589 an unidentified Venetian visitor to Egypt made his way far upriver. His impressions of Karnak, Luxor, and Philae may be the earliest surviving accounts of these sites by a European traveler after antiquity. Standing before the pylon of the Temple of Amon-Re at Luxor,

The base of Augustus's Solarium obelisk, restored on paper in Angelo Maria Bandini's *De obelisco Caesaris Augusti* of 1750.

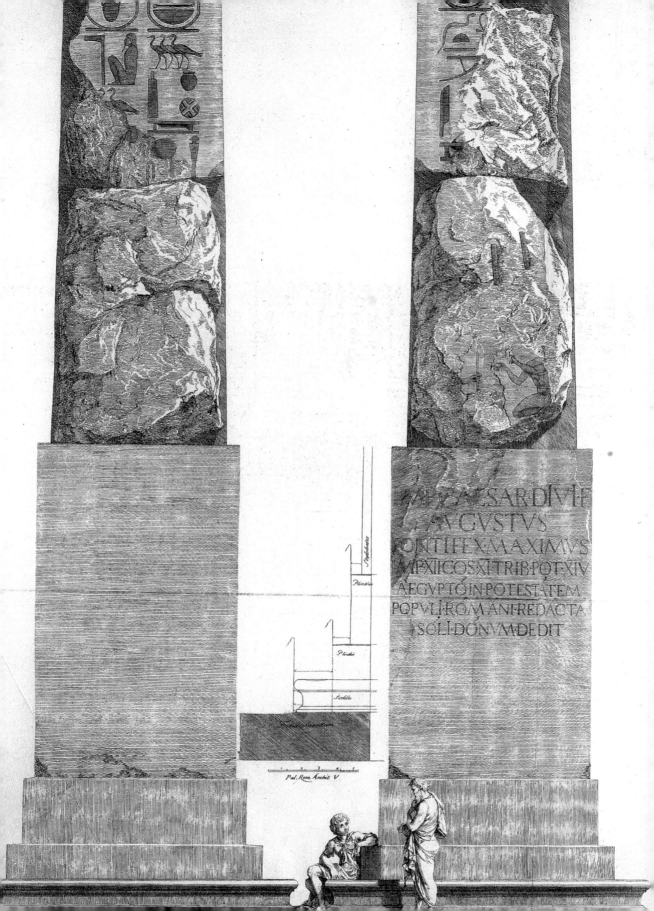

IMP·CAESAR·DIVI·F·
L·AVGVSTVS·
PONTIFEX·MAXIMVS·
IMP·XII·COS·XI·TRIB·POT·XIV·
AEGVPTO·IN·POTESTATEM·
POPVLI·ROMANI·REDACTA·
SOLI·DONVM·DEDIT·

Piedestallo

Plintho

Plintho

Scolio

Fondamento

Pal. Rom. Archit. V

humiliation, the papacy still had one more obelisk project left in it. This last, small project came more than two decades after Pius was laid to rest in the Vatican, when his successor, Pius VII, ordered that a small nine-meter (thirty-foot) obelisk be set up in a new public park at the top of the Pincian Hill. This was the obelisk originally carved by order of Emperor Hadrian and dedicated to the cult of his deified lover, Antinous, who had drowned in the Nile in 130 CE. Francesco, Cardinal Barberini, had acquired the obelisk in 1632, intending to install it as the centerpiece of the gardens at his splendid new palace on the Via di Quattro Fontane. The project never came to pass, and the obelisk remained lying in the gardens until about 1770, when it was presented to Pope Clement XIV as an ornament for the gigantic Cortile della Pigna in the Vatican palace – an Egyptian complement to the huge bronze pinecone that gives the courtyard its name. This idea, too, fizzled. In its ultimate setting on the Pincian Hill, where it finally came to rest in September 1822, the obelisk resembles nothing so much as the real-life model for the myriad seventeenth- and eighteenth-century paintings that show obelisks in gentle Arcadian landscapes. It represents perfectly the transformation of the obelisk from a symbol of resurrected imperium to a gentler sort of public ornament – suitable for the contemplation of weekend promenaders, lovers meeting to arrange a discreet tryst, and *au pairs* pushing baby carriages in the sun of a Roman afternoon on the aptly named Viale dell'obelisco.[47]

> I, formerly carved and cut from the mountain of Egypt, and by Romulean force dragged through the waves of the sea, that, as a pillar of awe, I might stand at the tomb of Augustus, where with its water the Tiber cools the Caesarean grove; I, who an unfriendly age, when I lay fallen and broken, tried, but in vain, to inter deep in a cavernous tomb; I was given back to life on the thundering fiat of Pius, ordered to stand, in good repair, over the unsurpassed statues of great Alexander: Proud I shall be to proclaim to the ages how much he was smaller than Pius.

later, and the meridian itself was not installed until 1998, when the pavement of the piazza was rebuilt to designs by the architect Franco Zagari.[44] Now, after more than two centuries, it is finally possible to enjoy the obelisk in something like its intended eighteenth-century context, and in a distant echo of its function in Augustan times.[45]

With its meridian or without, the obelisk was luckier than its patron. Up-to-date though the scholarship and antiquarian spirit behind the restoration may have been, Pius himself, and the Papal States in general, were fragile, dry, old-fashioned creatures. And times were changing. Just four days after the Roman aristocrats passed a pleasant morning diverting themselves with ices and obelisks, a crowd of Parisians invaded the Tuileries Palace, where they forced Louis XVI to don a liberty cap – symbol of the popular Revolution – and toast the health of the people. Within a month Maximilien Robespierre was calling for the removal of the king. The royal family was imprisoned by the middle of August, and the king was executed in January. Though Italian, Pius, with his imperial aspirations, was very much a creature of the *ancien régime.* Openly horrified at the events in France, he became an implacable opponent of the Revolution and found himself locked in an evolving conflict with the French. In 1791 the Republican government annexed the papal territories in France; in 1796 the young general Napoleon Bonaparte invaded and conquered the Papal States themselves. French forces occupied Rome in 1798, proclaiming it a republic. They took the pope prisoner and whisked him away from Rome. After being held at various places in Italy and France, Pius died at Valence, in southern France, on August 29, 1799. His body remained there until it was transported to Rome in 1802 and interred at St. Peter's, where he is commemorated by Antonio Canova's gigantic statue of Pius kneeling in prayer, installed in 1822 in the *confessio* before the tomb of St. Peter.

More than any pope since Sixtus V, Pius was driven by the idea of the papacy as a political, even imperial, force, not just a spiritual one. Within the gentle confines of the Papal States, it was an easy fantasy to maintain. But when Pius's dreams came up against real imperial power, his boasts about being a bigger man than Alexander were quickly revealed as hollow. Even his inscription to that effect on the base of the Quirinal obelisk was quietly replaced in the early nineteenth century by a more circumspect reference to "what exalted things Pius has done."[46] Yet even after Pius's

integrity and in the more modest message the obelisk conveys about how much scholars actually knew of the Egyptian past and how to read and write hieroglyphs.[41]

In another change from Pius's previous custom, it was decided to set the obelisk on its original base, rather than fashion a new one. One advantage of this decision, Antinori argued, was that it would preserve the ancient (both Egyptian and Roman) concept of the obelisk as a freestanding monument.[42] This plan meant that some restoration had to be carried out on the base, including re-carving parts of the original Augustan inscription that had disappeared over many centuries of neglect. The only ornamental additions were some modern inscriptions recounting the obelisk's history and recording the circumstances of its excavation and restoration. Finally, in an effort to restore the obelisk's original solar function, a large bronze globe, topped by an obelisk-shaped pointer and penetrated by a transverse "light-shaft" was to be placed at the summit, so the obelisk might cast its shadow and a small point of sunlight on a bronze meridian to be installed in the square below.

The work took nearly four years, partly because the obelisk was in such poor shape. Finally, in the summer of 1792, the monument was almost ready. Lorenzo Prospero Bottini, the city of Lucca's agent in Rome, reported back to his hometown that on June 16: "in the presence of an infinity of people" the last "big piece of the solar obelisk was installed by the Curia Innocenziana." It was a grand affair, but in a sign of how much had changed since the days of Sixtus V, the event was as much party as sacred ritual. Bottini noted that the work was "watched with pleasure" by a large group of nobles gathered in the apartment of Monsigor Albani, Auditor of the Camera of the Curia, "who served a selection of *gelati.*" Unfortunately, the happy event was followed quickly by a sad one. Less than two weeks after the installation, Antinori, the architect, was dead, killed by an "inflammation of the urethra."[43] Nor was the project destined to be realized in full. Antinori restored the stone to a height of nearly twenty-two meters (seventy-two feet). The globe and base added another seven feet, but the solar light-shaft, though apparently intended from the beginning, may have been added somewhat

The Montecitorio obelisk restored, and unrestored, from Zoega's *De origine et usu obeliscorum.*

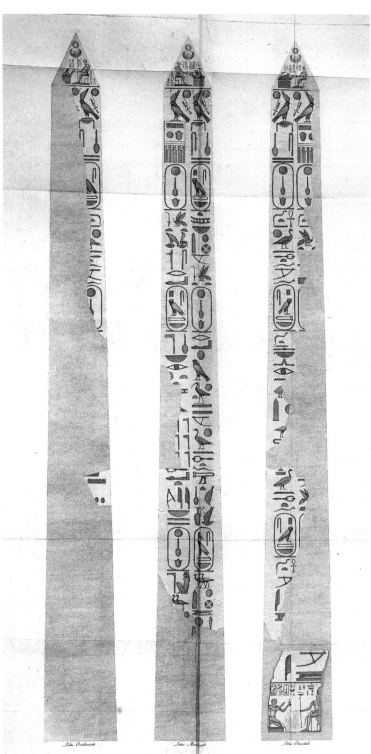

Latus Occidentale　　　　Latus Meridionale　　　　Latus Orientale

Obeliscus Campensis

As the inscription suggests, Benedict probably intended to raise the obelisk somewhere in the immediate vicinity, most likely in the Piazza di Montecitorio, before the seat of the Papal Tribunal or "Curia Innocenzia" (now known as the Palazzo di Montecitorio). Excavation of the monument proceeded under the direction of the architect Tomasso de Marchi and the British artist, architect, and antiquities scholar James "Athenian" Stuart, who made impressively accurate renderings of the obelisk and its hieroglyphic inscriptions.[38] Benedict's plans never progressed beyond the very earliest stages of planning, thanks probably to the challenge posed by the obelisk's very poor condition. Instead, an alternate plan was proposed to raise another red-granite monolith in the spot, the Column of Antoninus Pius (also just a bit less than fifteen meters high). This had stood nearby in its original location until 1705, when it was extracted from layers of accumulated earth and deposited, along with its marble base, in a corner of the Piazza di Montecitorio. Work on the foundation for this monument was not yet complete when Benedict died in 1758. A year later the column itself was damaged beyond hope in a fire that consumed the wooden shed built to protect it.[39]

With the column gone, attention shifted back to the obelisk. During the 1780s various proposals were discussed to restore and set it up in a variety of locations, but in the end Pius decided to go with the idea proposed by Cancellieri in 1786, before the Curia Innocenzia in the Piazza di Montecitorio. This plan had the advantage, as the architect Antinori put it, of raising the obelisk in a position close to its original location in one of the city's busiest squares.[40] As for the obelisk itself, it was to be restored with granite taken from the ill-fated Column of Antoninus Pius. In this case, however, it was decided – in a marked departure from the approach taken by Sixtus V and Innocent X, and by Pius VI himself with the Trinità dei Monti obelisk – not to restore the extensive missing sections of the monument with newly carved reliefs and hieroglyphs. Instead, great portions of the obelisk were filled in with plain, uninscribed granite, so the original pieces, with their crisp and beautiful hieroglyphs, are clearly differentiated from the restored portions. Antinori made a virtue of this almost inevitable necessity by describing the decision in terms of archaeological truthfulness and authenticity. The result is striking, and distinguishes this obelisk from all the others in the city, both in the concern for archaeological

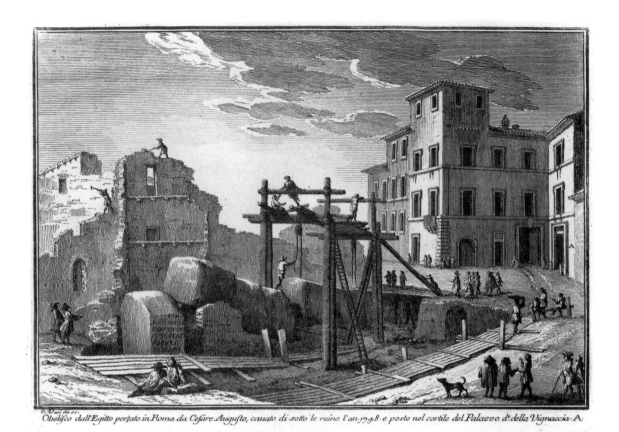

Obelisco dall'Egitto portato in Roma da Cesare Augusto, cauato di sotto le ruine l'an.1748. e posto nel cortile del Palazzo d: della Vignaccia. A.

Excavating Augustus's Solarium obelisk, from Giuseppe Vasi's
Concerning the Magnificence of Ancient and Modern Rome.

Benedict dug out with great skill this obelisk, elegantly carved with
Egyptian letters, brought to Rome by the Emperor Caesar Augustus,
when Egypt had been brought under the sway of the Romans, dedi-
cated to the sun and the extension of the days and nights on a pave-
ment of stone with inlaid lines of bronze. Broken and overturned by
the inclemency of time and [by] barbarians, buried under earth and
buildings, Benedict transported it to a neighboring site for the public
good and the support of letters, and ordered this memorial put up in
order that the ancient place of the obelisk should not eventually be
forgotten.[37]

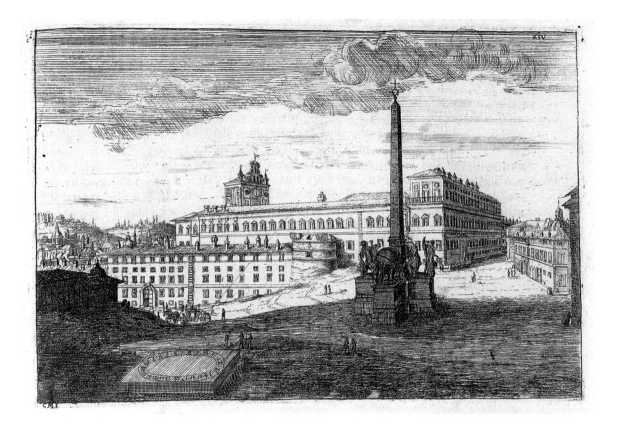

Cornelis Meijer's proposal for erecting the Solarium obelisk
between the horse tamers at the Quirinal.

the monument's awkward location, it's not surprising that Kircher's pro-
posal to excavate and raise it before the church of Santa Maria degli Angeli
came to nothing. This fate was shared by another proposal – by Cornelis
Meijer – to raise it on the Quirinal between the Horse Tamers.[36]

Then, in 1748, the obelisk was "discovered" again when the Augustine
fathers who owned the property decided to demolish and rebuild the houses
that covered it. The presiding pontiff, Benedict XIV, visited the site. He
ordered that the pieces – the obelisk was not "intire and unbroken" – be
removed and stored in a courtyard behind the nearby Palazzo dell'Impresa.
In keeping with the scholarly character of this pope, the find-spot was
marked by an inscribed tablet above the main door of what is now number
3 Piazza del Parlamento:

in pieces in the piazza until Pius took up the idea of restoring it. Though the obelisk was small, its placement was attended by extremely careful planning. In October 1786 Antinori set up a canvas mock-up of the monument in front of the church, so the pope could examine its effect as he drove by in his carriage.[32]

The little obelisk was a smaller monument than might normally be proposed for such a high and prominent spot. Antinori addressed that problem, and the potential lack of visibility from the steps, by setting the obelisk atop an unusually tall pedestal. Before the obelisk was actually installed, there was general agreement that the design was a failure, and the monument-to-be inspired a rash of jokes and satires. Goethe noted that one Roman wag made his displeasure known during Carnival in 1788: "Someone took this as an incentive for wearing a big white pedestal as a cap, on top of which was fixed a quite small red obelisk. Large letters were written on the pedestal, the meaning of which was perhaps only guessed by a few."[33] (Goethe, unfortunately, was too demure to let his readers guess for themselves.) The criticism continued after the obelisk was installed, but modern visitors are either less critical or less discerning, for the effect seems entirely satisfactory today. It provides agreeable views from every angle, while refusing to favor any one of the various streets from which the obelisk can be seen and enjoyed.[34]

Pius VI's third and final obelisk project was his most ambitious, since it involved the restoration of one of the largest and most famous obelisks in the city – the one Augustus had placed in the Solarium of the Campus Martius. Originally raised in Heliopolis and covered with sharply carved hieroglyphic inscriptions of Pharaoh Psammetichus II (595–589 BCE), this obelisk had first been located as early as the fifteenth century. It was partially excavated in 1511 and 1512, during the pontificate of Julius II, and proposals to dig it out had followed under Sixtus V. In the 1660s Athanasius Kircher again located the obelisk, examining the base and three fragments of the shaft in the basements of two separate buildings. Kircher's discovery was greeted with much enthusiasm. The English botanist John Ray, on a tour of the continent to visit scientific academies as preparation for the founding of Britain's Royal Society, reported excitedly that the obelisk had been found "under a row of houses, as big if not bigger than any of those already erected, and supposed to continue intire and unbroken."[35] Given

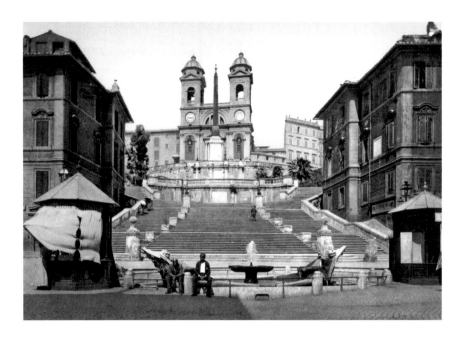

The Spanish steps and Trinità dei Monti in the early twentieth century.

place on the Quirinal would be taken by the so-called "Sallustian" obelisk. It was the ambition of the smaller "Barberini" obelisk to see itself installed atop Michelangelo's gate at the Porta Pia, with the result that from the crossing of the Quattro Fontane, in the northern part of the city, "one could see four obelisks from a single point, to the surprise and enchantment of Romans and foreigners who would be stupefied to see Sixtus V's ingenious idea of making one obelisk visible from three points outdone."[31]

In the end, Pius decided to let the Quirinal obelisk alone. The Porta Pia idea, too, was dropped. But Pius did decide to set up the Sallustian obelisk – a reduced, Roman-era copy of the great obelisk in the Piazza del Popolo – at the Trinità dei Monti. The Sallustianus had been known to generations of Roman antiquarians (and received its name) thanks to its easy accessibility in a ditch near the Porta Pinciana, in the ancient Gardens of Sallust. In the 1730s it had been moved by order of Pope Clement XII, who planned to raise it before the new façade of the Lateran Basilica, which was completed to Alessandro Galilei's design in 1735. This project never came to pass – perhaps because of a perceived disjunction between the smallness of the obelisk and the immensity of the church's façade – and the obelisk lay

shows a far more elaborate plan than was eventually built, involving tritons that supported the great granite basin and a set of guardian sphinxes for the whole ensemble. Ercolani's gift did double duty. It commemorated the new monument and served as a desk set, containing, beneath the pedestal, "an inkpot, powders, and other conveniences for the use of writing." And "simply by touching a lion's head in the base . . . it's possible to turn the two horses to their old position."[27]

Would that the real task had gone so smoothly. Early on, Antinori was embarrassed by a first, failed attempt to turn the Dioscuri, and the whole project took about four years to complete. Antinori had a new base for the obelisk made, using red-granite facing salvaged from the base of the Column of Antoninus Pius. This was placed atop a white-marble intermediary block on a larger plinth, also of white marble, that was tinted to match the color of the Dioscuris' weathered supports. A set of bronze eagles connected by festoons was cast for the bottom section of the obelisk, where they function visually as a set of astragals. When the monument was dedicated in October 1786, a bronze cross bearing relics of Saints Peter, Paul, Andrew, Gregory the Great, and Pius V was placed on the obelisk's summit. But even though the dedication took place, the monument was not really complete. The fountain was missing, as the plan to move the granite basin from the Forum proved too much; it was not brought until 1818, long after Pius's death.[28] Even though the monument was not quite as grand as Antinori had hoped, Pius still had the base carved with an inscription (quoted in full at the end of this chapter) that declared him a bigger man even than Alexander the Great – no small claim. Antinori's original design, if not the actual monument, and the boastful inscription capture the real spirit of Pius's reign, the last moment when the papacy seemed to believe its own rhetoric of worldly domination.[29]

Pius VI's appetite for obelisks was hardly sated by the completion of the Quirinal project. The same year it was dedicated, the papal advisor and historian Francesco Cancellieri addressed a "supplication" to Pius. In this imaginative work, a kind of official pasquinade, the up-till-then-unresurrected obelisks of Rome revealed their own secret hopes for re-erection in a series of locations around the city.[30] The obelisk at the Quirinal, not yet even dedicated, wanted to be removed to Trinità dei Monti, at the top of the Spanish steps, the better to be seen by its mate on the Esquiline. Its

So it's possible to imagine Pius's enthusiasm, in 1781, at the discovery of the second of the two obelisks from the Mausoleum of Augustus, which turned up during construction work in the area between the Roman churches of San Rocco and San Carlo al Corso. This was the mate to the obelisk erected at Santa Maria Maggiore by Sixtus V and, like that obelisk, bore no hieroglyphic inscriptions. Originally almost fifteen meters high (fifty feet), the shaft was broken in three pieces and damaged by fire, but was deemed suitable for restoration and re-erection. The pieces were purchased from the religious confraternity that managed the maternity hospital at San Rocco with a donation of a thousand *scudi* from the proceeds of the papal lottery. Almost immediately, competing plans were submitted to restore and raise the obelisk in the Piazza del Quirinale, in front of the pope's summer residence in Rome.[24] Since antiquity the plaza had been dominated by the Dioscuri, two giant sculptures popularly known as the "Horse Tamers," and sometimes identified as double images of Alexander the Great and his horse, Bucephalus, carved in rivalry by no less than Phidias and Praxiteles, the two greatest sculptors of ancient Greece.[25] These enormous sculptures had been restored and reinstalled, facing the long avenue of the Strada Pia, by order of Sixtus V back in the 1580s. Pius's decision to place the obelisk and its base between them required that they be turned again, a full forty-five degrees.

The design and construction of the new ensemble was entrusted to Giovanni Antinori. His plan became very elaborate. The obelisk was to sit between the horses, incorporating their existing bases, and atop a grand fountain whose bowl was to be a huge ancient granite basin that then sat in the Forum, used to water livestock. The result was to be one of the city's grandest monumental complexes. Setting up the obelisk and, perhaps even more, moving the giant sculptures of the horse tamers was a major undertaking and, in the eyes of the pope, a major political statement. So in 1785 Pius and Antinori commissioned a set of plaster models of the proposed design, showing (and sometimes giving) them to diplomats from, among other papal allies, Spain, Portugal, and Venice.[26] None of the plasters seems to have survived, but in 1792 Luigi Ercolani gave Pius the surprise gift of a gold-and-silver replica of the model, made by Vincenzo Coacci. The model

The Quirinal obelisk set up, from Georg Zoega's *De origine et usu obeliscorum*.

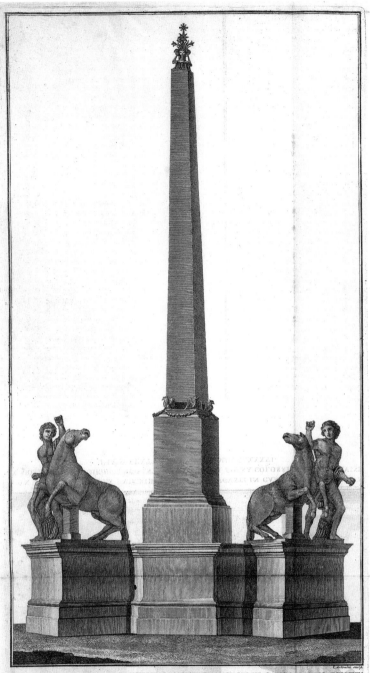

ICON OBELISCI QVEM EX RVDERIBVS MAVSOLEI AVGVSTI IN CAMPO MARTIO ERVTVM
IN AREA QVIRINALI MEDIO LOCO INTER CASTRORVM SIGNA COLOSSEA ADLEVARI IVSSIT
PIVS SEXTVS P. M. ANNO MDCCLXXXVI

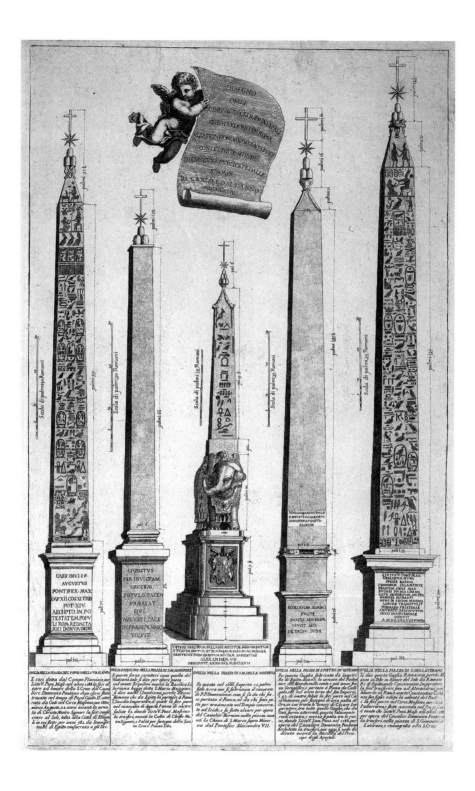

provincial: "You can see nothing more elegant than the floors of most of the largest churches in Rome."[20] There were less concrete attractions too. When they came to visit in the winter of 1788, the Holy Roman Emperor and the King of Sweden were regulars at the theatre, taking in a new opera and plays, and attending a grand masked ball.[21] Every winter there was the spectacle of Carnival, and always and everywhere was the solemn and gorgeous ritual of the church. There were also the passing delights, the sorts of small pleasures Rome provides still today – Leopold Mozart excitedly interrupting fourteen-year-old Wolfgang as he writes to his sister: "papa is just telling me that they are carrying the most exquisite flowers past our window." Or, on a hot November day, the pleasure Goethe and a friend, the German painter Johann Tischbein, took in a snack of grapes they enjoyed in the shadow of the Vatican obelisk – just wide enough for two.[22]

The flood of visitors and their reverential attitude resulted in a peculiar myopia. Even as the papacy became less and less a political force, the constant flow of foreigners allowed the city to retain its sense of being mistress of the world. After all, the emperor came to see the pope, not the other way around. The grand buildings and colonnades, the obelisks and basilicas so carefully raised and renovated over the previous three centuries had the intended effect: some viewers came away impressed deeply by the inherent and sublime mastery of the papacy. It was, however, the popes themselves who were most convinced. That self-delusion combined with the monumental ego of one ambitious pope for the last great burst of Roman obelisk projects. All were associated with the long reign of Pius VI, the last pope of the eighteenth century. The Jesuit-trained son of a noble but impoverished Roman family, Giangaleazzo Braschi had risen through the ranks of ecclesiastical office with a range of diplomatic and administrative jobs, culminating in his appointment to the College of Cardinals by Clement XIV in 1773. Braschi would be elected pope a scant two years later. Pius VI, as he fashioned himself, was deeply enamored of the trappings of imperial splendor, exemplified by his vast program of renovation in the Vatican Museum and his taste for triumphal arches and processions. One of his arches still stands in Subiaco, outside Rome – built to celebrate a visit he made to the town where he served as abbot prior to his election as pope.[23]

The obelisks of Rome – an eighteenth-century souvenir.

By the middle of the eighteenth century Rome had become a required stop. Everyone who was anyone made a point of coming through the city at some point. Around the constant flow of tourists grew up an elaborate service industry of tour guides, art instructors, printers, and publishers. Piranesi's prints found their way into aristocratic libraries all over northern Europe, but there were other publications as well, more suited to use on the go. Giuseppe Vasi published a series of pocket guidebooks in at least three languages; each stop was keyed to a large-format view he also published, so visitors could take the city home with them and relive their wanderings. There were enough visitors to support a colony of resident scholars, loafers, and intellectual hangers-on for each nation, able to give tours and advice in the appropriate language. When Edward Gibbon made his trip in 1764, his guide was James Byres, "a Scotch antiquary of experience and taste" who set out a rigorous course of study for his charges, recommending readings, viewpoints, and itineraries for getting the most out of the whole experience.[18] For some, like Gibbon, the history alone was transporting: "at the distance of twenty-five years, I can neither forget nor express the strong emotions which agitated my mind as I first approached and entered the *eternal city.* After a sleepless night, I trod, with a lofty step, the ruins of the Forum; each memorable spot where Romulus stood, or Tully spoke, or Caesar fell, was at once present to my eye; and several days of intoxication were lost or enjoyed before I could descend to a cool and minute investigation."[19]

Yet the city's charms were not just historical. Rome was a major center for the study, making, and collecting of art. It was almost *de rigueur* for rich English and French tourists to come back with a portrait, preferably by Pompeo Batoni, who specialized in pictures of aristocrats and their clothing. The city was also a shopper's paradise, and its merchants sent a constant flow of ancient marbles, Renaissance and Baroque paintings, books, and decorative objects old and new across the Alps to the new collectors of the north. Visiting in 1774 from tiny, wood-and-brick Boston, the American painter John Singleton Copley was moved less by ancient history than by more recent art and the city's very fabric. In his letters home he repeatedly marveled at the city's size and solidity – "if I were transported to Boston, I should think the people lived in huts. The magnificence of the public buildings, palaces, churches, etc. exceeds description." But it was the city's details as much as anything else that impressed a goggle-eyed

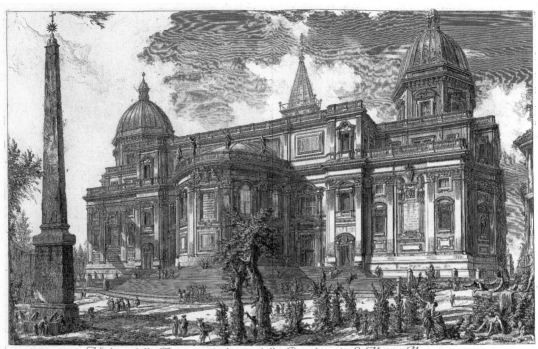

Veduta della Facciata di dietro della Basilica di S. Maria Maggiore

A view of Santa Maria Maggiore by Piranesi.

Now I see all my childhood dreams come to life; I now see in reality the first engravings that I remember (my father had hung views of Rome in a hallway); and everything long familiar to me in paintings and drawings, copperplates and woodcuts, in plaster and cork, now stands together before me. Wherever I go I find something in this new world I am acquainted with; it is all as I imagined, and yet new.[16]

Attentive and well-prepared visitors like Goethe were constantly comparing what they saw to their mental notes and expectations. Goethe found the actuality of the ruined Baths of Caracalla, "of which Piranesi has given us so many a rich imaginary impression," a little disappointing (he thought Herman van Swanewelt had done a better job communicating their state), but even Piranesi could not prepare Goethe for the majesty of the Cloaca Maxima – the great sewer of the ancient city.[17]

travel destination – and not just for pilgrimage.[12] It began to resemble the place it is today: the tourist city *par excellence.* A trip to Rome became a necessary educational ornament for aristocrats, artists, and scholars. Religious affiliation was no bar. In the mid-1680s, when offering advice to the natural philosopher Robert Boyle on what to see and do on the continent, Gilbert Burnet, the Anglican bishop of Salisbury, very simply summed up the sentiment of the age: "But now I come to Rome, which as it was once the Empress of the World; in a succession of many Ages, so hath in it at present more curious things to entertain the attention of a Traveller, than any other place in Europe."[13]

Rome's reputation built on itself, helped along partly by the printed views of the city that flooded northern Europe. In the late 1660s Arthur Balfour, a physician from Edinburgh who had made the trip, offered advice to a friend who was soon to go. After the manner of the time, he asked the friend to bring back a long list of items, including "a Book in Taildouce [i.e. a book of etchings], containing all the Antiquities, Palaces, Statues, Churches, Villa's, Fountains, Pyramids &c. in Rome. I would have it of the best, largest and finest Impression; and if you cannot get them so in one Book, I would have you take them in severall Fashions as you can best find them: You may inquire appresso Giacomo di Rossi a la Pace in Roma."[14] In faraway Edinburgh, Balfour wanted a reminder of the physical reality that was Rome. Such familiarity was as important to a man of education as "the new Books of Physick, Botany, and that any way relate to the Historie of Natur" that he also requested, or even the "Outlandish Curiosities, especially, such as are from the Levant, of whatsoever Sort that you can meet with. Buy me at Venice, a Stilletto, and a pair of Armenian Shoos, shod with Iron on the heels, such as they use to wear undermost."[15] The printed views played many roles: they could help the nostalgic traveler recall his Roman days as he sat by a coal fire in Edinburgh, but they could also serve as an introduction to the city's marvels for those who were planning a visit.

More than a century later, prints by Giovanni Battista Piranesi served much the same purpose. They were the school for visitors – the means they used to prepare for the experience of the real place. But all the preparation in the world could not equal the effect of the real thing. When he arrived in Rome for the first time in November 1786, Johann Wolfgang von Goethe wrote exultantly in his journal:

in some ways be read as a reflection of mid-century Catholicism's genuine, if somewhat chastened, self-assurance. The church was not going to disappear, but it was not going to reconquer the whole of Christendom either, at least not any time soon. It was painfully evident that real political power had disappeared north of the Alps. The pope, after all, had played almost no role in settling the single greatest political crisis of the period: the Thirty Years' War that had ravaged Germany between 1618 and 1648. That humiliation weighed all the heavier in light of the fact that the war had been, to a large degree, a religious one. Still, the papacy had not surrendered its traditional claim of temporal primacy to go along with its spiritual power, and as an institution the church retained enormous wealth and genuine prestige. So even if Rome could not act as an imperial capital, there was no reason it shouldn't look like one.[10]

The later obelisk projects reflected those lowered political expectations. Gone was Sixtus's martial, even belligerent, symbolism, replaced by more subtle intellectual programs that were much more difficult of access. For all the implied universalism of Kircher's Fountain of the Four Rivers, his message was encoded to such a degree that even now scholars disagree as to its specifics – a situation not helped by the fact that the decoder ring is *Obeliscus Pamphilius,* one of Kircher's trademark gigantic treatises, buzzing with ideas and texts. Yet it is telling that even the fountain, with its extraordinary visual splendor and intellectual complication, was ultimately a local affair. It was intended to immortalize Innocent's family, not the church triumphant. The inscription on the base mentions Innocent, the Pamphili (his family), and the Romans who brought the obelisk back from Egypt; it even refers to Kircher's "Nilotic mysteries," but it never mentions the church.[11] Only the dove of the pope's family, not the triumphant cross, stands atop the shaft – though Kircher did credit the dove with defeating "the monsters of the Egyptians." More to the point, the Piazza Navona was smack in the middle of Pamphili family territory. The erection of the obelisk in the Piazza Navona was a more elegant act of family pride than slathering Conti eagles all over the Vatican obelisk, but it grew from the same roots.

The papacy never recaptured the raw energy that characterized the era of Sixtus and the religious wars. But the city of Rome did not fade; it reinvented itself. Over the course of the later seventeenth and eighteenth centuries, Rome became less and less a center of power and ever more a

tians, his effort was for naught. It escaped no one that the eagle is the Conti family emblem. The shamelessness of "tagging" the obelisk with so much bronze pontifical graffiti prompted such mockery that Sergardi actually left the city for a time.[9] Nonetheless, the eagles remain in place today.

Whatever their artistic and archaeological significance, the obelisk projects of the seventeenth and early eighteenth centuries lacked some of the drama associated with those of the sixteenth. For not only were the obelisks smaller, the stakes were as well. In moving the Vatican obelisk, Sixtus had sent a message across Europe about the resurgent power of the papacy after half a century of religious challenge and institutional disarray. Moving the obelisk was not only an unprecedented engineering achievement, it was an immense propaganda coup for the church. Here, as the prints, poems, and celebratory books strove to make clear, was an organization that not only commanded the holiest of places and the symbols of ancient imperial power, but possessed the skill to manipulate those symbols in the most concrete of ways.

Or did it? Though Sixtus and Fontana put on a good show, there was a touch of wishful thinking about the whole obelisk affair. The end of the sixteenth century was not a comfortable time for the Roman Catholic Church. Religious wars raged across France and the Low Countries; the ultimate fate of many of the German states and England was still not settled; and the Papal States themselves were engaged in a delicate political balancing act between France, Spain, and the other Italian powers. Sixtus, it was evident to anyone paying attention, was no emperor, even if he was an effective Italian prince. But by the 1650s the situation had largely sorted itself out. France, southern Germany, Flanders, and Spain were firmly Catholic and were clearly going to remain so; northern Germany, Scandinavia, Britain, and the Netherlands were just as clearly lost. Neither side had come out completely ahead or completely behind, and by the middle of the seventeenth century much of the fervor that had fueled the wars had died down.

The fading of the religious wars meant that the act of moving and setting up an obelisk was far less freighted in the 1660s or the 1720s than it had been in the 1580s. The genuine symbolic urgency associated with moving the Vatican obelisk had dissipated by the time Alexander VII set to reframing it in the 1650s. Alexander's colonnades – indeed his whole program of rebuilding the city of Rome along grand and serenely ordered lines – can

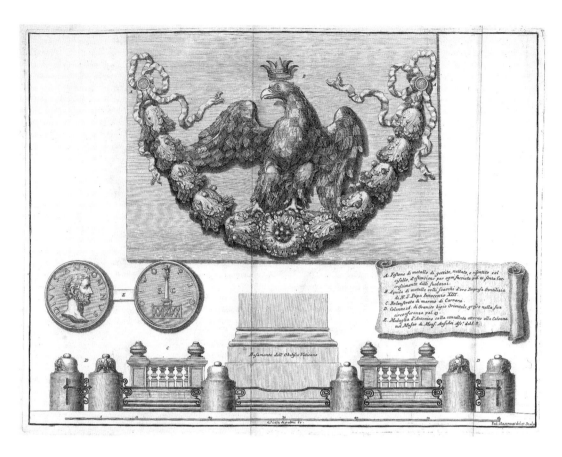

Innocent XIII's new ornaments for the Vatican obelisk.

birth name was Michelangelo dei Conti, decided to cover some ancient holes in the base of the obelisk with bronze festoons and eagles. At the same time, he had new handrails, also decorated with eagles, installed around the monument. In a short but pompous pamphlet explaining the new decorations, an anonymous author – probably Lodovico Sergardi, prefect of the basilica and the man who oversaw the work – explained that the design was intended to correct "some defects that, when examined carefully, are not a little distasteful to the delicate eyes of those most versed in the study of the fine arts."[8] The rest of the pamphlet gives a complicated explanation of how the new decorations reflect and harmonize, visually and intellectually, with the obelisk and its setting. Although the author pulled out all the stops, invoking Sixtus and Fontana and Bernini and the Romans and the Egyp-

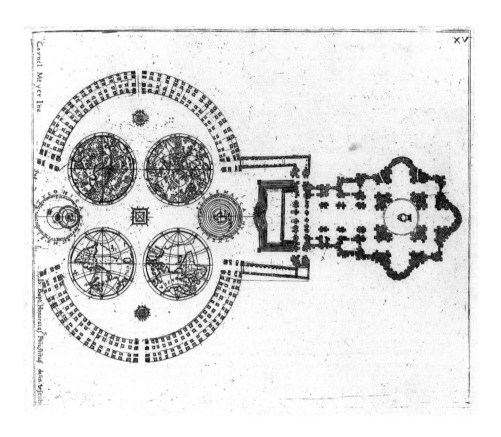

Meijer's cosmological scheme for the Piazza San Pietro.

hemispheres of the earth and the northern and southern hemispheres of
the heavens, as well as a group showing the cosmic "hypotheses" of Ptolemy
and Tycho Brahe (which feature an earth-centered solar system) and those
of Nicholas Copernicus and René Descartes (which are both sun-centered).
In what may be an oversight – or perhaps a calculated exclusion in the hope
his patrons might look only at the book's pictures – the print illustrating
Meijer's idea includes only the systems of Ptolemy and Tycho; the sun-
centered universe of Copernicus was, after all, still officially banned, even
if Jesuit astronomers had long since incorporated some of the results of
heliocentric astronomy in major churches at Rome and elsewhere.[7]

Meijer pitched his idea to both Innocent XI in the 1680s and Innocent XII
in the 1690s, but, like most of his schemes, the plan came to nothing. It was
left to Innocent XIII to set his mark on the obelisk. In 1723 Innocent, whose

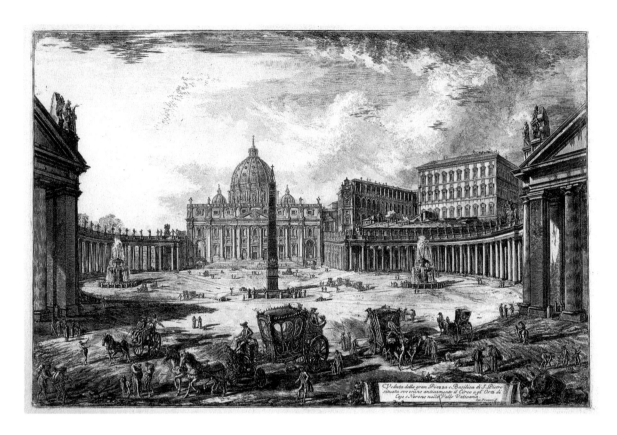

The Piazza San Pietro in a view by Giovanni Battista Piranesi from the 1750s.

the 1680s the Dutch engineer Cornelis Meijer issued a self-published book, ostensibly devoted to his scheme for guaranteeing the navigability of the River Tiber, which is prone both to silting up and flooding. Much of the book is, as promised, dedicated to the problem of river navigation, but Meijer had been all but blackballed by a rival, the Roman engineer and architect Carlo Fontana. Desperate for work, Meijer included descriptions of a half-dozen other engineering and architectural projects he had dreamed up.[5] Among these were schemes for putting the obelisk in the Piazza del Popolo to use as the gnomon of a giant sundial and a new design for the Piazza San Pietro.[6] Meijer suggested repaving the plaza as a gigantic cosmography in stone, using the obelisk as a centerpiece. Like the Universal church, the pavement would take in the whole of Creation. Arrayed around the obelisk would be six circles, one each inlaid with a map of the eastern and western

The Piazza della Rotonda, with
the Pantheon in the background.

can, that attracted the most frequent and ambitious redecorating schemes. Although Sixtus had moved the obelisk in 1586, the façade of St. Peter's was only finished in its current form in 1614, and the piazza in front of the basilica remained a scraggly mess into the 1650s. In that decade, Alexander VII seized his best opportunity to make a mark on the Vatican by commissioning, yet again from Bernini, the great colonnades that enclose the square. Bernini designed the piazza to highlight the relationship between the obelisk and St. Peter's, even going so far as to discuss the possibility of moving the obelisk again, to correct its compass position relative to the church (it's a bit south of the basilica's axis).[4] When Bernini's "arms" were finished, the obelisk, which had stood first beside and then in front of the basilica, was now in the most literal sense embraced by the sanctuary itself. Whatever ambiguity or tension about the relationship between pagan monument and Christian church might have remained after 1586 was erased forever in the new scheme.

The new piazza would seem to have foreclosed the possibility of anyone else leaving a mark in front of St. Peter's, but even Bernini's all-encompassing *mise en scène* did not discourage later architects or popes. In

A few obelisks remained within easy reach when Sixtus died in 1590 – the broken shafts near the Pincian gate and in the Circus of Maxentius, for example – but none was restored until the middle of the seventeenth century. Then, in 1650, Innocent X had Gianlorenzo Bernini set up the obelisk in the middle of the Piazza Navona. Fifteen years later Alexander VII put up another in front of the church of Santa Maria sopra Minerva, with Bernini again serving as architect. During the next century, Popes Clement IX, Benedict XIV, Clement XII, and Pius VI all tried to claim obelisks for themselves, though not all succeeded. None of these obelisks, save one, approached the size of those available to Sixtus. Perhaps in compensation, the architects entrusted with them often placed the stones in far more elaborate settings than Sixtus and Fontana had used. In doing so they followed the example of Bernini, who set Innocent X's Piazza Navona obelisk high atop the Fountain of the Four Rivers. With the obelisk raised far above the square, it's a safe bet few visitors notice it is several meters shorter than the one at the Vatican – if indeed they notice it at all amid the swirl of horses, palm trees, and river gods strewn about the fountain. Similarly, by placing Alexander VII's small obelisk on a stone elephant, Bernini gave added presence to this most diminutive of the genre.

While the supply of "new" obelisks may have been limited, the general process of urban renewal occasionally brought the opportunity to rededicate an older monument. The piazza in front of the Pantheon – the ancient temple to all the gods, adapted as a church to all the martyr saints – had been among the very first in Rome to be ornamented with Egyptian monuments, as far back as the twelfth century. In 1711 the need to repair the square's broken fountain provided Clement XI an opportunity to appropriate the little obelisk of Ramesses II, which still stood in its fifteenth-century location in the Piazza di San Macuto. Removed from that square, the obelisk was installed on a new fountain in front of the Pantheon, decorated with dolphins and large tablets carved with the arms of the pope.[2] The summit was topped with a cross and a star, symbols of the Albani, the pope's family. Designed by Filippo Barigoni, this new ensemble does double service, presenting the obelisk both as emblem of the pope and, through its association with the Pantheon, burial place of early Christian martyrs and more recent notables (including the artist Raphael), as a sort of funerary stele.[3]

Not surprisingly, though, it was the grandest of the obelisks, at the Vati-

Grandeur: Real and Delusional

I was given back to life on the thundering fiat of Pius, ordered to stand,
in good repair, over the unsurpassed statues of great Alexander. Proud
I shall be to proclaim to the ages how much he was smaller than Pius.

FROM THE ORIGINAL INSCRIPTION ON THE BASE OF
THE QUIRINAL OBELISK, CARVED FOR POPE PIUS VI IN 1786[1]

SIXTUS V HAD HIS PICK of Rome's obelisks. By the end of his pontificate nearly all the most important – and easiest of access – had been moved and re-erected. But just as the ancient Romans had set a standard of grandeur against which Renaissance popes could not help but measure themselves, so Sixtus set a measure for his successors. He may have been an especially vivid figure, but Sixtus had no monopoly on the devotion to self-memorialization. Unwilling to be outdone by a predecessor, later popes sought out their own monuments, sponsoring the excavation, restoration, and erection of ever smaller and more fragmentary obelisks as they emerged from the ancient detritus that littered the Roman landscape. Over the course of the seventeenth and eighteenth centuries most of the surviving obelisks of the ancient city were resurrected.

The Piazza San Pietro in a view by Giovanni Battista Piranesi from the 1750s (detail).

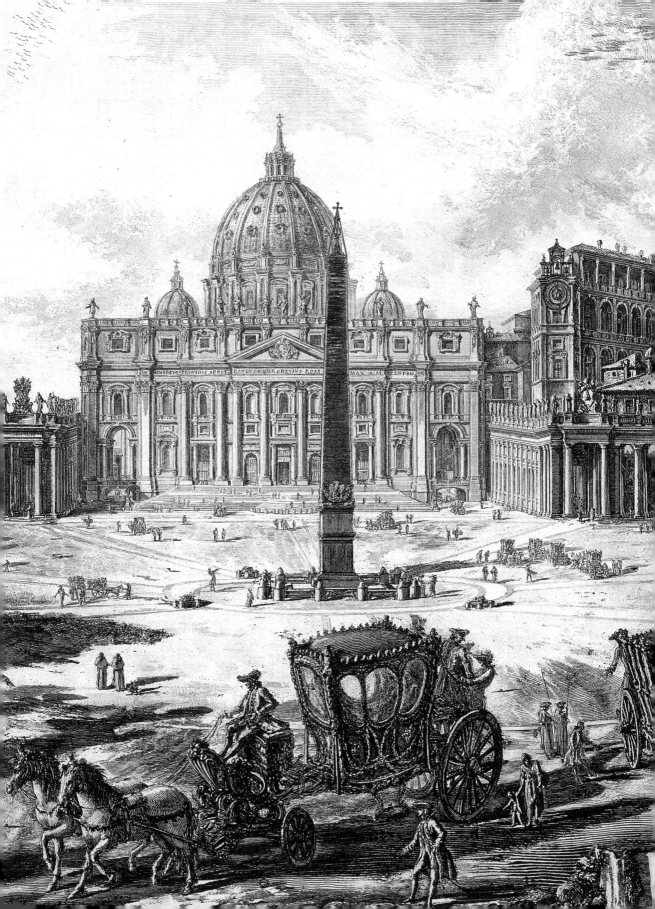

from Kircher and Schott. In the privacy of Kircher's museum, surrounded by model obelisks, stuffed armadillos, and those bones of ancient giants, Royer explained his art. He swallowed small sponges soaked in the various liquors he produced and squeezed them with his teeth to give the illusion that he could make water into vinegar or wine. The liquors that came out of his mouth looked and smelled as they should. Not surprisingly, he explained, none of his onlookers ever dared to subject them to the only definitive test – a tasting.

Delighted, Kircher and Schott willingly provided Royer with a certificate explaining that he achieved his results not with diabolic help but by natural means. He simply understood how to use his body as a sort of hydraulic machine – an organic automaton. In a way, Royer was exactly like the vomiting lobster Schott included in his 1657 book, *Mechanica hydraulico-pneumatica,* a splendidly illustrated exploration of hydraulic and pneumatic devices, both natural and man-made. The dead lobster, hanging over the edge of a chalice, emitted fluid from its beak, demonstrating the newly discovered principle of capillary action. Schott included Royer – the human being – in the same book. Like the ancient Egyptians, Royer used human means to work his magic – a practice that Kircher, as his mood determined, described sometimes as fraud and sometimes as the truest form that magic could take.[24]

In the 1580s, Sixtus V looked at obelisks with ambivalence. If their size, shape, and grandeur pleased him unequivocally, their Egyptian origins filled him with both fascination and horror. Yet in just a few short decades the obelisk metamorphosed from a bloody relic and dangerous survivor into the core of a positive performance of Egyptian magic as dazzling as *The Magic Flute.*[25] Working in a very different context and for very different popes, Kircher gradually removed the controls that had once kept the magic of the obelisks in check. It would remain one of their central features until magic itself gradually faded from the field of practices in which cultivated Europeans believed.

the works of ancient engineers like Heron of Alexandria – had used pneu-matics and hydraulics to obtain their effects. Speaking tubes had provided the statues of the gods with voices. Columns of water and other fluids had made them move and exude milk.[21] The fountain of the Piazza Navona – a dazzling piece of hydraulic engineering – thus exemplified the very Egyptian wisdom that the obelisk symbolized. And it did so in such a vivid, dramatic, and unexpected way that the very pope who commissioned the project, Innocent, found himself suspended in mystical rapture, *estatico,* when he first saw the fountain turned on.[22] The fountain not only celebrated but also demonstrated Egyptian magic at its best – a magic that challenged the very distinction between the organic and the mechanical. Even the Pamphili family dove that graced its summit probably recalled a creation of the ancient engineers – the flying wooden dove crafted by the Greek mathematician Archytas of Tarentum, a working model of which Kircher and his friend and colleague Gaspar Schott lovingly crafted.[23]

Contemporaries – even less-learned ones – seem to have heard the mes-sage that Kircher wanted his obelisk and fountain to speak. Certainly the conjurer Jean Royer, a sort of seventeenth-century Ricky Jay, did so. Shortly after 1650 he appeared in the Piazza Navona. Showing a skilled eye for a dra-matic setting, Royer took his stand in what Bernini and Kircher had trans-formed from a market square into the baroque city's sunlit central theatre, where high-ranking prelates and noblewomen took the air in carriages and sedan chairs. Standing next to the marvelous mechanical fountain, Royer challenged it. A professional regurgitator, he convoked slack-jawed crowds in the piazza, swallowed gallons of water, and then sprayed out streams of whatever liquid the members of his audience asked for: perfumed oils, vinegar, even wine. Like the modern street performers who use cosmetics and costumes to imitate statues in the same piazza, Royer played deftly with the distinction between art and nature.

But Royer's performance was more dangerous than those that nowadays take place on Sundays in the piazza. For he also toyed with the borders that separated magic from science and the natural from the demonic. In mid-seventeenth-century Rome, the citadel of the Counter-Reformation *ecclesia triumphans,* fountains could shoot foam-flecked arches of water into the air, but only priests could properly transform wine into blood. Challenged to show that he did not rely on diabolic collaboration, Royer sought help

While I went through the books [in Würzburg] one-by-one . . . , chance or providence led me to hit upon a book, in which all the Roman obelisks that Pope Sixtus V had set up in the city were elegantly represented with their hieroglyphical figures. Immediately fascinated, I tried to work out what sort of figures those were, for I thought that the sculptor had put them there arbitrarily. But the text informed me that those figures were monuments of ancient Egyptian wisdom, inscribed since time immemorial on these surviving obelisks at Rome, and that no one had given an explanation of them, since the knowledge of them had been lost. Longing possessed me, as a hidden instinct drove me to see if I could apply myself to knowledge of this sort. And from that time to this, I have never abandoned my intention of arriving at them. For I thought in the following way: the characters survive, the genuine Egyptian ones. Therefore their meanings must also be hidden somewhere even now, scattered in the innumerable works of the ancient authors. If they are not to be found in the Latin and Greek writers, perhaps they are in the exotic books of the Oriental writers. From that time to this, I began to examine all the texts of those authors, in the hope that I could restore the whole body of the Egyptian religion, by collecting the fragments of their learning that were scattered everywhere.[20]

Kircher would spend his life collecting and repairing the broken fragments of a lost tradition. He succeeded marvelously at this task, and made clear in vast, erudite, impressive books, as well as in the great projects he carried out with Bernini that the Egyptians had cultivated an essentially monotheistic theology and a profound natural philosophy, from both of which Christians could still learn much. Providence, Kircher argued, guided all of his excavations so precisely that they took on a magical quality of their own. The obelisks had been not naturalized, but supernaturalized – with all their accoutrements of hieroglyphs and magic.

More important than the messages Kircher found in the obelisks were the jobs he made them do – especially in the Piazza Navona. The Egyptians had been the masters of magic; this Kircher knew from Hermes, this the obelisks themselves confirmed. Egyptian magi – as Kircher inferred from

Kircher thus viewed his reconstruction of the obelisk as a holy mission, one realized in the teeth of ferocious opposition from pretty much everyone but the pope. Other antiquaries appear in his story as no more than jeering, diabolic figures, and Bernini, whose assistant, Antonio Canini, actually carved the red-granite restorations, makes no appearance at all. The text is of interest in one crucial respect. Egyptologists long ago noted that, though the shaft of the obelisk seems perfectly intact, Antonio Nibby discovered three fragments of it in 1825, and others have turned up since. Kircher's account makes clear that the whole antiquarian community of his time knew that the obelisk contained restored segments, and that the fragments they corresponded to were already in the museums of collectors.

Kircher was one of the most erudite men in Europe's great age of polymaths. His skills in mathematics and natural philosophy won him a European reputation, as well as at least one accusation of practicing magic. His all-embracing historical and philological interests expressed themselves in works of textual exegesis as unbelievably long and learned as they were varied in subject matter – works that shed light on everything from the route followed by Noah's ark during and after the Flood to the achievements of the Nestorian Church in ancient China. Kircher not only pursued the historical relation between the ancient Egyptian language and Coptic, but also collected giants' bones, explored volcanoes, and experimented with magnets. As a scholar he adopted one of the characteristic styles of his erudite and cosmopolitan age – that of the polymathic dinosaurs who made the world into their own Pedantic Park. They wrote more than any of us now has time to read, and read more than we can now imagine. The hot pursuit of learning was their passion – one that sometimes induced them to lower the political and confessional boundaries that normally separated them from their enemies, as Kircher himself did when he invited Protestant scholars like John Evelyn to inspect the ancient inscriptions and shin-bones of giants stored in his celebrated museum at the Collegio Romano.

In Kircher's view, however, the diversity of his pursuits was only apparent. In fact, God had propelled him along a clear trajectory towards a single goal. Not only had divine providence reached down and inspired him with prophetic knowledge: it had also given him a scholarly vocation. As he put it years later:

Let any beholder of the carved images of the wisdom of Egypt on the obelisk carried by the elephant, the strongest of beasts, realize that it takes a robust mind to carry solid wisdom.[17]

With a wicked flourish, Bernini and his adviser placed the elephant so that his bottom and trunk – which mimicked an insulting gesture known to all Italians – pointed squarely at the Dominican residence in whose gardens the obelisk was found. With this material and easily readable act of defiance, the speculative Jesuit cocked a snook at his order's frequent nemeses, the censorious Dominicans.[18]

In his autobiography Kircher made clear that he saw his great projects as a three-dimensional, material *summa* of Europe's multiple ways of dealing with and learning from obelisks. He described the Fountain of the Four Rivers, to begin with, as a straight archaeological project, the result of the pope's fascination with the obelisk recently discovered in the Circus of Maxentius: "The obelisk was defective at many points, and a fair number of the figures were absent. His Holiness wished the obelisk to be restored. So he gave me the task of filling all the gaps that cropped up, to the best of my knowledge." But Kircher also noted that only providential help had enabled him to carry out his task, since the other experts in the city had conspired against him:

At this point a remarkable event occurred. As it has to do with divine providence, I am compelled to mention it. All the fragments and figures that were missing from the obelisk were in the hands of the antiquaries. When they learned that the pope wanted the figures to be restored in the broken parts, behold, they rose up against me. Now, they said, let's see if he really understands the hieroglyphs, and if he can really supply all the figures. The light of divine grace, bestowed upon my unworthiness, and the expertise that I had acquired over many years, enabled me to fit the figures to their places, so that, when the obelisk was erected and they very minutely compared the figures I had supplied to the remaining fragments, they found nothing foreign in the true one. Then, forced to a posture of admiration, they could not believe it was possible, unless the Supreme Being by a singular act of grace had given me the key to this literature for which we had longed until now.[19]

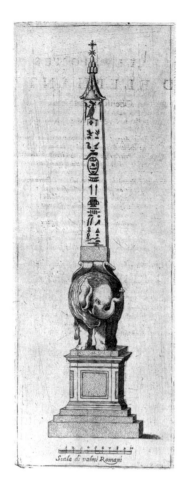

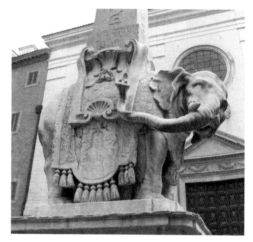

Bernini's elephant and obelisk, in Kircher's
Obelisci Aegyptiaci . . . Interpretatio,
and outside Santa Maria sopra Minerva.
See page 97 for Bernini's source.

pharaoh Apries (589–570 BCE) of Dynasty 26 – in the gardens of the Domini-
can convent at Santa Maria sopra Minerva brought Kircher and Bernini
together once again. By this time the reigning pope was Alexander VII,
Kircher's old friend Fabio Chigi. The product that Bernini and Kircher
eventually produced is perhaps the most engaging of all modern obelisk
ensembles.[16] For the basic idea, Bernini and his assistant, Ercole Ferrata,
translated the famous elephant-and-obelisk woodcut from the *Hypneroto-
machia Poliphili* into three dimensions. As Kircher interpreted it, the result
constituted a moral hieroglyph that Christians could learn from without a
single qualm. The inscription on the base facing the church explains the
sober moral of Bernini's wonderful, exuberant sculpture and the obelisk
it raises to the sky:

it had been encrypted formed the special task that Kircher set for himself, and which he came to see, as a good Jesuit should, as a divinely assigned vocation. He was, in effect, the modern Trismegistus.[12]

Imposing as it was, *Obeliscus Pamphilius* was only a prelude to Kircher's spectacular multi-volume epic, the *Oedipus Aegyptiacus,* or *Egyptian Oedipus* (1652–54), a work whose very title announces the author's claim to have solved the riddle of the Egyptian sphinx. In addition to an amplified retelling of his history of the hieroglyphic tradition, the book includes an illustrated catalogue of virtually every Egyptian monument and artifact known at that time, and provides, for the majority of them, sign-by-sign translations of their hieroglyphic inscriptions.[13] Kircher's bold "decipherment" of the Mensa Isiaca, which he explains as a cosmological and theological table, stands in stark contrast to Pignoria's more cautious approach.[14]

From a modern perspective, of course, Kircher's translations are all wrong, thanks to his continued allegiance to the notion that the hieroglyphs encoded the Egyptian doctrines in veils of allegory and enigma. In more specific terms, Kircher argued that the hieroglyphs functioned on a hierarchy of levels. At the lowest, simplest level, the individual signs stood phonetically and figuratively for the thing represented. These simple hieroglyphs served the most elemental and practical functions of language and were suitable for use by the ignorant masses. They also provided models for the development of cursive and alphabetic script, including Coptic and Greek letters. Indeed, Kircher identified several signs as alphabetic equivalents of Coptic letters and words, including the rippling water hieroglyph, which he correctly associated with the Coptic word for water, thus establishing himself as the first post-antique scholar to identify the phonetic meaning of an Egyptian hieroglyph.[15] But Kircher did not – could not – stop there. For his real interest lay not in the mundane world of ideographic and alphabetic signs, but in more lofty realms. It was in the other three "levels" of hieroglyphic meaning (as he defined them) – the natural-philosophical; the tropological; and the anagogical – that Kircher sought the allegorical method and theological meaning of the sacred writing.

In its scale, breadth of learning, and sheer ambition, Kircher's *Egyptian Oedipus* marked the climax of the Renaissance response to Egypt and its obelisks. But his work with obelisks was not yet done. In 1665 the discovery of the Minervan obelisk – a diminutive specimen inscribed for the

Paradigma Lectionis hieroglyphicæ .

Iuxta sensum proprium ita lege .		*Iuxta sensum mysticum ita lege* .
Anima Mundi vita rerum .		Hemphta supramundanum Numen, Sol Archetypus .
Totius orbis moderatrix .		Ofiris .
Cœlorum orbitas .		Genij cœleftes .
Solem .		Horus .
Lunam .		Ifis .
Elementa .		Dæmones fublunares velati per potentem .
Amore connectit & in fuo effe conferuat .		Amoris catenam trahuntur alliciunturque .

Varia Scarabæorum forma . Scarabæum , quem Græci à Sole Heliocantaron , & à felis forma æluromorphum vocant, Aegyptijs hieroglyphicum fuiffe , quod Solem indicaret , eiufque effigiem genuinam , non duntaxat hieroglyphicorum Obelifco præfenti infcriptorum , fed & irrefragabilia ex omni antiquitate , vetuftifque hiftoriarum monumentis allata teftimonia , fatis fuperque demonftrant . Atque vt alios innumeros omittam, teftantur luculentiffimis fanè verbis Suidas & Ælianus , Sacerdotes Aegyptios , Scarabæos fingulari quodam cultos , facris Obelifcis infculpere folitos ; quibus adftipulatur Abenephi de Antiquitatibus Aegyptiorum, dum fic ait : *Aegyptij Philofophi ad Solis denotandam excellentiam , Scarabæos paffim faxis infculpebant* . Verba eius funt : الحكما مصر فلما يريدون ان يدلون
الفضلة الشمس وذقشوا في العكار الصوره الخنفسه
Sapientes Aegypti excellentiam Solis significaturi in faxis infculpebant Scarabæum . Cui Manethon quoque in naturalium epitome , & Hecatæus de Aegyptiorum philofophia à Diogene Laërtio citati , de vitis philofophorum confentire videntur : *Aegypti* , inquit , *eiufmodi philofophiam de Dijs ac iuftitia dixere; materiam primam principium fuiffe rerum , & elementa difcreta , perfectafque complures animantes , Solem & Lunam Deos effe , alterumque Ofirim , alterum Ifim appellatos exprimere autem illos per Scarabæum & draconem (melius ferpentem aut afpidem) faxis infculptos* .

Eufe-

Kircher's levels of meaning, with simpler readings to the left of the signs and more complex ones to the right, from *Obelisci Aegyptiaci . . . Interpretatio.*

Idealis Lectionis
contextus.

Schematismus H. Lateris
secundi Meridionalis.

1 Polymorphus naturæ Genius 2 vſum rerum Meridiei ſubiectarum inferioribus 3, partibus neceſſariũ, primò ex 4 tribus Mundis, Triformis 4 Numinis vi &influxu, deriuat in 5 craterem 6 omniuidentis 5 Numinis, oculi cæleſtis 7 Mundo inuigilantis, & 7 dominantis inferioribus; deindè in Mundos 8 hylęos deriuat per 9 globum Lunarem. 10 Lunaris verò Genius hunc in 12 incremẽtum humidi, deſtinat ſubterraneis 11 receptaculis adytorum, quæ mundũ inferiorem exhibẽt, ad hos verò Genios propitiandos hæc ſacra ſignorum tabula ordinatur. *Not\#a, nos ſacram tabulam eam hìc dicere quæ omnia illa ſymbola, quali figuræ inclaſa continet.*

13 Abditus & inuiſibilis motus, proceſſuſque 15 cœleſtis. 14 Oſiris, per 16 Mophta 17 beneficum, quadruplici. 18 2t dominio 18 cęli inſignem, in inferis affluxũ 22 ſacri humoris actuat, vndè 23 agri fæcundati coluntur 22 velocitate & beneficentiâ Numinis ; 25 humidum. 26 quadruplici pariter dominio & in 27 quadruplicem inferioris Mundi plagam 28 potens, ſeminalium 29 rerum rationes per 30 Iſidem diſponit, ac proinde ſacro ritu 31 celebrari & coli debent.

Rationes myſticas ſingulorum in præcedentibus vide.

 SCHE-

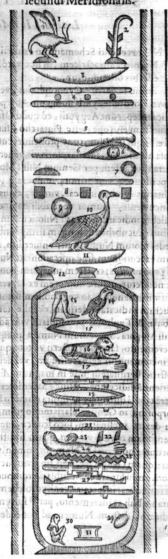

Kircher provides a detailed, if mostly imaginary, history of the obelisk, from its manufacture by the (non-existent) Egyptian Pharaoh Sothis in the fourteenth century before Christ to its transport to Rome by the Emperor Caracalla in the third century CE. A long discourse on the origins of the obelisk as a monumental type and the parallel development of the hieroglyphs follows. The book concludes with a sign-by-sign, illustrated translation of the obelisk's inscriptions. Each is individually labeled, and the overall meaning, a dense web of esoteric and religious-sounding pronouncements, is provided in a parallel Latin text.[9]

In its scope and cast of characters, Kircher's history bears some comparison to the work of Annius nearly two centuries earlier. Like Annius – whose *Berosus* he cites as an authentic text – Kircher ascribes the foundation of Egyptian civilization to Noah's son Cham, who in Kircher's version is identical to Osiris.[10] But Kircher traced the origins of Egyptian wisdom even further back, before the Flood, to the sacred knowledge imparted to Adam in the Garden of Eden. These doctrines, Kircher argued, had passed directly to Noah from the Adamic source. Alas, Cain invented and passed on an alternate, corrupt version, which included the heresies of idolatry and black magic. It was the great error of Cham-Osiris to combine both of these traditions, the good and the bad, which he passed in turn to his son, Misraim the Egyptian.[11]

Taking things yet further, Kircher identified not one but two Egyptian sages named Hermes. The first of these he credited with the invention of the pyramids, which he constructed to preserve his country's most exalted doctrines from the effects of calamitous floods. Kircher singled out the second Hermes – Hermes Trismegistus – as the author of the *Hermetica*. This second Hermes endeavored to purify the doctrines inherited by his people and return them to their uncorrupted truth. He also devised the obelisks and the hieroglyphs to encode and preserve the reconstituted doctrines for posterity. Despite his best efforts, this tradition was contaminated by the misunderstandings of later generations, who once again fell into idolatry and superstition. Over the intervening centuries, however, the more enlightened sages and philosophers of ancient Greece recognized and adopted the true doctrines. And so a glimmer, at least, of the original revelation to Adam was preserved in the philosophies of later peoples. The restoration and purification of this doctrine, and the decipherment of the hieroglyphic code in which

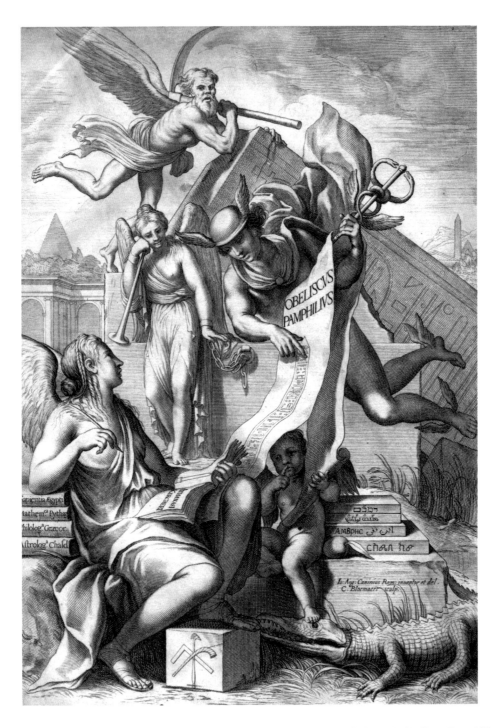

Hermes Trismegistus explains the mysteries of the obelisk, on the title page of Kircher's *Obeliscus Pamphilius*.

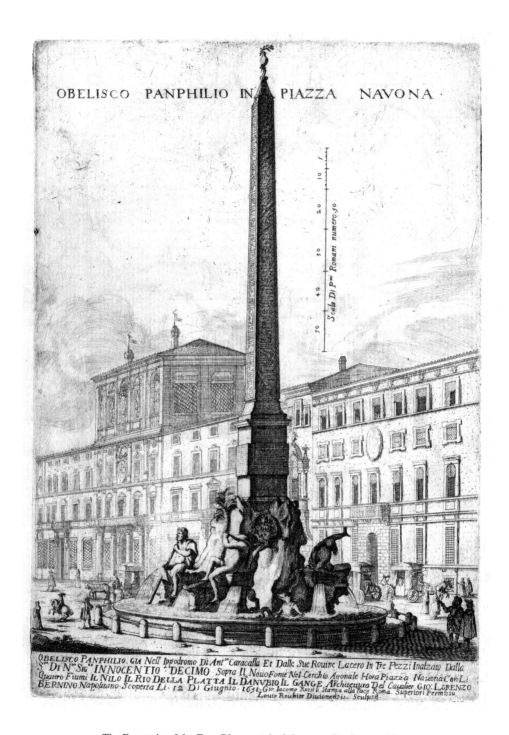

The Fountain of the Four Rivers, etched the year after its unveiling.

Egyptian sages and the magical powers of their hieroglyphic symbols. So in addition to his studies of Coptic, Kircher scoured the *Hermetica* and other late-antique, Neoplatonic materials – as well as a mysterious source in Arabic to which he often referred, but which he seems in fact to have conjured into being out of his own soaring imagination – for clues to decode the hieroglyphs.

He released his first tentative study, the *Prodromus Coptus sive Aegyptiacus,* or *Coptic Forerunner,* in 1636. Among other things, in this work he provided a sample decipherment of a human-headed scarab from the Mensa Isiaca. Kircher continued working, and in 1646 published a more extensive treatment of his Coptic material, the *Lingua Aegyptiaca Restituta,* or *Egyptian Language Restored.* By this point Kircher was fully convinced of his ability to read the hieroglyphs and had become Rome's reigning expert on all matters Egyptian. So a few years later, when Pope Innocent X set out to make the broken obelisk in the Circus of Maxentius the centerpiece of a cosmically grand fountain complex in the Piazza Navona, he naturally turned to Kircher for advice. Kircher was assigned to supervise the excavation and repair of the shaft. He also composed Latin inscriptions for its new base, interpreting its message as a benevolent one about the life-giving forces of nature. The fountain itself – a magnificent piece of work by Gianlorenzo Bernini – evoked the powers and harmony of nature. The rocky base on which the obelisk stands also bears vivid personifications of the four great rivers of the world: the Ganges, the Nile, the Danube, and the Plate. The caverns that split the base, as Ingrid Rowland has shown, represent the vast caverns inside the earth, which, in Kircher's cosmology, held and released its waters – as well as the rocky hills and mountain springs of Lazio (the region around Rome), which the pope manipulated with aqueducts and fountains to benefit the citizens of Rome. In Kircher's reading of the hieroglyphs, the modern sculptor's program precisely mirrored the meaning of the Egyptian enigmas carved on the obelisk's side.[8] Egypt itself, so it seemed, was reemerging – next to the tamer, exorcized Egypt of the Sixtine projects – onto the Roman cityscape.

Kircher commemorated his work on this project with a scholarly counterpart to Fontana's book on the moving of the obelisks: the publication of his own first truly monumental work on Egypt, the *Obeliscus Pamphilius* of 1650. In the 560-plus pages of this richly illustrated book,

Hemphta Numen supre- | mum & Archetypon
influit virtutem | & munera sua

in siderei Mundi ani- | mã, id est solare Numé sibi subdit ũ

vnde vitalis motus in | Mundo Hylæo, siue Elementari,
omniumque rerum abun- | dãtia, & specierũ varietas prouenit.
ex vbertate Cra- | teris Osiriaci, in quem mira
quadam sympathia | tractus continuò influit

duplici in sibi sub | dita dominio potens.

Vigilantissimus | Chenosiris
sacrorum canalium | custos, idest Natu ræ humidæ
in qua vita rerum | omnium consistit.

Ophionius | Agathodæmon
ad cuius fa- | uorem obtinendum

vitamque pro- | pagandam
Sacra, hæc ei | Tabula consecranda est;
cuius beneficio cæleste | Heptapyrgon idest arx planetarum
diuini Osiridis | Agathodæmonis humidi

assistentia ab om- | nibus aduersis conseruatur.

Præterea in sacri- | ficijs & cerimonijs in hunc
finem eiusdem | statua circumsetenda est;

Eparisterium Naturæ | siue fons Hecatinus, siue vetigineus
id est Naturæ efflu- | uium inter sacrificia aperiendum.

Quo allectus Poly- | morphus Dæmon, vberem (do
| rerũ cõcedet in quadripartito Mũ-
varietatem | vitæ insidiatrices, elidentur

Typhonis technæ | vitæ insidiatrices, elidentur

Vnde vita rerum | innoxia conseruabitur
ad quod plurimum | quoq;conducét hæc, quæ sequútur

pentacula, siue | periammata, ob mysticas

rationes, quibus | constructa sunt.

sunt enim viæ | bonorum omnium

acquirendorum potentes | illecebræ.

Reading hieroglyphs, from Kircher's *Obelisci Aegyptiaci . . . Interpretatio.*

Herwart von Hohenburg – a man who tormented Joseph Scaliger and Johannes Kepler for decades with strange questions about ancient chronology – included the Mensa in his *Thesaurus Hieroglyphicorum,* the first printed collection of hieroglyphic inscriptions.[4] This important but little-known book, originally intended to be accompanied by an interpretive text, included illustrations of the inscriptions on the obelisks, the Pantheon lions, and other Roman specimens, as well as a full-page engraving of the Mensa. On that engraving Hohenburg described the Mensa's figures as symbols of the thirty-three points of the compass. This idea was based on no Egyptian evidence of any kind. Nonetheless, it remained in circulation and was elaborated upon some years later when Herwarth's son published a treatise that explained the Mensa as a kind of hieroglyphic nautical map of the world.[5]

It was Hohenburg's style of imaginative license that set the tone for much of seventeenth-century Egyptology. To be sure, interpretive reticence of Pignoria's sort was always in short supply during the later sixteenth and seventeenth centuries, but it was nowhere to be found in the voluminous works of the most celebrated Egyptologist of the seventeenth century, the Jesuit polymath Athanasius Kircher, who turned his life's work as scholar and philosopher into one long meditation on obelisks.[6] Born in central Germany in either 1601 or 1602 and educated at Würzburg, Kircher eventually moved to Rome, where he became the central intellectual figure in the Jesuits' Collegio Romano. There he read omnivorously, mingling in one turbid pool the multiple streams of information about the natural world and human history that flowed in from his brother Jesuits around the world. Over the course of a long and varied career, Kircher returned over and over again to the subject of Egypt and its obelisks. Immediately after his arrival in Rome in the fall of 1633, Kircher took up the study of Coptic, the language of Egyptian Christians. With the help of the brilliant French scholar Nicholas-Claude Fabri de Peiresc – an avid collector of texts and antiquities, including Egyptian ones – as well as some ruthlessness on his own part, Kircher more or less mastered the language.[7] Like Joseph Scaliger and Pietro della Valle, Kircher saw that Coptic represented a late form of the ancient Egyptian language and thought that fact might hold a key to deciphering the inscriptions. His insight was prescient, but Kircher also believed as firmly as any of his predecessors in the wisdom and piety of the

less by Sixtus's ardently proclaimed religious triumph over pagan relics than by the sheer magnificence of the shafts themselves, for much of the new attention was devoted not to the theme of Christian triumph, but to the object of that triumph – the Egyptian religion and intellectual culture the obelisks embodied.

The new fascination with Egypt did not, of course, generate a new uniformity of approach or opinion. Scholars were still working with the same tools and the same sources, none of which gave a clear key to the meaning of the obelisks or the inscriptions they bore. The varied treatment of the Mensa Isaica is a case in point. The Mensa was an inlaid bronze table-top of Roman date that bore images of Egyptian gods and orthographically accurate but literally meaningless hieroglyphic inscriptions. Those inscriptions, ironically, became the focus of much study by scholars seeking a key to reading Egyptian script.[2] Known since at least the beginning of the sixteenth century, the Mensa was sketched and engraved many times. Drawings seem to have been in circulation already by the early 1520s, when the tablet entered the collection of the poet Pietro Bembo. In 1605 the Paduan humanist Lorenzo Pignoria published a monographic study of the Mensa. Pignoria was cautious and, like Mercati before him, viewed the hieroglyphic system as a hopelessly lost code, warning his readers that he would not follow the imaginative model of predecessors like Valeriano (although the latter's work is duly cited in Pignoria's text):

> I will describe to the best of my abilities the figures of this tablet, and not allegorically [*non allegorikos*] but rather based upon the ancient accounts. Indeed, I detest more than anyone the far-fetched interpretations of the Platonists, based on tenuous tales and almost ignoring the teachings of their master. And I have chosen to confess my ignorance rather than offend the erudite reader any longer.[3]

True to his word, Pignoria limited his discussion to iconographic explanations of the figures of gods and mythical creatures, based mainly on descriptions of these figures compiled from the ancient authors. The hieroglyphs themselves he passes over with hardly a word.

Others were not so circumspect. Around 1610, one of the most committed of the new students of Egypt, the Bavarian chancellor Johann

Baroque Readings: Athanasius Kircher and Obelisks

*A hidden and unseen movement and a progress of the heavenly Osiris
through the beneficent Mophta, distinguished by fourfold rule of the
heavens, drives a flood of heavenly moisture in the lower world, and
the fields made fertile by this are cultivated by the swiftness and good-
ness of the Divinity; and the moisture . . . arranges through Isis the
principles of the seed powers . . .*

ATHANASIUS KIRCHER'S TRANSLATION OF HIEROGLYPHS ON
THE PIAZZA NAVONA OBELISK, FROM *Obeliscus Pamphilius* (ROME, 1650)[1]

WITH IMAGES of Isis, Osiris, and Hermes Trismegistus painted
on the very walls of the Vatican, by 1600 few would have seen
fit to echo Guarino of Verona's ridicule of Niccolò Niccoli and
his obsession with obelisks. Thanks to Sixtus and Fontana, the largest and
most celebrated of Rome's obelisks had risen from the rubble to adorn a
revitalized city of wonders. In the decades after Sixtus's death those obelisks
came to new prominence in the eyes both of visitors to Rome and readers,
Catholic and Protestant alike, of Fontana's magnificently illustrated pub-
lication about the move. Those visitors and readers were perhaps inspired

Alexander VII's obelisk resurrected, on the title page of Kircher's
Obelisci Aegyptiaci . . . Interpretatio.

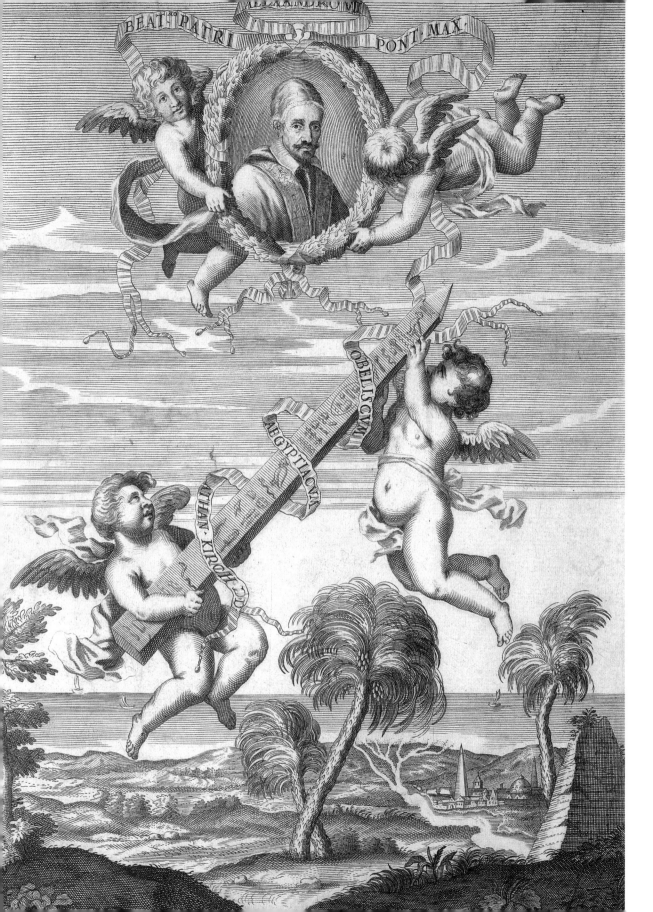

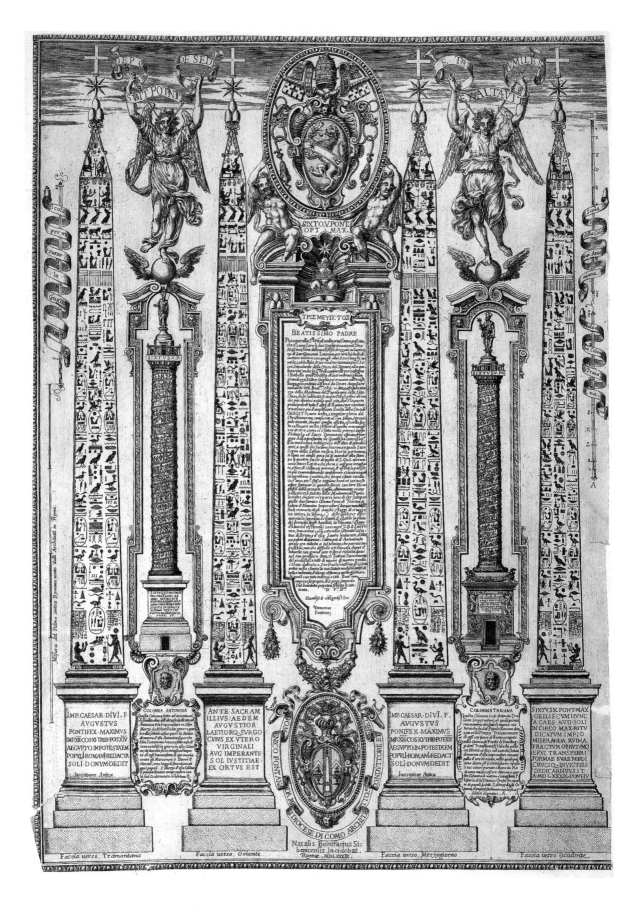

enterprise as a laudable effort to revive the best of barbarian culture: a triumph of "Wandalic emulation."

In fact, the evidence suggests that Sixtus discreetly shared at least some of the assumptions and interests that a humanist like Mercati brought with him when he contemplated Egyptian antiquities. After Fontana raised the Piazza del Popolo obelisk, he published a print in which he recorded its inscriptions with minute care. A long legend in Italian explains that he had done so in the hope that learned readers might be able to use these precise images to decipher the arcana of the lost wisdom of Egypt. And a title in Greek dedicated the work to Sixtus, whom Fontana described – splendidly – as "trismegistos" ("thrice-greatest") – a reincarnation of the ultimate Egyptian sage, Hermes himself. The connection was appropriate. Sixtus, whose own prime weapon in the culture wars of the late sixteenth century was magnificence, found it easy to identify with a predecessor who had given so vivid a demonstration of that quality with the obelisks.

Sixtus's hidden admiration for the very beliefs he set out to suppress was hardly isolated, even among members of his immediate circle. Cesare Baronio himself added a last-minute reference to Hermes's prophecy of the coming of Christ to the manuscript of his *Annales* of church history – as grand a statement of Counter-Reformation views as Sixtus's building projects.[45] A positive view of Egypt even found its way to the very center of Sixtus's great program of renovation at the Vatican. Amid the splendor of the Salone Sistina, the great hall of Sixtus's new Vatican Library, the designers of the decorative program of frescoes made sure to include among their imaginary portraits of the inventors of letters and writing no fewer than three Egyptian figures: the Goddess Isis, the "Egyptian Hercules," and Hermes Trismegistus himself, described so:

MERCURIUS THOYT AEGYPTIIS
SACRAS LITTERAS CONSCRIPSIT.

Mercurius Thoth devised sacred letters for the Egyptians.[46]

The Piazza del Popolo obelisk, with Sixtus as "thrice-greatest" Hermes.

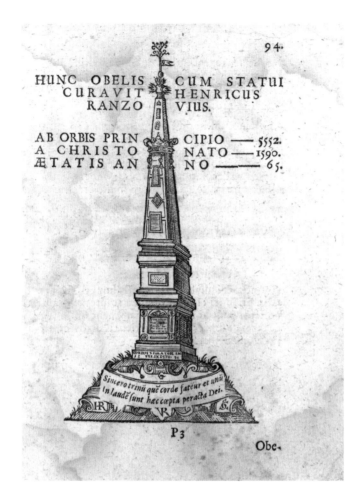

Rantzau's obelisk, recorded in Peter Lindeberg's
Hypotyposis arcium palatiorum of 1592.

Instead, he erupted with enthusiasm. Shown an illustration of Rantzau's obelisk, he "warmly praised Rantzau's magnificence and Wandalic emulation, and confessed that he, who merely set up ancient obelisks, had been far surpassed by Rantzau, who carved new ones, on a grand scale, from the mountains themselves."[44] In the privacy of his study, the pope could confess what all his carefully coordinated public gestures strove to deny – that he, too, admired the "magnificence" of the ancient Egyptian obelisks. Like Bramante, almost a century before, Sixtus appreciated the obelisk for its grandeur, its rhetorical force. And he clearly described Rantzau's

No wonder, then, that the Vatican obelisk hovered so fascinatingly before the mind's eye of that obsessive, paradoxically puritanical figure, Sixtus V. When he set out to make the Vatican obelisk and its siblings harmless, Sixtus was combating attitudes that flourished in his own curia. Yet the story has one more twist. It has long been understood that Sixtus was an enthusiastic connoisseur of obelisks. In the late winter of 1587, for example, when fragments of a large obelisk came to light in the Circus Maximus, he made a special expedition to see the shaft and examine the inscriptions on its base – just as fifteenth-century patrons like Lorenzo de' Medici, whose attitudes towards ancient barbarians were much friendlier than his, had done.[40] What historians have so far failed to realize, however, is that Sixtus actually admired obelisks – and admitted as much, though not in public.[41]

One of Sixtus's contemporaries, the Danish humanist Heinrich Rantzau, was a scholar of encyclopedic interests and a patron of both old and new forms of learning. He sheltered Tycho Brahe, for example, during that great astronomer's move from Denmark to the Imperial court at Prague. Typically for his period, Rantzau took a strong interest in both humanistic and scientific pursuits, and as a historian he studied material remains as eagerly as texts. He assembled a remarkable museum and a great library. And finally, like Sixtus V, he saw antiquarianism and architecture as intimately connected arts. Accordingly, Rantzau excavated and published some early medieval tumuli discovered on his estates, and celebrated the barbarian cultures that had once flourished in his part of the world. He also erected, on his estates at Nordoe and Segeberg, two pyramids and an obelisk, the latter explicitly modeled on the obelisk Sixtus had moved from the tomb of Augustus to Santa Maria Maggiore.[42] When Rantzau published illustrations and accounts of these achievements, he made clear his belief that the barbarians of northern Europe had devised an alien wisdom – and a profound and original way of writing – that challenged comparison with those of the Egyptians. The way was thus laid open for the great Olof Rudbeck, who would argue, some decades later, that ancient Sweden had been Plato's Atlantis.[43]

Sixtus reacted to Rantzau's accomplishments in a most revealing way. He could have condemned the erudite Protestant – as the church would soon condemn Bruno – for reviving paganism, Egyptian and northern alike.

ter Hanno in Plautus's play *Poenulus* (*The Little Carthaginian*) hardly enabled modern scholars to reconstruct that ancient language, Agustìn insisted, so the few dozen definitions given by Horapollo certainly could not put a modern scholar in a position to understand whole texts. Mercati, in contrast, took a positive and even hyperbolic approach to the issue. The Egyptians, he argued, had understood life, the universe, and everything so profoundly that they had been able to predict the future rigorously. To read their texts in detail, one would have to master their lost sciences – a task he considered too ambitious to be carried out. In the absence of living witnesses to the Egyptian tradition, or full translations of their works, one could not hope to crack their hieroglyphic codes.

Nonetheless, Mercati still thought it possible to fix the general character of the inscriptions that most obelisks had borne. True, Diodorus and Ammianus Marcellinus had reported, prosaically, that obelisks recorded historical events, commemorating the deeds of individual pharaohs. But others, such as Pliny, claimed that the carvings on the obelisks conveyed the core truths of Egyptian religion and natural philosophy. And Hermes Trismegistus himself predicted, in the *Asclepius,* that after Egypt was destroyed only the words sculpted in stone would survive to attest to the pious works – the *opere pie* – of the Egyptians. Indeed, even the Greek name for Egyptian writing – hieroglyphs, or sacred letters – suggested that their content must be religious. Moreover, the sciences began to flourish in Egypt at a very early date, since there were already interpreters of dreams and portents there when Joseph arrived.[37] The Egyptian priests, Mercati decided, "used this mysterious manner of writing to inscribe the most important principles of their sciences in certain stones, appropriate to the sciences in question, to preserve their memory for the long term."[38] Taken together, then, the evidence showed that the Egyptians had used their obelisks to record their religion, the secrets of their astrology and medicine, and their requisite predictions of the future, as the Chaldeans and Phoenicians had also done. Only in later times did they devise "that second way to use obelisks, dedicating them to men illustrious for their virtues and (as still happens nowadays) to please the present king."[39] For Mercati, then, the obelisks and their inscriptions constituted a tragically encoded record of a lost astrology more accurate than any existing one – a permanent stimulus, as it were, to nostalgia for an irretrievably lost age.

whose pupils visited Rheticus in Cracow and wrote enthusiastically to his master. Ramus tried to bring Rheticus to join him at the Collège Royal in Paris and stuffed his own *Scholae mathematicae* of 1569 with detailed, laudatory references to the lost "astronomy without hypotheses" of the Egyptians, which flanked highly critical discussions of the feebler astronomy of the Greeks.[33] By so doing, Ramus dramatized and provided contemporary weight to Herodotus's ancient vision of the peculiar nature of Egyptian science – its long-term, empirical character – and did this so effectively that a generation later Johannes Kepler still felt impelled to confront the thesis in his own *Rudolphine Tables.* When Kepler insisted, on the title page of that work, published in 1627, that the ancients had been ineffective astronomers who worked with modest instruments, he showed how seriously the world of science had taken Rheticus's enterprise.[34]

In Sixtine Rome as well, Egyptian themes and objects continued to fascinate collectors and scholars. Some of the most erudite among them shared Rheticus's optimism about the powers of ancient Egyptian magic and science. Among these, Michele Mercati, the pope's personal physician, organizer of the vast papal collection of stones and fossils, and more-or-less official obelisk advisor, was more given to direct study of stones than to theoretical disquisitions about their classification. In his book *Concerning the Obelisks of Rome,* which appeared in 1589, Mercati carefully described the size, shape, and origins of the Roman obelisks, collecting every scrap of information provided by the Latin and Greek sources and thus providing the first real scholarly history of these monuments.[35] Mercati addressed the problem of the hieroglyphs in a remarkable chapter. He began by agreeing with Counter-Reformation theorists of images like Gabriele Paleotti, who held that these were a primitive form of communication mostly appropriate for the uneducated. Image-writing had, Mercati noted, been adopted in antiquity by many early peoples, such as the Ethiopians and the Mexicans. Nonetheless, the Egyptians had transformed this rudimentary form of communication into the complex system of concealed allegory described by the ancient authors and imitated in Mercati's own time by the inventors of emblems.[36] Like the great numismatist Antonio Agustìn before him, Mercati argued that the surviving evidence was inadequate to support translation of hieroglyphic texts. But Agustìn's arguments had been purely negative. Just as the short passages in Punic spoken by the charac-

science of divine things."[28] By the second half of the sixteenth century, virtual and material reconstructions of Egyptian culture and "wisdom" had become so vivid and detailed that it was commonplace for European scholars, Protestant and Catholic alike, to fashion intellectual genealogies of wisdom in which the Greeks occupied secondary places at best.[29]

Consider the case of the Austrian mathematician and astronomer Georg Joachim Rheticus, who is remembered today mainly because, as a young man, he worked with Nicholas Copernicus and composed the *Narratio prima,* the first published report of his teacher's hypothesis that the sun, not the earth, is at the center of the solar system.[30] In later life, however, Rheticus's career became far more colorful. He tried to find out the secrets of the motion of Mars, notoriously a conundrum to astronomers, by consulting a familiar spirit. Unfortunately, it seized him by the hair, smashed him up against the ceiling of his study, hurled him to the floor and then said: "That is the movement of Mars."[31] After being forced to leave his teaching post (having been accused of sexually molesting a pupil), he fled to Cracow, a great center of speculative natural philosophy and alchemy. There, he devised a wholly new theory about ancient Near Eastern science. The Egyptians, he claimed, had developed a far more accurate astronomy than the Greeks, since they refrained from the Greek vice of composing wild theories and elaborate geometrical models. Instead, they concentrated on long-term observation of the heavens, unhindered by theory. The obelisk had been not the record of their work but its instrument; and Rheticus himself, as he claimed more than once, had managed to construct his own new obelisk in Cracow, fifty-four feet high, with the help of a public-spirited patron. By this means, he claimed, he would eventually replace the rickety structures of Greek mathematical astronomy with something leaner, cleaner, and more accurate: an astronomy built without hypotheses, founded entirely on the evidence. It would be a purely empirical science, perhaps something like the science of weather prediction that Johannes Kepler still hoped to found on careful compilation of hundreds of observations.[32]

Rheticus's theory lacked any foundation in the sources. He simply conflated Pliny's account of how Augustus had set up an obelisk on the Campus Martius and used it as the gnomon of a meridian instrument with the legendary solidity and age of Egyptian astronomy. But it proved attractive to another, more influential Protestant intellectual, Petrus Ramus, one of

The title page of Rheticus's *Ephemerides novae* — a compendium
of astronomical data — showing his emblematic obelisk.

of Giorgio Vasari's *Lives of the Artists*, described the many surviving monuments and statues of the Egyptians as "manifest signs of these very powerful
and copious people, and of their very rich kings" that had been carefully
preserved by the people of subsequent eras "from a proper desire to prolong the memory of them for infinite centuries, and further than this the
memory of their marvelous intelligence and singular industry and profound

Scaliger's enthusiasm – like the extra thousand years he tacked onto the age of the mummy in question – is revealing, especially in light of the story he told next: "Someone persuaded Gourgues [a student who arrived at Leiden in 1593] that it was one of the bodies of the kings. He adored it, and wrote to his father, as if he had seen the relics of a saint's body. Paludanus, who is himself half-Catholic, made him aware of this deception."[24] Scaliger had savagely criticized the German-born antiquary and scientist Melchior Guilandinus for arguing, in his 1572 book about papyrus, that the use of paper went back for many thousands of years in Egypt.[25] But the sight of a real mummy evidently dispelled some of Scaliger's reservations about Egyptian antiquity – even if he was amused at the spell this relic of dark ages cast on a gullible younger man.

Scaliger's experience was not unusual. Hundreds of pounds of mummy passed from Egypt to Europe, where physicians prescribed it, following the recommendations of the eleventh-century Persian doctor and philosopher Avicenna, for "abcesses, eruptions, fractures, concussions, paralysis, hemicrania, epilepsy, vertigo, spitting of blood from the lungs . . . nausea, ulcers, and spleen," among other ailments. (The seventeenth-century English natural philosopher Robert Boyle still mentioned its use for falls and bruises, and Francis Bacon recommended it for "staunching the blood.") One English merchant cheerfully recounted bringing home "divers heads, hands, arms and feet for a shewe," though others told worrying stories of the storms at sea that had threatened ships carrying mummy. An army of dead Egyptians, whole and fragmentary, mutely testified to the truth of one of the strangest items in Herodotus's whole catalogue of Egyptian *mirabilia*.[26] By the time the Huguenot scholar Isaac Casaubon – no blind believer in the antiquity of Egyptian culture – read Herodotus, he was certain, as he noted in his copy of the text, that Herodotus's decision "to seek ancient history" from the barbarians and their monuments was his best quality – especially given the Greeks' "blindness to the past and self-love."[27]

As collections in Italy and Europe continued to fill with diverse tokens of pharaonic culture and Egyptian monuments were described and illustrated, with varying degrees of veracity, in manuscripts and printed collections, an armchair canon of Egyptiana began to emerge – one that continued to expand into the next century and beyond. As early as 1568 the Florentine academician Giovanni Battista Adriani, in his preface to the second edition

a colorful set of historical and hermeneutical visions. During the same period, a collecting culture took shape in which material remains from Egypt played a central role. In Rome itself, collections included Egyptian sculptures, large and small, most of which had been discovered in the ruins of Isiac sanctuaries or sumptuously decorated villas like the Emperor Hadrian's great complex at Tivoli.[21] But there were other kinds of collections and collectors that favored smaller and more fragile tokens of pharaonic civilization, usually imported from Egypt itself by merchants and other travelers. Indeed, by the early sixteenth century, any patron of learning who aspired to style needed not only a fine and orderly library but also, adjacent to it, shelves and cupboards with niches and honeycombs of elegant drawers for the display and storage of a profusion of natural and man-made marvels. Sea shells flanked primitive weapons, narwhal horns hung next to engravings, splendid vessels of precious metal gleamed next to jars full of *materia medica* in the *Wunderkammern* (literally "rooms of wonders") of cultivated collectors like Count Wilhelm Werner von Zimmern, at whose collection Sebastian Münster marveled in the 1540s. Advanced universities, first in Italy and then in the Low Countries, Germany, and England, founded botanical gardens, anatomical theatres, and museums, offering students direct experience of nature's varieties and the history of human efforts to change and exploit them.[22]

Any good collection, by the middle of the sixteenth century, would include at least a few Near Eastern objects. Ragged sheets of papyrus, the mysterious writing paper of the ancient world; dark chunks of mummy (called *mummia*) – at once the relic of a fascinating, unique burial custom and a much-valued medication prescribed for various ailments; funerary statuettes; and genuine and fake scarabs decorated walls and desks.[23] Those who visited the museums where such objects were stored and displayed seem to have found them gripping, even enchanting, and exaggeration came naturally to their lips. When the scholar Joseph Scaliger moved to Leiden in 1593, for example, he made a tour of North Holland in the course of which he visited Enkhuisen. In the collection of the city doctor, Bernardus Paludanus, he saw a mummy, which Paludanus himself described as that of a child, dead for more than two thousand years. Scaliger, however, told his Leiden pupils that "Paludanus in Enkhuisen has a complete mummy, an Egyptian body buried three thousand years ago – that's a real antiquity."

the magical powers of the Egyptian priests. By turning the obelisk into the signature set-piece of Sixtine Rome, the pope and his advisors hoped not only to honor the martyrs of the early church but also to follow the instructions of the greatest of the Latin Fathers, St. Augustine. In *De doctrina Christiana,* Augustine had told Christian philosophers who wished to use the works of pagans to imitate the Israelites, who robbed the Egyptians of their gold and silver vessels, at God's express command, on their way out of the country.[19] By Christianizing such a famous Egyptian monument and placing it so prominently at the threshold of the most exalted sanctuary in Rome, Sixtus celebrated the triumph of the church over paganism in the most dramatic imaginable way.

Far from seeking to display the merits of Egyptian thought and religion, in other words, Sixtus sought above all to suppress them and subject them to the superior power of the Christian God. His contemporaries insisted that he took no special interest in hieroglyphs. Indeed, one of the pamphlets written to celebrate the exorcism of the Vatican obelisk emphasized the happy fact that it lacked any Egyptian inscription, and therefore was not "defiled with hieroglyphic signs, that is, the certain marks of Egyptian superstition."[20] When Sixtus chose to exorcise and erect this and three other obelisks, in short, he deliberately confronted what he must have seen as a worryingly powerful strain of ancient paganism; indeed, he proclaimed that the very fabric of Roman culture needed reweaving. He did so, moreover, in a way that dramatically emphasized that both ancient Roman and contemporary technology were more powerful than the forces of Egyptian magic. As they transformed the piazza around the obelisk into a forest draped with ropes, Sixtus and Fontana re-created and improved on the ancient obelisk-moving procedures that the historian Ammianus Marcellinus had described, and showed that they held Egypt in their grasp as securely as had the ancient Romans, or even more so. Sixtus made clear, in every way he could, that he wanted to close down the Near Eastern raree show. Yet by spending so much – so much time, so much effort, so much hard-won gold – Sixtus implicitly admitted what the protagonist of a triumph always admits: that the extent of his victory was directly proportional to the power and attractiveness of his enemy.

The scholars and architects of the fifteenth and early sixteenth centuries wreathed obelisks and other evidences of Egyptian wisdom with

Why then, one wonders, did Sixtus see fit to place – of all things – an Egyptian obelisk at the center of his Holy City? And why did he take such tremendous pains to erect three more of them by the other great basilicas of the city? More generally, why did the same church that would, only a few years later, burn the renegade Dominican Giordano Bruno on the Campo de' Fiori in part because of his plan to revive the religion of ancient Egypt, labor so strenuously to revive these most conspicuous products of that same religion in this unique and dramatic way? The answers are not hard to find. For centuries, visitors to Rome had venerated the obelisk as a sort of relic, a silent witness to the slaughter of Christian martyrs in the Circus of Nero and an object that had soaked up the blood of the Apostle Peter himself. By Pope Sixtus's time, the early-Christian associations of the obelisk had been enriched and sharpened by the rise of a new kind of sacred archaeology. Learned priests, roped together and equipped with torches, crawled into the perilous underground city of the catacombs, which had been visited and explored over the centuries but now became the object of systematic, carefully publicized study – as well as one of systematic plunder, as the bones of presumed martyrs were excavated, assembled into skeletons, given holy names, and sold to pious Bavarians.[16] Dedicated scholars and artists collaborated on efforts to study and recreate the styles and iconography of early Christian art. In perhaps the most ambitious project of this age, the Oratorian priest and scholar Cesare Baronio drew on the efforts of many assistants and friends to forge a new and exhaustive history of the early church. Gazing upon the obelisk from this perspective, it seemed out of keeping for so precious a relic of early Christianity, however paradoxical, to remain tucked away in its small, dank piazza. Only formal transportation and consecration could transform this blood-soaked idol into a proper monument to the heroes of early Christianity whose deaths it had observed.[17]

It would, however, be wrong to think that these considerations alone moved Sixtus to move the obelisk, or that they alone shaped his understanding of the stone. He and his advisors knew that the obelisk had a history long before it came to Rome. They described it as a product of an Egyptian antiquity far deeper than that of Rome, a finished work of high culture completed long before Troy fell or Romulus set foot on the Seven Hills – centuries before Rome itself began to build anything substantial.[18] And they knew that the earlier humanists had often connected it, directly or indirectly, with

The Septizodium of the Palatine,
from Bernardo Gamucci's 1565 *Antiquities of the City of Rome*.

build his new Rome. Before the Vatican obelisk was actually moved, Guido Gualtieri believed Sixtus would succeed where others had failed precisely because doing so formed only part of a conscious campaign "to expunge all memory of ancient idolatry."[13] Gualtieri noted that Sixtus was fortunate in all things, and "it must not be believed that good fortune would be lacking to him, since especially the very holy sign of the cross would be placed on the obelisk."[14] Galesino noted that Sixtus "could not bear" having an idol, especially one soiled by the ancient superstition of the Egyptians, stand so close to the holiest place in Christendom.[15]

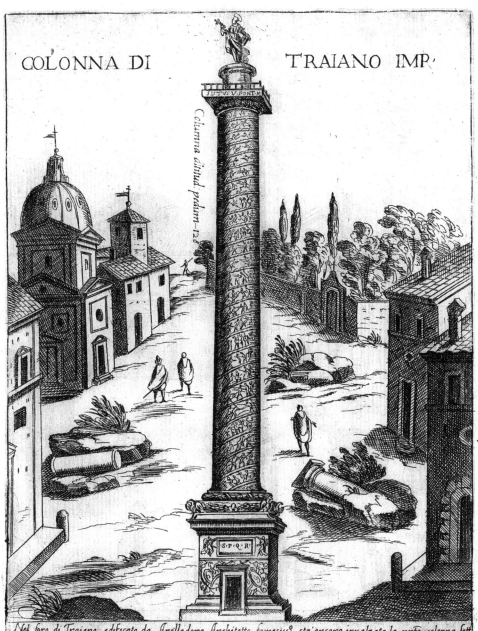

COLONNA DI TRAIANO IMP·

Columna diitud prdum·128

SIXTVS·V·PONT·M

S·P·Q·R

Nel foro di Traiano edificato da Apollodoro Architetto famosiss⁹ sta ancora innalzata la pñte colonna fatt a à lumaca, oue sono scolpite bellissime figure l'imprese di Traiano della guerra contra i Daci ei Parthi statagli dedicata dal Senato oue in cima erano le sue ceneri dentro una palla d'oro con la sua imagine la qual colonna è alta piedi 123· escalini 185 e 45 finestrette et Sisto V l'ano 1589 la dedico al glo: apo: S. Pietro·

The Column of Trajan, topped with a figure of St. Peter.

he encouraged work designed to ensure the supremacy of the Catholic Church. What mattered to him about the city of Rome was not its classical but its Christian ruins, not its victorious military and imperial past but what came to be called its "triumphant" Christian present. To this end, Sixtus pushed ahead on an astonishing array of architectural and urban projects. These included the completion of the great dome of St. Peter's, the construction of a new wing at the Vatican palace to house the ever-expanding Vatican Library, demolition and replacement of the old papal palace at the Lateran, the provision of water and monumental fountains in previously underserved quarters of the city, and much more, all of which involved prodigious investments of capital and material. Clearly, Sixtus deliberately set out to match and surpass the achievements of his ancient and papal predecessors.[10]

Sixtus's most celebrated interventions in the city involved the renovation of its streets and public squares. By straightening and widening the streets that connected Rome's basilicas, and erecting a series of obelisks where key roads converged, he hoped to remake the city in a manner that embodied his vision of the church triumphant. What he imagined was not an ideal, classical city – symmetrical and elegant – but a new Christian capital that would serve the practical concerns of pilgrims and provide a spectacular stage for the public pageants of the Counter Reformation. By the time Sixtus decided to move the Vatican obelisk, he had already ordered that the statues of the emperors atop the spiral columns of Trajan and Marcus Aurelius be replaced with statues of St. Peter and St. Paul, and the columns themselves be consecrated to those saints. So just as the statues of emperors had celebrated imperial victories, Christian Rome was now provided "with very powerful guards of the city."[11] With that act, Sixtus transformed the city's most visible symbols of Roman, Imperial power into embodiments of Christianity's triumph over paganism and the papal inheritance of Rome's ancient *imperium.* In a similar move, he also ordered that the "statues of ancient idols" be removed from the Capitoline Museum.[12] Sixtus, in fact, became famous, even infamous, among Roman admirers of antiquity for his willingness to destroy ancient monuments – most notably the celebrated Septizodium of the Palatine – in his search for materials to

The storage reservoir for the Acqua Felice, an ancient aqueduct restored by Sixtus V.

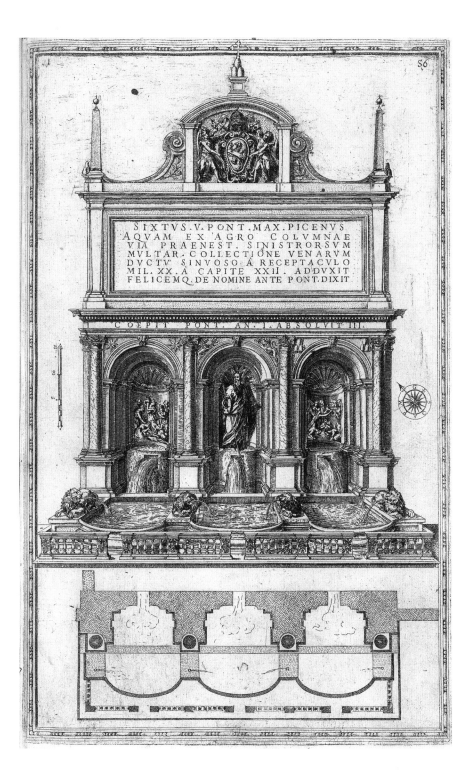

SIXTVS·V·PONT·MAX·PICENVS
AQVAM EX·AGRO COLVMNAE
VIA PRAENEST· SINISTRORSVM
MVLTAR·COLLECTIONE VENARVM
DVCTV SINVOSO À RECEPTACVLO
MIL·XX·A CAPITE XXII· ADDVXIT
FELICEMQ·DE NOMINE ANTE PONT·DIXIT

COEPIT PONT· AN·I·ABSOLVIT III·

it from the "impious cult of pagan gods," "laboriously" transported it to its new location and consecrated it "more justly and appropriately to the invincible cross."[4] On the base facing the western approach to the basilica, an exhortation taken from the exorcism ritual proclaimed the monument a kind of apotropaic guardian of the sanctuary from the forces of darkness:

ECCE CRVX DOMINI / FVGITE PARTES ADVERSAE /
VICIT LEO DE TRIBV JVDA.

Behold the cross of the Lord. Enemies, flee.
The lion of the tribe of Judah has conquered.[5]

Under Sixtus's careful supervision, both the meaning and the function of the Vatican obelisk were transformed. No longer consecrated to the sun or dedicated to the memory of pagan kings, the obelisk became an instrument of Christian devotion in the service of a militant church. According to Sixtus's biographer, Pietro Galesino, the obelisk's very shape – its length and straightness – served to remind all Christians that their one end in life was to meditate on the sacrifice of Jesus Christ.[6] Even the dates of the obelisk's lowering and re-erection were believed to have a hidden meaning, assigned by Divine Providence – or so Petrus Bargaeus, another of Sixtus's biographers, claimed when he explained why the event had been postponed. As a result of the delay, the obelisk that had once served the worship of the sun in Egypt began to bear the cross just as the sun itself entered the sign of Libra. Astrologically, the sun begins to move southwards – and its full strength to decline – when it reaches the beginning of Libra, which marks the autumn equinox. By placing the cross on the obelisk when he did, Sixtus taught the sun itself a much-needed lesson about the supremacy of the Son of God over all created things.[7] Thus the force of Christian theology proved powerful enough to reverse astrology's normal mode of transmission and send a benign influence upward to the rebellious, pagan planets. Accordingly, all those who watched the obelisk being exorcised received an indulgence for fifteen years, and all those who when passing it bared their heads and prayed received one for five.[8]

A paradox begins to emerge. Sixtus V ranked with the fiercest of the Counter-Reformation popes.[9] In scholarship and literature, as in the arts,

I exorcize you, creature of stone, in the name of God, the omnipotent father, and in the name of Jesus Christ, his son, and in virtue of the Holy Spirit, that you may be an exorcized stone.[1]

Cleansed of pagan spirits, the obelisk was ready to receive the gilt bronze crucifix. The crucifix was blessed by the bishop and installed by a deacon in the place previously occupied by the bronze globe, which had been removed and examined for traces of Caesar's ashes. None were found. The sphere was then presented to the leaders of the city government.[2]

These solemn rituals made clear the pope's desire to purge the obelisk of its pagan past and proclaim its transformation into a Christian monument, worthy of dedication to the Holy Cross. So did the splendid new inscriptions on the base, carved in a specially designed "Christian" font devised by Luca Orfeo del Fano for use on Sixtus's monuments.[3] Taken together, the inscriptions described how the pope had the obelisk "torn away and stolen from its original place under Augustus and Tiberius Caesar," and after purifying

The Vatican obelisk's new base, featuring an inscription
in Sixtus's signature "Christian" font.

Changing the Stone:
Egyptology, Antiquarianism, and Magic

Exorcizo te, creatura lapidis, in nomine Dei patris omnipotentis, et in nomine Iesu Christi, filii eius, domini nostri, et in virtute Spiritus sancti: ut fias lapis exorcizatus.

EXORCISM SPOKEN OVER THE VATICAN OBELISK
AT ITS DEDICATION IN ST. PETER'S SQUARE

THE TRANSPORT of the Vatican obelisk involved more than a stunning piece of engineering. Sixtus and Fontana staged it as a solemn public ritual. On the day the obelisk was lifted from its base, a papal ordinance forbade the onlookers who crowded the area to speak or even to spit while Fontana and his men worked, on pain of death. All involved in the project took communion before starting work. The following September, after the obelisk was set in place in its final location, a bishop climbed a ladder in solemn silence to baptize the stone with holy water, formally exorcising it with words adapted from those used for every newborn baby. (The original Latin provides the epigraph for this chapter.)

The dedication of the Vatican obelisk, rendered by Giovanni Guerra and Natale di Bonifacio.

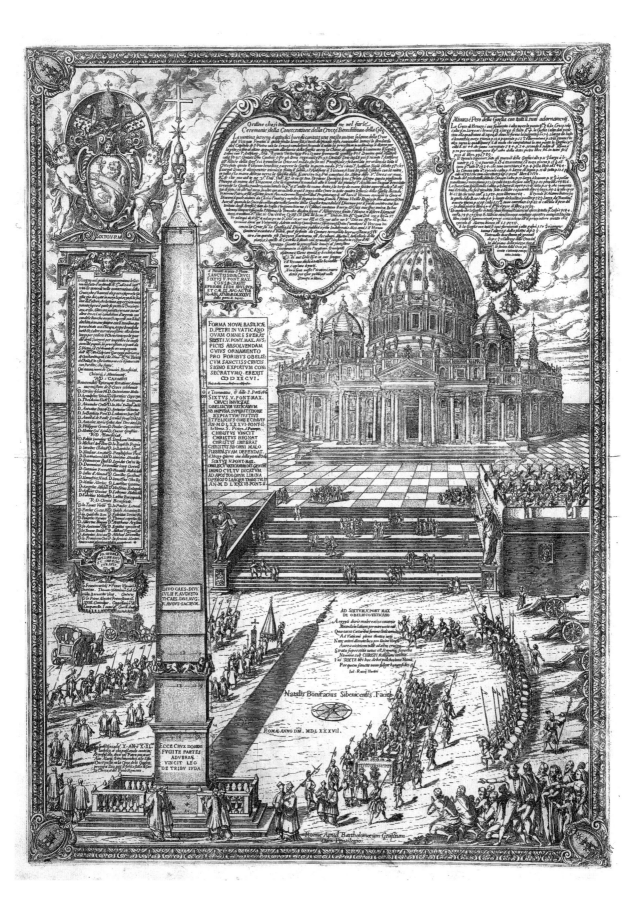

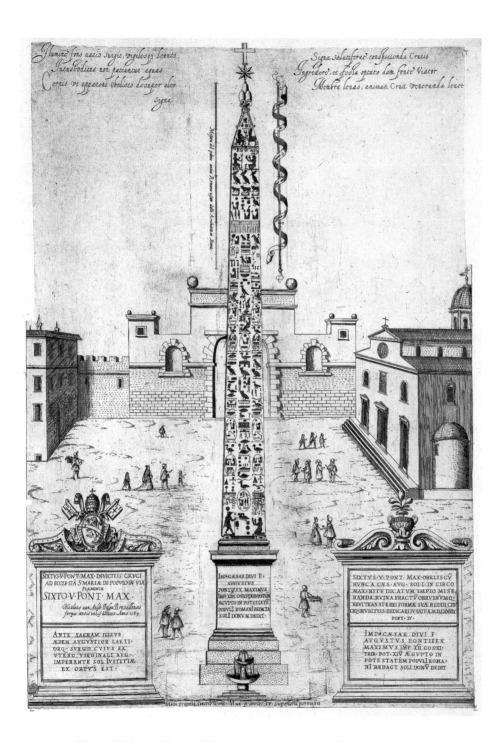

The obelisk in the Piazza del Popolo, engraved in 1589 by Nicolaus van Aelst.

the north. Here, even as Sixtus restored one part of the ancient city, he destroyed another. The pedestal for the obelisk was made from travertine acquired by destroying an imposing ancient monument, the Septizodium, a façade of marble constructed to hide the lower stories of the Palatine. Despite loud and vocal protests, the pope instructed that the ancient monument be torn down and its materials used for this new purpose. This obelisk, too, had broken in three. By now Fontana had become an expert not only in raising obelisks, but in repairing broken ones; he skillfully fixed this one as well.[44]

Sixtus had some small competition for obelisks. Around 1587, a small one inscribed for Ramesses II and discovered near the church of Santa Maria sopra Minerva some decades earlier found its way to the gardens of the Villa Medici in Rome. The patron was a Florentine, Cardinal Ferdinando de'Medici (later Grand Duke of Tuscany), who echoed Pope Leo X's unrealized project for the Piazza del Popolo by raising the obelisk on a set of bronze tortoise-shaped astragals. Unlike Sixtus's grand public statements, this was a private monument, albeit one on a princely scale. Ultimately, the Medici transferred their "family" obelisk to Florence in 1790, where it assumed an archaeologically appropriate position on the spine of the pretend Roman circus at the bottom of the Boboli Gardens, behind the Palazzo Pitti, the family's main headquarters.[45]

The four obelisks erected by Sixtus and Fontana were the first of many that would follow in the next centuries. Over those centuries Rome was gradually transformed into a city of obelisks. Exorcised and Christianized by crosses and papal symbols placed on their summits; erected on new bases, or later on elaborate baroque fountains, obelisks marked and defined the renewed city in powerful ways. But the obelisks' influence extended far beyond the spaces over which they towered, or even the city of Rome itself. They inspired a community of writers and scholars, from Rome to Germany, who immortalized the obelisks and the men who moved them in a huge array of writings, from brief news reports, odes, and sonnets, to lengthy treatises on Egyptian antiquities, hieroglyphics, and engineering – not least of which was Fontana's own remarkable book.

As the workers dug, the hole kept filling with water, and in the end a crew of five hundred was put to work scooping water, day and night. When the dirt and mud were gone, the obelisk was found in three pieces. Moving the pieces to the new site was also tricky, for they had to be carried up the steep Caelian Hill and through narrow streets.[42]

Then came the problem of erecting the obelisk. Its base was badly damaged and, ultimately, had to be removed. Nor would the other pieces fit neatly together. To assemble them, Fontana used the *castello,* first enlarging it because of the obelisk's great height. He had to redesign the apparatus slightly, as the first piece of the obelisk needed to be held up by the *castello* while the second and third pieces were successively drawn up beside it and placed on top. The pieces were narrow at their ends, and Fontana greatly feared they would slip their bindings. The problem was compounded by the fact that ropes couldn't be put underneath the ends, as that would prevent the pieces from fitting together. Fontana's ingenious solution was to make cross-shaped cuts at the end of each piece. The cuts "were made in the form of a swallowtail," large at the base and narrow at the opening. The ropes could then be slipped inside and hold the piece from below. Once the two pieces were joined together, it was easy to pull out the ropes. Fontana then fit wedge-shaped stones into the cuts of the joined ends and leaded them, creating a strong and invisible binding. The intact obelisk was then pulled straight onto its pedestal as a single piece. It was topped with heraldic emblems and a cross, and was exorcised and consecrated on August 10, 1588.[43]

Sixtus also ordered the excavation and restoration of the other obelisk in the Circus Maximus, raised by Augustus in 10 BCE – the very first obelisk brought to Rome. Although Leon Battista Alberti had pointed out the location of the monument to a group of friends more than a century before, Fontana had to search for it again. He finally found it on February 9, 1587. After some discussion, the pope decided to erect the obelisk in the Piazza del Popolo as a gift to the Roman people. It is not clear whether either Sixtus or his engineer was aware of Leo X's plan to raise an obelisk in that very spot, but the decision represented a kind of fulfillment of the idea, using a much larger obelisk that also had direct associations with Augustus. Once set up, the obelisk provided a majestic center for the square, marking the entry point to the city for pilgrims and other travelers who arrived from

the *castello* and other equipment must have ensured that Fontana held a virtual monopoly on the transport and erection of obelisks until the pope's death in 1590. The first reuse of the apparatus came as a result of a gift the Commune of Rome had made to Ciriaco Mattei, a member of the Roman nobility and a lover of antiquities, who was building a villa on the Caelian Hill. That gift was the obelisk lying on the Capitoline Hill, which the Commune had presented to Ciriaco on September 11, 1582. The reasons for the gift are unknown. It is surely germane, however, that Ciriaco had been appointed to a committee of four to oversee construction on the Capitoline about five months previously – the only time he seems to have served in such a capacity. Fontana's *castello* was used to transport the obelisk to its new site, where Ciriaco placed it in a garden ensemble constructed in imitation of an ancient circus.[40]

The next project was in a far more public place – behind the apse of the Basilica of Santa Maria Maggiore. The spot marked the end of a newly planned and never fully completed street, the Strada Felice. It also fronted the eastern entrance to Sixtus's villa, Montalto, and its monumental gate. Fontana had designed both. This obelisk was one of the pair that had stood by the Mausoleum of Augustus. Excavated in 1519, it had been found broken in three pieces, which were placed in the adjoining street after Leo X's ambitious plan to erect it in the Piazza del Popolo was abandoned. The fragments remained there as annoying obstacles to traffic for sixty-six years. In September 1585 Sixtus paid Badino da Stabia an advance to move the pieces to the Esquiline Hill. Then, in 1587, Fontana used the *castello* to erect the obelisk. He built a very high new base and then raised the obelisk one piece at a time, attaching the pieces to each other with dovetailed stone mortises.[41]

Fontana's greatest engineering challenge involved the obelisk Sixtus placed near San Giovanni in Laterano. This, the tallest extant obelisk, was the great monument of Thutmose III and IV that Constantius had set up in the Circus Maximus to commemorate his visit of 357 CE, more than twelve hundred years earlier. At some point in the intervening centuries, the obelisk had been deliberately pulled down, as indicated by scars suggesting levers and signs of fire. Matteo Bartolani, one of Fontana's collaborators, was assigned the difficult task of digging up the obelisk, which was buried in swampy ground seven meters, or nearly twenty-five feet, underground.

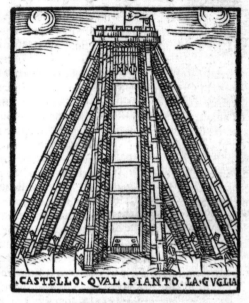

.CASTELLO. QVAL .PIANTO. LA.GVGLIA

*La forma della mole, ouero machina di legno, che si
chìamò il Castello, con il quale fu rimosso, abassato
& alzato l'Obelisco Vaticano, & poi vi furono al-
zati quelli del Cerchio Massimo, & del Mausoleo
d' Augusto nell' Esquilie, & nel Monte Celio.*

T RATTANDO Sisto V. sommo Pontefi-
ce nel principio del suo Pontefficato, cioè
l'anno 1585. di rimuouere l'Obelisco Vati-
cano da la sua prima sede (percioche staua
prima quasi nascosto, & mezzo sepolto in
vn ritirato,& angusto luogo) e trasferirlo nella piazza di
San Pietro, oue al presente si vede; vi concorsero molti
de' principali architetti (vdito di ciò la fama) non solo di
Roma,ma ancora da molti luoghi d'Italia,percioche nella
Città di Roma si apparecchiaua vn grande,nuouo,& ma-
rauiglioso spettacolo. I quali producendo à gara i suoi
disegni

Fontana's *castello* as tourist attraction.
A cheap woodcut rendering in Andrea Fulvio's 1588 guide to Rome.

richly – making him knight of the Golden Spur, giving him a golden portrait medallion with a golden chain, providing a substantial financial reward, including a pension of two thousand *scudi,* and, finally, making a gift of all the materials used for the operation. Fontana's achievement was commemorated in one of the inscriptions on the pedestal and broadcast to the world on commemorative medals. In addition, the city council bestowed upon him the privilege of Roman citizenship, "because of his immense virtue and knowledge in conducting and elevating the pyramid" in the Piazza San Pietro.[36]

The fame of the engineering feat spread far, as is attested by the numerous reports and writings of various kinds about the operation. In Venice, Girolamo Ferucci mentioned the "grand, new, and marvelous spectacle" and even included a picture of the *castello* in his 1588 revision of Andrea Fulvio's guidebook to Rome.[37] As far away as Nuremberg, the mathematician Cornelis de Jode mentioned the feat in the introduction to his *Little Book on the Geometric Quadrant*, a guide to surveying and measurement; he even included an obelisk as an example of the sort of object one could use to test his methods of determining height and distance.[38] A particularly notable description of the mechanics of moving the obelisk appears in Mercati's 1589 treatise on obelisks. Mercati astutely pointed out that while the Romans had used thousands of men to move their obelisks (according to Ammianus Marcellinus), Fontana used not more than seven hundred. He emphasized "how different this new way of erecting the obelisks is from that used by the ancients." The difference, he noted, lay in Fontana's use of new kinds of machines and equipment, most importantly the capstans. But Fontana's reputation has endured mostly because of his own detailed account of the operation, beautifully illustrated with the designs of the Modenese painter Giovanni Guerra, as engraved by Natale di Bonifacio. In his book Fontana described the move in lucid detail, and also provided accounts of his many other architectural and engineering projects. First published in 1590, and reprinted in 1604, the book is an important early example of authorship on the part of an engineer. It is also the source of most of the images in this chapter.[39]

Sixtus envisioned the transport of the Vatican obelisk as the first of many. Even while the obelisk was being moved, he and Fontana were hatching other plans. All were to use Fontana's *castello.* Indeed, Sixtus's gift of

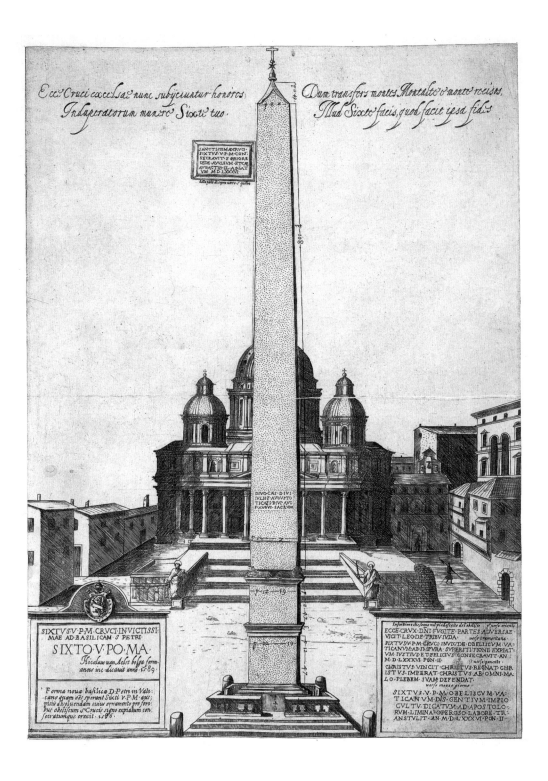

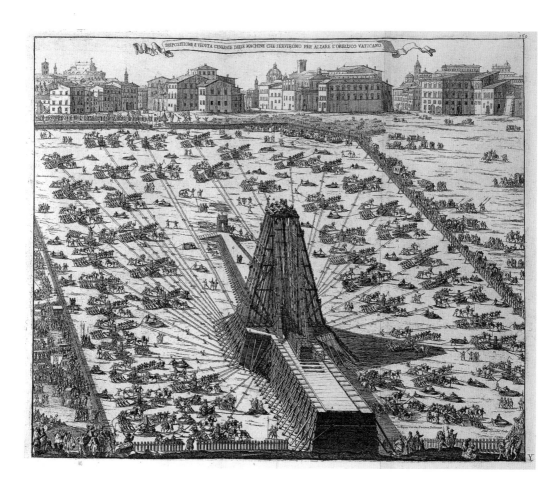

Raising the obelisk, from Carlo Fontana's *Templum Vaticanum* (1694).

The obelisk was checked with a plumb line to see whether it was leaning, and bronze plates were put under some of the astragals to level the monument and make it stand absolutely straight. Finally, the obelisk was unwrapped. The entire operation was completed on September 26, 1586. On the same day, Sixtus V ordered a procession and a solemn ceremony be held to exorcise the obelisk of pagan spirits and consecrate the cross that was to be placed on its summit. Now that the danger of failure had passed, the pope himself presided over the ceremony. An *Avviso* claimed that "half of Rome had gathered" for the occasion. Sixtus also rewarded Fontana

The obelisk in place, as shown by Nicolaus van Aelst.

at the break of dawn everyone took their places. A huge, silent crowd watched as the point of the obelisk slowly rose. Ropes were attached at the obelisk's bottom and top. Four capstans pulled the base forward so the lines pulling the monolith up could work vertically without having to be pulled from behind or need counterbalancing if the foot was halted, "as the ancients must have done." The obelisk's peak rose, and the weight on the *castello* and ropes gradually lessened as the obelisk was eased onto its new pedestal. Fontana explains that his own method was more efficient than that probably used by the ancients because of his innovation in pulling the base with separate capstans. At this point, with the obelisk placed over but not yet settled on its base, it was buttressed so everyone could eat. When work resumed, some notable spectators arrived. The ambassadors from France came through the Porta Angelica and stopped to see two turns of the capstans. An *Avviso* reports: "the architects . . . in order to show their wonderful contrivance of this undertaking" to the French ambassadors "stopped for a long time without doing anything while they [the ambassadors] were in sight of so rare a move." Eventually the process began again, and after fifty-two turns the obelisk was erect at last.[34]

An *Avviso* captured the excitement of the day. The reporter noted one hundred and eighty horses and sixty-eight huge capstans, reporting that workers "under the discipline of that master Domenico Comasco [*sic*] began to raise and position the obelisk of Caesar over its ancient base." Covered in wood, the obelisk itself could hardly be seen, but just as in the previous move, a great multitude watched, many crowding the windows of nearby houses. The Piazza San Pietro was as crowded as in a Holy Year. Fontana also reported the enormous crowd, many of whom, in order not to lose their vantage point, stood, fasting, into the evening. Others built platforms, charged customers for a space and "profited handsomely from doing so." By evening, when the obelisk had been raised on top of its pedestal but the sledge remained in place, the mortars on the Castel Sant'Angelo were discharged and the entire city rejoiced. All the drummers and trumpeters of Rome flocked to the house of the architect, playing to great applause. The next day, the workers began the intricate process of setting the obelisk on its four bronze supports, which would be hidden by new bronze lions.[35]

The obelisk in triumphal procession along the elevated track to the new site.

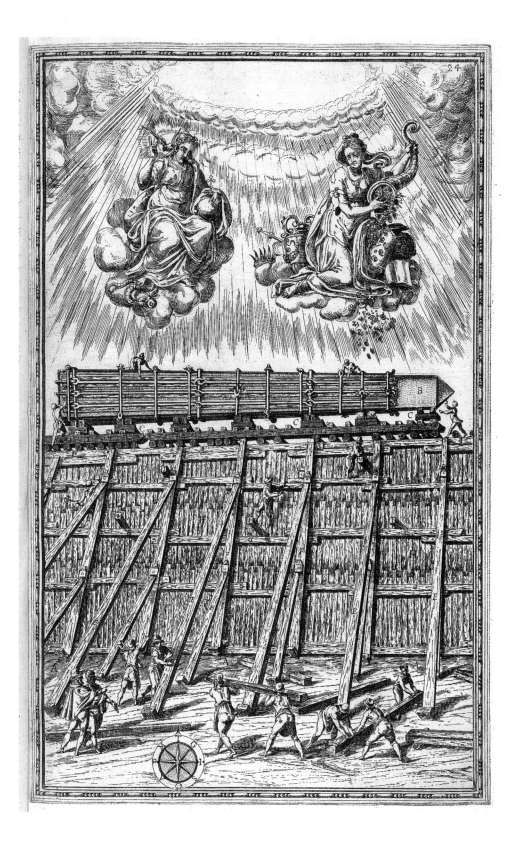

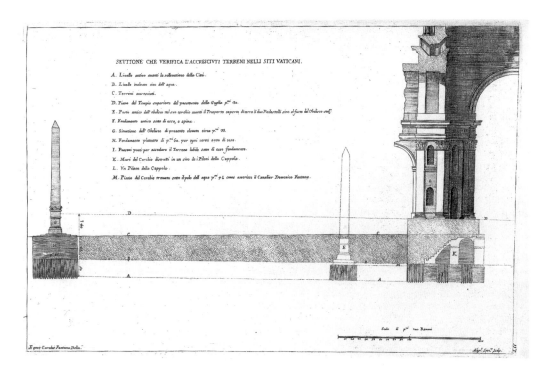

SETTIONE CHE VERIFICA L'ACCRESCIVTI TERRENI NELLI SITI VATICANI.

A. Livello antico avanti la sollevatione della Città.

D. Livello inclinato cioe dell'aqua.

C. Terreni accresciuti.

D. Piano del Tempio superiore del pavemento della Guglia p.mi 40.

E. Parte antica dell'obelisco nel suo cerchio avanti il Trasporto capivano di terra li due Piedestalli sino al fuori del Obelisco cioè.

F. Fondamento antico sotto di esso, o spina.

G. Sinvatione dell'Obelisco di presente elevato circa p.mi 99.

H. Fondamento piantato di p.mi 50. per ogni verso sotto di esso.

I. Passoni posti per assodare il Terreno labile sotto di esso fondamento.

K. Muri del Corchio diruvuti in un sito de i Piloni della Cuppola.

L. Vn Pilone della Cuppola.

M. Piano del Corchio trovato sotto il palo dell'aqua p.mi 4 L come asserisce il Cavalier Domenico Fontana.

Difference in elevation from the old site to the new.

location was still three palms lower than the old. To compensate for the difference, Fontana ordered an elevated, sloping ramp be constructed, thirty-seven palms high at the new site, and had its sides reinforced with buttresses. At the new site, workers built a floor of travertine over the foundation constructed the previous year. In the foundation they placed boxes containing medals, some of which bore effigies of Pius V (the pope who had made Sixtus V a cardinal) and of Religion and Justice. They then built a new pedestal and reassembled the *castello*. On August 30, an *Avviso* reports that the piazza was closed off with a great palisade fence so the master would not be impeded during the passage of the obelisk from the side of the basilica to the front. The obelisk was pulled along the ramp to a spot underneath the castello and again rigged with its pulleys. Forty capstans were reconstructed in their new positions and their ropes readjusted, ready for one hundred and forty horses.[33]

Everything was ready on Wednesday, September 10, 1586. Two masses were celebrated and, again, all the workers took communion. After prayers,

had demonstrated the apparatus's weak point: the iron hoops surrounding the vertical rods on the obelisk itself, most of which had been moved out of position, broken, or bent. Fontana remedied the problem by substituting the massive three-inch-wide rope, which had turned out to be stronger and more flexible than the iron bands. The next steps were to construct a platform for the obelisk and put the sledge on rollers. These tasks occupied eight days. Then came the most dangerous part of the operation – lowering the obelisk onto the sledge. For greater security, Fontana found ways to support the great stone as it was lowered. He had long iron bars and wooden beams prepared to buttress the obelisk from below. To hold it from above Fontana ran ropes to pulley blocks fixed on the vault of the now half-destroyed sacristy. He moved the capstans to new locations and again adjusted the tension of the ropes. When the trumpet sounded, four capstans with ropes attached to the foot of the obelisk pulled, while the others slacked off. The foot of the obelisk was then attached to the sledge, which could move as the obelisk pivoted. As the obelisk was gradually lowered onto the sledge, both slid into the sacristy. Slowly and gently, the great stone descended until it lay prone. The obelisk had been safely brought down without causing or suffering a single injury. An *Avviso* reported that many had doubted such a great stone could be lowered without fracturing and ruining it, and remarked on the great skill involved. Fontana himself reports that "news of the success was received with infinite jubilation, and in recognition, the architect was accompanied with drums and trumpets to his home."[31]

Once the obelisk rested safely on its sledge, the workers dismantled all the pulley blocks and capstans. Using four repositioned capstans, they then pulled the sledge entirely out from under the *castello*. Freed from the danger of beams falling on the monolith, they dismantled the *castello* so that every beam, board, hoop, wedge, and rope was arranged in an orderly way, making it easy to reassemble. Then they excavated the obelisk's original pedestal. They moved the first piece (which had held the iron astragals or "claws" on which the obelisk had rested) to the new site. But further excavation of the pedestal presented numerous problems, and the decision was eventually made to build a new substructure.[32]

The 275-foot trip from the old site to the new had to be planned carefully. Fontana had discovered that the new site was forty palms lower than the original. Taking the height of the new pedestal into account, the new

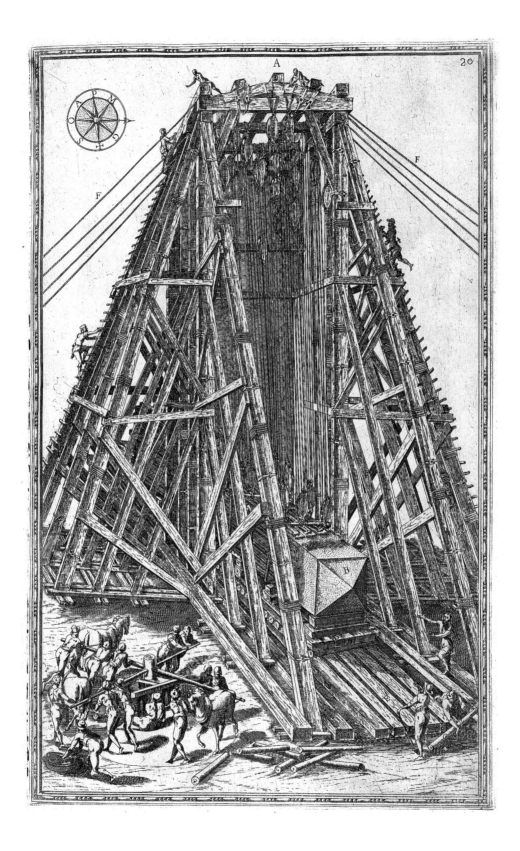

Fontana first asked all the workers and onlookers to kneel in prayer. Then the trumpet sounded and the operation began. Five levers, forty windlasses, 907 men, and seventy-five horses were set in motion. The earth shook and the *castello* let out a loud noise as its timbers tightened under the weight. The obelisk, which had begun leaning slightly, straightened. The bell rang. One of the iron bands secured around the vertical rods had broken. Workers repaired it immediately, using ropes and pulley blocks rather than iron, and then resumed the operation. In twelve movements, the capstan crews raised the obelisk two palms, while the carpenters underneath the *castello* hammered their wedges under the stone. Workers pushed the sled underneath the obelisk and removed the ancient iron supports from the stone's base. Work stopped and crews supplied further support underneath with heavy stumps and more wedges.[29]

An *Avviso* also reported the events of the day, giving details only slightly different from Fontana's. The operation lifted the obelisk four palms (rather than two), using six hundred men and sixty-four horses. The reporter remarked on the wonderful coordination of the procedure. "Our head" of the work (whose name he appears not to know) directed the entire operation with (presumably hand and arm) motions, aided by the thirty skilled supervisors under him and by the trumpet and the bell. The crowd was remarkably well behaved. "Although to such a noble spectacle a great part of Rome was gathered, and many cardinals and other princes camped out in these surroundings," nevertheless, complete silence was observed, in accordance with a papal edict. No violence or disorder originated from the "innumerable tumult," order being kept by Michele Peretti (the pope's nephew) and his mounted guards. After the obelisk was lifted, workers discovered metal supports made in the shape of bones, and something else most remarkable. There lay some metal coins arranged in the shape of a cross. Perhaps, the *Avviso* speculates, the master who raised the obelisk under "Gaio" (the emperor Gaius Caligula) was secretly a Christian and put them there to the glory of this sign while he supervised the erection.[30]

Fontana himself reports that when the first stage of the operation was complete artillery was discharged as a sign of joy. Workers brought baskets of food to each capstan so the teams could remain at their posts. The first stage

Safely down and on the sledge.

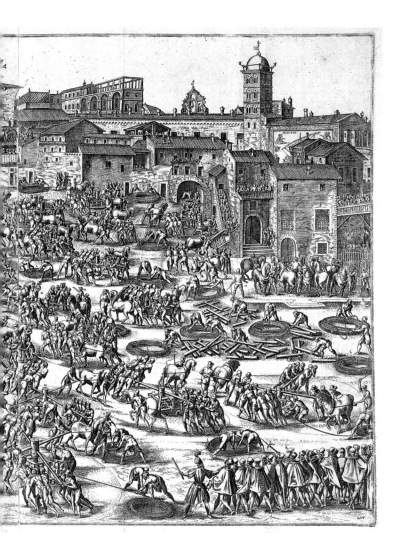

Taking the obelisk down. The second of Giovanni Guerra and Natale di Bonifacio's gigantic prints of the operation.

the pope himself), dukes and duchesses, ladies and lords of Rome, as well as "the ambassadors and all the great figures residing in the city along with an enormous number of foreigners coming from all parts of Italy to see so novel and marvelous a spectacle." So many were present, Fontana reports, that all the windows looking out on the piazza were crowded with people. The entire fabric of St. Peter's was occupied by crowds, as were all the rooftops of the surrounding houses and churches. The streets so teemed with people that it was necessary to station Swiss Guards and light cavalry at the railings so that disorder would not erupt.[28]

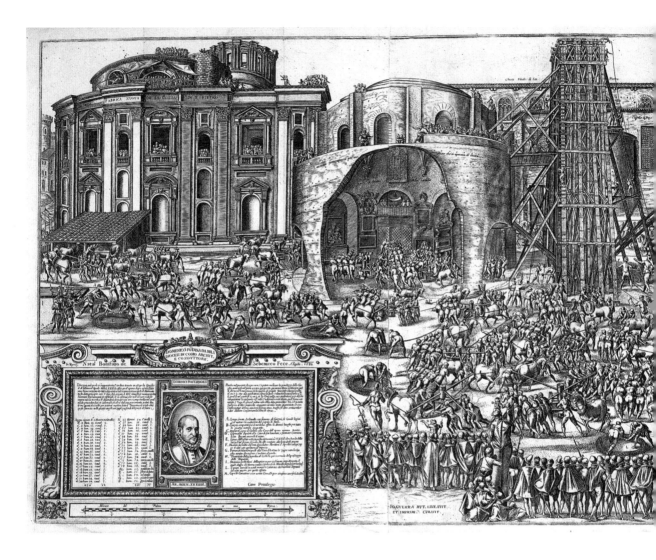

men were assigned to carry any supplies – blocks, cords, and replacement parts – wherever they might be needed. Twelve carpenters positioned under the *castello* (presumably wearing their iron hard hats) would continuously drive iron and wooden wedges under the obelisk, both to help lift it and provide support so that it would not dangle in the air beneath the cords. Thirty men were assigned to watch the *castello* so that each part of the operation was observed at all times.[27]

The move provided a dramatic spectacle. A huge crowd gathered, including, as Fontana tells us, the pope's immediate family (though not

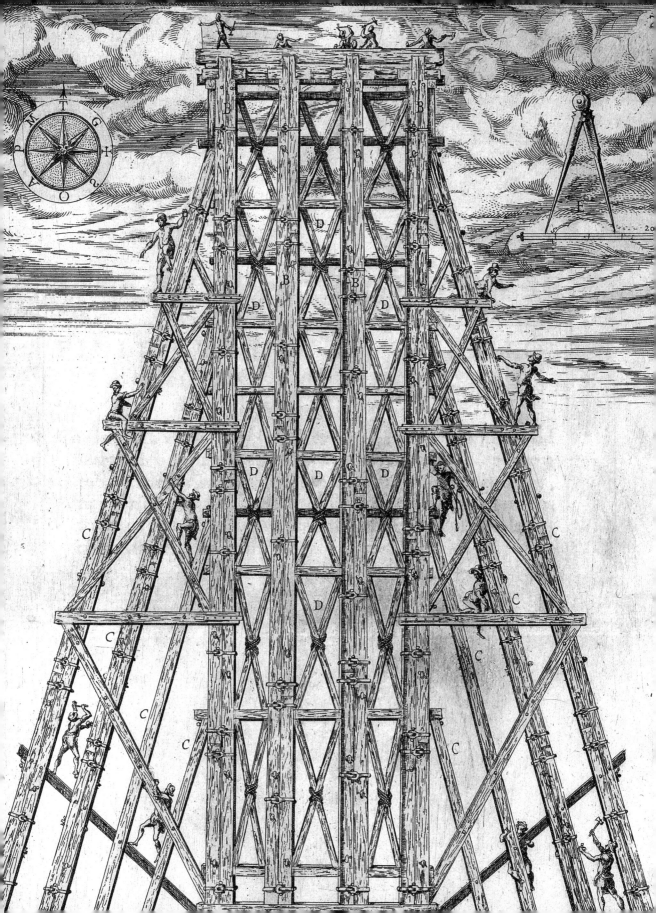

covering for the obelisk and the bed upon which it was to be pulled. Other towns supplied oak for making the capstans and elm for rollers, crossbars, and planks.[24]

At the obelisk site, a large area had to be cleared around the monolith for the capstans. Fontana demolished a number of houses as well as parts of the old sacristy of St. Peter's to make the necessary space. As the machines were built, each was given a number that corresponded to a pulley that would be attached to the obelisk. Thus, the master in charge of each capstan could instantly respond without confusion when the foremen on the *castello* ordered that any particular rope be slackened or tightened. After it was constructed, each capstan was tested to make sure it worked and that it held its rope in tension equal to the others.[25]

As work proceeded, public opinion seems to have been divided about the merits of the scheme. An *Avviso* of November 16, 1585, reports that a *pasquino* was written against the architect, who is unnamed. (A *pasquino* is a note placed on Pasquino, an ancient statue where Romans posted – and still post – opinions, usually satirical, and sometimes downright insulting, anonymously.) Others, the reporter observed, sang the architect's praises: "the most polished minds and the best pens have always sung of him."[26] Whichever side they were betting on, Romans seem to have watched the preparations with intense interest.

Fontana and his workers were ready for the first stage of the operation on April 30, 1586, almost exactly a year after Sixtus's coronation. Crowds had been gathering to witness the preparations. Now, police kept them behind certain lines and ordered them to maintain strict silence. Two masses of the Holy Spirit were said before the start of work, and "all officials, workers, master builders, and carters who were to assist in this great deed took communion." Then the workers entered the enclosure and took their places. Two master builders were assigned to each capstan. The trumpeter was positioned so that all could see him. As in the practice sessions, each trumpet blast meant the capstans should be turned; each ring of the bell atop the *castello* that they must stop immediately. Fontana had arranged backup support for every aspect of the operation. The head of the carters stood by with twenty extra horses and twenty extra men. Another twenty

Construction workers wearing their hard hats.

the new site, whereupon the obelisk would be raised and placed on a new pedestal. The key element was a great machine Fontana called the *castello,* which combined the functions of scaffolding and crane. It took the form of a twin tower made of huge timbers that was to be erected on both sides of the obelisk. The *castello* would support a complex arrangement of pulley blocks, tackle, and ropes that would lift the monolith. The obelisk itself would be protected by reed mats surrounded by five-centimeter- (two-inch-) thick wood planking, covered in turn by a sheath of vertical iron rods held by horizontal bands that were joined together by key bolts. This iron sheath further protected the obelisk and provided a stable structure on which to attach pulley blocks. Those blocks were fitted with heavy ropes made of hemp, each three inches (7.6 centimeters) in diameter and 750 feet, or about 230 meters, long. Forty capstans were to be arranged around the *castello,* one to pull each rope. Slowly, the capstans would lift the obelisk off its pedestal, which was again completely buried after having been excavated in the fifteenth century. Each capstan was to be turned by three or four horses, assisted by a number of men and supervised by two masters. It was crucial that weight be distributed equally among all the capstans, to avoid imbalance that could overload any single one, since the breaking of even one rope could threaten catastrophe. Precise synchronization was key. Fontana organized practice sessions in which a trumpet blast signaled that the horses should begin turning and a bell that they should stop.[23]

Gathering the materials and making the equipment for the job was a major enterprise. Fontana sent men to Foligno to acquire hemp for the ropes. He contracted ironworkers in several towns near Rome to make tools, such as axes, hammers, and adzes, and the hundreds of iron parts needed for the *castello* – pulleys, bolts, iron rings, and rods. He also must have had smiths make the iron hard hats he insisted the carpenters working under the *castello* wear. Finally, huge amounts of timber were needed for the *castello* itself. Fontana had his agents purchase all large beams available in the supply houses. From Campomorto, some twenty-eight miles from the work site, he obtained a large number of long, thick oak beams that were carried to Rome in huge two-wheeled carts, each drawn by seven oxen. At Terracina, near Naples, he found the elm boards needed to make the wood

A bird's-eye view of the arrangement of capstans and *castello* for lowering the obelisk.

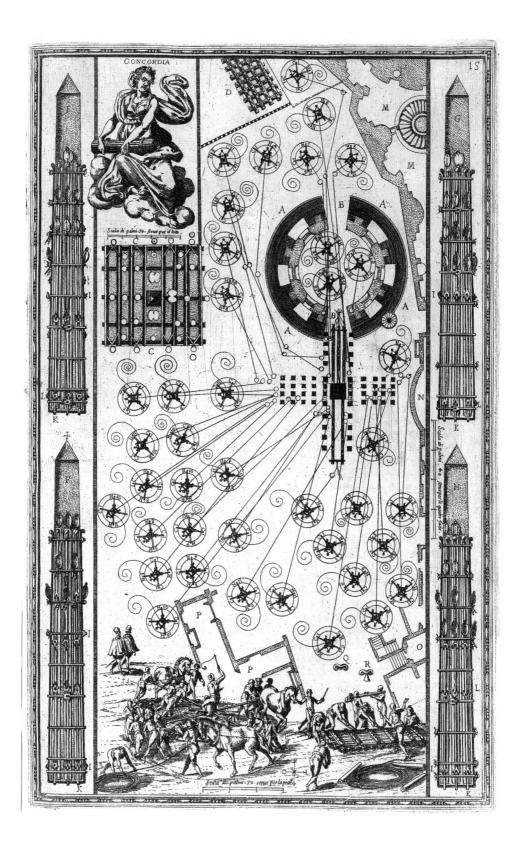

CONCORDIA

Scala di palmi 50. serve per il busto

Scala di palmi 40. serve per le quattro statue

Scala di palmi 50. serve per la piazza

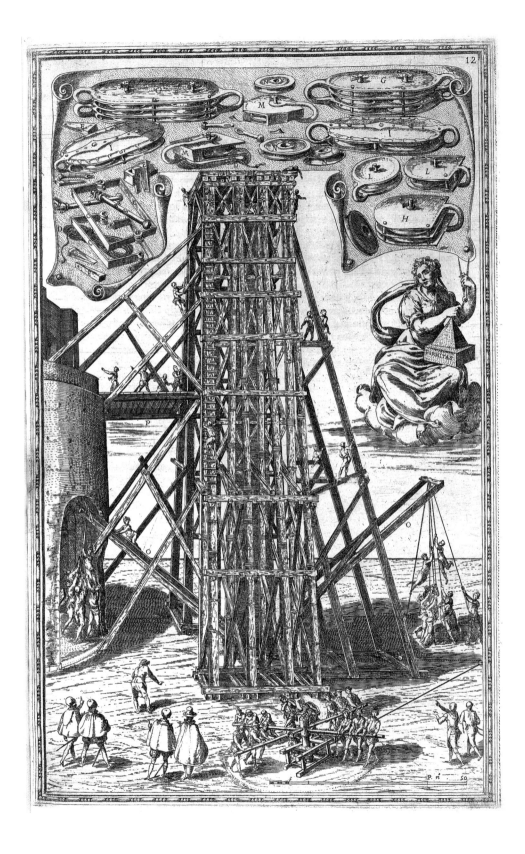

12

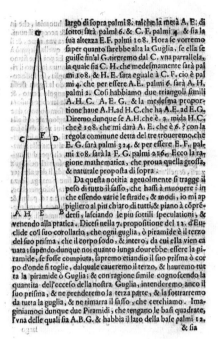

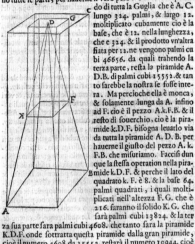

largò di fopra palmi 8. talche la metà A. E: di fotto farà palmi 6. & C. F. palmi 4. & fia la fua altezza E. F. palmi 108. Hora ne vorremo faper quanto farebbe alta la Guglia, fe ella fe guiffe fin'al G. tireremo dal C. vna parallela, la quale fia C. H. che medefmamente farà pal mi 108. & H. E. farà eguale à C. F. cioè pal mi 4. che per effere A. E. palmi 6. farà A. H. palmi 2. Cofi habbiamo due triangoli fimili A. H. C. A. E. G. & la medefma propor tione haue A. H. ad H. C. che ha A. E. ad E. G. Diremo dunque fe A. H. che è. 2. mida H. C. che è 108. che mi darà A. E. che è 6. ? con la regola commune detta del tre troueremo, che E. G. farà palmi 324. & per effere E. F. pal mi 108. farà la F. G. palmi 216. Ecco la ra gione mathematica, che proua quella groffa, & naturale propofta di fopra.

Da quefta notitia ageuolmente fi tragge il pefo di tutto il faffo, che haffi à muouere : in che effendo varie le ftrade, & modi, io mi ap pigliero al piu chiaro di tutti, & piano à cópré derfi, lafciando le piu fottili fpeculationi, & venendo alla pratica. Dicefi nella 7. propofitione del 12. d'Eu clide co'l fuo corollario, che ogni guglia, ò piramide è il terzo del fuo prifma, che il corpo fodo, & intero, da cui ella vien ca uata : fapendo dunque noi quanto lunga dourebbe effere la pi ramide, fe foffe compiuta, fapremo etiandio il fuo prifma ò cor po d'onde fi toglie, dalquale caueremo il terzo, & hauremo tut ta la piramide ò Guglia; & con ragione fimile cognofcendo la quantita dell'ecceffo della noftra Guglia, intenderemo anco il fuo prifma, & ne prenderemo la terza parte, & la fottrarremo da tutta la guglia, & ne rimarra il faffo, che cerchiamo. Ima giniamoci dunque due Piramidi, che tengano le bafi quadrate, l'vna delle quali fia A. B. G. & habbia il lato della bafe palmi 12, & fia

& fia alta palmi 324. & l'altra piramide fia C. D. G. il lato della cui bafe fia palmi 8. come nella prima figura fi difcerne. Sia an co per piu chiarezza in quefta feconda figura la Piramide, oue ro Guglia grande A. D. B. & la fua bafe quadrata A. B. & il fuo prifma A. C. & la piramide piccola, che è parte della piramide fia k. D. F. & il fuo prifma k. G. Hor mifuriamo di mano in ma no tutte le parti, per hauerne il vero pefo. Prima il corpo fo do di tutta la Guglia che è A. C. lungo 324. palmi, & largo 12. moltiplicato cubamente cioè la bafe, che è 12. nella lunghezza, che e 324. & il prodotto vn'altra fiata per 12. ne vengono palmi cu bi 46656. da quali trahendo la terza parte, refta la piramide A. D. B. di palmi cubi 15552. & tan to farebbe la noftra fe foffe inte ra. Ma percioche ella è monca, & folamente lunga da A. infino ad F. cioè il pezzo A. k. F. B. & il refto di fouerchio, cioè la pira mide k. D. F. bifogna leuarlo via da tutta la piramide A. D. B. per hauerne il giufto del pezzo A. k. F. B. che mifuriamo. Facci fi dun que la fteffa operation nella pira mide k. D. F. & perche il lato del quadrato k. F. è 8. & la bafe 64. palmi quadrati, i quali molti plicati nell'altezza F. G. che è 216. faranno il folido K. G. che farà palmi cubi 13824. & la ter za fua parte fara palmi cubi 4608. che tanto fara la piramide K. D. F. onde fottratta quefta piramide dalla gran piramide, cioè il numero 4608. da 15552. reftarà il numero 10944. cioè

D li palmi

Diagrams from Pigafetta's *Discourse.*

Cardinal Alessandro Peretti, the pope's nephew. Pigafetta's text included a history of obelisks, particularly those in Rome, and underscored the necessity of moving the Vatican obelisk, emphasizing its poor location, its association with Christian martyrs, and the value of sanctifying the pagan monument. He discussed in detail a method of determining the obelisk's weight and described the equipment needed to move it. The description corresponded precisely to, and justified, the machinery Fontana was preparing to use. Pigafetta eventually named Fontana himself as the engineer most qualified for the job.[22]

Fontana divided the operation into a series of carefully organized steps. He planned to lift the monolith from its base and then lower it slowly into a horizontal position, placing it on a sledge. The sledge would be rolled to

The *castello* and the pulleys.

DISCORSO
DI M. FILIPPO
PIGAFETTA;
D'INTORNO ALL'HISTORIA
DELLA AGVGLIA, ET ALLA
ragione del muouerla.

CON PRIVILEGIO.

IN ROMA,
Appreſſo Bartolomeo Graſſi. MDLXXXVI.
CON LICENTIA DE' SVPERIORI.

duties, and could appropriate work animals in Rome or other cities without license or receipt. He could seize capstans, ropes, and blocks, even if broken, for which he would pay rent. He could use any and all equipment belonging to St. Peter's and could command all the officials of the basilica to clear the piazza. He could tear down any houses or other structures near the obelisk, but was instructed to compensate the owners. He and his men could bear arms (except those specifically prohibited) any place and any time. Sixtus ordered all magistrates and officials of the ecclesiastical state to "obey, favor, and assist him without delay or any manner of excuse notwithstanding any other commands whatever," and all the others were enjoined not to obstruct him in any way on pain of a five-hundred-ducat fine. Such sweeping powers allowed Fontana to complete the great project efficiently, as they must also have created deep resentments – resentments that brought inevitable consequences. Soon after Sixtus's death in 1590, Fontana stood accused of reaping illegal profits from the many projects he completed under Sixtus. His lucrative Roman career came to an end. Fontana would spend most of the rest of his life working in Naples, where he died in 1607.[20]

Fontana began work on September 25, 1585, a day chosen for its symbolic importance to Sixtus. It was the anniversary of the day, many years before, when he had been made bishop. From that point on Fontana would begin each major step of the great project on a day symbolic either to Sixtus himself or to the church as a whole. Continuing work that had been started by the two fired architects, Fontana had fifty men dig a deep ditch (forty-five feet square and fifty-five feet deep) in the center of the square for the new foundation. Upon finding water and mud at the bottom, they reinforced the spot with oak and chestnut joists they drove into the ground with a pile driver. Then the bottom was surfaced with concrete made of stone and brick mixed with a lime based on a volcanic material called *pozzolana*.[21]

In March 1586, a month before the first stage of the transport operation, Fontana received support for his plan in the form of a small treatise on obelisks written by Filippo Pigafetta, a soldier, diplomat for Sixtus, and translator (from Latin to Italian) of an important work on mechanics. Pigafetta dedicated his work to a military engineer, Giulio Savorgnano, and to

Pigafetta's *Discourse* on the obelisk.

called "Architect of Our Lord" (i.e. Sixtus), in the document, came in at 16,000 *scudi.*[18]

Fontana's bid was the highest by a full two thousand *scudi,* but the *congregazione* chose the Architect of Our Lord anyway. Fontana reports that almost immediately a problem arose because at age forty-two he was considered too young to undertake such an immense task. So the *congregazione* appointed two older architects to carry out the work. These "coworkers" were also his competitors: Bartolomeo Ammanati of Florence, a man of sixty-five years, and Giacomo della Porta, who, in addition to his role at St. Peter's, had been in charge of numerous projects involving aqueducts, fountains, and other construction for both the papacy and the commune. Fontana claims to have been happy that his invention placed first and was put in the hands of two skilled architects. Seven days later, however, needing to see the pope about another matter, he went to Monte Cavallo, the palace on the Quirinal hill where Sixtus spent his summers. Fontana writes that he then began thinking about the obelisk again. He decided that his plan for the transport would succeed, but worried that it would not be fully understood by the architects assigned to the task. What if they did not carry out the plan correctly? Even he himself might not follow someone else's invention as well as one of his own devising. Sixtus was evidently persuaded, if persuaded he needed to be. In a bald assertion of power over the cardinals and the commune, the pope appointed Fontana the one and only head of the project and removed the two architects appointed by the *congregazione.*[19]

The full impact of papal power can be seen in the "substance" (as Fontana calls his summary) of the privilege Sixtus gave to his architect. Fontana received complete power to hire all the workers, skilled and unskilled, and to acquire all necessary tools, instruments, work animals, and materials. He could appropriate all the timber he needed (after paying for it), and could cut all timber belonging to the church, the commune of Rome, the canons of St. Peter's, the estate called Campomorto (which belonged to the canons), the Hospital of Santo Spirito in Sassia, and the Apostolic Camera – without payment. He could transport this timber in whatever way he wished and let the animals used for transport graze wherever it was convenient without penalty (although any damage would be paid for, after just estimates were made). He could buy whatever he needed without taxes or

were in proportion, including cords, pulleys, and other elements. His account of the presentation reveals a public and highly rationalized process of demonstration and persuasion. All the Lords of the Congregation were there, he says, as well as all five hundred masters of the arts. In the presence of this company: "I lifted that *guglia,* and lowered it in a very orderly way, showing with words from thing to thing the reasons, and the principles of each of these movements, thus as I followed then directly in effect." A document noted by Cesare D'Onofrio shows that the model was constructed by one Colantonio Liante and paid for by the *Reverenda Camera* – that is, the papal state.[16] Clearly, the deck was stacked in Fontana's favor.

Fontana's report is supplemented by other sources that both add information and present the decision-making process in a somewhat different light. The *congregazione* that met to organize the competition was not created especially for the obelisk project, as might be inferred from Fontana's account. Rather, it was a standing committee of papal administration: the *Congregatio super viis pontibus et fontibus* (Congregation on Streets, Bridges, and Fountains). Such standing committees, in occasional operation since the 1560s, became standard after Sixtus V's reform of papal administration in 1588, and remained so until the twentieth century. Created by Pius V in 1567, the Congregation on Streets, Bridges, and Fountains had met on about a monthly basis for nearly twenty years.[17]

The *congregazione*'s minutes for September 18, 1585, provide further details. Seven men are listed – apparently the finalists. These men not only offered a plan or model (which model each presented is not revealed in the document), but also described the funding they would need. Three of the finalists were Florentines. Of these, one Antonio Ilarione Ruspoli asked for a contract of 10,000 *scudi* and was ready to make 9,000 of it a security. A second, Francesco Tribaldesi (the favorite of Cardinal Medici, according to an extant letter), asked for a contract of 14,000 *scudi.* The third Florentine, Bartolomeo Ammanati, did not propose a contract but asked simply to supervise the work and be given the costs. The other candidates mentioned were old Roman hands. Giacomo della Porta, the longstanding architect for the Commune of Rome and head architect of St. Peter's, asked only for costs. Giacono del Duca, a Sicilian who had been a favored student of Michelangelo, requested a contract of 7,000 *scudi.* Giovanni Fontana (brother of Domenico) wanted 13,500, and Domenico Fontana,

convened in the nearby palace of Cardinal Pier Donato Cesi. In addition to Cesi three other cardinals attended: Filippo Guastavillano, who would become *camerlengo,* or treasurer, of the Holy See, Ferdinando de'Medici, and Francesco Sforza. The group, as Fontana listed it, also included thirteen additional members, men who either worked for the cardinals or for the government of the commune. Several of those in attendance dealt with financial issues, including the treasurer-general to a cardinal, and the *fiscale,* an officer appointed by the pope to ensure taxes were gathered and to protect the papal income collected in the city. The *congregazione* also included members of the city government, including the three *conservatori* (elected officials who served together for three-month terms and headed the government), and officers of the magistracy known as the *Presidenza delle strade,* including the two "masters of the streets."[13]

The charge of the *congregazione* called upon "men of letters, mathematicians, architects, engineers, and other valiant men" to offer their opinions and proposals for the project. To facilitate the search for the best solution, the members agreed to convene again twenty-eight days later "to give time to many skillful foreign men who gathered in Rome from various places to show the force of their ingenuity concerning the matter." In fact, many knew of the pope's interest and had already arrived in Rome. Thus, Fontana reports, the second gathering, on September 18, drew five hundred men from a multitude of places: Milan, Venice, Florence, Lucca, Como, Sicily, Rhodes, and Greece. Each carried his "invention" in one form or another. Some brought drawings; some carried models; some offered written descriptions. Others explained their ideas verbally to the *congregazione.* From this collection of what were apparently hundreds of proposals, Fontana provided illustrations of eight scattered about a page of his book.[14] One used a half-wheel to lower a standing obelisk to a horizontal position; another relied on wedges; two others moved the monolith in machines built around large screws; another used huge levers; yet another consisted of a ratcheted quadrant. Fontana's own model is depicted at upper left, carried aloft by *putti,* a celestial sign of its superiority.[15]

Fontana brought a wooden model of his machine for his presentation. He had an obelisk of lead to go inside the model, and all the working parts

The various proposals. Fontana's successful entry is held aloft by *putti.*

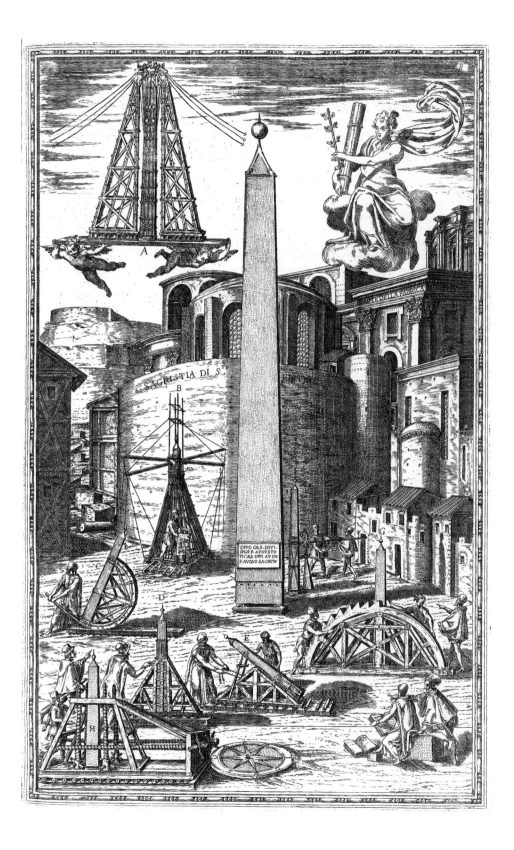

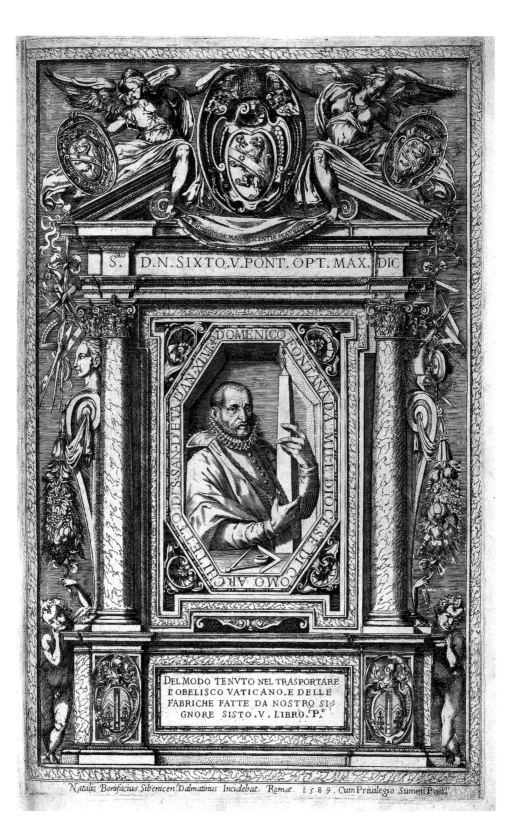

RELIGIO SÆ MAGNIFICENTIÆ MONVMENTV

S.ᵐᵒ D.N.SIXTO.V.PONT.OPT.MAX. DIC

DOMENICO

D E S. SAN. DI ETA DANXLVI. FONTANA DA MIL DIOCESE DI COMO ARCHITELLO

DEL MODO TENVTO NEL TRASPORTARE
L'OBELISCO VATICANO, E DELLE
FABRICHE FATTE DA NOSTRO SI‍
GNORE SISTO.V. LIBRO.P.°

Natalis Bonifacius Sibenicen. Dalmatinus Incidebat. Romæ. 1589. Cum Priuilegio Summi Pont.

the necessary funds. Fontana saved the day, continuing work and lending his patron the needed money. He was able to provide the funds because he and his brothers owned land in their native region of Lugano (in present-day Switzerland) and in Rome itself, from which they derived income.[11] After such a history, it was perhaps inevitable that, in the end, it was Fontana who created the plan chosen for moving the obelisk, but the process of selection was complex, as befitted a city in which total papal control was only an aspiration.

Formally, two entities governed Rome. First, there was the commune – the city government – based at the Campidoglio, or Capitol, and organized around a council made up of noble Roman citizens. Second, there were the pope and papal curia, based at the Vatican. Sixtus aimed for absolute power, but he could not avoid working through the offices and committees of both the curia and the city council as he made his plans. The cardinals in particular were a powerful force. They elected the pope, and the most eminent among them headed their own courts and exercised substantial influence through family and political ties with rival European powers. The communal government of the city (the *Populus Romanus*) had existed since the twelfth century, but by the later sixteenth century it had lost nearly all its authority to the papacy. Nevertheless, the commune still attempted to assert its power, especially in the mundane but crucial day-to-day aspects of the running of the city.[12]

Both the complexity of the Roman government and the ultimate authority of the pope are made clear by the documentation that records the selection of a plan and engineer for the obelisk project. In the book he wrote about the project in 1590, *Della trasportatione dell'Obelisco Vaticano* (*On the Transportation of the Vatican Obelisk*) Fontana relates that on August 24, 1585, Sixtus ordered a meeting, or *congregazione*, of lords and prelates to discuss how the monolith might be moved most safely, and who the "artificer" should be – the person who was most skilled because of knowledge and experience (*esperimento*) in such things. The *Avvisi di Roma* – the handwritten news bulletins sent from Rome to Urbino and other places in these years – report that on this date a wooden obelisk was built on the proposed new site in front of St. Peter's. The meeting itself was

The frontispiece to Fontana's *Della trasportatione*.

new site, the levers would again be put into action to lower the great stone onto its new base.[8]

In his classic 1939 study of Renaissance engineering, William Barclay Parsons noted that Agrippa's illustration of the tower apparatus "shows that the main timbers were unsupported at any point in their entire length, that there was no diagonal bracing and that the design was lacking in every essential of sound engineering principles." But if, as Gregory XIII rightly surmised, Agrippa's invention would not have stood the test of actually moving the obelisk, it did contain some ingenious ideas. Several, including the tower, reappeared in the machine Domenico Fontana used to move the obelisk just a few years later. In the pamphlet's final section Agrippa invented a philosophical dialogue between two brothers, Fabritio and Agapito Fossani, on weight and the theoretical aspects of the nature of motion – a rhetorical capstone for a work that neatly bridges the worlds of engineering theory and practice.[9]

There were many other obelisk schemes in these years, but concrete evidence remains for only a few. In 1586 Francesco Masini proposed one in a very rare booklet, published at Cesena (near Ravenna, in Emilia-Romagna). Taking the standard Renaissance approach to currying favor, he dedicated the tract to Adovardo Gualandi, the local bishop, who was deeply engaged in enforcing Tridentine reforms and had close ties high in the ecclesiastical hierarchy. Masini proposed to move the obelisk by constructing a canal system from its location at the side of St. Peter's to the new site around front. He described a raft-like container that would surround the obelisk, leaving hollow sections for air, the theory being that the air pockets would allow the obelisk to float. He planned to construct the encasement around the obelisk while it was still standing and lower it into the canal for its short ride to the new site.[10]

The idea of moving the obelisk really came to life when Felice Peretti was elected as Pope Sixtus V in 1585. A man of tremendous energy and drive, he attacked the project of moving the obelisk without delay. While still a cardinal, Peretti had hired the architect Domenico Fontana to build a new palace, Montalto, on the Esquiline Hill, near the Basilica of Santa Maria Maggiore. Objecting to such conspicuous extravagance on the part of his cardinals, Gregory XIII had tried to bring the vast building project to a halt. He stripped Cardinal Peretti of his benefices, leaving him without

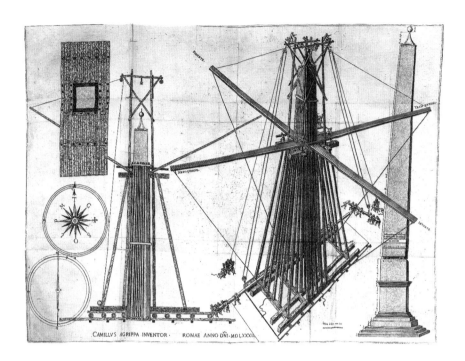

Camillo Agrippa's scheme for moving the obelisk.

Agrippa's booklet is a revealing early example of an engineering treatise, as much an exercise in Renaissance rhetorical traditions as a specimen of technical writing. He recounts the prominent figures who had worked on the problem and then details his own plan, providing an illustration of his apparatus. Boldly, he proposes to avoid the problem of lowering the obelisk by moving it upright. First the obelisk would be encased in a protective armature made of thick oak boards. Then Agrippa would construct a high tower around the monument, consisting of forty timbers that leaned together towards the top. This tower would support the monolith as it was being moved. Next, he would build a platform around the base of the obelisk, also made of large timbers and equipped underneath with eight rollers. Suspended from a platform two-thirds of the way up would be a giant set of levers made of oak beams, eight on each side. An arrangement of pulleys and ropes attached to grappling hooks would grasp the iron chains that encircled the monument. This mechanism of levers and pulleys would raise the obelisk. It would then move to its new location while suspended vertically in the tower. Once the assembly of beams and obelisk reached its

raised the question. According to an anonymous report sent in July 1574 from Rome to the Hapsburg court in Vienna, Gregory resolved to move the *guglia* ("needle") to the piazza in front of San Pietro "for the greater commodity of viewing for the people who will come to Rome in the Holy Year [1575]." The pope estimated the cost at thirty thousand *scudi*.[5]

Clearly, serious planning was essential for such a delicate and expensive operation. Camillo Agrippa, a fencing master from Milan, drew up one proposal around 1580, publishing a small booklet about it in 1583. He explained, in point-by-point detail, a plan for moving the great stone. Agrippa recalled that when he had arrived in Rome almost fifty years before, in October 1535, many people were discussing such a project, including the well-known architect Antonio da Sangallo, the famous Michelangelo, and "infinite others." For the next thirty years he thought about the task, while also finding himself "frequently occupied with inventions not less useful than honorable to the public." One such had involved the extension of the Acqua Vergine, one of Rome's aqueducts, up the Pincian Hill to the Villa Medici. Agrippa's achievement was commemorated in an inscription on one of the new fountains fed by the aqueduct: "Marcus Agrippa [son-in-law of the Roman Emperor Augustus] conducted the Acqua Vergine only up to the low region of the Campus Martius; and it was called an excellent work. But Camillo Agrippa succeeded in raising it to the top of the Pincian Hill: that demonstrates a higher skill."[6]

Agrippa failed to duplicate that success in the area of obelisk transport. In 1581 he won an audience with Gregory XIII and Michele Mercati to describe his plan. Mercati records that Agrippa had made a proportionate model of his machine and that the pope asked him to demonstrate it. The demonstration took place in the Metallotheca Vaticana, a room in the Vatican palace that Mercati had designed as a display of natural history focusing on metals and metallurgy. Although Agrippa put forth many reasons why he could carry out the work securely and easily, the pope was unconvinced, concluding that, Agrippa's boasts about the modern engineering skill that had gone into his fountain notwithstanding, the architects and engineers of his time could not move such a heavy weight. The engineer continued to press his case, writing his treatise and dedicating it to the pope's son, Giacomo Buoncompagno, who held the office of General of the Holy Church. All to no avail.[7]

sought to transform and reclaim them for new, more explicitly Christian purposes. Reviving ideas put forward by earlier popes such as Nicholas V and Leo X, some suggested that the obelisks – almost all of which still lay broken or buried where they had fallen centuries before – could be excavated, repaired, and re-erected in some of the most prominent locations in the modern city. In their new settings, the monuments would provide dramatic centerpieces for the city's great public spaces and prominent markers for orienting public processions and ceremonies. Raised before the most venerated Roman basilicas, the obelisks could be transformed from symbols of pagan idolatry into emblems of the church triumphant.[3]

But relocating obelisks presented serious difficulties. The most obvious was simply the daunting task of moving these immense objects, the largest of which weighed hundreds of tons. With a few minor exceptions obelisks had not been moved or raised in Rome since antiquity, and the methods the ancients had used were not precisely known. In the case of the Vatican obelisk, whose transport had been considered (and postponed) for over a century, the difficulty was compounded by the fact that it still stood, and needed to be lowered safely before it could be moved. The prospect of a broken Vatican obelisk could only be envisioned with dread, since an engineering failure of that magnitude would certainly undermine papal authority. Many of the other obelisks had fallen and broken long before. While that meant they did not have to be lowered, they presented the difficulty of having to be repaired. A third problem was spiritual. The obelisks were associated with the gods of ancient Egypt. Theologians, humanists and preachers knew that Hebrew prophets and Christian apologists alike had denounced these gods as pagan idols and monsters. There were serious concerns that demonic spirits might still cling to the ancient stones.

In the middle of the sixteenth century Pope Paul III, apparently undaunted by the doubts that had plagued his predecessors, pushed especially hard to get the Vatican obelisk moved. Michele Mercati, the learned geologist, botanist, physician to several popes, and author of an important treatise on obelisks, reported that Paul repeatedly pressed his architect, Michelangelo Buonarroti, to undertake the task. The renowned artist was never willing to try. Mercati learned from Michelangelo's surviving associates that when they asked why he was so reluctant, he had replied simply: "And if it were broken?"[4] A few decades later, Pope Gregory XIII again

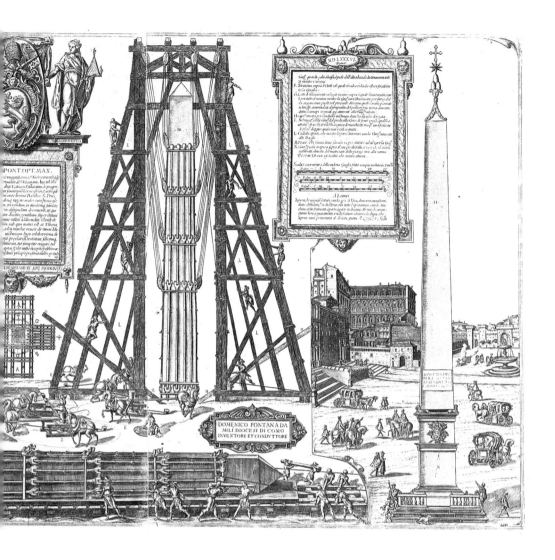

new focus and energy in its attempt to combat Protestantism. As the church instituted reforms in liturgy, art, and music in response to the council's deliberations, the popes also turned their attention to the city of Rome, pouring enormous resources into making it express more fittingly the papacy's claim to both temporal and spiritual authority. In these Counter-Reformation decades, papal and city authorities built (and rebuilt) palaces and churches, straightened and paved the streets, repaired the old Roman aqueducts, and constructed numerous fountains. The city's ancient monuments were looked upon with new eyes by the reforming pontiffs, who

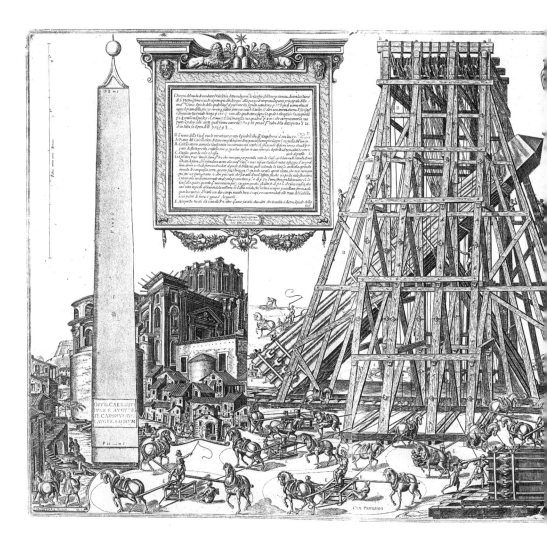

Three stages of moving the obelisk. One of a pair of gigantic prints celebrating the move by Giovanni Guerra and Natale di Bonifacio. The original is more than a meter wide.

drama. Performances took many forms, from solemn papal processions, to the flamboyant pageants that occurred when an ambassador and his entourage paraded into the city, to street-corner acrobats. During the papacy of Sixtus V, from 1585 to 1590, a dramatic new form of popular entertainment caught the Roman imagination – great feats of engineering involving the transport and erection of obelisks.[2]

The conclusion of the Council of Trent in 1563 gave the Catholic Church

Moving the Vatican Obelisk

*By sunset, the needle had been raised on top of its pedestal. . . . At once,
the signal was given by several mortars in the Castel Sant'Angelo,
where they shot off many artillery pieces, and the entire city rejoiced
greatly. All the drummers and trumpeters of Rome flocked to the house
of the architect, playing to great applause.*

DOMENICO FONTANA, *Della trasportatione dell'obelisco vaticano*[1]

LATE SIXTEENTH-CENTURY ROME was a cacophony, resounding with
the talk and shouts of a polyglot population; with the loud clatter of
horses pulling carriages (a new vogue among the elite); and with the
sounds of hammers and saws wielded in new construction. It was a vibrant
city where the pope, cardinals, ambassadors, and Roman nobles shaped
squares and streetscapes in both subtle and dramatic ways. The population
of about 110,000 was growing rapidly, and was augmented by a continu-
ous stream of travelers and pilgrims from all over Europe. But amid all the
new buildings and ancient ruins, what most impressed many travelers was
the dazzling richness of the city's public life and ritual. Rome was a living
theater, its streets and *piazze* regularly transformed into stages for urban

Moving the obelisk, by Giovanni Guerra and Natale di Bonifacio (detail).

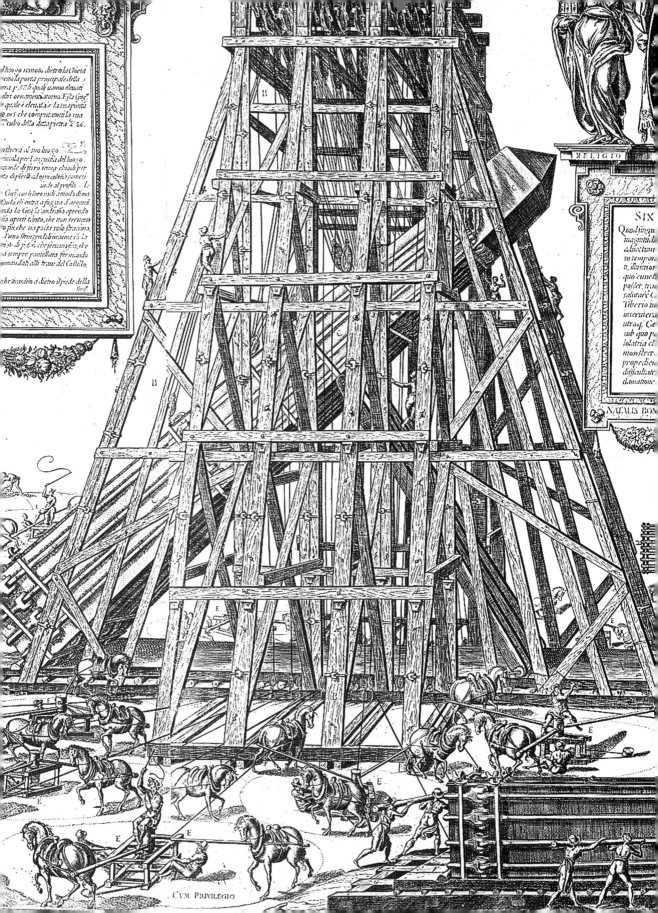

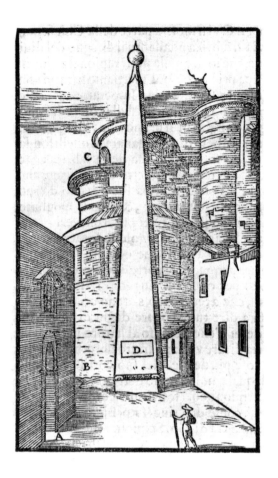

The Vatican obelisk before its move, from Bernardo Gamucci's 1565 guidebook to Rome.

was translated into Italian and French and reprinted again several times. Others, such as the Fleming Jan Becan van Gorp, followed up by creating their own staggeringly complex and imaginative handbooks. By the end of the century both the hieroglyphs and the great obelisks that bore them were entwined in a fantastically complicated web of history and symbolism – of ideas about Egyptian wisdom and religion, about ancient Roman power and modern papal privilege, of imagined genealogies and intellectual games. And thanks in large part to the efforts of one indefatigable pope and his equally determined architect, the moment of truth had come – it was time for the stones to move.

up-to-date Italian styles. But the culmination of High-Renaissance Egyptian taste was a much smaller – though equally magnificent – work of art: the astonishing illuminated frontispiece to the Mass of St. John the Baptist in the Missal of the Roman Cardinal Pompeo Colonna. Dating to the early 1530s, the page is a visual encyclopedia of the Egyptian imagery known to the Renaissance. Yet it, too, had a "practical" purpose. It is an archaeological excursus on the Colonna family's Borgia-like claim to descent from Osiris.[40]

At the same time that Europe's aristocrats, artists, and scholars were inventing entrancing Hermetic puzzles, a parallel, and much more critical and monument-centered approach to archaeological study began to develop as well. As the sixteenth century wore on, an army of scholars fanned out across Rome, creating an ever-more-systematic and comprehensive record of the city's ancient past. The sketchbooks and albums of artists and antiquarians like Pirro Ligorio, Étienne Dupérac, and Jean-Jacques Boissard include many drawings of Egyptian monuments and copies of hieroglyphic inscriptions. In several cases these were gathered into specifically Egyptian sections, or even whole Egyptian albums. A number of Egyptian images seem to have been copied and passed about, so it's possible they provide a glimpse of an otherwise lost plan, however loosely organized, to collect and publish copies of Egyptian inscriptions, in much the same way collections of Latin and Greek inscriptions were gathered together in printed editions. Similarly, the period's guides to ancient myths and legends show a deep interest in Egyptian imagery. The encyclopedic studies produced by scholars like Lilio Gregorio Giraldi in 1548, and Natale Conti and Vincenzo Cartari in the 1550s, provided extended (and sometimes bewilderingly syncretic) accounts of the Egyptian gods.[41] Would-be Egyptologists of the period were especially fascinated with the hybrid human-animal figures of the Egyptian pantheon, such as Anubis, the Egyptian god of the dead, his human body topped with a jackal's head, and also by the curious, vase-bodied images of Osiris that late-antique sources identified as the "idol of Canopus."[42]

All of this material mingled together in a great and savory scholarly stew, one that never ceased to attract new chefs as well as new consumers. A revised edition of Valeriano's *Hieroglyphica* from 1567 features an appendix of some ninety additional signs by Celio Augusto Curio. The work

ſpatio continetur. Stereobata,quod Baſſamentum uulgo nuncupatur,integer perpetuuſque abſq; ulla par
tium conglutinatione exiſtebat. Poſtremus Obeliſcus R conſonantis inſcriptione donatus, in Antonini
Caracallę circo ſtatuitur; &, quemadmodum ex eius deſignatione perſpicitur,fractus ac diminutus complu
ribus locis eſſe uidetur: Ima quidem craſsitudo quinario pedum denarioq; minutorum numero compre-
henditur,altitudo uerò in pedes lvj minutaq; xxxij contendit,craſsitudoq; ſumma tandem tripedali minuto-
rumq́ue ſenum magnitudine terminatur. Cunctiq́; ſtylobatę hic à nobis deſcripti, cum ueris exemplaribus
maximam utique ſimilitudinem gerunt. Quanuis autem pręter hos alij complures nobis incogniti forſi-
tan Romę habeantur Obeliſci : eorum tamen duntaxat,quorum contemplandorum dignoſcendorumq́; fa-
cultas nobis exhibita fuit,formas in pręſentia modulosque tradidimus.

L 4　　　　Romanum

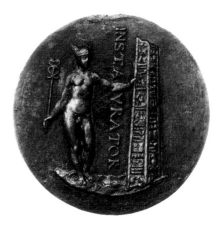

Pierio Valeriano celebrated as INSTAURATOR – "Restorer" – of the hieroglyphs,
with Hermes Trismegistus and an obelisk.

to patrons and colleagues throughout Europe's learned elite, Valeriano
recalled halcyon days spent on antiquarian picnics and field trips, where
Roman aristocrats and ladies amused themselves as they tried – often with
some skepticism, and even trepidation – to apply Valeriano's codes to the
decipherment of statues, friezes, obelisks, and other monuments, Egyptian
and Roman alike. Valeriano's expansively neo-Platonic explanations of the
hieroglyphs, which he saw as symbolic expressions of a higher wisdom that
could be found in the symbolic lore of virtually all ancient and modern cul-
tures, helped fuel a broader enthusiasm for enigmatic poetry and emblems,
variants of which seemed to appear almost everywhere across Europe and
in every context from courtly ballets to festive pageant floats to the most
erudite academic debates.[38]

Interest in Egyptian themes spread far beyond the papal court. The
Roman-Sienese banker Agostino Chigi erected pyramids in his burial cha-
pel at Santa Maria del Popolo; Rome's Cesi family assembled a collection
of Egyptian antiquities and ornamented their family tombs with Egyptian
sphinxes; and the Gonzaga family commissioned hieroglyphic decorations
from the painter Giulio Romano for the Palazzo del Te in Mantua.[39] The
fashion soon spread to France, where royal and princely patrons appropri-
ated motifs from Roman Egyptian statuary as part of a broader adoption of

Rome's obelisks and columns, from Sebastiano Serlio's *Five Books on Architecture* (1569).

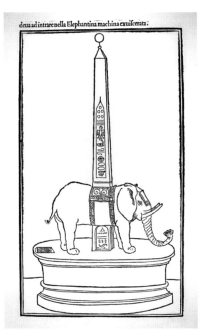

Antonio da Sangallo's sketch for Leo X's obelisk;
the elephant obelisk from the *Hypnerotomachia Poliphili.*

In the end, the obelisk scheme came to naught. Even so, the compli-
cated symbolic program reflects both the period's love of many-layered
symbolism and the intense scholarly interest in ancient history in general
(and Egyptian lore and hieroglyphs more specifically) among the humanists
at the courts of Leo and his successors. Among the Egyptological studies
that emerged from Rome in the middle third of the sixteenth century were
Latin translations of Horapollo's *Hieroglyphica* and Plutarch's *De Iside et
Osiride* by the Ferrarese humanist Celio Calcagnini, published after his
death in 1541. It was also in these years that Pierio Valeriano carried out
his study of hieroglyphs.[37] Valeriano's lifelong commitment to this proj-
ect culminated with the publication of his monumental *Hieroglyphica* in
1556. In this text Valeriano assembled an immense corpus of Greek and
Latin sources on the hieroglyphs and all other forms of symbolic writing
and imagery, from which he drew a magisterial guide to the allegorical
and philosophical meanings expressed by the figures that the Egyptians
used on their monuments. In the prefaces to his many chapters, dedicated

almost immediately.[30] According to the Venetian diarist Marino Sanuto, Raphael proposed to raise the obelisk in front of St. Peter's as a kind of surrogate for the much larger Vatican obelisk.[31] A second proposal envisioned placing it in the nearby Piazza del Popolo. A drawing by Sangallo reveals one of the more fantastic proposals for its erection in the piazza.[32] The obelisk is supported on its ancient base by a set of tortoise-shaped astragals. That structure in turn rests on a stepped foundation with four elephants, topped by a group of sphinxes wearing pharaonic headdresses. With this outlandish monument, Leo's architect (Sangallo, Raphael, or both) exceeded in sheer audacity even the most ambitious schemes of Nicholas V. The personal, dynastic, and Egyptianizing imagery of this proposal shows how much tastes had changed since Nicholas V's more austere age.

The whole confection was a tissue of references: to Rome, to Egypt, to the Medici family, to Leo himself. For example, the tortoise astragals appear to provide a deliberate echo of similar ornaments Leo's father, Lorenzo, employed on the funerary monument for his father and uncle, Piero and Giovanni de'Medici, in Florence's church of San Lorenzo. But there is the possibility of an Augustan reference as well, since the San Lorenzo turtles may refer to the Medicis' adoption of Augustus's motto, *Festina Lente* ("Make Haste Slowly"), a maxim that also found expression in the *Hypnerotomachia*'s hieroglyphs.[33] If so, the application of these creatures to a re-used ornament from the emperor's Mausoleum seems particularly appropriate. The elephants and sphinxes also suggest the influence of the *Hypnerotomachia,* where both creatures appear in illustrations as obelisk supports. The pachyderm had more personal resonance for the pope as well. It evoked the memory of Leo's own late elephant, named Hanno after the ancient Carthaginian general who tried to invade Italy from the north, crossing the Alps with fully outfitted war elephants. Hanno the elephant's brief but brilliant career established him as a kind of living antiquity and a recurring emblem of the Medici papacy.[34] But elephants, too, had Augustan overtones, since they recalled the emperor's dedication of a group of four obsidian elephants at the Temple of Concord.[35] Finally, the sphinxes, emblems both of Leo's papacy and Egypt, provided a fitting ornament for a combined monument to Egypt's Roman conqueror and the Tuscan pope who restored the obelisk, whose sacred kingship drew from the traditions of all his predecessors: Osiris, Augustus, and Peter.[36]

symbols, swarmed Rome's streets and palaces, all of these sphinxes and lions would have been instantly understood as variations on the pope's own leonine insignia. And it was in this spirit that they proliferated in the copious decorations that the pope and his nephew, Giulio de' Medici, commissioned for the Vatican Palace, the Villa Madama, and elsewhere. In all of these instances, the creatures harmonized nicely with the erudite scholar Pierio Valeriano's explanation of the sphinx as a combined symbol of human intelligence and the dominion of humanity over all the creatures of the world. His description seems particularly fitting for a pope who claimed primacy over the secular princes of the world:

> As however for those sphinxes which have a human head, but a lion's body, which can be seen everywhere in front of temples, some men interpret these as a hieroglyphic fantasy, with the meaning that we are reminded that in our human nature we are superior to other living creatures. For elsewhere we have argued that by the head should be understood the notion of leadership. Furthermore it is clear that the lion is the chief of all brute animals, who is subject to human authority but drags all other creatures after him. Yet in the Bible we read that authority over all brute animals has been given to man. Adamantius [Origen] records that the sphinx, which is of course in one half of its form a monster, bears a girl's form at the front through a fantasy of the Greeks. The interpretation of others is that religion grants mastery over the whole world to one whom even the fiercest animals are to subject themselves and accept his authority.[27]

A final project brought together all these Egyptian and imperial themes. In the summer of 1519, excavators working on the restoration of the Via Leonina (today's Via Ripetta) under the supervision of Raphael and Antonio da Sangallo the Younger discovered one of the twin obelisks from the Mausoleum of Augustus.[28] It had long been known from written sources that the Mausoleum had featured obelisks. Fragments of one had even been identified in the 1490s and then forgotten.[29] Now, in stark contrast to Julius II's neglect of the Campus Martius obelisk a few years earlier, this obelisk's broken fragments and base were quickly extracted and moved into the street near the church of San Rocco. Plans for restoration were discussed

adopted home of Venice. As pope, Leo would employ Fra Urbano's nephew, Pierio Valeriano, who loomed very large as an expert on hieroglyphs later in the sixteenth century.[18] Leo was also familiar with Egyptian artifacts, as the antiquities collection assembled by his father included at least one Egyptian work, a Ptolemaic-era sardonyx cup decorated with an elegantly classical sphinx.[19] The pope himself owned a statue of Isis that reportedly provided the model for a golden image carried in the Carnival procession of 1520.[20] And among the ephemeral monuments created for Leo's triumphal entrance into Florence in 1515, two years after he was elected pope, was a full-scale copy of the Vatican obelisk, erected on the bank of the Arno at the north end of the Ponte Santa Trinità.[21]

Like Julius, Leo took an expansive view of the papacy. He continued the process of rearranging the city's ancient remains to emphasize the papacy's imperial privileges.[22] Not surprisingly, given his name, he showed a particular affinity for lions and sphinxes, which he saw as powerfully charged expressions of papal authority. Toward the end of 1517 he ordered the transfer of two colossal statues of the Tigris and Nile rivers from Monte Cavallo (the Quirinal Hill) to the portico of the Palazzo dei Conservatori on the Capitoline.[23] It was also almost certainly Leo who installed a pair of black-stone, hieroglyph-inscribed sphinxes on the steps of the Senator's Palace in the same piazza toward the end of 1513.[24] Sometime around 1515 he was responsible – certainly this time – for the restoration of a celebrated pair of Egyptian lions, inscribed with hieroglyphs, in front of the Pantheon.[25] The lions were set up on either side of the large porphyry basin that had sat in the piazza for centuries. At about the same time, two lions at the Lateran basilica were restored and set up on columns in front of a statue of Emperor Marcus Aurelius. At the Pantheon, Leo's imperial message was especially clear. Although the current building dates from the reign of Emperor Hadrian, in the second century CE, the inscription on the portico reminds visitors that the original Pantheon was built a century and a half earlier by Marcus Vipsanius Agrippa, one of Augustus's generals. The connection to Augustus particularly appealed to Leo. Following the war-ravaged pontificates of Alexander VI, "Maximus," and Julius II, the "second Julius Caesar," Leo was hailed as a *rex pacificus,* a new Augustus whose reign would inaugurate a new age of peace.[26]

In an age when ambassadors and secretaries, trained to decode political

obelisk in a highly traditional way, as the tomb of Caesar. Yet the architect also clearly saw the obelisk as a unique and uniquely impressive object, one that could affect those who passed it so deeply as to change their lives and make them receptive to true piety. The patron, however, had views of his own. For the art historian Ernst Gombrich, Julius's rejection of Bramante's obelisk scheme, as well as a second project for an inscription in rebus-like hieroglyphs for the portal to the new Cortile del Belvedere, reflects the pope's hostility toward Egypt, hieroglyphs, and strange theories about either emanating from the general direction of Viterbo.[15] A third incident appears to support this thesis. According to an eyewitness, the antiquary Antonius Laelius Podager, the discovery in 1511–12 of the buried remains of Augustus's Solarium obelisk, near the church of San Lorenzo in Lucina, was greeted with calls for its excavation and restoration. The pope, however, was "too distracted by his wars" to be bothered, and the barber who discovered the obelisk "finally lost his patience and buried this miracle of antiquity all over again."[16]

And yet, even with these episodes suggestive of Julius's antipathy (or at least apathy) to Egypt in mind, it may be worth noting that soon after the Solarium obelisk was abandoned to the pit in which it lay, the pope had no apparent objection to the display of yet another obelisk – in this case, an ephemeral, float-borne concoction that was a featured attraction in the carnival celebrations of February 1513. On its four faces were painted inscriptions in Greek, Latin, Hebrew, and "Egyptian letters" (*lettere egyptie*) that took the following form: "At the top, a sheaf of corn, then an ape, an oak, and a hawk, with a palm on the left and an eye on the right, with a stork at the bottom," signifying (along with the other inscriptions) "Julius II Pont. Max: Liberator of Italy and expeller of the schismatics."[17] No illustration of this short-lived monument has survived, but from the description it seems close in spirit to the hieroglyphs of the *Hypnerotomachia Poliphili,* so often the source of such imagined Egyptiana.

Whatever Julius's opinions about Egypt and obelisks, his successor, Giovanni de'Medici, who took the papal name Leo X, seems to have liked both immensely. In his youth this son of Lorenzo the Magnificent had been tutored by such Egyptologically inclined humanists as Marsilio Ficino, Angelo Poliziano, and Fra Urbano Bolzanio. Fra Urbano, who had traveled in Egypt, was considered something of an authority on hieroglyphs in his

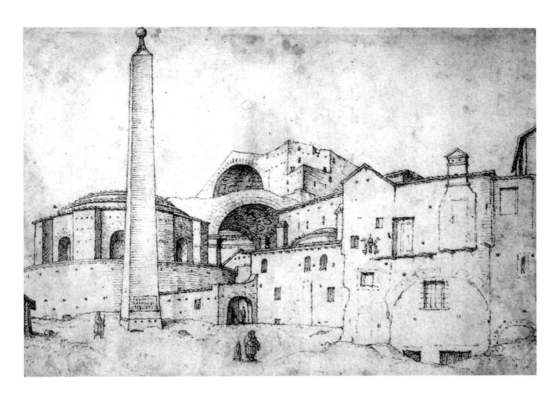

Maarten van Heemskerck's record of the Vatican in the early sixteenth century.

of this new monolith." "It is hard," the architect admitted, to move rocks
that are firmly attached to mountains, "but once they are moved from their
places, it's easy to make them go all the way to the bottom. Similarly, souls
that feel no emotion remain unmoved; but once emotion stirs them up, it
is easy to induce them to prostrate themselves at churches and altars." The
architect offered to "take on himself the task of moving the tomb [of Peter]"
and assured the pope that "nothing would be disturbed but the tomb with
the earth that is adjacent to it," and that any damage could be avoided by
transporting the tomb whole, in one piece. Julius proved just as stubborn
as Bramante. He refused to allow "anything from the old site of the temple
[to be] overturned, or anything from the tomb of the first pope destroyed."
As to Caesar's obelisk, he declared that he himself would determine what
was proper, adding that he preferred sacred things to profane, religion to
magnificence, and piety to ornaments.[14]

This story shows that Julius II and Bramante still viewed the Vatican

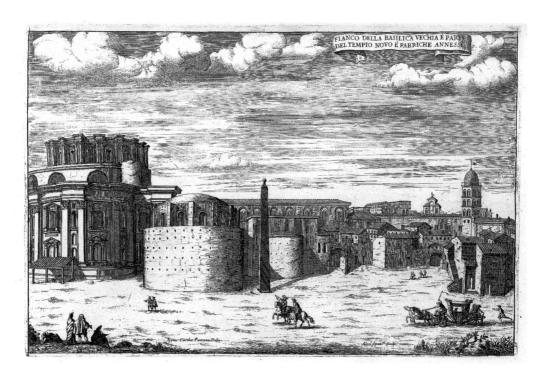

The Vatican before the move of the obelisk, from Carlo Fontana's *Templum Vaticanum*.

involved in reproducing the ancient feat of moving it. The pope's equally ambitious (and frankly ruthless) architect, Donato Bramante, went so far as to propose – or so the pope's close advisor, Cardinal Giles of Viterbo, later recalled – that he could achieve the desired effect by moving not the obelisk but the basilica itself. Evidently Bramante, unlike Fioravante decades earlier, had no faith that he could transport the huge shaft. But it would be simple enough, he explained, to reorient the basilica so that its façade faced "not east, but south, so that the great obelisk, in the piazza before the church, would confront those coming up to the temple." According to Giles's account, Julius was reluctant to accept this startling proposal, since it was clear that the tomb of the Apostle Peter itself would almost certainly have to be moved in the process.

Bramante persisted. He tried to explain that if "what is commonly thought to be the monument of Julius Caesar" were in the basilica's vestibule, it would help promote a sense of awe and piety, since those entering the church for divine services would be "moved and astonished by the sight

once. Through much of the sixteenth century, the enthusiasm that texts had generated for the profound wisdom of the ancient Near East helped, in turn, drive both the creation of new art and the study of antiquities. The texts helped shape how objects were understood, and may even have generated some antagonism for certain types of objects. It is against this interlaced backdrop of new art, antiquarian, archaeological, and textual studies that the next chapters in the history of Rome's obelisks play out. Despite the new scholarship and the new context, many familiar themes reappear. For just as ancient Egyptian pharaohs and Roman emperors competed with their predecessors, rededicating monuments and effacing inscriptions, so did Rome's new rulers, the popes, engage in rivalry and emulation across time – with other popes, other emperors, and even other gods.

When Alexander VI died in 1503, he was succeeded (following the month-long papacy of Pius III), by his nemesis, the great and "terrible" Cardinal Giuliano della Rovere, who took the papal name of Julius II. Where the Borgia pope had fancied himself a second Alexander the Great, the new pontiff encouraged his own identification as a second Julius Caesar, a claim he made in remarkably explicit terms when he celebrated his 1507 conquest of Bologna with a medal that proclaimed him "IVLIVS. CAESAR. PONT. II" – "Julius Caesar Pontifex Maximus the Second."[12] Contemporaries recognized that this allusion was well suited to Julius's aggressive character.[13]

In keeping with his grandly imperial conception of the papacy, Julius instituted a campaign of rebuilding and renovation at the Vatican palace. It amounted to a near-complete transformation and included the construction of the great arms that enclose the Belvedere Court, the installation of a celebrated collection of ancient marble statuary – ancestor of the Vatican Museums – and the commissioning of new fresco cycles: the *stanze,* or "rooms," that are among Raphael's crowning achievements, as well as Michelangelo's ceiling in the Sistine Chapel. But in addition to rebuilding his own palace, Julius sought to remake God's primary house in Rome, the Basilica of St. Peter itself, on a scale that would dwarf the grandest churches in Italy and Europe, including the great cathedrals of Florence and Milan. To this end, Nicholas V's old plan to move the Vatican obelisk to the front of the basilica was considered anew. This time, however, the planners paid due heed to the obelisk's immense size and the technical difficulties

became a widespread effort to connect new European monarchies, some of which were of very shaky legitimacy, with the most ancient kingdoms in the historical record.[9]

One of this book's most extraordinary qualities was the way it integrated material and textual evidence, reflecting the most up-to-date antiquarian practice. Annius actually deciphered a hieroglyphic inscription, which he discovered in his native Viterbo, as a reference to Osiris's many journeys. Annius described this as "a column or tablet of alabaster . . . inscribed with sacred Egyptian letters in the form of birds, animals, heads, and trees." He took the oak in the relief as standing for a scepter – which in turn, according to Macrobius, "expressed Osiris in the sacred letters." The tree's many branches indicated that Osiris ruled many different empires. The whole relief, he argued, could be translated: "I am Osiris the king, who was called by the Italians and hastened to fight the oppressors of the Italian dominion . . . I am Osiris, who taught the Italians to plow, to sow, to prune, to cultivate the vine, gather grapes, and make wine." Annius's imaginary Egypt was shaped in strikingly peculiar ways by the two- and three-dimensional materials available to him. His "column" was in fact a medieval lunette set in an early Renaissance frame, and the texts from which he drew his explanations were either standard works in Latin, Poggio's partial translation of Diodorus, or his own inventions.[10]

Even when Annius worked from few and modest materials, his magnificent imagination filled in what was needed. The results provoked and inspired his readers. Annius's Egyptian studies were likely a source for Pinturicchio's stunning Egyptian-themed frescoes of 1494–95 in the Sala dei Santi of the Vatican Palace, where the myth of Isis and Osiris was depicted in the style of a Renaissance courtly pageant. This extraordinary cycle was designed to reinforce Pope Alexander VI's claim to an inherited right to rule the regions of central Italy that Annius had claimed were liberated by those Egyptian gods. Alexander's argument was demonstrated by his family emblem, the Borgia ox, identified in the frescoes with Apis, the Egyptian sacred bull and symbol of Osiris's role as a cultivator of peace.[11]

Modern scholars distinguish between the study of texts and that of material objects. Archaeology and architecture are also now separate disciplines, each with its own specialized course of study. As is clear by now, scholars in the Renaissance tended to pursue all of these disciplines together, all at

With so many new texts to explore, the way to the Near East lay open: a grand Silk Trail to a magnificent, if imaginary, Samarkand of the mind. Creative readers could stitch whatever variegated quilts they liked from Hermetic revelations that vouched for the historical age and purity of Egyptian theology, the valid eschatological prophecy or the lurid idol-making magic of the *Asclepius,* and the evocative, if scattered, references of the Greek historians. The ancient Near East became the home of the cryptic, the uncanny, and the profound. The author and illustrator of that strange, sumptuously illustrated novel from 1499, the *Hypnerotomachia Poliphili,* made clear that the ruined ancient city through which his protagonist wandered in his tortured dream spoke, mysteriously, in hieroglyphic inscriptions – though the hieroglyphs were cobbled together with only slight reference to the look of actual Egyptian writing.[8]

A final boost came in 1498 when a whole series of Near Eastern texts mentioned and quoted in small portions by Josephus and other ancient authors came on the market in their entirety, expensively printed and with extensive commentary by a highly respectable figure, the Dominican *magister sacri palatii,* or papal theologian, Giovanni Nanni (or Annius) of Viterbo. In this grand book ancient writers like the Babylonian priest Berosus and his Egyptian colleague Manetho, along with any number of others, retold the history of the world, in detail. Their narrative matched the Bible and Josephus, for the most part, as those of Herodotus and Diodorus did not. They offered information gathered not by mere Greek intellectuals, moreover, but by Near Eastern priests, the keepers of the ancient public archives. They told rich stories of the development of astrology in ancient Babylon, which had enabled Noah to foresee the flood, and connected the pure, virtuous nations that had sprung from Noah and his sons with the great peoples of modern northern Europe. Isis and Osiris, the creators of the center of Etruscan culture in Viterbo, appeared as the ancestors of the Spanish royal house (whose ambassador in Rome kindly paid the costs of printing the whole book, including this stop-press supplement). Samothes, the founder of Celtic culture, and Drius, the founder of the order of Druids, appeared cheek-by-jowl with Longo and Bardus, the founders of the Longobards, or Lombards. These texts were forged, of course, but they encouraged every nation in northern Europe to tie its own legendary genealogies into the history of the ancient Near East, and fueled what

Jewish onlooker.[5] Hermes himself turned up, suitably attired in a Turkish headdress, among the other pagan prophets who adorned the late fifteenth-century pavement of the cathedral at Siena, where he remains today near the main portal of the nave. Egypt had arrived. For the next century and more, many would agree with the seventeenth-century Leiden scholar Otto Heurnius, who argued in a wonderfully titled book, *The Antiquities of Barbarian Philosophy,* that Ficino's collection and translation of the Hermetic texts marked the real beginnings of the revival of Near Eastern tradition.

Mercurius and Ficino were hardly isolated figures in the rich tapestry of the revival of early philosophy – the *prisca philosophia* – as Heurnius showed in a work that also described the foundation of priestly orders by Ninus in Babylon, the pious expedition of Dionysus into Thrace, and the invention of hieroglyphs by the ancient Ethiopians.[6] Some of the late-Byzantine scholars who preserved the Greek tradition and passed it on to Western intellectuals of the fifteenth century – above all Giorgios Gemisthos Plethon, who brought a commented version of the oracles of Zoroaster, the supposed fount of Chaldean wisdom, with him to Italy in 1438 – taught their disciples to believe that the wisdom of Plato and his followers derived from an ancient Eastern source. Some of the new Greek texts that became available in Latin translation around the middle of the fifteenth century seemed to confirm this lesson. Highly respectable early-Christian authors, such as Clement of Alexandria and Eusebius of Caesarea, offered goggle-eyed readers fragments of the Hellenistic Jewish writers who had argued, in their time, for the superiority of Eastern to Hellenic traditions of wisdom. Diogenes Laertius, the third-century historian of philosophy whom the Dominican monk Ambrogio Traversari had translated into Latin in the 1430s, made clear that most of Diogenes's contemporaries had thought philosophy began with the Druids and the Brahmans. Though Diogenes himself rejected this view, he also paradoxically lent it support by describing Plato's and Pythagoras's journeys to Egypt in search of Eastern wisdom. Strabo told the many readers of his *Geography,* which reached a large public in Guarino's Latin translation, of his sight-seeing expedition to Egypt, where he had seen Plato's house and marveled that Egyptian learning did not seem as profound as some cracked it up to be. Diodorus Siculus, translated by Poggio, offered astonishing revelations about the journeys of Isis and Osiris and the sophistication of ancient Egyptian – and Druidical – science.[7]

containing fourteen Hermetic dialogues (in Greek) arrived in Florence and was given to the city's greatest patron and *de facto* ruler, Cosimo, il Vecchio, de'Medici.[3] Almost immediately, Cosimo ordered the humanist and philosopher Marsilio Ficino, then in the early stages of translating the collected works of Plato, to stop what he was doing and translate the Hermetic texts first.

The translations were presented to Cosimo in April 1463 as the *Pimander* (after the title of the first dialogue in the collection) and achieved almost immediate renown. This success was owed to the claims Ficino made in his "Argumentum," or prologue, where he described the dialogues as cornerstones in a series of prophetic anticipations of the Christian revelation. Among other things, the Hermetic dialogues seemed to show that the original Egyptian religion, despite its eventual entanglement in a web of strange gods and enigmatic figures, had been monotheistic. In fact, it had contained among its most sacred doctrines the notion of the Fall and eventual Salvation of humanity. In anticipation of these events, the Egyptian sage and his priestly successors instructed their followers to purify themselves as part of the struggle to achieve eternal life for their own souls. The earliest Egyptians, it seemed, had been almost Christian in their approach to the divine. This was exciting stuff. Ficino's Latin version was translated into Italian already by September 1463, and both versions circulated in manuscript in considerable numbers – over forty manuscripts of the Latin survive, along with about twenty of the Italian. Many more must have existed in the fifteenth century. The Latin version was printed for the first time in 1471, followed by many editions right through the seventeenth century.[4]

Given the enthusiasm that greeted the discovery and dissemination of the Hermetic texts, it is no wonder that an enthusiastic votary of eastern wisdom, Giovanni Mercurio da Correggio – a characteristic figure of the age of street-corner prophets that ended, more or less, with the Sack of Rome by Imperial troops in 1527 – took these revelations to the streets. He appeared in Rome on Palm Sunday 1484, marching through the Campo de'Fiori and the piazza in front of San Pietro wearing a black silk toga, a golden girdle, and scarlet boots. His headdress included both a crown of thorns and a moon-shaped decoration bearing the words: "This is my son Pimander, whom I have elected." Giovanni prayed at the great altar of St. Peter's – before being arrested, the sad outcome that was recorded not by his disciples, but by a

The High Renaissance:
Ancient Wisdom and Imperium

. . . it was of course not for nothing that Pythagoras, Plato, and other persons of the highest caliber set out to Egypt for the sake of teaching: for nothing is said in hieroglyphics other than to reveal the nature of divine and human affairs.

FROM THE TITLE PAGE OF PIERIO VALERIANO'S
Hieroglyphica (BASEL, 1575)[1]

LEON BATTISTA ALBERTI'S interest in Egyptian antiquities – like that of Poggio Bracciolini and Niccolò Niccoli – derived from what he had seen in Rome and what he had read in a few mostly descriptive and, from a theological point of view, "harmless" books. In the later fifteenth century, however, a series of newly discovered and translated texts about Egypt flooded into the intellectual marketplace.[2] Among these, the *Corpus Hermeticum,* the collection of religious and philosophical dialogues attributed to the Egyptian sage Hermes Trismegistus, offered the fullest and most attractive revelations. In the first years of the 1460s a manuscript

An imaginary reconstruction of the Esquiline obelisk, compared to the
Column of Marcus Aurelius in a print by Enea Vico from the 1550s.

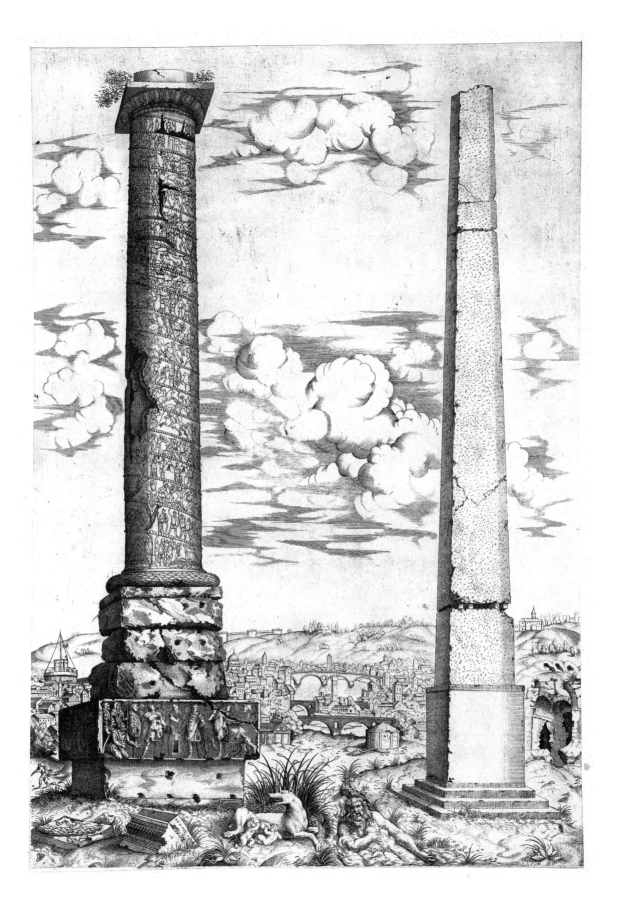

pyramid is a long, square stone or edifice, which starts out wide and then, like a flame, becomes steadily narrower. A good many of the ancients had these as their tombs, and a number of them can be seen at Rome."[44] Some time later, when Perotti returned to his commentaries, he had worked out the problem:

> Pyramids are very large masses, constructed so that they taper from a broad base to a point. Two of them still exist at Rome, both very dilapidated with age. Their name derives either from their resemblance to flames, since the Greeks call fire *pur,* or from the fiery and variegated stone from which they were often made. This is often called Theban, and from its fiery and variegated color it is called *pyropoecilos....* We Romans call a pyramid a *meta,* because the boundaries of fields, which are named *metae* from the verb *metior,* measure, are often built in the form of a pyramid.... Pyramids are different from obelisks. These are stone beams, far smaller than pyramids, dedicated to the sun god. That is why they were made to resemble the sun. Their Egyptian name derives from their word for "ray," and their form is clearly that of a ray of light when it passes through a window. The Greeks drew their name for them from their resemblance to a spit, which they call an *obelos,* and in a diminutive form, *obeliskos.*[45]

So by the time this note took on its final shape, Perotti (or Leto) could tell the difference between Rome's obelisks and the so-called *metae* or pyramid tombs. It seems likely that the transition between these two glosses, which took place in the last decades of the fifteenth century, marks a wider change. By the end of this period, most humanists – and with them popes and patrons – probably knew in considerable detail the many layers of meaning that clung to monuments like the Vatican obelisk. The situation proved unexpectedly fruitful. As more and more connoisseurs poked and prodded the obelisks, as architects began to think harder about their possible uses, and as popes began to see that Nicholas's plans had immense potential, a novel sort of energy began to invest the very fabric of Rome's obelisks with a new and urgent significance. To some, it must have seemed that a rebirth of the Egyptian gods was at hand.

Lequale uetuſtiſſime & ſacre ſcripture penſiculante, cuſi io le interp̄tai.

EX LABORE DEO NATVRAE SACRIFICA LIBERA
LITER, PAVLATIM REDVCES ANIMVM DEO SVBIE
CTVM. FIRMAM CVSTODIAM VITAE TVAE MISE-
RICORDITER GVBERNANDO TENEBIT, INCOLV
MEM QVE SERVABIT.

Invented hieroglyphs from the *Hypnerotomachia Poliphili.*

humanist Niccolò Perotti, together studied the verses of the Roman poet
Martial. Martial refers to the pyramids of Memphis, and the two men –
whose interpretations Perotti preserved – set out to explain what he had
in mind. Unfortunately, neither could decide for sure whether the "pyra-
mids" should be understood as stelae fashioned from single stones or as
larger composite structures – in short, whether they were obelisks or pyra-
mids. The gloss they prepared dances carefully around the question: "A

ars disagree sharply about what Alberti intended with this choice of symbol – but it may be the very multiplicity of possible readings that attracted him. Alberti set a precedent. Over the next several generations, the taste for invented hieroglyphs and pictorial symbols that served as signatures (known as *imprese*) would spread across Italy and to the four corners of Europe, as patrons and artists competed to invent and try to decipher these ingenious compositions.

Not everyone, of course, interpreted obelisks and hieroglyphs in the same way. At the same time that Alberti and his successors began taking the first steps toward the invention of a modern equivalent of Egyptian symbols, other students of antiquity, such as Cyriacus and his north-Italian follower, Michele Fabrizio Ferrarini of Reggio Emilia, continued to focus their attention on the real thing. They made and circulated accurate and potentially legible copies of the inscriptions on the obelisks and other Egyptian monuments in Rome.[42] Over time, these copies themselves helped to inspire the invention of fanciful new, sentence-like hieroglyphic inscriptions such as those that appear in the *Hypnerotomachia Poliphili,* the bizarre, hallucinatory novel filled with Egyptian-inspired inscriptions and illustrations published at Venice in 1499. Scholars like Filippo Beroaldo the Elder, Pietro Crinito, and Angelo Poliziano, to name some of the most distinguished, continued to ponder the problem of the hieroglyphs and attempted their own comparisons of the inscriptions on the monuments to the information provided by ancient authors.

Expertise regarding both the obelisks themselves and the texts that described them spread slowly and unevenly. Despite Poggio's and Alberti's efforts, the confusion between obelisks and pyramids survived well into the sixteenth century in some circles. The shared Egyptian origins and rough physical correspondence between the types was certainly a factor in this. In 1452 or 1453, Nicholas V's advisor, Giannozzo Manetti, commented:

> We perceive with what great industry those vast and most celebrated pyramids of Egypt were built, and also that pyramid still to be seen in Rome, which is a very high tower, raised in pyramidal form.[43]

Some years later, in the winter of 1471-72, two of the most learned men in Rome, the hard-bitten field antiquarian Pomponio Leto and the erudite

[*maximum Obeliscum*]. For instead of the four small bronze lions which now serve this colossus as a base and a support somewhat higher than the ground, he placed on the ground four great statues, life-sized, of the Evangelists, of solid melted bronze separated from each other in proportion to the width of the colossus; over these bronze statues, very finely sculpted figures differing from one another according to the various conditions of the person, the obelisk rested. On top of the same colossus he placed another statue made of bronze of Our Savior Jesus Christ holding a golden cross in his right hand.[36]

This idea presented Nicholas's engineers with a truly daunting prospect. They were expected to lift this eighty-two foot, 681,221-pound monolith, which still stood upright and intact on its original base, and move it approximately 275 yards; then raise it even higher on a new statuary base![37] Given this, some scholars have questioned the veracity of Manetti's description.[38] His reference to the legendary lion supports in particular has prompted suggestions that little had been done beyond the most preliminary discussions.[39] Visual evidence, though, in the form of contemporary drawings that show the obelisk resting on its knuckle-shaped bronze astragals, show that the base was, in fact, uncovered during just this period.[40]

While the full extent of Alberti's involvement in the obelisk project remains unclear, his interest in the obelisks and Egyptian antiquity is borne out by his study and citation of such fundamental texts as Pliny, Diodorus, Ammianus Marcellinus, and the Hermetic *Asclepius,* whose vivid and elaborate description of the doomed speaking cities of the ancient Egyptians informed his own conception of the commemorative power of the figurative arts. With the ultimate downfall of all civilizations in mind, Alberti argues in his own treatise on architecture that hieroglyphs provide the most appropriate and effective "language" for commemoration. Inscriptions in the actual words of a dead language – such as that of his own ancestors, the Etruscans – could be rendered silent and useless by the passage of history. But symbolic inscriptions like the hieroglyphs would speak forever, since learned men would always know how to decipher them.[41] Suiting his practice to his precept, Alberti went so far as to devise a hieroglyphic symbol for himself, a winged eye accompanied by the sardonic question "Quid tum?" ("Do you want to make something of it?"). Ironically, modern schol-

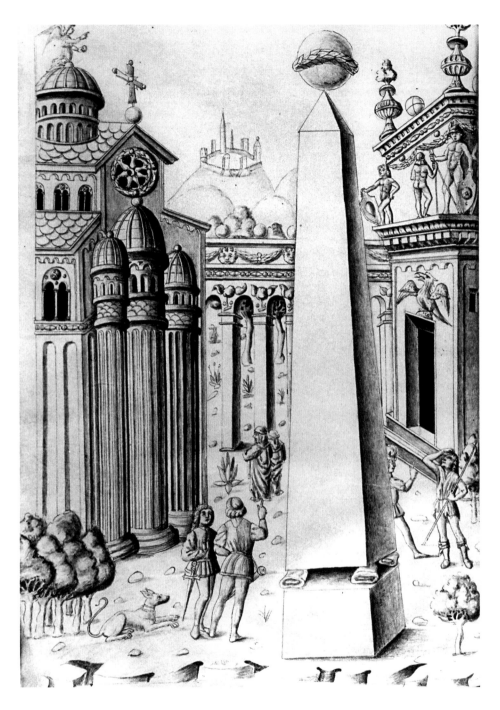

The Vatican obelisk in the mid-1460s, from a manuscript of
Giovanni Marcanova's *Collection of Antiquities*.

"Guarino" argues that any attempt to understand the true character of the monument must proceed, not from the naïve repetition of oral legends, but through a close and accurate description of the obelisk's size, shape, and material composition. To this effect, it seems that Alberti and his team measured the obelisk's height, using a staff, a reflecting device, a ruler, and similar triangles (a diagram and explanation of his procedure appear in his treatise on geometry, the *Ludi rerum mathematicarum*). They also examined the damage caused to the obelisk's south side by "the continual exhalations and blasts of the south wind" and compared the obelisk to some of its fallen cousins.

The report reflects what we may presume to be Alberti's conversations with other architects and engineers as well – men like Aristotile Fioravanti, who promised to "use devices to move the stone, still standing, either into the mouth of the church of San Pietro or elsewhere in the city." It would seem then that Alberti – who some years earlier had praised Filippo Brunelleschi's great dome on the Florence cathedral as proof that Nature had not grown old – saw the obelisk as the noble creation of skilled men, and its potential transfer from its current out-of-the-way site as a challenge fitting to the skills and imagination of his contemporaries. It was only men, after all, and "not the art or the power of the demons that they chatter about," that could imagine and execute marvels like the ones accomplished by the ancients. It was always tempting to connect obelisks with the mythical powers of Egyptian magic; Alberti's insistence on their human origin was characteristically individual.

Perhaps the most striking revelation in the text is that by the middle of the fifteenth century humanists and engineers were already discussing the possibility that the obelisk could be moved. They probably did so at the behest of Nicholas V, who hoped to place the shaft in front of St. Peter's as part of a renewed temple complex that would put the ancient one in Jerusalem in the shade. According to a description written after the pope's death by his Apostolic Secretary, Giannozzo Manetti, the obelisk was to have been incorporated into a spectacular sculptural ensemble:

> In the middle of this wide and beautiful piazza, or, as the Greeks more clearly put it, *platea*, in front of the central portal of the Basilica, he intended to set up, beautifully and devoutly, the great obelisk

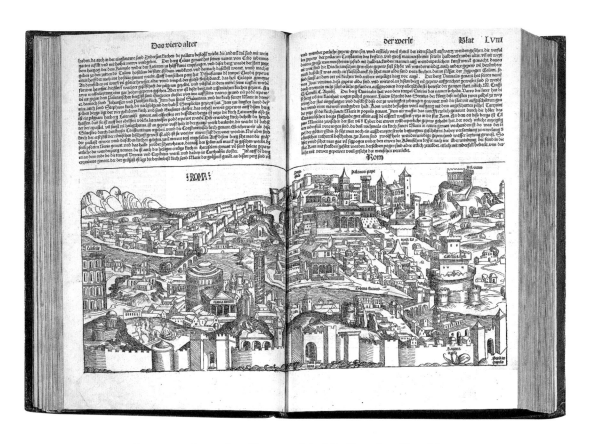

Rome around 1490, from Hartmann Schedel's *Nuremberg Chronicle.*

its obelisks from his translation of Strabo's *Geography,* also commissioned by Nicholas V. Guarino lived long enough to have been the recipient of a "site report" such as the one Decembrio cites, but the dialogue itself is set, like the others in the collection, at the court of Ferrara in the 1440s, during the reign of Leonello d'Este. That seems a little too early for a report of this kind, which probably reflects developments from the latter part of Nicholas V's pontificate.

In the text, Guarino/Alberti laughs at the folly of the ignorant observers who speculate that the obelisk might be hollow or composite, and mocks the superstitious pilgrims who chip off small pieces "which they repeatedly smell and weigh in their hands, and at last they babble about how the work was carried out not by human power but by necromancy, magical arts, and the incantations of Virgil." In contrast to these ludicrous theories,

who is the man most interested in these things."[32] Niccoli would have had little time to ponder his friend's transcription, since he died on February 3, 1437, just a few months after Cyriacus's ascent.[33]

By the middle of the fifteenth century the twofold historical meaning of the Roman obelisks had become firmly established, at least among those with a particular interest in ancient literature and archaeology. On the one hand, the newly recognized obelisks provided specimens of the primordial, symbolic script of the Egyptians – a language where, as Ammianus explained, the carved image of a bee making honey represented a good king who combined sweetness with a sting. On the other hand, these majestic monuments also bore witness to the prowess of the Roman conquerors who had subjugated the Egyptians and brought their gods and obelisks home to adorn the new marble city of Augustus and his successors. Further, the monuments spoke of the technological prowess of both peoples: the Egyptians who had originally quarried and raised the great monoliths, and the Romans who had removed them and transported them across the sea. For this new generation of scholars, the obelisks represented more than a powerful fusion of Egyptian and Roman associations: they also posed a challenge, and opportunity, to the great men of their own time. By the sixteenth century, the Latin motto *Roma quanta fuit, ipsa ruina docet* – "How great Rome was, her very ruins show" – would become the battle cry of the artists and scholars who saw the renewal of Rome's lost greatness as a key to the creation of a more vital contemporary culture.[34]

It was in this spirit of creative reinvention that a somewhat younger Tuscan, Leon Battista Alberti, endeavored to apply some of these antiquarian ideas to modern artistic practice. Alberti, who served as architectural advisor to Pope Nicholas V (ruled 1447-1455), seems to have studied the Vatican obelisk while surveying its piazza and the nearby southern walls of the old basilica of St. Peter's, which had become the object of an ambitious restoration project that eventually spread to the entire Vatican area. Details from a report most likely compiled by Alberti and some of the pope's other advisors seem to have found their way into Angelo Decembrio's celebrated collection of dialogues, *De politia litteraria* (*On Literary Refinement*), completed at Ferrara in 1462.[35] In this text, Decembrio places the account of the obelisk in the mouth of the famous humanist and teacher Guarino of Verona, who would have known a few things about Egypt and

Poggio mentions several obelisks that the Anonimo had overlooked, including those at the Capitoline and on the Via Appia, and one of the pair at the Mausoleum of Augustus. But more significant were the critical intelligence and extensive familiarity with ancient texts he brought to the discussion. Even more clearly than his predecessor, Poggio was determined to free history – solid, material fact – from the haze of local memories that obscured it from view. His description of the "figures of birds" that the Egyptians "used in the place of letters" firmly anchors his conception of the hieroglyphs in the realm of ancient inscriptions – which he had studied and recorded with great diligence. The inscriptions even helped to inspire his innovative contribution to the revival of ancient Roman letter forms in a new sort of handwriting, consciously designed to be different from that in normal use in early fifteenth-century Italy.[28] Poggio's study of ancient texts and inscriptions also informed his assured reading of the inscription on the Vatican obelisk, and helped him correctly identify the emperor responsible for erecting it – unlike the author of the *Mirabilia* three hundred years earlier. It is this complex but economical interweaving of personal observation and informed study that made Poggio's dialogue so formative a work for Renaissance archaeology.

As early as the 1430s and 40s the obelisk studies initiated by Niccoli and Poggio began to spread among the larger community of humanists and proto-archaeologists in Italy. Prominent among these was Niccoli's friend Cyriacus of Ancona, who recorded his admiration for the Theodosian obelisk in Constantinople after his visit to that city in 1418, though he mistook the origin of the monument's inscriptions: "Most of all he admired the enormous obelisk (*obilyscum*) made from a single block of Numidian stone, and inscribed on all sides with Phoenician characters."[29] Some years later, in 1436, Cyriacus traveled to Alexandria, where he admired "the huge Numidian obelisk transported from Thebes in past times by Philadelphus."[30] Moving south, he stopped at Cairo and ventured out to explore the "marvelous Memphite pyramids" of Giza.[31] Near the summit of the Great Pyramid of Khufu, he discovered a "most ancient" inscription, again in "Phoenician characters," which he explained as a form of writing "unknown by the men of our own age, I think because of its antiquity and our ignorance and loss of the great arts of antiquity. But I transcribed this remarkable text and rightly added it to my notebooks, and sent the final copy to Niccolò Niccoli,

Italian scholars and patrons. For those interested in things Egyptian, the most celebrated of the Greek sources was Horapollo's *Hieroglyphica,* the dictionary of hieroglyphic signs with allegorical explanations that Cristoforo Buondelmonti discovered around 1422, during his wanderings in the Aegean Sea.[25] Buondelmonti presented his find to Niccoli just as the latter was completing his study of Ammianus, and just before Niccoli embarked on a much-anticipated trip to Rome to explore the ruins in the company of his friend Poggio.

That trip was probably the moment when the carvings on obelisks were first recognized as the "sacred letters of the Egyptians" and the obelisks themselves as the Egyptian imports described by Ammianus and Pliny.[26] This idea, put forward by Karl Giehlow at the beginning of the twentieth century, is supported by the fact that Poggio went on to become the first post-antique writer to identify – in public, as it were – the characters on the obelisks as Egyptian hieroglyphs. The relevant passage appears in the description of Rome's ancient monuments that Poggio began to compose in the early 1430s, and published in 1448 as the opening section of his great *De varietate fortunae* (*On the Vicissitudes of Fortune*). Poggio's description takes the form of a dialogue between the author and his curial colleague, Antonio Loschi, who have come to rest amidst the disordered squalor of the once-magnificent Capitol. When the discussion turns to the Vatican, Poggio notes the ruined pyramid known as the Meta Romuli and launches into a description of the city's obelisks:

> In the Vatican, there is also a pyramid of great construction, similar to a shapeless mass of rock stripped of all of its ornaments. There is no need to tell about the obelisks, which were transported from Egypt with great effort and expense, as Pliny records. One only is conserved upright in the city, that was erected in the Vatican by C. Caesar Caligula in honor of the Divine Augustus and sacred to the Divine Tiberius. I saw another one of them, a little smaller, and with various figures of animals and birds that the ancient Egyptians used in the place of letters, lying in the hippodrome on the Via Appia, broken into four pieces. There are also other erected fragments of obelisks, one on the Campidoglio, and another in the *rione* today called Pigna, and others in smaller pieces, of which all [historical] memory is lost.[27]

church and city, creating intellectual opportunities and giving a new sense of urgency to the study of Rome and its monuments.[20]

It was with this sense of the potential for renewal and reinvention that the next generation of humanists looked upon Rome's obelisks. The old legends still abounded, of course, including a tradition that ascribed the magical transport of the Vatican obelisk to the levitative powers of the magician-poet Virgil, but the humanists were deeply interested in the obelisks as physical artifacts, as evidence of the ancient city.[21] Great connoisseurs of inscriptions, they were attracted above all by the hieroglyphs that covered the two obelisks standing in the city center: the small obelisk on the Capitoline hill and the recently restored one in the Piazza di San Macuto. The mysterious inscriptions inspired an intensification of interest in all sorts of antiquities that bore the hieroglyphs. At first, though, the scholars were not entirely sure what to make of either the script or the monuments. The answer would come partly as a result of the humanists' grand project to gather and reclaim ancient literature.[22]

The pivotal figure in this quarrelsome, erudite group of antiquarians was Niccolò Niccoli.[23] A scholar, collector, and self-styled arbiter of taste, Niccoli took more than a casual interest in art and archaeology. As early as 1413 the influential teacher Guarino of Verona ridiculed Niccoli's obsessive enthusiasm for antiquities, including obelisks, which he, too, apparently tried to measure. More to the point, though, was his enthusiasm for unknown or little-known Latin texts, which Niccoli avidly gathered for his massive library. Among the many manuscripts that came into his possession were newly discovered or more complete versions of works by Tacitus, Pliny the Elder, and Apuleius's *Metamorphoses,* as well as a version of Ammianus Marcellinus's *Rerum gestarum libri,* discovered by Poggio in a German monastery at Fulda in 1417.[24] Taken together, these works provided the group with a rich fount of information and lore regarding Egypt, hieroglyphs, and the obelisks.

Even more important was the recovery of Greek texts. Greek was practically unknown in Europe during the Middle Ages, and very few Greek books were to be found in European libraries. During the first decades of the fifteenth century the works of Herodotus, Isocrates, Diodorus Siculus, Plutarch, Strabo, Iamblichus, and others – many brought back from manuscript-hunting trips to Constantinople – began to circulate among

was a more plausible candidate – despite the lack of inscription and the fact that the obelisk had been found in the wrong part of the city, quite some way from the Forum.[17] The Anonimo is our earliest literary source for this obelisk, which had been extracted from the ruins of the Iseum Campense at an unknown date and set up in the small piazza in front of San Macuto at the beginning of the fifteenth century.[18] During the Renaissance, this obelisk (now in front of the Pantheon) achieved an importance far out of scale with its modest size, thanks to its relatively accessible inscriptions. The Anonimo also mentions a number of other broken or fallen obelisks, and provides the first report of the discovery of one of the Circus Maximus obelisks, exposed by the plows of cabbage farmers.[19]

For all the new thinking and sharp observation his work contains, the Anonimo's comments remain essentially traditional. He has nothing to say about the hieroglyphs that cover many of the obelisks and does not seem to have recognized the Egyptian origins of the monuments. That had to wait for the next generation of scholars, a generation that included the Florentines Niccolò Niccoli and Poggio Bracciolini; the traveling merchant and epigrapher Cyriacus of Ancona; the historian, geographer, and antiquarian Flavio Biondo of Forlì; and the author, architect, and all-around Renaissance polymath Leon Battista Alberti. All of these men shared a profound interest in ancient history and literature, but even in the fifteenth century such an interest did not pay the bills. Many of the early humanists worked as professional scribes, letter writers, and teachers for various dukes and princes, including the popes. Poggio, Biondo, and Alberti were all employed as secretaries at the papal court, or curia, and the others had close ties to the papacy.

The early part of the fifteenth century was a time of transition for the Roman Catholic church. During the decades that flanked 1400, the church had been riven by dissent and political infighting, with two, and at one point even three, competing popes. The leading faction had come under the protection (or control) of the French kings, and as a result much of the curia had been absent from Rome for many years, based instead in the southern French town of Avignon. (This is the period of the so-called Babylonian Captivity.) The schism was finally resolved in 1417, and in 1420 a new pope, Martin V, brought the curia back to Rome, trailing pilgrims, money, and inhabitants in its wake. The curia's return brought new confidence to

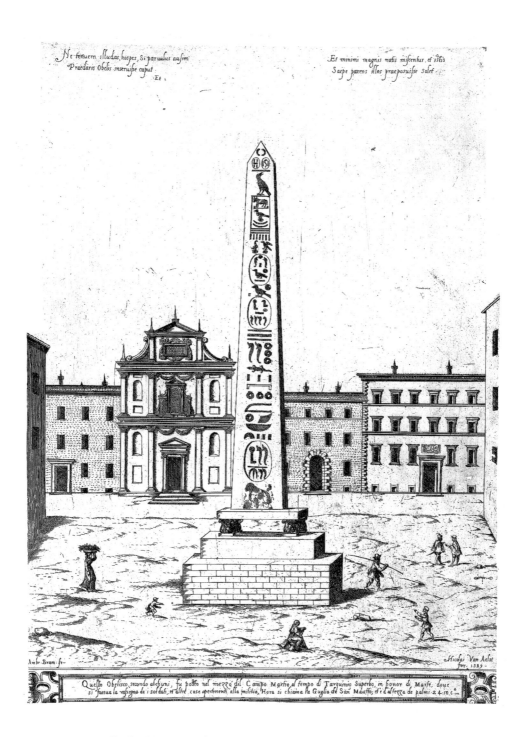

The San Macuto obelisk, as engraved by Nicolaus van Aelst in 1589.

Here are the *aguliae* which were in Rome, what and how many there were, and in what manner, for what cause, and by whom they were ornamented.

Two great ones, one of 112 feet, and the other of eighty feet, were marvelously erected in the circus of Tarquinius Priscus, where today are the cabbage gardens. Another, but of lesser height, was erected in the Vatican with the ashes of two emperors: Octavian and Tiberius. Another, of fifty feet, which was afterwards in the Mausoleum, on the Pincio near the Porta Salaria, lies broken in a *canneto* [a thicket of reeds], where it was originally erected, in front of its base.

Another was erected in the great Forum under the Capitol at the side of Sant'Adriano, which is entered from the Via Sacra. It had been erected with the ashes and bones of Julius Caesar, with a height of forty feet, with a star at its summit, because at the time of Caesar's death a comet appeared in the heavens and was seen by all, and Suetonius says that the soul of Caesar had ascended into heaven.

Another one stood in the circus of Capo di Bove, in which place, people say, there were spectacles held by Titus and Vespasian. It lies broken in two near its base, which is raised above the earth.

Another, today broken, is at San Macuto. I believe, although it doesn't have inscriptions, that this was the one that was in the Forum, where the ashes and bones of Julius Caesar were, because its length, with the other three pieces which are in the area, is almost the same. Regarding the location where this obelisk was found, there is said only that it came to be vulgarly called the "Scuola of Brutus" [*scola Bruti*].

Another, the greatest of all, is today submerged in the ruins of the above-mentioned circus, where the farmers frequently bump into it with their plows.[15]

Unfortunately, we know nothing at all about the author of this text, not even his name. For as Roberto Weiss observed some years ago, his work reveals an unusual willingness to depart from long-held ideas when the inscriptions or evidence from texts suggested otherwise.[16] For example, he rejected the traditional identification of the Vatican obelisk as the tomb of Julius Caesar, suggesting that a smaller obelisk in the Piazza di San Macuto

the Roman nobleman Ciriaco Mattei, who set it up in the garden of his villa on the Caelian Hill.[13] The obelisk was moved again in 1817 to a shadowy grove in the same garden, now renamed the Villa Celimontana. At the start of the twenty-first century it stood there still, seen only with difficulty through a rickety fence, tall weeds, and rusty scaffolding.

As the fourteenth century drew to a close, Rome's obelisks began to attract new attention. Around 1375 the Paduan physician and astronomer Giovanni Dondi dall'Orologio visited Rome, where he took a particular interest in the Vatican obelisk. He made a fresh copy of its inscription and discussed methods of determining its height with a local priest, who had measured its shadow to come up with a reasonable estimate of forty-five *braccie*.[14] Dondi's interest in measuring the monument anticipated the attitudes of slightly later scholars, who, as the fifteenth century wore on, subjected the physical and literary remains of antiquity to ever more systematic study and analysis. This new group of intellectuals, who made the study of the languages and traditions of antiquity their special project, have become known as the humanists, though they would not have identified themselves as such. Instead, they would have noted that they shared a passion for ancient literature, rhetoric, and history, fields they identified as the *studia humanitatis* — humane studies, or in more modern terms, the humanities. For this new cohort of scholars, the study of antiquity was more than an end in itself. It represented just one part of a larger project of cultural revival that would, or so the more enterprising of them seemed to claim, help the Italian people and states recapture their proper status as inheritors of ancient culture and political power. Rome's ruined monuments and ancient inscriptions played a fundamental role in this endeavor. As the physical leavings of lost ancient glory, they provided authoritative models worthy of imitation and emulation by contemporary artists, princes, and popes.

Many of these scholars found their way to Rome to take in the ruins. Between 1410 and 1415, one of them, known today as the "Anonimo Magliabechiano" after a manuscript in the Magliabechi collection of the National Library in Florence, devoted an entire chapter of his *Treatise on the setting and ancient things of the City of Rome* (*Tractatus de rebus antiquis et situ urbis romae*) to the obelisks. His account represents the state of research on the subject at the beginning of the fifteenth century:

Vestigij del circo di Caracalla Vicino alla via appia et chiesa di S. Bastiano, il quale serviva anticamente a celebrare feste et altre diversi giuochi, la sua larghezza e' canne .223. la larghezza .77 ½ . ogidi questo luoco e' un prato al segno A. era un tempio di monte secondo li vestigij che si vede

40

The Circus of Maxentius, with its broken obelisk.
A sixteenth-century view by Étienne Dupérac.

apparently carved from a column made of the same pink Syenite granite. This new composite obelisk was set up on a custom-made base (complete with the half-lions mentioned above) in the northeast corner of the Piazza del Campidoglio, by the transept entrance to the church of Santa Maria in Capitola (later renamed Santa Maria in Aracoeli).[9] The decision to restore the obelisk has inspired scholars to connect the effort with some historical event. Proposals have included the recreation of Rome's civic government by the re-foundation of the Senate in 1148–51, the Papal Jubilee of 1300, and a civic uprising of the early fifteenth century.[10] Given the complete lack of documentation, any proposed date must depend almost exclusively on the style of the surviving lion, which appears to be from the thirteenth century, or just before or after.[11] Whatever the reason for its restoration, this obelisk, too, began to accrete new associations. By the fifteenth century, some claimed it as a tomb or memorial of Augustus, echoing the supposed role of the Vatican obelisk.[12] But even this weighty association could not protect the little obelisk from the vicissitudes of fortune. Around 1540 it was pulled down during Pope Paul III's renovation of the Campidoglio. It lay more or less abandoned until September 1582, when the city leaders presented it to

was an issue of some confusion. The original text of the *Mirabilia*, though in Latin, slips into Italian when it gets to the obelisk, calling it a needle, a *guglia.* Nor did Gregorius, who was more concerned than some of his contemporaries with the historical background to Rome's monuments, retain the monument's ancient name. He referred to obelisks as "pyramids," accepting a conflation that goes back to late antiquity. This mixing of types even seeped into the visual arts. In many medieval depictions, the Vatican obelisk, though clearly identifiable by its position next to St. Peter's and the gold ball on its top, looks not like an obelisk so much as a very tall, narrow pyramid. This confusion, too, persisted long after the correct Roman name "obelisk" had been restored to common use in the fifteenth century. During the Renaissance, some even put that linguistic ambiguity to work. In 1524, during a period when Renaissance popes had begun to display a renewed enthusiasm for the excavation and re-erection of obelisks, the stylish dramatist and pornographer Pietro Aretino used the term *guglia* to describe the priapic member of his protagonist in his infamous collection of erotic verse, *I modi.*[8]

The Vatican obelisk was the most impressive and famous in Rome during the Middle Ages, but there were others to be seen if one was willing to take the time to seek them out. Within the ancient walls, near the Pincian gate, the broken fragments of the Sallustian obelisk remained above ground and easily accessible. Outside the ancient city, the fragments of Domitian's obelisk could still be seen in the ruins of the Circus of Maxentius, while pieces of its smaller Roman cousin, the obelisk dedicated to Emperor Hadrian's lover, Antinous, were visible in the ruins of another circus in the Via Labicana. There were also, presumably, various smaller obelisks and fragments lying about, including a few that must have been discovered during building operations in the historic center of the city, the area once occupied by the Iseum Campense.

Only one or two of the fallen obelisks were the objects of restoration during the Middle Ages. The best-documented and most intriguing of these is the top section of a small obelisk inscribed in hieroglyphs for Ramesses II that was discovered during the later Middle Ages, its bronze globe and other ornaments still in place. Some time before the beginning of the fifteenth century, this fragment – now 2.7 meters long, or about ten feet – was restored to a suitable height by the addition of a newly fashioned four-sided shaft,

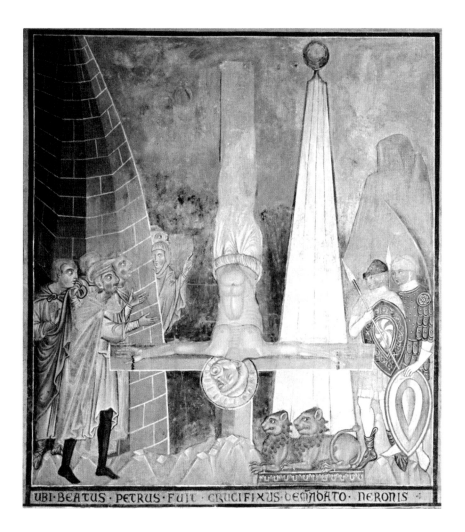

UBI·BEATUS·PETRUS·FUIT·CRUCIFIXUS·DEMANDATO·NERONIS

St. Peter crucified by the obelisk.
A fourteenth-century fresco in San Piero in Grado, near Pisa.

happened, the Vatican obelisk did not have such supports, but such is the power of tradition that even after the base was excavated in the middle of the fifteenth century, the idea continued to figure prominently in designs for obelisk projects both real and imaginary. The theme came full circle in the 1580s when Sixtus V gave physical form to the tradition by providing the reinstalled Vatican obelisk with a set of bronze lion-supports, masking the original bronze astragals.

By the high Middle Ages even what obelisks were supposed to be called

of a single porphyry block. It is indeed a marvel how a block of stone of
such a height could have been cut, or been raised, or remain standing;
for they say its height is 250 feet. At the top there is a bronze sphere, in
which Julius Caesar's ashes and bones are deposited. Someone marvel-
ing at it has commented:

> "If it be one stone, tell me how it was raised.
> If there be many stones, tell me where they join."[6]

These concluding verses – and they, unlike the rest of the description,
are written in rather doggy Latin verse – entered the literary tradition. The
verses would be incorporated into later versions of the *Mirabilia,* where
they are said to have been inscribed in Greek on the obelisk itself.

In a subsequent passage Gregorius ruminates on the ironies of fortune
and describes contemporary pilgrims' treatment of the monument as a relic
of the Apostle Peter:

> And so Caesar, lord and master of the world, who assumed power after
> first suppressing liberty, now reposes in this bronze sphere, his body
> reduced to ashes. The pilgrims call this the pyramid of St. Peter, and
> they make great efforts to crawl beneath it, where the stone rests on
> four bronze lions, claiming falsely that those who manage to do so are
> cleansed from their sins, having made a true penance.[7]

This passing mention of the obelisk's supports introduces another per-
sistent theme of Medieval and Renaissance obelisk lore: the idea that the
obelisk was supported by statues of lions. How this idea arose is unclear,
as the obelisk's base was almost certainly well buried at this point. Despite
this (or probably because of it) the idea of the lion supports was widespread.
The tradition found an early visual expression in a fresco of about 1300
showing the crucifixion of St. Peter, in the church of San Piero in Grado,
near Pisa, quite some distance from Rome. On the right side of the crucified
Apostle, the Vatican obelisk appears, topped by a globe and supported by
a pair of golden lions. The same idea may have inspired the more-or-less
contemporary restorers of a small obelisk on the Capitoline Hill to pro-
vide that monument with its own set of marble half-lions at the base. As it

basalt, and marble; Corinthian, Ionic, and Composite – each slightly different in height and all taken from the ancient buildings that spread out around the base of the hill.

Despite its reduced state, Rome was still a place of great importance. It was the seat of the pope, the site of many important Christian shrines, and attracted thousands of pilgrims every year. And even in the Middle Ages tourists needed guidebooks. A brief but influential guide of the mid-twelfth century, known as the *Mirabilia urbis Romae,* or *Marvels of the City of Rome,* mentions the Vatican obelisk, identifying it not as an ornament to a Roman circus, but as the monument and tomb of Julius Caesar. His ashes were believed to have been secreted in the bronze globe at the obelisk's summit. This odd idea derived partly from a misunderstanding of the inscription on the obelisk itself (which is, like many Roman inscriptions, telegraphic in the extreme), and partly from a misunderstood passage in Suetonius's *Life of Caesar,* which described a "solid column of Numidian marble" that had been set up in the Forum after Caesar's assassination. Wrong though it was, this legend persisted long after both the true origin and function of the Vatican obelisk had been established by Renaissance admirers.[5]

The *Mirabilia* is a very short text, not more than a few hundred lines. Later guidebooks were a bit more extensive. Around 1200 an English traveler known only as Magister Gregorius wrote his own description of Rome, filled with revealing details about how pilgrims and residents understood the ancient monuments they encountered. In a section dedicated to the "pyramids" of the city, Gregorius mentions the Vatican obelisk, along with the surviving Roman pyramid tombs, which dated to Imperial times. These included the supposed tombs of the city's founders, Romulus and Remus, the so-called Meta Remi (actually the tomb of Gaius Cestius, one of Augustus's officials) and another in the Vatican area known as the Meta Romuli. Gregorius described these as "tombs of the mighty" of "enormous size and height" whose summits rise to a point "in the manner of a cone," and whose hidden chambers contain marble sarcophagi "in which the body of the deceased was placed." Among all of these monuments he granted pride of place to the one at the Vatican:

> There are many pyramids in Rome, but of all of them, the one which
> deserves the greatest admiration, is the pyramid of Julius Caesar, made

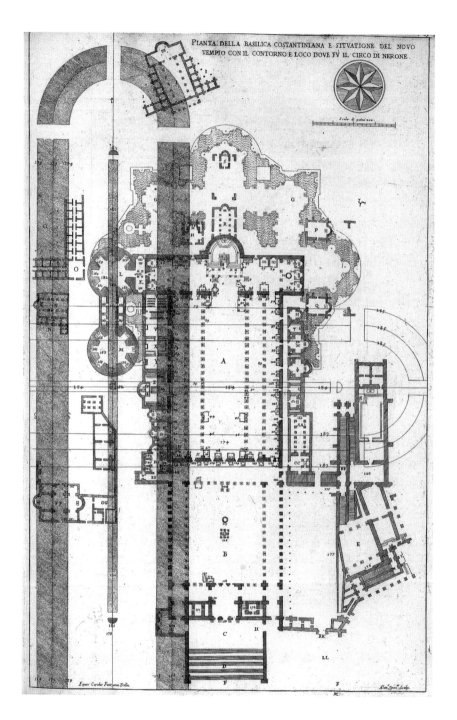

A 1694 plan showing the locations of all the buildings ever constructed at the Vatican, from Carlo Fontana's *Templum Vaticanum*.

Arab scholars turned their attention to the hieroglyphic carvings on the obelisks and other pharaonic monuments as well, calling them by a variety of names, including "bird's script," "temple script," and "hieratic" script.[2] In Egypt, at least, the obelisks retained their association with the pharaohs into the medieval period and beyond.

The situation was rather different in Europe. Some learned works, like the encyclopedic *Etymologiae* of Isidore of Seville, written in the late sixth century, preserved the memory of the obelisks' Egyptian origins as well as the word *obeliscus* itself.[3] In Rome, however, as the city's obelisks fell victim to time, earthquake, and vandalism, memory of their Egyptian origins began to fade, replaced by new, invented associations with prominent figures of more local history and legend. The precise sequence of the fall of the Roman obelisks is difficult to determine. The *Einsiedeln Itinerary,* a Christian pilgrim's guide of the late eighth or early ninth century, gives the positions of the solarium obelisk in the Campus Martius and the so-called Sallustianus – a Roman copy of the Augustan obelisk at the Circus Maximus. But the equally prominent obelisks of the Circus Maximus itself are not mentioned at all, suggesting they had already fallen and been buried in the debris that would cover them for centuries to come. By the middle of the twelfth century the Vatican obelisk was the only one still standing in Rome.[4]

Rome had become an architectural boneyard. Once home to more than a million people, by the eleventh century the city had shrunk to a few tens of thousands, most of whom lived in the area of the ancient Campus Martius (near the Pantheon) and across the river in Trastevere. Important early Christian churches, like San Giovanni in Laterano or Santa Maria Maggiore, which had been well within the walls of the ancient city, though not directly in the center, were now quite far from the edge of town. The pilgrimage routes to such places passed through farmers' fields and pasturages, agricultural lands that happened also to be littered with ancient imperial palaces and temples, arenas and baths, all of which, though ruined, were in far better shape than they are today. Those ruins were under constant assault from both nature and Rome's citizens, who used the ancient city as a quarry. All of medieval Rome, and much of the Renaissance city, was built with bits and pieces (called *spolia*) taken from the ruins. Atop the Capitoline Hill, the church of Santa Maria in Aracoeli is a case in point. It has a fine set of twenty-two grand, mismatched columns in its nave – porphyry,

Survival, Revival, Transformations:
Middle Ages to Renaissance

Who could help bursting with laughter when this man . . . diligently
explains the ruins and half-collapsed vaults of destroyed cities, how
many steps there were in the ruined theater, how many columns either
lie dispersed in the square or still stand erect, how many feet the base
is wide, how high the point of the obelisk rises?

GUARINO OF VERONA ON NICCOLÒ NICCOLI, 1413[1]

AS THE FOURTH CENTURY WANED obelisks ceased their peripatetic ways. As far as we know the great obelisk Constantius set up at the Circus Maximus was the last to come to Rome; the one in Constantinople's Hippodrome among the last to leave Egypt. But obelisks continued to draw the attention of learned observers. They even acquired some new names. In Egypt itself, after the Arab conquest of the seventh century, obelisks came to be known as *mislah* or *missala,* from an Arabic word for patching needle; so the obelisks at Heliopolis and Alexandria were referred to in medieval and later Arab literature as *messalat far'un* – pharaoh's needles.

Rome around 1490, from Hartmann Schedel's *Nuremberg Chronicle* (detail).

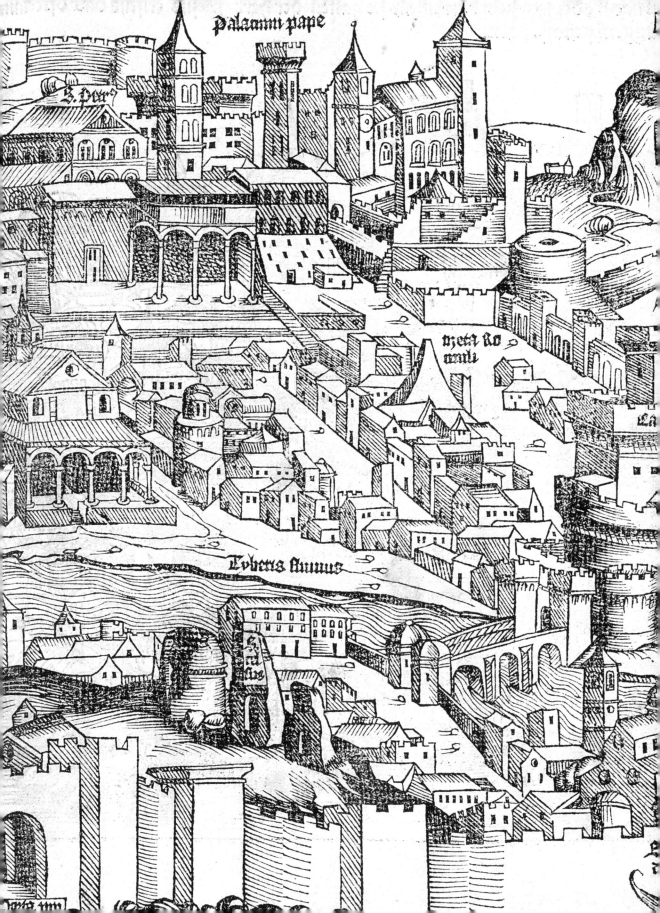

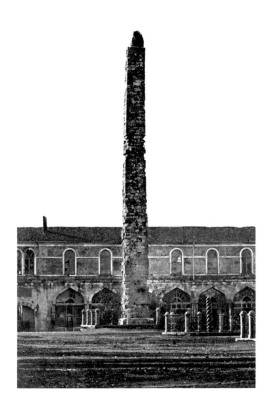

The "built," or composite, obelisk
in Istanbul.

those put to death was St. Peter, selected by Christ as leader of the apostles.
By the end of the second century CE, the cemetery to the north of the circus
had become the site of a shrine at St. Peter's presumed grave, and as the
circus itself fell into disuse tombs began to encroach on the area. Early in
the following century a domed imperial mausoleum was constructed over
the *spina,* directly behind the obelisk to the east. Then, between 319 and
329 CE, the site was transformed. A basilica dedicated to St. Peter was built
over the cemetery, and the entire area came to be viewed as sacred ground.
Over time, it came to be believed that St. Peter himself had been cruci-
fied near the obelisk – that it had been a witness to his martyrdom. It was
probably this tradition that helped preserve the monument, as the obelisk
became a kind of Christian relic in its own right.[54] This was the only obelisk
in Rome to survive through the Middle Ages intact and upright. Its story
dominates the next chapters of this book.

imperial soldiers. In the aftermath of this bloody event, Arcadius pardoned Tatianus and ordered that Proclus's name be (posthumously) re-inscribed on the obelisk.[50]

At least four other obelisks were set up in Constantinople during the waning years of antiquity. Three of these are mentioned in topographical writings and travelers' reports but have disappeared without a trace. A fragment of a fourth, a rare obelisk made of porphyry, an extremely hard and highly valued stone, was discovered in the nineteenth century and set up in the gardens of Istanbul's archaeological museum. Since it lacks a hieroglyphic inscription and was made from this unusual material, which was quarried mostly in post-pharaonic times, it is likely that the porphyry obelisk was a Roman or late-antique creation.[51] Even more unusual is a second large obelisk – or, more properly, an obelisk-shaped monument – that was set up in the Hippodrome probably in the fifth century. Only Rome boasted two obelisks on the *spina* of its main circus, so Constantinople, in all ways Rome's equal, needed two such monuments as well. The second obelisk on the Hippodrome's *spina* is not a monolith. Instead, it was built up of separate blocks, which were originally covered with bronze reliefs. Whether the eastern emperors could not obtain a second obelisk of an appropriate size or simply thought a true obelisk unnecessary because of the plan to cover the monument with a shining metal coat is unknown. The bronze plaques were stripped away when western crusaders conquered Constantinople in 1204. What messages or images they bore is unknown. Only the ragged pile of stones remains.[52]

Constantinople outlived Rome as an imperial capital. As the western empire crumbled in the fifth century, the emperors in the Greek-speaking east held their territories, ruling from a palace next to the Hippodrome, whose obelisks served as a reminder of the unbroken link with Roman precedent going back to Augustus. The eastern empire lived on until 1453, when Constantinople fell to the Ottoman Turks, the Hippodrome obelisks yet standing, as they do today. But it was the Vatican obelisk, in crumbling Rome, that was the key player in the later history of obelisks. It achieved that role somewhat by accident. According to the Roman historian Tacitus, after the great Roman fire of 64 CE the Vatican circus became the scene for public executions of Christians condemned by Emperor Nero, who accused them of setting the city alight.[53] According to Christian tradition, among

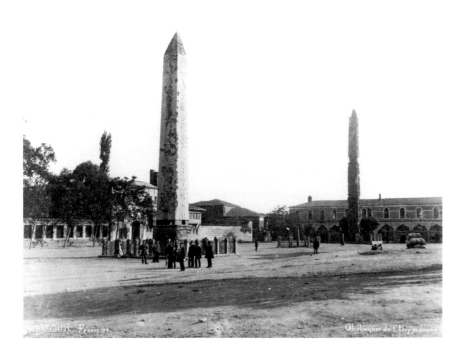

The obelisks in Istanbul's Hippodrome,
photographed in the late nineteenth century by Abdullah Frères.

and then carefully re-inscribed at a later date. Proclus (born in 360) was the prefect of Constantinople during Theodosius's reign, having been appointed through the influence of his father Tatianus. Tatianus had served as governor of Egypt from 368–370, and from 388 as governor general of the eastern provinces. He engaged in a bitter struggle for influence with Rufinus, another powerful figure in the imperial bureaucracy. In the end Rufinus headed a tribunal that condemned Tatianus to death, but Theodosius commuted the sentence to deportation. When Proclus was summoned to appear before the tribunal, he fled and went into hiding. Swayed by the oaths and guarantees of Rufinus, Tatianus persuaded his son to appear, whereupon he was summarily executed in front of his father. When Theodosius died in 395, he was succeeded by Arcadius, his oldest son. Understanding that Rufinus still aspired to the imperial throne, Arcadius called him to the Hippodrome, supposedly to be acclaimed co-ruler of the empire. As he moved toward the throne, Rufinus was surrounded and dismembered by

Alexandrians, Julian offers to send a colossal bronze statue of himself as a replacement. The emperor gives some urgent reasons why he should be allowed to remove the obelisk:

> The news has reached me that there are certain persons who worship there and sleep at its very apex, and that convinces me beyond doubt that on account of these superstitious practices I ought to take it away. For men who see those persons sleeping there and so much filthy rubbish and careless and licentious behavior in that place, not only do not believe that it is sacred, but by the influence of the superstition of those who dwell there come to have less faith in the gods.

Julian therefore ordered the Alexandrians to bring the obelisk to Constantinople, "which always receives you hospitably when you sail into the Pontus, and to contribute to its eternal adornment, even as you contribute to its sustenance." The translator of Julian's text, Wilmer Wright, suggests that the people living around the obelisk were Christian or Jewish ascetics, about two thousand of whom lived in the vicinity of Alexandria at that time, a circumstance that would have added force to Julian's expression of concern.[48]

Julian's effort seems to have come to nothing. It is more than likely that the obelisk remained in Alexandria until it was moved to Constantinople by Theodosius. Inscriptions on the monument and an account in the sixth-century chronicle of Marcellinus Comes suggest that the obelisk was erected in Constantinople's Hippodrome in 390. This was just two years after Theodosius won the battle of Aquileia against Maximus, who was attempting to become the independent ruler of Italy. One of the inscriptions on the monument reads: "It was only the Emperor Theodosius who succeeded in raising the four-sided column, which had ever lain as a burden to the earth. He committed the task to Proclus and so great a column stood erect in thirty-two days." The inscription omits some essential details, since the obelisk as it stands had clearly been broken at some point and is missing up to a third of its original height.[49]

Another sort of catastrophe, brought about by a power struggle within the imperial court, is evidenced by the fact that in two of the obelisk's inscriptions the name Proclus has been erased by chipping away the stone,

turned wheels resembling millstones [i.e., capstans], it was finally placed in the middle of the circus." The obelisk was topped with a bronze globe covered in gold leaf. That was soon struck by lightning and replaced with a gilt-bronze figure of a torch, which glowed in the sunlight like a flame.[45] Constantius's obelisk eventually fell and sank into the marshy terrain of the Circus Maximus. When it was rediscovered in the sixteenth century, the excavators found holes for levers and evidence of fire damage, suggesting it may have been purposefully overturned and mutilated, perhaps by Christians attacking a potent symbol of paganism that had, ironically, been set up by one of the early Christian emperors of Rome.[46]

Whatever the original plan for this second Circus Maximus obelisk, it seems likely that both Constantine and Constantius would have wanted to erect an obelisk in Constantinople as well. Neither succeeded. The obelisk that did finally end up in Constantinople, taken from Karnak, still stands in the city's ancient Hippodrome, where it was installed by order of Emperor Theodosius I, who ruled the eastern empire from 379–395 CE.[47] The precise date of the obelisk's transport to Alexandria from Karnak is not certain. It may have been moved by order of Constantine at the same time as the Thutmose III–IV obelisk, or perhaps later as part of Constantius's obelisk schemes. Either way, it certainly reached Alexandria by the 360s, when it became the subject of an intriguing letter sent by Emperor Julian "the Apostate" to the Alexandrians in 363. Julian was raised as a Christian, but became increasingly interested in the Platonic and Neoplatonic traditions that he studied as a young man. Following a visit to Athens in 355, he converted to the worship of the pagan gods and began to rebuild their temples.

Although Julian proclaimed his tolerance for all religions, he rescinded some of the imperial favors granted to the Christians by his predecessors. His letter concerning the obelisk reveals his own religious views, and also provides a rare glimpse into the ways that even a fallen obelisk could stir enthusiasm and religious anxiety. Writing from Antioch, Julian says that he has heard of a tall obelisk that "has been thrown down and lies on a beach as though it were entirely worthless." He notes that Constantine had had a freight boat built for this obelisk "because he intended to carry it to my native place in Constantinople." The city claims the obelisk on his (Julian's) behalf because it was the city of his birth, but to compensate the

It quickly acquired the trappings of empire, including palaces, basilicas, and a circus – a *hippodrome* in Greek, the language of the city and of the eastern empire generally. After it was removed from its base at Thebes, the obelisk lay on the ground while transport was prepared. Then it was carried down the Nile to Alexandria, where a huge seagoing ship requiring three hundred oarsmen was constructed to carry it, according to Ammianus at least, to Rome. But Constantine died in 337, before the obelisk could be loaded for its final voyage.[42]

The obelisk lay at Alexandria for two decades until Constantine's son, Emperor Constantius, finally brought the monolith to Rome in time for his own triumphal visit in 357. He ordered an elaborate inscription be carved on the monument's new base, detailing its history and transfer to Rome. In an interesting detail, the inscription claims that Constantine originally planned to send the obelisk to Constantinople.[43] Garth Fowden has suggested that Ammianus's account rather than that of the inscription may be correct, since the plan to bring the obelisk to Rome makes sense "in the context of [Constantine's] finely balanced relations with his pagan subjects, and in particular of his desire to conciliate the pagan establishment of Old Rome." Constantius, on the other hand, had recently recovered Rome from a usurper, and decided to mark his triumphal visit in 357 with the erection of the obelisk. In his desire to impress the capital city and its largely pagan senatorial class, it made sense for Constantius to raise the value of his gift to the city by claiming that while his father planned to bring the monolith to the "new Rome" of the east, he himself favored Rome over its rival by presenting the obelisk to the more ancient capital.[44]

Ammianus provides a number of details concerning the transport of the obelisk. Upon arrival in Italy, the monolith was floated up the Tiber and unloaded about three miles from the city. Here it was put on a *chamulcus,* a kind of sled, and carefully pulled through the Ostian gate into the city. Then came the difficult task of setting it upright in the Circus Maximus. "Tall beams" of wood "were brought and raised on end (so that you would see a very grove of derricks)." They were fastened with long, heavy ropes "in the likeness of a manifold web hiding the sky with their excessive numbers." The ropes were attached to "that veritable mountain engraved over with written characters," which was "gradually drawn up on high through the empty air, and after hanging for a long time, while many thousand men

Christian emperors, it turned out, were no less tempted by obelisks than their predecessors. Indeed, the biggest obelisk in Rome, and probably the last to be transported to the city, was the project of not one but two Christian emperors. The greatest ever erected, it was originally set up by Thutmose III and IV in the great temple of Karnak and stands today in the Piazza di San Giovanni Laterano. It is also the first obelisk whose travels were discussed in much detail in a text that survives today. The reports about it, and about the other obelisks taken from Egypt in the fourth century, capture something of the complications entailed in moving such monuments – complications that remain forever hidden in the more fragmentary histories of earlier obelisks.

In the nearly two thousand years since its erection at Karnak, the solitary obelisk of Thutmose III and IV had been a major cult object, standing in its own temple dedicated to the sun god. According to later accounts, even the most ruthless foreign conquerors hesitated to touch it. Pliny reports that when the Persian King Cambyses sacked Thebes in 525 BCE, he ordered the fires be put out before they reached the monument, "thus showing respect for the obelisk when he felt none for the city itself." The fourth-century historian Ammianus Marcellinus writes that even Emperor Augustus, who was responsible for moving at least five obelisks, refrained out of piety from touching this one, because "it was consecrated as a special gift to the sun god, and because being placed in a special part of his sumptuous temple, which might not be profaned, there it towered aloft like the peak of the world."[41]

Three centuries later Constantine suffered no such compunction. Ammianus reports that the emperor took little account of the sacredness of the Karnak obelisk. Without hesitation, he "tore the huge mass from its foundations, and rightly thought that he was committing no sacrilege if he took this marvel from one temple and consecrated it at Rome, that is to say, in the temple of the whole world." Constantine had visited Egypt in 301/302, before he became emperor, and may have conceived the idea of moving the obelisk at that time. Yet his plans for moving it must properly be seen against the complex political background of his reign. In addition to his various edicts favoring the Christians, Constantine also established a new imperial city at Constantinople (modern-day Istanbul) in 324. The city became the capital of the eastern part of the empire, fully equal with Rome.

survived in cultural memory.[36] This development is epitomized by a text known as the *Hieroglyphica,* a sort of hieroglyphic dictionary written by one Horapollo "Niliacus," probably to be identified with the late fifth-century Alexandrian scholar Horapollo the Younger, son of Asklepiades.[37] Horapollo describes nearly two hundred hieroglyphic images, providing a more-or-less elaborate (and sometimes multiple) allegorical explanation for each. A number of these images and their meanings do, in fact, derive from authentic Egyptian tradition.[38] But despite these notes of authenticity, the text provides no explanation of how these image-signs could be joined to form sentences or compound thoughts.[39] Such limitations would have important consequences for Horapollo's readers in the Renaissance, as the *Hieroglyphica* served as a standard reference work when scholars of that era turned their own eyes to the obelisks and their mysterious carvings.

In the end, it was not the adherents of Isis and Serapis or Hermes Trismegistus who took greatest advantage of the peace Rome brought to *mare nostrum* – "our sea"; it was the Christians. Although the gradual spread of Christianity across the Mediterranean world in the second and third centuries was encouraged by the empire's stability, it was a moment of instability that brought the religion to a privileged place. The later third century was a time of weakness and internal strife, as the empire faced pressure from without and political division within. By the end of the century the empire had become increasingly difficult to govern, and in 293 CE the Emperor Diocletian divided the empire in fourths, creating a "tetrarchy" of two co-equal emperors and two Caesars (essentially junior emperors). The system broke down quickly, and the first decades of the fourth century saw the empire riven by civil war. Christians had been increasing in numbers and influence for centuries, and though they still suffered substantial political and legal disadvantages, they had become an important faction. Constantine, one of the four warring emperors, threw his lot in with the Christians. When he emerged as the sole emperor of the west in 313, he immediately removed legal restrictions and granted Christians access to the highest levels of power. Although the empire did not become officially Christian, Constantine issued a series of edicts over the next twenty years granting Christianity an ever more prominent place in the state. Constantine himself eventually converted, but was baptized only on his deathbed. Most of his successors were Christian.[40]

twined with other aspects of Roman religion and with the cult of the emperor himself. During the reigns of the Flavian emperors in the later first century, the worship of Isis and Serapis attained imperial sponsorship and the status of a dynastic cult. That may explain why Domitian had the Iseum rebuilt. It may have been during this reconstruction that the sanctuary began to fill with obelisks, sphinxes, lions, and other imported or made-to-order statues in the Egyptian style.[34] When those relics – some genuinely Egyptian, others just Egyptianizing – began to emerge from the ruins of the ancient city during the Renaissance, they would exercise immense influence on the ways scholars thought about and tried to understand Egyptian history and religion, and the relationship of Egypt to the classical world.

In addition to the hugely popular worship of Isis and Serapis, other cults emerged during the period. One of these, concentrated in the East and especially in Egypt itself, was comprised of small groups devoted to Hermes Trismegistus, a figure who combined characteristics of the Greek god Hermes and the Egyptian god Thoth. Evidence for these groups includes an important body of Greek writings compiled, in part from earlier sources, about 300 CE – a collection now known as the Hermetic Corpus.[35] The followers of this movement were influenced by late-antique Neoplatonic philosophies that were disseminated among other religious groups, often led by a charismatic figure who sought philosophical understanding of the divine. For the Hermetic cults, the most intriguing aspects of the obelisks and Egyptian monuments in general were their hieroglyphic inscriptions. As early as the first century BCE, the notion that the hieroglyphs contained historical and religious information encoded in allegory had become prevalent in Greek and Roman thinking. The esoteric character of the signs was stressed ever more during the later centuries of antiquity, and came to be associated with the supposedly secret doctrines of the Egyptian priesthood and its founders. The third-century Neoplatonic philosopher Plotinus, who was born in Egypt and studied in Alexandria, believed that the hieroglyphs represented symbols and allegories of ancient Egyptian wisdom.

By the end of the fourth century, knowledge of hieroglyphs as a writing system, which had become accessible only to the remnants of an ever-weaker Egyptian priesthood, was lost entirely. This meant that only the later, and essentially Hellenic, allegorical explanation of hieroglyphs

of reverse conquest was unfolding at the very same time. Just as the Roman emperors had gone east to conquer Egypt, Egyptian gods and other eastern religions found their way west to colonize Rome. The cults of Isis and Osiris, of Mithras, Judaism, and, ultimately, Christianity all spread through the Mediterranean basin, encouraged by the peace and the political and commercial links fostered by Roman rule. Though the eastern religions were not entirely newcomers in the west – the cults of the Egyptian gods Isis and Serapis had been established in Italy already by the second century BCE – the mixing and movement of people encouraged by commerce and the slave trade stimulated their growth throughout the empire.[28]

Those eastern religions were not always welcome. There were some efforts to suppress or limit the new cults during the late Republican period. Those efforts seem to have had little effect, for in 43 BCE the Triumvirate of Antony, Octavian, and Lepidus ordered the construction of a temple of Isis and Serapis in Rome.[29] It has been argued that the subsequent conflict between Antony and Octavian prevented the construction of this sanctuary, and that Augustus's reforms of 28 BCE, which restricted the worship of the Egyptian gods to areas outside the *pomerium* (the sacred boundary of the city of Rome) represented a reversion to the policy of suppression.[30] But even Augustus, who was profoundly dedicated to traditional Roman religion, sought to restore the most venerated Roman temples, and granted Apollo and Mars special status among the gods of the city, made sure there were temples for the Egyptian gods outside the *pomerium*. He even oversaw the restoration of some of these himself.[31] And at some point in this period the greatest Isiac sanctuary in Rome, the Iseum Campense, was established, outside the *pomerium* and close to a number of late-Republican and early-imperial buildings (including the Pantheon), though the date is frustratingly elusive. It is possible that the complex originated with the Triumvirs' project and survived the Augustan sanctions, or it may have been founded after Augustus's reign. Either way, early imperial policy remained inconsistent. There was suppression anew in 19 CE, during the reign of Tiberius, when we know that some statues from the Iseum Campense were thrown into the Tiber.[32] That was followed by another renewal of the sanctuary, sometimes attributed to Caligula on the basis of his presumed (but hardly proven) interest in Isiac religion.[33]

Initial uneasiness aside, the eastern cults soon became deeply inter-

a new town, Antinopolis, on the burial and temple site. The obelisk's hieroglyphic inscriptions were composed by priests in Hermopolis, just across the river, and show vividly the continuity of Egyptian and Ptolemaic religious tradition and symbolism long after the Roman conquest. On the pyramidion Hadrian is depicted presenting offerings to Re-Herakhty, Amen, and Thoth. In the inscriptions Antinous is called an "Osiris" and is said to be "known as a god in all the divine shrines of Egypt," where "a temple has been built for him, and he is worshipped as a god by priests and libationists of the south and the north," and "a city is named after him," where "Greek soldiers and lords of the north" have come to live and worship at the temple of "Osiris Antinous." The temple is described as having been "built of beautiful stone," with "sphinxes and many statues similar to those which the Greeks make. All the goddesses give him the breath of life, and he breathes the air that makes him young again."[27] Reflecting the flexibility of ancient religions, and what might be called their cultural pragmatism, Antinous, identified with Osiris in Egypt, became associated with the Greco-Roman god Dionysus elsewhere in the eastern Mediterranean. Ultimately, though, the Romans showed no more reverence for the obelisks of their own emperors than they did for those of their Egyptian predecessors. During the third century, the Antinous obelisk was torn from its original site and brought to Rome, where it was raised in the Circus Varianus near the Via Labicana. Two fragments of its broken shaft were still visible in the ruins of the complex during the fifteenth and sixteenth centuries. In 1570 the Saccocia brothers, who owned the property, excavated the pieces and partially re-erected the monument. Even then it kept moving. After a series of unsuccessful efforts to restore the obelisk, in the early nineteenth century it finally found a permanent home in Rome's Pincian gardens – for now, at least.

The Romans exerted enormous efforts and spent vast sums to transport obelisks from Egypt. In the process they claimed the monuments as their own, subjecting them to a variety of changes, both physical and symbolic. Created as symbols of one sort of religious and imperial power, the obelisks became symbols of another. In the earliest stages of their Romanization, the obelisks were appropriated to serve as trophies of conquest, monuments to the cult of the Roman imperial family, and rededicated to the solar gods as the Romans, not the Egyptians, understood them. But a kind

Ptolemaic models with a newly composed dedication to Domitian on the occasion of his accession to the imperial throne in 81 CE.

> He [Domitian] has received the kingdom of his father, Vespasian, in the place of his brother, Titus the Great, after his soul flew up to heaven.[23]

We do not know where this obelisk was meant to be set up. The dedication and a reference to the restoration of "that which had been destroyed" have prompted some to associate it with the rebuilding of the Iseum Campense, which was destroyed by fire in 80 CE and rebuilt by order of Domitian. This idea has its merits. Cartouches containing Domitian's name also appear on a pair of partially preserved obelisks discovered in the south Italian city of Benevento, where they may have been associated with a sanctuary dedicated to Isis.[24] And the emperor had strong dynastic reasons to favor the cult of Isis and her Greco-Egyptian consort Serapis. An oracle at the temple of Serapis (the Serapeum) in Alexandria had predicted that Domitian's father, Vespasian, would rise to the imperial throne. Vespasian and Domitian's brother Titus acknowledged that debt by spending the night before the triumphal parade that celebrated their suppression of the Jewish Revolt in 71 CE at a Roman temple of Isis – presumably the Iseum Campense itself.[25] But the inscription is formulaic, and it's also possible that the obelisk was destined for another spot in Rome, or carved originally for erection somewhere in Egypt and only later found its way to Italy. The one thing we do know is that about two hundred years after the obelisk was made, the early fourth-century Emperor Maxentius had it moved to the *spina* of his new circus on the Via Appia, outside the walls of the city. The circus belonged to a memorial complex he built for his son, Romulus, who died at age four in 309 CE. Over the intervening centuries, the obelisk fell from its pedestal and broke. In the seventeenth century it was restored by order of Pope Innocent X and began yet another life as the centerpiece of the Piazza Navona, atop Gianlorenzo Bernini's dramatic Fountain of the Four Rivers.[26]

The Romans even sponsored some new obelisks in Egypt itself. The second-century Emperor Hadrian commissioned a small obelisk (just under ten meters, or about thirty-one feet) in honor of his lover Antinous, who drowned in the Nile during an imperial visit to Egypt. Hadrian founded

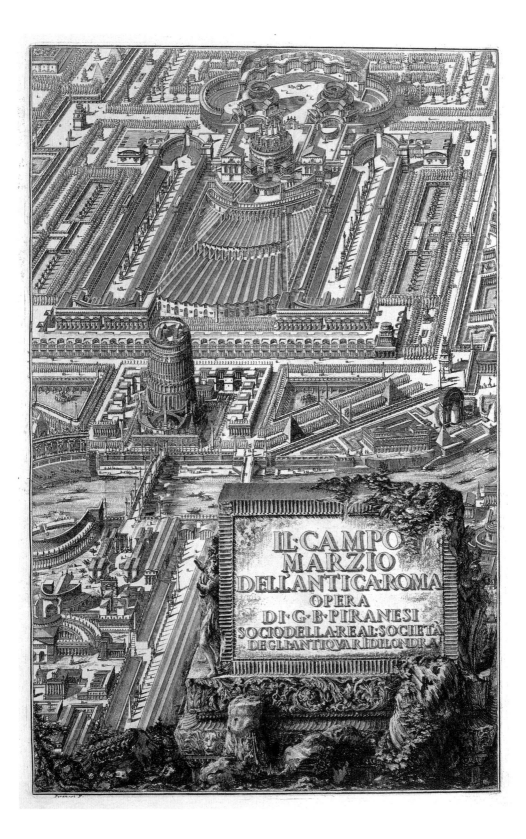

IL·CAMPO
MARZIO
DELL'ANTICA·ROMA
OPERA
DI·G·B·PIRANESI
SOCIO·DELLA·REAL·SOCIETÀ
DEGLI·ANTIQVARI·DI·LONDRA

Cornelius Gallus, now bore a replacement inscription placed there by Tiberius. Caligula resented his predecessor, who had executed a number of Caligula's family members, and placed the obelisk so the inscription faced the short (north-south) side of the circus, where it would be invisible to the majority of spectators. Unknowingly following the practice of Ramesses II and other pharaohs before him, Caligula was in the process of having Tiberius's inscription removed and rededicating the monument to himself when he died.

Many smaller obelisks came to Rome as well. At least six were installed in the Iseum Campense, a sanctuary in the Campus Martius dedicated to the Egyptian goddess Isis. The obelisk now in the Piazza della Rotonda, in front of the Pantheon, is one of these, along with its more fragmentary counterpart in the gardens of the Villa Celimontana, near the Colosseum.[21] Somewhat more prominent was the pair of medium-sized obelisks set up before the entrance of the Mausoleum of Augustus, also in the Campus Martius. Like their counterpart at the Vatican, these obelisks lack hieroglyphic inscriptions, making it impossible to determine when and where they were made. When they were installed at the Mausoleum is also unknown, though most scholars favor a date during the first century CE. Erik Iversen has suggested they were set up in imitation of the pair Augustus installed at the Caesarium in Alexandria (Cleopatra's Needles), raising the possibility that Augustus himself may have been responsible. Like most of their Roman cousins, the Mausoleum obelisks fell and broke sometime during the Middle Ages. During the sixteenth century one was excavated and set up on the Esquiline Hill, behind the Basilica of Santa Maria Maggiore. The other was recovered in the eighteenth century and restored in the Piazza del Quirinale.[22]

Imperial demand for obelisks was such that the Romans began making new ones. It's possible that the obelisks at Augustus's Mausoleum may be of Roman date, but we know that the late first-century CE Emperor Domitian ordered an obelisk be quarried in Egypt and dedicated to the sun god and other deities. The hieroglyphic inscriptions on this slender, elegant obelisk, which stands 16.5 meters (about 54 feet), combine formulas copied from

Obelisks everywhere. Rome's Campus Martius
as imagined by Giovanni Battista Piranesi in the eighteenth century.

The obelisk-raising scene on the base of the Theodosian obelisk.

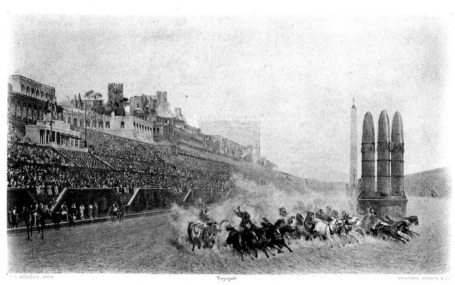

THE CIRCUS MAXIMUS.
From the Original Painting in the Collection of Mrs. A. T. Stewart, New York.

Racing at the Circus Maximus, as imagined by Jean-Léon Gérôme in 1876.

another first-century-BCE author, the Alexandrian engineer Heron, who wrote extensively about weights, machines, and ballistics. The basic components of such machinery included massive wooden beams for the crane, composite joints, heavy ropes, blocks and tackles containing numerous pulleys, trusses, capstans, and treadmills to provide power.[15] A glimpse of these devices at work is provided by a famous first-century-CE relief sculpture from the tomb of the Haterii (now in the Vatican Museums), which shows a crane powered by a tread wheel being used to construct a monument.[16]

There is only one ancient depiction of an obelisk on the move, and it dates from the very end of antiquity. It is a relief carving on the base of an obelisk the Emperor Theodosius set up in Constantinople during the mid-fourth century CE. Though damaged when holes were cut for a fountain, and highly schematic (the process surely required more people than are depicted), the relief nonetheless gives a sense of the process that is unavailable anywhere else. In the upper section, the obelisk is shown lying on a ramp. At the far right of the lower section is the base on which the obelisk will be raised, and the circle at upper right probably represents laid-out ropes. On the far left of the upper part are two capstans, which are being turned by teams of four men, aided by a figure who sits on the ground and seems to be holding the rope tight as it is turned. There is an identical pair of capstans in the lower register. In each register a man stands on an elevated platform; he is probably the supervising master of the operation. Additional figures of musicians, including a drummer, provide the beats for coordinated pulling. Finally, there is an image of the erect monument at lower right.[17]

Although the risks were great, the Romans clearly mastered the art of moving obelisks, for later emperors followed Augustus's precedent with enthusiasm. By the middle of the fourth century, nearly fifty, of varying sizes, graced Rome.[18] After those brought by Augustus, the first we know of is the obelisk that stood in the Forum Julium near Alexandria, transported to Rome in the first year of the reign of Tiberius's successor, Caligula. Upon arrival in 37 or 38 CE, the great stone was raised on the *spina* of a new circus in the Ager Vaticanus, or Vatican garden.[19] It was supported on a granite base by a set of four bronze astragals, and bronze acanthus leaves held the gilt-bronze globe that was installed on its summit in emulation of those that topped Augustus's obelisks.[20] The obelisk, first claimed by the disgraced

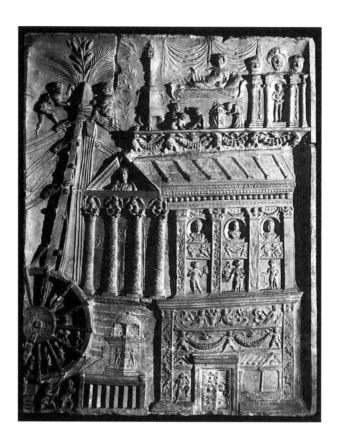

A human-powered crane in use, from the Tomb of the Haterii,
now in the Vatican Museums.

very different techniques than those of the Egyptians. For, unlike the
Egyptians, the Romans had pulleys and other equipment fabricated with
iron. The only detailed ancient account of the moving and setting up of
an obelisk comes from the end of the Roman period, but a variety of other
sources reveal the techniques and machinery the Romans developed over
the centuries to lift and move very heavy weights. A key early text is *De
architectura* (or *Concerning Architecture*) by the first-century-BCE architect
Vitruvius, a client of Augustus's sister, Octavia. The only ancient treatise
on architecture that survives complete, *De architectura* includes a chapter
on machines in which Vitruvius describes timber cranes and hoists, includ-
ing those intended for lifting colossal weights.[14] Such machinery was used
throughout the empire, and further evidence is found in the *Mechanica* by

in a new time and place would play out again and again across the history of obelisks and their journeys.

For Roman commentators like Pliny, the transport of the obelisks to Rome was almost a greater marvel than their fabrication and erection in the first place.[11] Modern scholars have been similarly intrigued, since the Romans had to move the stones not just down the Nile but all the way across the Mediterranean – a far more daunting task. Pliny reports that the ship constructed to carry Augustus's obelisks to Rome was considered such a wonder that it was placed on display in a permanent dock at Puteoli (modern Pozzuoli), though it was later destroyed by fire. He adds that another obelisk ship, used by Caligula, was similarly preserved until a more practical use was found; it was filled with concrete and deliberately sunk to provide foundations for the harbor-works at Ostia, Rome's ancient port. Excavations conducted in the late 1950s near the eastern edge of Rome's Fiumicino airport uncovered the concrete that filled that ship, which preserved a partial impression of the vessel itself.[12]

From a close examination of this find and other evidence, including the representations of obelisk ships in Hatshepsut's temple, written accounts by Pliny and Ammianus Marcellinus, and information provided by modern archaeology, the German scholar Armin Wirsching has proposed reconstructions of both Egyptian and Roman obelisk ships. He has revised the traditional view that the Egyptians laid their obelisks on top of barges, arguing instead that they carried obelisks and large columns between the hulls of specially constructed double-hulled ships. Before loading the obelisk, they used ballast to lower the double ship in the water so the obelisk could slide onto a support constructed between the two hulls. Then they removed the ballast, allowing the ship to rise and hold the stone above the water. Rather than invent a new ship technology, it seems, the Romans, ever pragmatic, learned directly from the Egyptians, adopting their basic idea but adapting it for the more treacherous open sea. They did this by constructing a vessel made of three interconnected hulls. Two of these replicated the double ship used in Egyptian river transport, while the third was centered in front, between the bows of the carrier ships, to provide propulsion and sufficient streamlined water flow for transport in the open sea, as well as extra room for a mast and rowers.[13]

Once the obelisks arrived, the Romans moved and raised them using

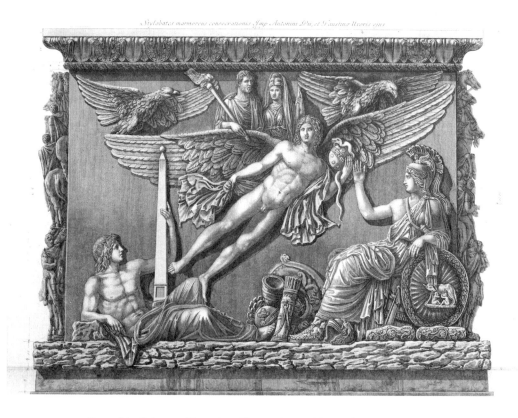

Base of the Column of Antoninus Pius, etched by Giovanni Battista Piranesi.

Heliopolis and Thebes, some of which were still standing "but thoroughly eaten by fire," or had fallen and were "lying on the ground."[10] In his description, Strabo provides a kind of justification for taking the obelisks from the desolate site, using the now ruinous sanctuary of the Egyptian sun god – where, he noted, even such sages as Plato had learned the secrets of the Egyptian priests – as a sign of the contrast between Egypt's glorious past and its broken, conquered present. Romans were accustomed to parades and triumphs that featured the display of treasures taken from defeated lands, so Augustus's appropriation of ancient symbols of kingship and state power must have seemed entirely in character to Strabo's readers, and to the public that marveled at these Egyptian wonders when they arrived in the capital of the new empire. Strabo's rhetorical trick of contrasting the decline of ancient Egyptian glory with the reappearance of imperial majesty

divided the racecourse lengthwise.[7] The idea that chariots racing around a circus could serve as a cosmological metaphor had already developed by the time of Augustus, encouraged by the growing influence of the cult of Apollo, the sun god. By the mid-second century the cosmic allegory of the chariots as planets moving around the sun would be well established, even though the Romans viewed the cosmos as being centered around the Earth. The presence of an obelisk that had originally stood in Heliopolis, center of the Egyptian sun cult, reinforced the Circus's cosmological symbolism and dedication to the sun. But that was not all. After Augustus's death, in 14 CE, the Circus obelisk took on yet another layer of meaning, becoming a memorial to the emperor himself, who was deified after his death. Like many of Augustus's works, the obelisk became a symbol of the increasingly idealized age over which he had presided.[8]

Augustus installed his second obelisk in an even more explicitly solar context. He had it set up close to his own Mausoleum and the Altar of Augustan Peace (the Ara Pacis Augustae); the altar celebrated the peace and prosperity the emperor had brought after the Roman civil wars. The obelisk was placed on a foundation of red granite at the center of a pavement decorated with bronze inlays arranged so that the obelisk functioned as a gnomon or pointer. The resulting device served as a meridian instrument, measuring the highest point attained daily by the sun over the course of the year. Pliny the Elder reports that the mathematician Novius Facundus designed the instrument and had the gilt ball placed at the pinnacle to sharpen the definition of the stone's shadow. Pliny, writing in the 70s CE, also noted that the readings had failed to correspond to the calendar for about thirty years. This suggests that the instrument worked for about fifty years before it went out of sync.[9]

By the time Augustus removed the obelisks from Heliopolis, the venerable city had fallen into ruins. Writing at about the same time, the Greek geographer Strabo reported that "the city is now entirely deserted; it contains the ancient temple constructed in the Egyptian manner, which affords many evidences of the madness and sacrilege of Cambyses [the Persian king who conquered Egypt in 525 BCE], who partly by fire and partly by iron sought to outrage the temples, mutilating them and burning them on every side, just as he did with the obelisks." Strabo also suggests that Augustus's agents chose two of the more intact obelisks among many available in

LEX

IVLI·TERTII·PONTIFICIS·OPTIMI·MAXIMI·IVSSV·SANCTIONE
AC·DECRETO
BIBLIOPOLA·IMPRESSOR·MERCATOR·INSTITORVE·LIBRORVM·QVIS
QVIS·ES·TABELLAS·HASCE·CIRCI·MAXIMI·DESCRIPTIONIS
A·MICHAELE·TRAMEZINO·EDITAS·AB·EDITIONI·QVAE·FVERIT·ANNO
A·CHRISTO·NATO·M·D·LII·MENSE·IVNIO·EIVSDEM·FELICISSIMI
PONTIFICATVS·ANNO·III·INTRA·DECENNIVM·MICHAELIS·IPSIVS
IN·IVSSV·NE·IMPRIMITO·NEVE·VSQVAM·GENTIVM·CITRA·EIVSDEM
PERMISSVM·IMPRESSAS·VENALES·HABETO

SANCTIO

QVI·VERO·SECVS·FECERIT·ANATHEMA·SVPRA·SCRIPTO
MICHAELI·ET·POENAE·MVLTAEVE·NOMINE·AVREOS
QVINGENTOS·DARE·DAMNAS
ESTO·

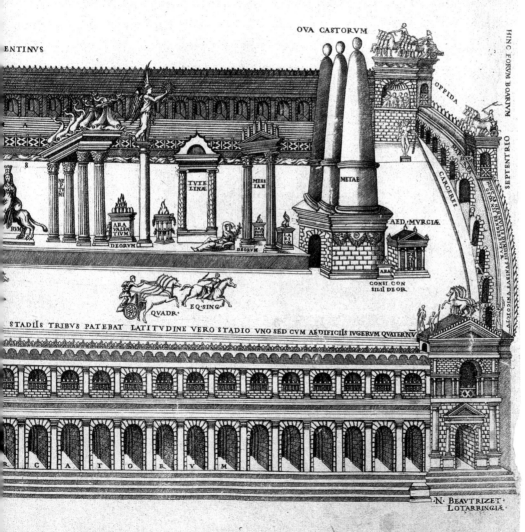

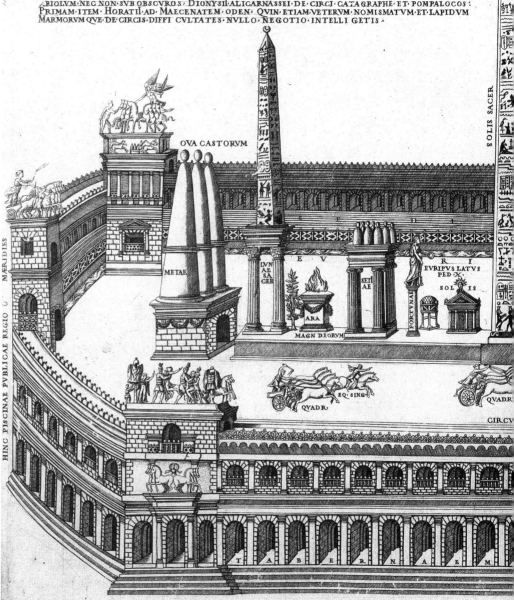

ANTIQVITATVM · STVDIOSIS

EN·VOBIS·CANDIDISSIMI·ANTIQVITATVM·STVDIOSI·CIRCI·MAXIMI·DESCRIPTIONEM·NON·QVALEM·PLANE
SCIOLI·QVIDAM·CAECVTIENTES·ΑΜΟΥΣΟΤΑΤΟΙ·ΚΑΙ·ΓΕΛΟΙΟΤΑΤΟΙ·ΦΙΛΑΡΧΑΙΟΙ·IN·SVIS·ILLIS·DE·VRBE·PRISCA
MENDACISSIMIS·VNDE·CVNQVE·VOLVMINIBVS·EFFIGIATAM·INVVLGARVNT·SED·QVALIS·APELLAEA·PYRRHI
LIGORII·PICTORIS·NEAPOLITANI·MANV·EX·VETERVM·ET·CLASSICORVM·AVCTORVM·MONVMENTIS·AD·VNGVEM
REPRAESENTATA·ET·SVMMA·CVM·MICHAELIS·TRAMEZINI·CVRA·ET·INPENSA·EX·AENEIS·TABVLIS·MIRIFICE
INCISIS·FORMATA·CVM·HIS·OMNIBVS·COGNITIONE·DIGNISSIMIS·QVAE·AD·HVIVSCE·REM·ATTINET·PVLCHE
RRIME·DEPICTIS·AC·NOMINATIM·EXPRESSIS·NVNC·PRIMVM·IN·LVCEM·PRODIT·ATQVE·ITA·QVIDEM·AB·SOLV
TE·VT·EO·NOMINE·NIHIL·AMPLIVS·ADICI·AC·DESIDERARI·POSSIT· QVARE·SI·CONTEMPLATI·OTIOSE
HANC·TABELLAM·FVERITIS·ATQVE·VNVM·QVODQVE·DILIGENTER·CONSIDERAVERITIS·DOCTISSIMAM·ILLAM
CASSIODORI·AD·FAVSTVM·PRAEPOSITVM·DE·LVDIS·CIRCENSIBVS·EPISTVLAM·AB·IMPERITIS·ANTIQVA
RIIS·MINIME·INTELLECTAM·AD·HANC·FRVGIFERVM·ILLVM·TERTVLLIANI·DE·SPECTACVLIS·COMMENTA
RIOLVM·NEC·NON·SVB·OBSCVROS·DIONYSII·ALICARNASSEI·DE·CIRCI·CATAGRAPHE·ET·POMPALOCOS·
PRIMAM·ITEM·HORATII·AD·MAECENATEM·ODEN·QVIN·ETIAM·VETERVM·NOMISMATVM·ET·LAPIDVM
MARMORVMQVE·DE·CIRCIS·DIFFICVLTATES·NVLLO·NEGOTIO·INTELLIGETIS·

obelisks' erection by the prefect Publius Rubius Barbarus and an architect named Pontus.[4]

Those first obelisks may have served as a sort of test run. For in 10 BCE, twenty years after the defeat of Antony and Cleopatra, Augustus accomplished the much more difficult task of transporting two obelisks from Heliopolis across the Mediterranean Sea for installation in Rome. He set up the first – the obelisk of Seti I and Ramesses II – just south of the Forum, in the gigantic racecourse known as the Circus Maximus. The second, the obelisk of Psammetichus, was brought to the Campus Martius, the area of the city in the bend of the River Tiber that embraces the neighborhoods around the Pantheon and today's Piazza Navona.[5] Upon arrival, both were capped with gilt-bronze spheres topped by obelisk-shaped pointers and provided with identical inscriptions:

IMP. CAESAR. DIVI. FIL. AVGVSTVS. PONTIFEX. MAXIMUS. IMP. XII. COS. XI. TRIB. POP. XIV. AEGVPTO. IN. POTES-TATEM. POPVLI. ROMANI. REDACTA. SOLI. DONVM. DEDIT.

When Imperator for the twelfth, consul for the eleventh, and tribune of the people for the fourteenth time, Imperator Augustus, son of divine Caesar, dedicated this obelisk to the sun, when Egypt had been brought under the sway of the Roman people.[6]

This inscription makes it clear that the obelisks were meant to commemorate Augustus's conquest of Egypt. But it also makes clear that they were not simply trophies. Rome's religious life was even more multifarious than Egypt's, and while the Romans did not have, in the strict sense, a cult of the sun, the sun played an important religious role nonetheless. By retaining the obelisk's original solar dedication, Augustus wove a new Egyptian thread into Roman religion. That dedication would take on a new and distinctly Roman twist. The Romans viewed counter-clockwise movement around a solar symbol as a metaphor for the cosmos. The Circus Maximus obelisk was placed at the center of the *spina* – the axial rib that

Overleaf: Pirro Ligorio's Renaissance reconstruction of the Circus Maximus.

Gallus ordered that inscriptions boasting of his accomplishments be carved on pyramids and elsewhere, and set up statues of himself all over Egypt.

One of Gallus's projects was the completion of a complex called the Forum Julium near Alexandria, perhaps in Nicopolis, a new town created by Octavian. As the centerpiece of this space Gallus set up a very large obelisk, the big 25.3 meter (83 foot) monolith that stands today in St. Peter's Square at the Vatican. Since the obelisk lacks a hieroglyphic inscription, it is impossible to know when or by whom this most celebrated of obelisks was originally quarried. Pliny the Elder reports that it was commissioned by a pharaoh he calls "Nencoreus, the son of Sesostris," but it has been persuasively argued that it was ordered by Cleopatra VII herself as a monument to Julius Caesar, and was already lying on site when Gallus appropriated it and added an inscription in bronze letters proclaiming his own accomplishments. Gallus's glory was short-lived. He was forced from office on charges of corruption and took his own life to avoid prosecution. The letters were removed soon after. The erasure, like that of Hatshepsut in pharaonic days, was very effective. All knowledge of this episode was lost until the letters' fastening holes were discovered during close analysis of the obelisk's surface in 1959. From the pattern of the holes it proved possible to reconstruct the inscription. Eventually, probably during the reign of Emperor Tiberius between 14 and 37 CE, the obelisk was rededicated to Augustus and Tiberius in a celebration of dynastic continuity, and a new inscription carved.[3]

Like his ill-fated prefect, Augustus was more than willing to appropriate obelisks. With all the resources of the empire to draw on, he immediately began behaving just like the pharaohs he had succeeded. Around 13 BCE he ordered that the pair of obelisks erected by Tuthmose III at Heliopolis be transported to Alexandria, where they were set up before a building known as the Caesarium, at the edge of the sea. This structure had apparently been begun by Cleopatra as a mausoleum for Marc Antony, but after the conquest it was dedicated to the cult of Julius Caesar and his descendants. In a fine bit of historical irony, Augustus, Cleopatra's conqueror, here failed to leave his mark, as she ultimately got credit for the obelisks; these are the two that have been known for many centuries as "Cleopatra's Needles." Each was supported by a set of four bronze astragals, made in the shape of crabs, that rested between the base and the shaft. A bilingual inscription in Greek and Latin on one of the surviving astragals tells the story of the

The Obelisks of Rome

IMP. CAESAR. DIVI. FIL. AVGVSTVS. PONTIFEX. MAXIMUS.
IMP. XII. COS. XI. TRIB. POP. XIV. AEGVPTO. IN. POTESTA-
TEM. POPVLI. ROMANI. REDACTA. SOLI. DONVM. DEDIT.

INSCRIPTION FROM THE BASE OF THE OBELISK
EMPEROR AUGUSTUS BROUGHT FROM EGYPT TO ROME IN 10 BCE[1]

IN 30 BCE Cleopatra VII and her husband, Marc Antony, the last of
the Ptolemies, were defeated by the forces of their Roman nemesis,
Octavian. Following his triumph, Octavian (who after 28 BCE became
Emperor Augustus) ordered that Egypt be governed by a Roman official
accountable directly to the emperor, without the intervention of the Roman
senate. Egypt was to be imperial property, not just a province of the empire.[2]
Augustus appointed Cornelius Gallus, a poet, general, and personal friend,
as the first prefect of the new territory. Gallus had been instrumental in the
conquest, taking over Antony's forces and helping capture Cleopatra. He
cemented Roman control, crushed local rebellions, and stabilized the south-
ern border by accepting the ruler of Ethiopia into Roman protection, creat-
ing a buffer state. He also made vigorous efforts to ensure his own renown.

Base of the Column of Antoninus Pius, etched by Giovanni Battista Piranesi (detail).

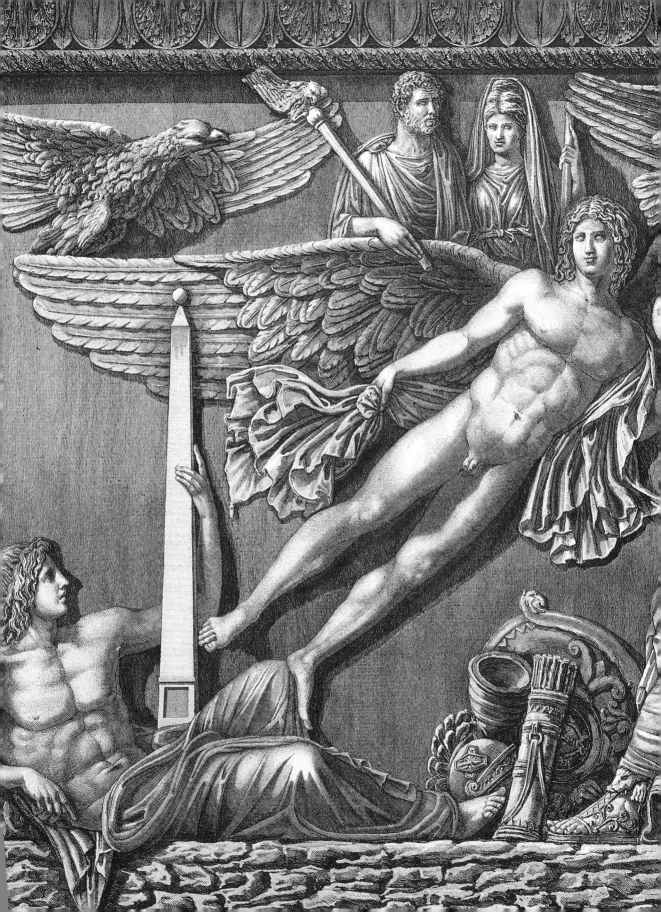

from the Peloponnesus to Afghanistan – and Ptolemy I Soter established the Ptolemaic dynasty in Egypt. Though the Ptolemies were Greek and in many ways made Egypt part of the larger Hellenic community of the eastern Mediterranean, they did not try to extinguish traditional Egyptian culture or religion. The Ptolemies built temples and other monuments in the traditional Egyptian mode. They even sponsored the erection of a few obelisks, including a smallish pair that Ptolemy IX (107–80 BCE) raised at the Temple of Isis in Philae.[37] One of these, or, more precisely the bilingual hieroglyphic and Greek inscriptions on its base, would play a key role in the history of obelisks, and of Egyptology generally, when it was transported to England two thousand years later.[38]

The Ptolemies marked the end of an Egyptian monarchy that had endured for nearly three thousand years. The pharaohs represented a culture that, for all its change and development, its moments of political weakness and strength, of conquering and being conquered, was characterized by stunning continuities. Egyptian language, religion, art, and architecture evolved in a nearly unbroken tradition from the age of the pyramids down almost to the time of Christ – a span more than half again as long as the time that has passed since. Obelisks appeared nearly at the beginning of that history and endured until its end, maintaining always their double relationship to the realms of mortals and the gods. When the Ptolemies fell in the first century BCE, the particular relationship of obelisks to Egyptian kings was severed. But the obelisks' relationship to power, both earthly and divine, continued, and the end of their Egyptian story marked only the beginning of journeys – physical and intellectual – that have never ceased. In the centuries to come, Romans and others would interpret obelisks in complex and creative ways, investing them with an extraordinary range of meanings – political, theological, and aesthetic. More important, they would pull these huge shafts from the Egyptian earth, transport them across oceans, and even make new obelisks of their own. We turn now to the obelisks' first – but not last or strangest – odyssey.

of grooves found in extant obelisk pedestals. He suggested that the obelisk was first pulled onto a platform where it lay, horizontal, exactly parallel to the top of its future pedestal. Then it was levered and pulled with ropes onto the pedestal with the help of wooden footholds set into the grooves to prevent slippage.[34] The existing grooves seem to support Borchardt's proposal, but there is no reason to assume that builders used this or any other method exclusively. The ancient Egyptians raised obelisks of many different sizes over a span of more than two thousand years. It is reasonable to suppose they may have used more than one method, depending on the obelisk, its size, and the conditions of the site.

The New Kingdom was the great era of obelisk making. Yet pharaohs of later dynasties continued to make obelisks, sometimes out of different types of stone and often on a smaller scale than those of the New Kingdom. Pharaoh Psammetichus II raised a large pair at Heliopolis in the seventh century BCE,[35] but the last obelisks to be ordered by a native Egyptian ruler were quarried under the direction of Pharaoh Nectanebo II between 360 and 343 BCE. Nectanebo governed for eighteen years, until he was defeated by a large Persian army and fled to Ethiopia. Before his inglorious end, though, Nectanebo encouraged a major revival of traditional Egyptian arts. A specialty of the time came to be the quarrying and carving of schist, an extremely hard black stone. Among the examples of fine schist work from his reign are two small obelisks now in the British Museum. Both were dedicated to the Egyptian god Thoth, the god of the city of Khemenu, or Hermopolis. First raised in or near Hermopolis, they were subsequently moved to the area of Cairo, and then to London during the nineteenth century.[36]

In the waning centuries of its long history, pharaonic Egypt suffered a series of invasions and defeats and came to be ruled by a succession of foreign powers. The Persian King Cambyses conquered the country in 525 BCE and, according to reports, destroyed many cities and monuments. The Egyptians threw the Persians out in 359 BCE, re-establishing native rule for a while. A second Persian conquest was followed by a more decisive occupation at the hands of the Macedonian conqueror Alexander the Great, who swept across Egypt in 332 and 331 BCE, establishing a new capital he called Alexandria at the northernmost point of the country. On Alexander's death in 323 BCE, his generals divided up the vast territories he had conquered –

Four stages of raising an obelisk, as imagined by Reginald Engelbach in the 1920s.

eral hypotheses. Although they differ significantly in detail, all involve frighteningly dangerous operations.[33] The first, worked out by Reginald Engelbach back in the 1920s, is that the Egyptians constructed sand ramps so that workers could pull the obelisk above the pedestal and then lower it in an upright position. This proposal begs the question of where the hundreds of needed workmen were to stand while pulling the obelisk upright. A second proposal, made by Jean-Claude Golvin and Georges Goyon, suggested the Egyptians constructed facing brick ramps that could be used to erect two obelisks that were to stand side by side. The workers could stand on one ramp to pull up the first obelisk, then on the other to pull up the second. This method requires that a perfect balance be maintained during the excruciatingly precise operation of lowering the obelisk onto the pedestal; the slightest imbalance would result in a catastrophic crash. A third proposal, by Ludwig Borchardt, takes into account the depth and arrangement

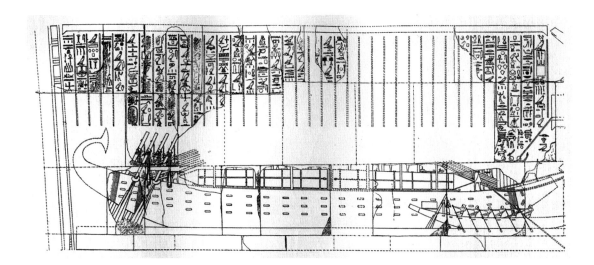

An obelisk barge, as carved into the walls of Hatshepsut's valley temple at Deir el-Bahri.

with a sled and a track that has been watered to reduce friction, moving giant stones requires a ratio of one man per half-ton. Surviving account records confirm the huge numbers involved. One document from the reign of Ramesses IV, around 1150 BCE, lists the number and kinds of men sent to haul a monumental stone. In all, the move took 8,362 men. They included one director of works, nine civil and military officers of rank, 362 subordinate officers, ten trained officers and artists, 130 quarrymen and stonecutters, 2,000 gendarmes, 5,000 slaves, and 800 "men from Ayan." A final figure underscores the grim hardship and high risk that accompanied such work: 900 workmen were listed as dead and therefore excluded from the total.[32] Further evidence of the sheer scale of the endeavor comes from a relief that depicts two obelisks being transported down the Nile, carved into the walls of Hatshepsut's funerary temple at Deir el-Bahri. The obelisks are shown end-to-end on a ship that is pulled by three rows of boats; nine in each row pull the obelisk ship and a tenth serves as the pilot boat. To the side are three boats on which religious ceremonies are performed. Hundreds of men must have been required to man the ships and thousands of people along the Nile must have watched these great riverine processions.

Finally, there was the task of raising the obelisk onto its pedestal. Again, how this was done is not precisely known, and scholars have proposed sev-

they had to use stone tools, on the principle that harder stones can break softer ones. Balls of dolerite, an extremely hard, green-black stone from the eastern desert of Egypt, were found around the failed obelisk. It became evident that workers used these dolerite "pounders" to separate the obelisk from the bedrock, striking downward with great force. Archaeologists found no chisel marks around the obelisk, only parallel vertical cuts with rounded surfaces that made it look as if the rock had been removed with giant ice-cream scoops. Only the dolerite balls could have left such markings on the trench. Rather than being cut or chiseled, the trenches were literally bashed out of the rock.[30]

Working areas about sixty centimeters wide (about two-and-a-half feet) were marked off in the trench, providing minimal space for a squatting or kneeling man. Hundreds of workers would have surrounded the site to dig the trenches, a grueling task. Nearby, a group of men probably chanted to help maintain the rhythm of the blows. When the trenches reached sufficient depth, the difficult task of undercutting the monolith began. Working from both sides, the crews cut away the underside almost completely until the obelisk rested on a small central ledge. (The workers may have provided additional support by pushing stone blocks underneath.) Then the obelisk was broken from the remaining ledge with huge timber levers that were set into the trenches. At least on some occasions, hieroglyphic inscriptions and other decorations were begun while the monument was still in the quarry. Another unfinished obelisk found near Aswan (also commissioned by Seti I) had its pyramidion decorated on three sides before it was abandoned. Workers polished the obelisks by pounding and grinding the surface with dolerite balls, and probably used stone tools and abrasives like emery to engrave the inscriptions.[31]

After the obelisk was freed from the bedrock, it had to be transported to its final destination. The Egyptians' precise methods of moving obelisks on land are unknown, but relief carvings from tombs and temples show they used sledges, rollers, ropes, and levers made of large timbers, as well as huge amounts of manpower. First they constructed a track or transport ramp from the quarry site to the river. Then they lifted the obelisk, or more likely cut out the rock around it, and rolled it out of its bed onto a large sledge that was waiting on the track. Ropes for pulling obelisks were thick and probably made of palm fibers. Modern experiments have shown that,

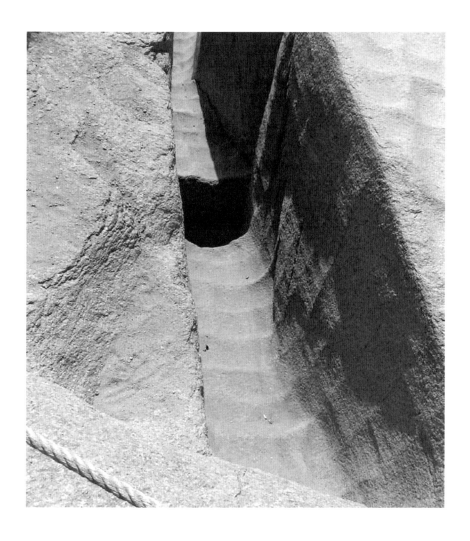

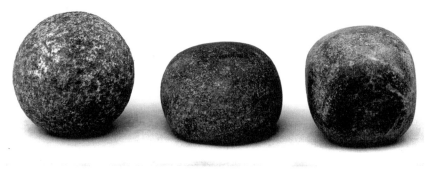

Dolerite pounders and the excavation trenches around the unfinished obelisk.

CREATING THE SLOPE: The overseer of the work chose the *seqed* (length of the horizontal line) depending upon the desired degree of the slope. In this diagram, the *seqed* is ¼ inch. A cubit is represented by one inch. Begin from a horizontal line drawn on the stone, which will be the bottom of the obelisk. From this line draw a straight, vertical line one inch long (the cubit). At the top, draw a horizontal line to the left ¼″ long (the first *seqed*). From the left end of the *seqed,* draw another vertical line one inch long (the second cubit). Repeat this operation until you reach the top of the obelisk (but before the pyramidion, or *benben*). After this has been measured out, draw a line (illustrated by the dashed line). Voilà! A slope.

The slope of the pyramidion at the top is greater than that of the shaft of the obelisk, so a new *seqed* must be chosen — say ¾ inch for that!

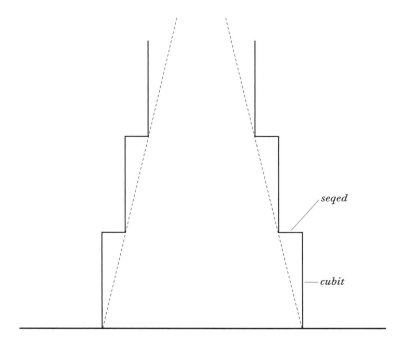

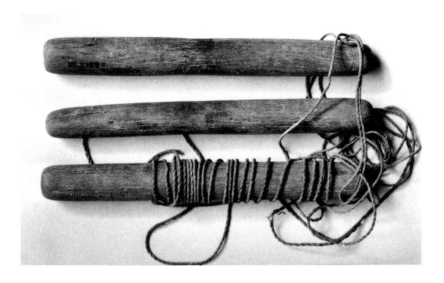

Egyptian measuring and marking ropes, used to ensure a level surface.

by sighting with the square level, then lowered it onto the stone, leaving a straight-line mark up the length of the future obelisk. Then they lined up the corners of the base of the pyramidion with the obelisk's own base. Obelisks were carved at a slight incline from bottom to top, and the Egyptians had a simple and exact way of determining the inclination, using the *seqed,* or "setback." The *seqed,* measured in palms and digits, designated the horizontal change of the sloping side for a vertical drop of one cubit. Once the *seqed* was decided upon, it was marked by one-cubit increments up the length of the obelisk. The Egyptians' expertise in these matters was informed by long experience surveying fields and canals, measuring and leveling stones, and building massive structures such as pyramids.[29]

Then the carving began. Workers first removed the uneven surface stone. Placing bricks and papyrus reeds on an area that would eventually become one side of the obelisk, they lit a fire and let it subside. While the surface was still burning hot, they poured on water. The sudden cooling cracked the rough surface. After removing the loose stone, the workmen came to smooth granite. Then began the arduous task of digging out trenches on the two long sides of the obelisk. For most of the period when the Egyptians were making obelisks they had no iron tools. The bronze and copper ones they did have were not hard enough to carve granite, so

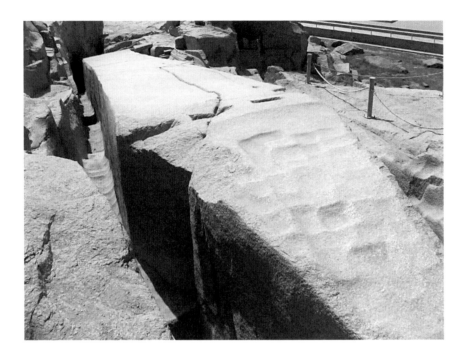

The unfinished obelisk at Aswan.

charge. Nevertheless, it is a rare archaeological treasure, and its excavation by Reginald Engelbach in 1921 and 1922 yielded valuable insight into Egyptian methods of making obelisks and of quarrying in general. In a sense, this failed project underscores the remarkable achievement represented by the numerous obelisks the Egyptians did successfully excavate, haul long distances, carve with inscriptions, and raise on their pedestals.[28]

The unfinished obelisk provided many details about how the Egyptians extracted such monuments from the surrounding rock. First, they sank test shafts to make sure the rock was without flaw. Then, once they had decided on the site, they laid out the obelisk on the surface. It was critical that the sides be straight and even. They accomplished this with simple but highly effective tools: measuring cords and cubit rods (each cubit was about 52.5 cm, or just over eighteen inches); the plumb, consisting of a plumb-bob suspended from a peg or stick; builder's squares; and the square level, a right-angled level crossed like an "A," with a plumb line hanging from the apex. To lay out the obelisk, a line of men stood down the center of the site, holding a cord covered with lampblack or ochre. They positioned the cord

he had made from scratch; others he appropriated by cutting out the names of previous rulers and substituting his own; and in some cases he simply added his name to existing inscriptions.

By the time of Ramesses II, obelisks had assumed the form, and size, generally associated with the term today. The great obelisks of the New Kingdom were fashioned from a single piece of durable, mottled-pink granite extracted from the quarries at Aswan, at the first cataract of the Nile. Aswan, which lies just over two hundred kilometers from Luxor and nearly nine hundred south of Cairo, marked the southernmost edge of what was traditionally understood as Egyptian territory.[25] After completing the onerous task of hewing out an obelisk, the quarry workers would have transported it to the Nile and loaded it onto a specially constructed ship to be carried downriver. This difficult and dangerous task required enormous manpower, as well as great skill acquired by long experience. The task of calculating the necessary resources even became a test for scribes and other officials. The Papyrus Anastasi, a New Kingdom–era document, contains a fictional letter that includes a debate between two scribes. It mentions a newly made obelisk and gives its size as part of an instruction to send men to haul the monument. Based on the size, the scribe is expected to be able to estimate the number of men needed.[26] This was a task repeated time and time again over the centuries, as the pharaohs of the New Kingdom and succeeding eras extracted ever-larger obelisks from the Aswan quarries and loaded them aboard ever-greater ships.[27]

The methods the Egyptians used to quarry, transport, and erect these stones are not fully understood, but much has been learned from the study of texts and reliefs, the examination of surviving monuments, and other archaeological evidence. Among the latter, the richest source of information has been a large unfinished obelisk, believed to be of eighteenth-dynasty (New Kingdom) date, that still lies in the Aswan quarry where it was abandoned when it developed a large crack in its upper section. This obelisk, originally laid out at a height of almost forty-two meters (about 137 feet), would have weighed about 1,168 tons. After it cracked, the workers reduced the obelisk's length by about two meters in an attempt to save it, but gave up when additional fissures appeared. The unfinished obelisk represents a significant engineering failure, an ancient tragedy that meant thousands of hours of lost labor, not to mention possibly dire consequences for those in

in Roman times and then, in the nineteenth century, to London and New York City – and one of the obelisks from Karnak, which is now in Istanbul. More imposing than any of these was the single obelisk Thutmose ordered, probably toward the end of his reign, for the temple at Karnak. This giant, the obelisk now at the Lateran, was apparently never intended to be one of a pair, since its inscription proclaims it to be the first single obelisk set up in Thebes, the city where the temple was located. Thutmose III died before he could have the obelisk inscribed and erected, and it lay abandoned throughout the thirty-five-year reign of his son, Amenhotep II. It was finally completed by Thutmose III's grandson, Thutmose IV, who ordered that the inscriptions originally planned by his grandfather be placed in the center of each of the four sides. Beside these he added his own inscriptions, describing the obelisk's abandonment and his decision to complete it in honor of his grandfather.[22] As he put it: "I am the son, the one who reveres his father," who did this "in order that the name of his father might be permanent and flourish in the temple of Amen-Re."[23]

As the thirty-five-year wait suggests, the quarrying, transportation, and raising of obelisks required immense manpower and expense, and could be accomplished only by pharaohs whose reigns were long and successful enough to see the task through. So whatever message a pharaoh wished to convey with an obelisk, once one had been quarried or set up it made more sense to finish or reclaim it than start another from scratch. This was certainly the case with the Lateran obelisk, but is also true of the one that now graces the Piazza del Popolo in Rome. This obelisk was originally quarried by order of the nineteenth-dynasty Pharaoh Seti I (1294-1279 BCE). Seti came to the throne after his father, a general in the Egyptian army, was proclaimed king following the extinction of the previous dynasty. A dynamic ruler who restored the strength of the monarchy after a period of decay, he undertook military campaigns in Asia and was able to muster the resources needed for making obelisks. Though the obelisk was quarried and had been carried upriver to Heliopolis, Seti's monument was only partially carved when the pharaoh died. His son and successor, Ramesses II (1279–1213 BCE), completed the inscriptions with his own name and installed the obelisk at Heliopolis, where it stood for more than a thousand years.[24] Where Seti managed only to begin one obelisk in his fifteen years on the throne, Ramesses II dedicated at least twenty-five in his sixty-six year reign. Some

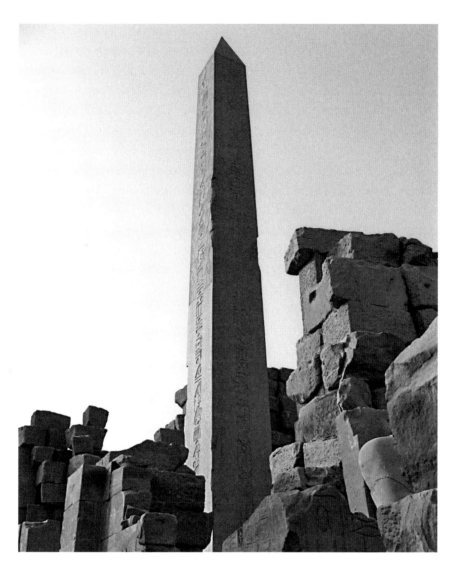

Hatshepsut's obelisk, showing the walls built by Thutmose III.

have been political, religious, or both, but Thutmose III was almost entirely successful in obliterating Hatshepsut's name from the annals of Egyptian rulers. Her existence and accomplishments have been recognized only in modern times.[21]

Of Thutmose III's seven obelisks, four survive. Not one is still in Egypt. These include the pair originally raised in Heliopolis – moved to Alexandria

As one Egyptian king's rule ended and another's began, obelisks could become links of continuity or marks of discontinuity. Both possibilities were realized within one succession of rulers in the eighteenth dynasty, bracketed by the reigns of Thutmose I and Thutmose IV, between 1525 and 1417 BCE.[17] Around 1500 BCE Thutmose I set up a pair of large obelisks at the entrance to the temple of Amun-Re at Karnak. One of these still stands nearly twenty meters high on its original pedestal in the temple precinct. Only fragments of the other remain.[18] When the pharaoh died, he was succeeded by his son, Thutmose II, who ruled with his older half-sister and wife, Hatshepsut. They had but one child, a daughter named Nefrura, before Thutmose II died. A son by another of Thutmose's wives was crowned king while still a very young child, and took the name Thutmose III. Since he was far too young to take power, Hatshepsut ruled for several years as regent, eventually declaring herself king in her own right. In statuary and reliefs from her reign, she is often depicted as a man, wearing the artificial beard that was a traditional marker of kingship, and is frequently referred to as king using the traditional male form of the title. In other images, notably some statues found in her temple at Deir el-Bahri, Hatshepsut appears in more androgynous form or more explicitly as female.[19]

An energetic ruler who initiated a wide-ranging program of building projects, Hatshepsut erected no fewer than four obelisks, in two pairs, at the great temple at Karnak. Of the pair she raised in the eastern section of the temple, at the beginning of her reign, only fragments survive.[20] Some years later, at the time of her jubilee, she had a second pair set up. One of these still stands at Karnak today. This great obelisk, nearly a hundred feet high (or 29.5 meters), is second in size only to the colossus at the Lateran. The lower part of its companion remains nearby on its original base; fragments of its upper half can be seen on site and in various museums throughout Europe and the United States. Thutmose III came to full power at Hatshepsut's death. He outdid his predecessor, erecting at least seven obelisks at Karnak and two more at Heliopolis. At first he honored Hatshepsut and followed her traditions, but in year forty-two of his reign he abruptly removed her name from many monuments and destroyed others – including the statues in her temple at Deir el-Bahri. He also built stone walls around her Karnak obelisks in a rather half-hearted attempt to block their inscriptions from view. The reasons for this about-face are unknown. They may

and sixth dynasties of the Old Kingdom (2494–2184 BCE), the era that saw the construction of the pyramids at Giza, obelisks of various types and sizes were being made in Egypt. But it was some time before they took on the exact form and size associated with the term today. During the fifth dynasty, a series of obelisk-like centerpieces was set up at solar temples near the pharaonic cemeteries at Saqqara and Abu Sir. These "obelisks" were fashioned not from a single block of stone, but from multiple stones, laid in courses, in the manner of the pyramid tombs of the time. During the same period, diminutive obelisks began to be erected in pairs at the entrances to tombs. These were generally installed facing east, apparently to present themselves to the rays of the rising sun, which represented the resurrection of the dead. These mini obelisks were usually made from limestone, and inscribed on one side with the name of the deceased.[14]

The Egyptians do seem to have made a few large obelisks in the early period, including a pair recorded as having been transported on large ships from southern Egypt to Heliopolis by the Pharaoh Pepi II (2278–2184 BCE),[15] but the earliest surviving large, monolithic obelisk dates to the period known as the Middle Kingdom, between 2055 and 1650 BCE. Inscribed for the twelfth-dynasty Pharaoh Senwosret I (1985–1956 BCE), it was one of a pair dedicated to the sub-god Re-Harakhti and was set up before the main gateway of the temple at Heliopolis. Rising some twenty meters (about sixty-seven feet) and weighing around one hundred and twenty tons, it stands today as the sole marker of this otherwise obliterated sanctuary. A single line of inscription, repeated on all four sides, reports that Senwosret dedicated the obelisks on the occasion of his *sed*, or jubilee festival, so that "life might be given to him forever."[16] Since no other obelisks datable to the Middle Kingdom survive, so far as we know, the true successors to Senwosret's monuments are the ones produced by the New Kingdom rulers of the eighteenth and nineteenth dynasties (1550–1186 BCE), more than five hundred years later. Most surviving obelisks date from this short period of Egyptian history. Only a few, however, have survived intact in their original locations. Some fell in earthquakes. Some were toppled by men. Many have disappeared completely, while others survive only in fragments. Of those that do survive, a remarkable number have been moved (often more than once) or rededicated to new pharaohs, kings, or emperors. It's a process that began in Egypt itself.

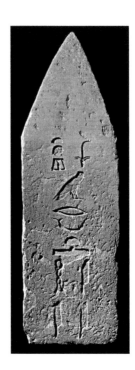

Cartouches on the obelisk
of Psammetichus, from
Francesco Maria Bandini's
De obelisco of 1750.

A miniature obelisk dating
to the Old Kingdom,
carved for the tomb of a
royal official named Ihy
and found at Giza.

uses pictorial characters, but it is not picture writing. It is a fully developed
writing system, employing phonetic, ideographic, and "determinative," or
classificatory, images that, in combination, can convey all the grammatical
and syntactical complexity of the ancient Egyptian language.

Yet hieroglyphs are also closely related to the Egyptian system of rep-
resentational art, and like that art they were imbued with religious and
magical significance. The Egyptians believed that both representational
and hieroglyphic images endowed the things depicted with a magical kind
of life – a life that could be sustained as long as the image itself survived.
Thus the name of a person written or carved in hieroglyphs literally embod-
ied the identity of that individual and helped ensure his or her continued
existence in the afterlife. The converse of this meant that the destruction
of a hieroglyphic name obliterated that person's eternal life. Hieroglyphs
of the names of rulers are surrounded by an oval ring, called a cartouche
today. To destroy the name and cartouche of a dead pharaoh, as sometimes
happened in cases of disputed or rejected legitimacy, was to destroy not only
the memory but the very life of that ruler in the other world.[13]

Inscriptions and archaeological evidence reveal that as early as the fifth

specific localities, most temples were associated with more than one god and most gods with more than one temple. The syncretism of Egyptian religion – its ability to amalgamate diverse gods and religious ideas – gave it a flexibility that contributed to its remarkable staying power over more than three thousand years. Even important gods could change and combine. During the fourth dynasty, for example, Re was joined to another god, Atum, and became known as Re-Atum.

This interconnection of heaven and earth took human, mortal form in the figure of the pharaoh, who ruled according to the sacred principles of *ma'at* (harmony, order, and truth) and represented the people of Egypt before the gods. The pharaoh claimed divine origins through his association with Horus (the god of the skies) and his identification as the "son of Re" (the son of the sun god). Often depicted praying, crawling, or kneeling before the gods, the ruler was nonetheless at one with them and provided the crucial link between the earth and the divine.[11] The obelisk, set up by the pharaoh as a monumental intermediary between heaven and earth, embodied this relationship in a profoundly physical and literal way. The typically boastful inscriptions on Hatshepsut's obelisks at Karnak drive the connection home with almost incantatory language, stressing over and over again the pharaoh's role as "son of Re," who is "beloved of Re," and recalling how the pharaoh had raised the obelisks in honor of Re and Atum.[12]

In order to fulfill its combined religious and commemorative function, an obelisk had to bear the names of the king who set it up and the god, or gods, to whom it was dedicated. The obelisks' mystical force was literally animated in Egyptian thought by the magical and symbolic power of the inscriptions that covered the sides of most from top to bottom. These inscriptions were carved using the picture-script the Egyptians called the "words of god" and the Greeks labeled "hieroglyphic" or "sacred writing." Hieroglyphs are the oldest form of Egyptian writing, and also one of the earliest writing systems anywhere. They made their first appearance on a variety of ceramic, ivory, and stone objects just before 3000 BCE and persisted in much the same form for more than three thousand years. Formal hieroglyphs were largely restricted to inscriptions on religious and funerary monuments, but over time a cursive version of the script, called hieratic, developed for use in more practical, day-to-day contexts, such as administrative, literary, and other kinds of documents. Hieroglyphic script

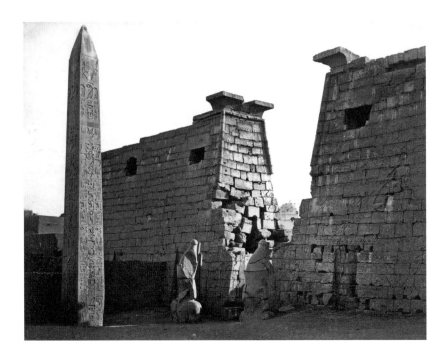

The pylons and obelisk of the temple at Luxor
in a late nineteenth-century photograph by Maison Bonfils.

That the obelisk was made from a single block was a sort of obeisance to Amun, but it was also a reminder of the pharaoh's earthly might. Only the most powerful of rulers could command the creation and erection of such extraordinary objects. One of Ramesses II's obelisks, now in Cairo, describes him as: "The King, the son of Ptah, who is pleased with victory, who makes great mounds of corpses."[9] The use of obelisks to commemorate military events and valorize sometimes brutal conquest would have a long career in subsequent centuries.

 This fusion of the earthly and divine – of religion and kingship – is the key to the context in which obelisks were first created. Egyptian religion was polytheistic, with a great multitude of gods whose realm was seen as a very real place, apart from but interwoven with the earthly one. The gods lived not in Egypt, but in distant places. Re, for example, the sun god who traversed the heavens by day and the netherworld by night, had no specific home in Egypt itself.[10] The temples were resting places, where the gods could accept offerings. And while particular gods became associated with

Obelisks pierce the sky at Karnak, captured by Francis Frith.

I and Hatshepsut were placed to the north and south of the temple gates, on the main east-west axis of the complex. In the morning, the sun would rise behind the obelisks and pylons, setting before them come evening to begin its night-long journey through the underworld. At Luxor, by contrast, the obelisks of Ramesses II rose to the east and west of the north-facing gate, where they marked the positions of the rising and setting sun.

The fact that obelisks were made of a single stone was not an accident of custom; it was inherent to their very meaning. The inscription on the base of Hatshepsut's Karnak obelisks includes a passage framed as a speech by the pharaoh:

> So as regards these two great obelisks,
> Wrought with electrum by my majesty for my father Amun,
> In order that my name may endure in this temple,
> For eternity and everlastingness,
> They are each made of one block of hard granite,
> Without seam, without joining together![8]

An early twentieth-century stereoscope view of the processional way at Karnak.
Originally, obelisks stood before the pylons.

obelisk's pyramidion, which they called the *benbenet.* By lifting the gold-plated *benbenet* to the heavens on a tapering, four-sided shaft, the inventors of the obelisk united their most potent symbol of earthly creation with the life-giving power of the sun's rays.[5]

When set before the pylons that marked the entrance to a temple, obelisks helped define the symbolic structure of the whole architectural ensemble. The pylons themselves served as monumental "horizons," or portals, that marked the passage from the realm of mortals to the king-dom of the gods, connecting the earth to the heavens and the underworld through the daily birth and death of Aten, the sun. In harmony with this idea, the obelisks rose to pierce the sky and catch the sunlight, so that, as the inscriptions on Hatshepsut's obelisks at Karnak say: "Seen on both sides of the river, their rays flood the Two Lands when Aten dawns between them, as he rises in heaven's lightland."[6] To guarantee the obelisks' bril-liant effect, Hatshepsut "gave for them the finest electrum. I measured it by the gallon like sacks of grain."[7] But different obelisks corresponded in different ways to the course of the sun. At Karnak, the obelisks of Thutmose

raised as single monuments, most obelisks were set up in pairs before the entrance gates of temples, where they were flanked by statues and faced the main processional way to the sanctuary. They usually stood on simple, cube-shaped pedestals of Aswan granite, the same material favored for the obelisks themselves; the pedestal rested on a lower base with one or two steps. Obelisks were almost always dedicated to the solar gods of Egypt, and the Egyptians often sheathed the pyramidion in bronze, gold, or electrum (an alloy of gold and silver) to catch the sun's rays. But obelisks had more mundane associations as well, marking the embellishment of a sanctuary or commemorating some other notable event in a pharaoh's reign. The details of the dedication and the name of the pharaoh who set up an obelisk were usually carved in hieroglyphs on its four faces. Over the more than two thousand years they were made, obelisks varied in size from small funerary stones to giant monuments, culminating in the five-hundred-ton colossus of Pharaohs Thutmose III and IV that stands today outside the Lateran Basilica in Rome.[2]

The word obelisk derives from the Greek *obeliskos,* a diminutive meaning "little spit" or "skewer." In ancient Egypt, though, these monuments were called *tekhen* – plural *tekhenu* – from a verb meaning "to pierce," evoking the obelisks' needle-like shape.[3] The idea may have been to create a monument that literally pierced the sky, connecting the earth to the realm of the sun god, as the Roman author Pliny the Elder suggested when he reported that "an obelisk is a symbolic representation of the sun's rays, and this is the meaning of the Egyptian word for it."[4] It's an idea that has much to recommend it, for most scholars today connect the obelisk's origin to the cult of the sun, and to a specific prototype in a much older type of stone monument known as the *ben* or *benben,* which was preserved in the temple of the sun god Re-Atum at Heliopolis – literally "Sun City" in Greek. According to Egyptian mythology, the *benben* originated at the beginning of time, when it provided the seat for the sun god's creation of the universe. It was also supposed to mark the spot where the sun's rays touched the earth for the first time and was linked to the cult of the phoenix, or *Benu*-bird, whose cycle of self-creation, death, and resurrection was associated with the cults of the dead and the rising and setting of the sun. The *benben* presumably had a pyramidal or stunted obelisk-like shape. Its relation to both forms is strongly suggested by the Egyptian name for the

The Sacred Obelisks of Ancient Egypt

Re shines forth, rejoicing over them in his House of millions of years.
It is His Majesty who has completed ["beautified"] this monument
for his father, so that his name might be granted to aid in the House of Re;
Made for him [by] the Son of Re, Ramesses II,
The beloved of Atum, Lord of Heliopolis, and given life forever.

HIEROGLYPHIC INSCRIPTION ON THE EAST FACE OF THE OBELISK
NOW IN THE PIAZZA DEL POPOLO, ROME[1]

UNTIL THE EARLY third millennium BCE, the Egyptians constructed buildings using materials associated with the Nile River – reed, wood, and mud. Then, around 2700 BCE, a dramatic shift occurred. Suddenly, Egyptian builders began to create a monumental stone architecture, including pyramids and temples and colossal statues – some made with huge stone blocks that weighed as much as two hundred tons. They also invented the obelisk.

An obelisk is a single quarried stone – a monolith – that, when placed upright, forms a square at the bottom and gradually tapers as it rises, ending with a pyramid-shaped cap, or pyramidion. Although some were

Hatshepsut's obelisk at Karnak, photographed by Francis Frith in the 1850s.

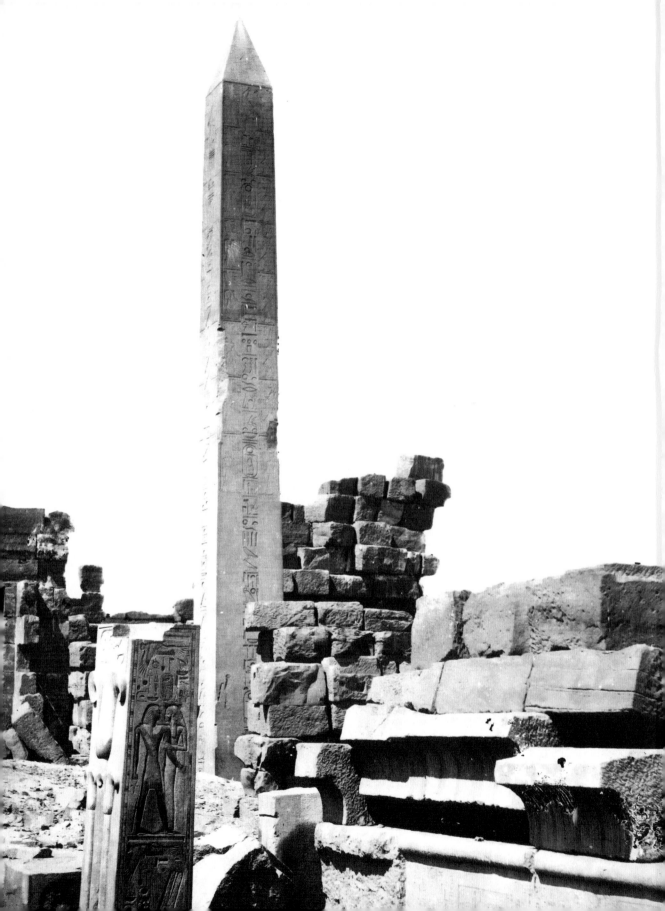

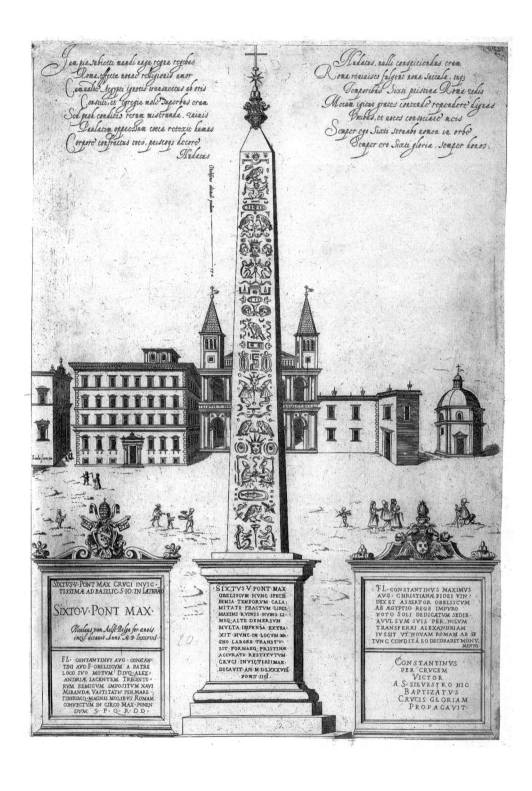

in Brooklyn, New York, in 1941, and was first housed in extra space at the factory of the Burndy Corporation, a manufacturer of electrical connectors. The Library soon moved to Norwalk, Connecticut, when the company moved its headquarters there during corporate America's great migration to the suburbs after the Second World War. The Library flourished in Norwalk, under the close eye of its founder, Bern Dibner, who commissioned Minoru Yamasaki to design an elegant jewel box to house its treasures.

After Bern Dibner died, in 1988, the Library moved to Cambridge, Massachusetts, to the campus of the Massachusetts Institute of Technology; in 1992 it opened to scholars in a beautifully renovated building on the banks of the Charles River. Under the patronage of David Dibner, Bern's son, Burndy grew tremendously at MIT. But the arrangement was temporary, and in the Fall of 2006 the collection moved yet again, to a permanent home at the Henry E. Huntington Library, Art Gallery, and Botanical Gardens, in San Marino, California. There, it joins one of the world's great research libraries, housed in one of the most seductive settings for scholarship anywhere on earth. Over the decades since its founding, Burndy has been very fortunate in its homes. Depending on your perspective, *Obelisk: A History* can be seen either as the Burndy Library's last act in its old guise, or the first act in its new. In truth, it is both, and this book, which is, ultimately, about the complicated interplay of historical continuity and discontinuity, seems an appropriate way to bridge that transition. With discontinuity comes change, but Bern Dibner's vision of a great and comprehensive repository dedicated to the history of science and technology will endure, with some luck, as long as the obelisks themselves.

The obelisk outside Rome's San Giovanni in Laterano,
rendered with very inventive hieroglyphs by Nicolaus van Aelst in 1589.

that all but a few of the images reproduced here are from Burndy's own holdings.

It is similar testament to the richness of the subject that it could inspire two such very different books. *Moving the Obelisks* is devoted to just that. Bern Dibner was an engineer and was entranced by the range of solutions different societies have invented for the problem of moving and setting up such peculiar monuments as obelisks. Although now out of print, *Moving the Obelisks* is easily available, so the authors of this book have decided not to duplicate work already well done. Instead, most of this book examines how people have thought about obelisks in the long periods when they were standing, or lying, still.

The book as it exists in your hands is very much a collaborative effort. The four scholars who came together to write it, Brian Curran, Anthony Grafton, Pamela O. Long, and Benjamin Weiss, have each come to the subject from different backgrounds and with different questions – different directions that reflect the wide-ranging history of obelisks themselves. At one point we considered trying to sublimate our styles and our personalities to a single voice. We quickly realized that was both impossible and, given the long and complicated history of the subject, inappropriate. The result is a book with a multiplicity of voices. Chapters 1 and 2 are the collaboration of Pam and Brian, with a heavy admixture of Ben. Chapters 3 and 4 belong largely to Brian and Tony. Chapter 5 is the fruit of Pam's long efforts in the Vatican Library and the Roman archives. Chapters 6 and 7 are largely the work of Tony, with interventions from Brian. Chapters 8 and 9 are a three-way collaboration, with equal parts Ben, Brian, and Tony. Chapters 10 and 11 are Ben's. Chapter 12, the epilogue, belongs to all of us. But this is truly collaborative work. Every chapter has been read, critiqued, and reworked by every member of the team. The whole has been immensely satisfying for us to write; we hope it is just as satisfying for you to read.

THE HISTORY OF OBELISKS demonstrates that even the largest and most ungainly of monuments move from one place to another with some regularity. Libraries are most certainly both large and ungainly, but they, too, move – far more often than their air of permanence would suggest. It seems fitting that this book was in preparation just as the Library that was its inspiration was itself preparing to move. The Burndy Library was founded

they serve no practical purpose, obelisks have served as a sort of Rorschach test for civilizations. In each place and time they have taken on new meanings and new associations. To the Egyptians, who invented the form, the obelisk was a symbol of the pharaoh's right to rule and his (occasionally her) connection to the divine. In ancient Rome, obelisks were the embodiment of Rome's coming of age as an empire. In the Rome of the Renaissance, they became a symbol of the ultimate weakness of pagan religion in the face of Christianity. To a citizen of nineteenth-century Paris, the obelisk was a symbol both of French engineering and scholarly prowess and a reminder of the complications of French politics. To a nineteenth-century New Yorker, the obelisk in Central Park played a double, and perhaps inconsistent, role as testament both to the unstoppable growth and immense reach of the United States, and the country's rejection of the trappings of imperialism just as it was itself beginning to acquire imperial power. And so on, and so on.

This book traces the story of the fate and many meanings of obelisks across nearly forty centuries. It is a story of technical achievement, imperial triumph, Christian piety, Christian triumphalism, egotism, scholarly brilliance, antiquarian obsessiveness, political hubris, bureaucratic indifference, bigoted nationalism, democratic self-assurance (and self-doubt), Modernist austerity, and Hollywood kitsch – in short, the story of Western civilization.

THE FIRST BOOK devoted exclusively to obelisks was published at Rome in 1589. Since then there have been dozens, focusing on every aspect of the history of obelisks: from why they were first made, to the problem of how to move and set them up again, to their purported supernatural powers. One of those books, *Moving the Obelisks,* was written by Bern Dibner, the founder of the Burndy Library, a special collection dedicated to the history of science and technology. Dibner was fascinated with obelisks, and for his Library – the publisher both of that book and this – he gathered one of the finest and most complete collections of "obeliskiana" in the world. The books in that collection range from flimsy tourist pamphlets to enormous folio volumes. Dibner used Burndy's collection as his primary source when he was writing *Moving the Obelisks,* and it has been the essential source for this book as well. It is testament to the depth and range of the collection assembled by Dibner and the librarians and curators who followed him

Introduction

AN OBELISK seems an awkward souvenir of a trip to Egypt. Obelisks are large. They are heavy. They cannot be disassembled, since, by definition, an obelisk is made of a single stone. Until the most recent of times they fit in only the very biggest of ships, specially designed for the purpose of transporting obelisks. They are not made of a precious material – most are granite – and despite their size obelisks are fragile and prone to cracking. They serve no practical function, and for much of history their inscriptions, in Egyptian hieroglyphs, were completely inscrutable. Yet over the centuries dozens of obelisks have made the voyage from Egypt. They have gone to Rome, Constantinople, and Florence; Paris, London, and New York. Every empire worthy of the name – from ancient Rome to the United States – has sought an Egyptian obelisk to place in the center of a ceremonial space. Obelisks, everyone seems to sense, connote some very special sort of power.

It is an obvious association. After all, who but the most important of states and rulers could cause such large, ungainly rocks to move over such large distances? But the simple association of obelisks with political might is too simple. For though they have always been associated with power, obelisks have not always represented the same sort of power or represented power in the same way. Partly because they are so inscrutable, partly because

The obelisk at Heliopolis.

Contents

Copyright © 2009 The Burndy Library

Library of Congress Cataloging-in-Publication Data

Obelisk : a history / Brian A. Curran . . . [et al.].
 p. cm. – (Burndy Library publications ; new ser., no. 2)
 Co-authors: Brian A. Curran, Anthony Grafton, Pamela O. Long, and Benjamin Weiss.
 Includes bibliographical references and index.
 ISBN 978-0-262-51270-1 (pbk. : alk. paper)
 1. Obelisks. I. Curran, Brian A. (Brian Anthony), 1953– II. Grafton, Anthony.
III. Long, Pamela O. IV. Weiss, Benjamin.
 DT62.O2O53 2009
 731´.76—dc22

 2008034163

Portions of Brian Curran's contributions to chapters 3, 4, 6, and 7 derive from or develop material recently published in his book *The Egyptian Renaissance: The Afterlife of Ancient Egypt in Early Modern Italy* (University of Chicago Press, 2007) and are included here with the permission of the press.

Diagram on page 27 by Mary Reilly.

Distributed by the MIT Press, Cambridge, Massachusetts, and London, England.

Printed and bound in Spain.

OBELISK

A HISTORY

Brian A. Curran | Anthony Grafton | Pamela O. Long | Benjamin Weiss

BURNDY LIBRARY, CAMBRIDGE, MASSACHUSETTS, 2009

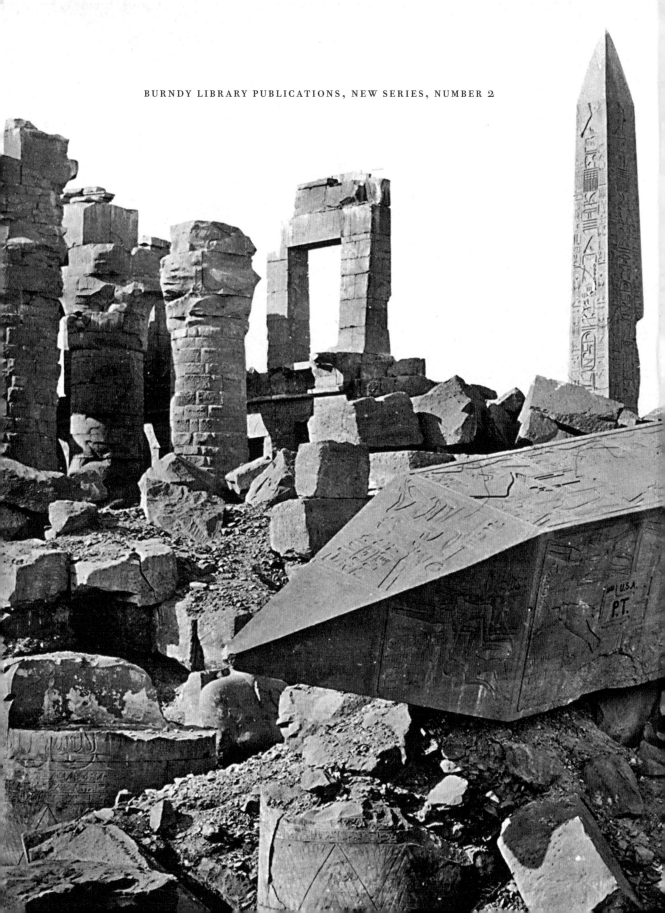

OBELISK